LADY-FAME;

OR,

THE FLUKE.

BY

PETER SANTINO

ARTIST & AUTHOR OF
"MOUNT SHASTA," A PHOTO-NOVELLA FOR THE INTERNET

~~~~~~~~~~~~

FAILURE INSTITUTE

NEW YORK  FIRENZE  EUREKA

2014

LADY-FAME; or, THE FLUKE is a sea story.
Names, characters, places, and incidents are, in part or in full, the products of
the Truth; the author's imagination; and a fanciful collaboration with Herman Melville.
Exception to this is the account given of the capsizing and ensuing heroics,
which falls so far outside the normal realm of human belief
it could only be presented as a sea story.

Failure Institute Trade Paperback, 1st Printing, July 2014.
Second Edition, November 2019

Copyright © 2014 by Peter Santino
LADY-FAME; or, THE FLUKE – non-fiction novel (sea story).
All rights reserved. No part of this publication may be reproduced,
stored in a retrieval system, or transmitted, in any form or by any means,
electronic, mechanical, photocopying, recording or otherwise,
without the prior permission of the publishers.

ISBN-13: 978-1483905617
ISBN-10: 1483905616

FAILURE INSTITUTE
NEW YORK   FIRENZE   EUREKA

IN TOKEN
OF MY ADMIRATION

𝔗𝔥𝔦𝔰 𝔅𝔬𝔬𝔨 𝔦𝔰 𝔍𝔫𝔰𝔠𝔯𝔦𝔟𝔢𝔡

TO

HERMAN MELVILLE
&
H. STEVEN DOCKTER

[A reader may choose to skip over both Etymology & Prologue, returning to them at a later point, or not.]

## ETYMOLOGY & PROLOGUE

*The Failure (1):*
Normally proposed as the opposite of The Success.
*The Failure (2):*
Beginning an essay, thesis paper, doctoral dissertation, journal, novel, fairy tale or sea story with a definition.

*The Fluke vs. The Rogue:*
Fluke is okay, but Rogue, O! What a great word! Fluke does the job and has all those fish, ocean, whale associations. But Rogue! Standing apart, never caring about society's judgment of success or failure, up against the wall in stiff, dirty, never-washed Levi's®, white T-shirt and grimy leather; smoking and pulling a smelly rat-tail comb out of the well-worn Perfecto® and running it through the greasy duck's ass. Then here comes that Rogue Wave.

O! What a great concept! Rogue.

Why did that winking, whining,  of an Alaskan ex-governor, have to go and step all over my beautiful Rogue? If not for her, I might have presented all this to you as the fascinating ramblings of The Rogue Artist struck and shaped in youth by The Rogue Wave!

A Fluke, I suppose. Serendipity. Leading to whales. And naturally then to books about whales; books about whales, the sea and such.

*The Fluke (1):*
Trematode. A giant flatworm with big, glistening, tooth-filled suckers that attach to the sorry host and drain nourishment; freeing the parasitic creature from the need to brush his teeth, shave, shower, get a job, have a pleasant personality or pretty much do anything normally necessary for survival.

*The Fluke (2):*
An unknowable phenomenon, luck, chance. An unpredictable incident or occurrence that pops up within or drops down into the stream of a life and alters the flow of that already established rivulet of existence. Irreversibly. For better or worse. Like bending down to pick up the glimpsed coin on the curb just as the un-glimpsed assassin pulls the trigger... like the ring of a telephone on a cold Saturday afternoon.

*The Fluke (3):*
The whale's tail. But not just a whale and not the whole tail. The fluke is either one of two lobe-shaped horizontal parts of the tail of a cetacean: whale; dolphin; porpoise. Flukes, it seems, have to be attached to a sea mammal and are the last thing visible when, after taking a deep breath, it plunges into the depths.

*The Fluke (4):*
A barb. As on the tip of a fishhook. As on the end of an arrow's tip. As on the anchor; that flat blade that digs into the floor of the ocean, as the boat, as the ship and miles of line and chain all dragging, that flat blade digs in and stops, holds it steady, saves it, lets the bow (pulling so tight on the line now) come about and put itself into the weather. That handy part of the anchor that would grab the sea bed if your ship were a hundred yards offshore and in danger of being pulled into shore and smashed into a thousand sharp and pointy pieces which fly about, churn about in the surf, impaling you as you are being pounded into the rocks and smashed by wave after wave breaking on you with the force of brick buildings collapsing, until there is nothing left but little globs of bloody mess floating gently now, gently... quietly... drawn back out to sea, gently... merging again with the One, the Mother... back into the pudding. Food for the crabs... nibble, nibble.

*The Crab (1):*
Crustacean. The word clicked and clacked sideways into English as crabba from a Germanic root: krab, krabbe, krabbi, krabben.

Thousands of species of this shelled animal live in every source of water, fresh and salt, everywhere on earth.

Research reveals that while some species might well be suitable as filler material in frozen crab cakes, the one variety that surpasses all crabs and in fact all other delicacies from the sea, stream and lake – including lobster fresh from the boat in Gloucester, scampi hot from the grill in Rome, a little butter, olive oil and rosemary, salt, pepper – surpasses them all in texture, aroma and indescribably delicious taste is found only along the West Coast of North America, from mid California to Alaska: The Dungeness Crab!

*The Crab (1a):*
The Dungeness Crab! Early in the crab's annual migration north, the harvesting begins while the Dungeness, already fine tasting, has not yet achieved its peak of flavor. That peak is only reached after a long and difficult swim in mammoth clusters, hundreds of thousands, swimming as a group along the sandy ocean bed, their legs locked one crab to the other for protection from predators. Building character with each stroke, feeding all the time, north, San Francisco, flavor beginning to improve, north, Fort Bragg, worth catching and eating now. But wait! Further still where perfection is finally achieved!

Now deserving of the sobriquet "Humboldt Strawberry," the Dungeness are scooped at great risk from the turbulent waters between Cape Mendocino and Point St. George, boiled alive and presented whole and steaming on thousands of Christmas tables.

*The Crab (2):*
The crab louse, pubic louse. Not actually a true crab, Pthirus Pubis is a tiny insect that lives exclusively in the pubic hair of humans, feeding on human blood four or five times a day! It waits patiently for the hot sweaty contact of sexual intercourse to jump to the warm, dark, hairy regions of a new host.

*The Crab (3)*
Cancer. From the Greek word, karkinos, which had three meanings, as does cancer: a) the spreading sore, the tumor; b) a constellation in the Zodiac; c) the crab as a creature.

Hippocrates made reference to some tumors looking like crabs.

Those born between June 22 and July 22 are said to be under the sign of Cancer the crab. They tend to be patriotic – natural enough since so many are born on the 4$^{th}$ of July. Cancers are emotional and wear their hearts on their sleeves, but, much like their crustacean friends, have a hard shell into which they duck during times of stress or personal danger.

Out among the stars is found the Crab Nebula, so named for its distinctive shape. Sadly, it is located in the Taurus (the Bull) Zodiac region.

Then there's the term cancer stick for cigarette dating from 1959, dear friend to all those hearty salts on the bounding main, fishing, catching crab.

Also, this:

*The Harmonics:*

    **ALL IS VIBRATION - ALL IS FREQUENCY - ALL IS HARMONICS**
    *Woodbass*

*Considering Memory:*

    **DON'T LOOK BACK**
    *Bob Dylan*

## *Prologue:*
### Loomings

Thank me dry! After the really bad time, I ran. Some forty years ago, young, broke and looking, searching for an alternative-something to the depressing shit-life I had going on. I listened to that wise-ass coyote and chose to go Home, go to work, go to sea. The choices were limited and since Academe and its Ivory Towers had been rejected in the midst of that same heady epiphany which rejected swooping in low over thatched-roofed villages and loosing floods of orange-hot burning gelled gasoline; well then, working in the woods cutting down the towering Redwoods, or pulling on foul weather gear and crossing the bar to chase the wily Dungeness and the slippery Chinook out in the cold, blue Pacific, were the only possibilities that would keep me from the sad office, the miserable warehouse, the auto parts sales counter.

*Home* was the port city of Eureka! on the Humboldt Bay, at the very center of the universe for the Wiyot people and at the very end of the world for the Immigrant people. A place once hemmed close to the water by those same, aforementioned towering Redwoods, thick and dark, and dripping with fog. Ten thousand, twenty thousand years! Each of the days beginning and passing in the same manner with only the slightest flickering changes in weather: sun; rain; fog; wind. The feet of the Original People finding the paths and imprints of those who walked the day before and the week before and the years before.

Ten thousand, twenty thousand years without change, without need for change and then the people came whose very nature was change and whose religion was the need for change. They came from the East. Cocksure changers. Changing things. Fixing things. Making the world better. Fixing the world forever. Fixing the world for Good.

My Immigrant relatives (Maternal) were fine changers and fixers from Scotland across the other sea, where they had run out of things to fix. Coming from the East and up from the South and down from the North. Following those clear and fast rivers, picking up the gold that just lay there. Following those rivers and coming to the edge of this big ocean, and the bay that sat hidden – its entrance missed by explorers, pirates and privateers for hundreds of years.

Coming to this forest of Redwoods! Trees of unimaginable size and age like something from a fairy tale. Yes, a fairy tale but a Northern European grim and frightening fairy tale forest. A dark and damp place where evil trolls and wolves and Satan and dancing naked natives must certainly dwell untouched by God's Holy Sun. An opportunity! A chance to rid the world of this dark and damp and evil place by felling Redwoods and letting the Lord's cleansing light in! A chance to let that same healing light fall upon the naked backs of the local savages. An opportunity to fix this world; to change this evil world for the Good. And to make a shitload of money in the process. A happy ending like the best pornography and the best tales.

Aye, a best tale, a best sea story, I will tell ye.

Ye have heard the difference between a fairy tale and a sea story? If not, I can remind ye. A fairy tale always begins thus: "Once upon a time..." And a sea story always thus: "Now, this is no shit..."

Now, this is no shit.

## Chapter 1
### The Telephone Rang

The telephone rang. Just when I had the cocksucking picture steady. And now it's going to do its stupid thanking little horizontal roll and roll and roll a roll a roll a roll on to that pop! into diagonal lock and there the thank it is. David's music so loud, YES. The 49ers on a Saturday afternoon, the 23rd of December 1972 to be exact and yes, yes it does matter. It does matter since all of this really happened.

Thank me dry, the telephone rang. The Dallas Cowboys from blonde and bosomy, sun-addled Texas, led by Roger Staubach (America's team!) beat the San Francisco 49ers from the land of the dirty darkie homos and commies, led by John Brodie, 30 to 28. I can tell you this now even though I never saw much of the game; even though all I ever wanted to do was watch it. Escape for a few hours in something banal and normal. Freezing cold, pacing back and forth wrapped in a blanket, smoking cigarettes, drinking coffee and hoping for a few minutes of clear television reception.

I remember that television set. A Philco® Seventeener – green and cream, two-tone – with rabbit ear antennae coming out the ends of a swiveling luggage-style handle on top. Portable television design at its highest. A shortened picture tube with that luggage handle on top conjuring up an image of Mom or Dad just grabbing the thing like a little valise and toting it into whatever room desired for viewing at the moment, all the while holding a cocktail in the other hand. It had been the only TV set in the house I grew up in on P Street until it was replaced with something better. I grabbed it for my artist's garret. If only it actually worked.

Rolling and rolling and when the vertical hold was just holding the horizontal would pop and motherthaaaaaaa arrrgh shit! David's music so loud, yes, YES. Thanky, thank, thank, thank thank.

The telephone rang. Not exactly. It sort of sputtered. It hadn't been ringing too well for some time now. Not since F. Scott, in an effort to get some sleep, had castrated it.

♪ *Roundabout*, Yes

"David, could you turn that down! The TELEPHONE!" I yelled.

## Chapter ii
### *The Telephone*

Whether it was a normal offering, or someone knew someone, or some administrative mistake, I never figured out, but the telephone in the warehouse was a public pay telephone mounted on a wall in the dark hall upstairs near the bathroom and kitchen.

A clever solution to the worry of huge long-distance charges built up by ne'er do well residents and visitors; the local Pacific Bell® office had been happy to do a free installation. No monthly bill, no equipment rental.

> **AHOY!**
> **ALEXANDER GRAHAM BELL FELT THE PROPER GREETING**
> **WHEN ANSWERING THE TELEPHONE SHOULD BE:**
> **AHOY!**
> *Anonymous. Posted near telephone*

## Chapter iii
### *The Ice & Cold*

I took a job almost as soon as arriving Home. In that new first week of that new first month of that new first year of that new decade, 1970. Not on a boat as I was hoping, but as close as I was going to thanking manage right now.

"Can you start this afternoon?" Jack ▮▮▮▮ the manager had said, with his nervous giggly voice, carefully looking down at my boots to avoid eye contact as always. Jack giggled again to my boots.

Three or four years before, Kento and I had spent many long days and nights working at the ice plant during high school Christmas vacations and summer breaks, manhandling and hard-freezing the slippery, slimy catch of Humboldt fishermen.

# THE ICE & COLD

Eureka Ice & Cold Storage, right on the bay with its cold concrete docks and windswept loading bays that seemed like tropical beaches during breaks from the freezer rooms. Every forty minutes hit that hanging cord with a gloved agony hand that could barely grasp; a motor parts the vault doors and midst clouds of fog, enter into Ipanema. *Tan and lovely... Caipirinha, sir?* Pull off layer after layer of wool and thick fish-oiled canvas. Throw that shit on the heaters, try to drink coffee, smoke cigarettes. Twenty out, forty in. The twenty was gone real quick and it was back in after reassembling the layers of stinky, steamy, slimy, partially hardened clothing, pushing a heavy steel bucket cart of fresh black cod to be laid out on the frigid galvanized shelves at minus 30 degrees – Fahrenheit mother thanker!

♪ *Baba O'Riley*, The Who

"You guys are thanking crazy to do this job," said the most talkative of a group of dumbfounded stevedores who'd come down to the ice plant to pick up a little easy money during a week of slack dock work. They'd lasted a couple of hours – forty minutes in, twenty minutes out – and were anxious to get the thank out of there.

"I wouldn't thankin' do this for three times the thankin' money," said another. Kento and I just smiled.

"It's therapy, fellas. It's all about therapy," I said. *Arbeit Macht Frei* had been scrawled in lumber marker above the back freezer door by somebody, some joker.

Therapy, yeah, plus workmates. And while Johnny didn't actually work at the Ice & Cold, he was there every day picking up brine frozen crab and delivering fresh fish for Lazio Seafood a couple of blocks up the bay. Kento and I'd known Johnny Tashtego since high school and we'd bonded while surfing together over the years, frolicking with Steve, *mit den Bieren*, down at Shelter Cove.

Most of the time we used our old surfing nickname for Johnny:

> [THEY CALL OUT POINTING,
> ARMS OUTSTRETCHED TO THE SEA FROM THE BEACH,
> NEAR A SMOKING DRIFTWOOD FIRE:
> "LOOK, THERE! THERE NOW!
> FOR HE IS ON THE NOSE!
> LOOK NOW! HOW HE IS!
> O!, AT THE WAY HE STANDS THERE!
> SLOUCHY, YET BACK ARCHED BACK AND FIVE TOES OVER!
> GROOVY, GROOVY DADDY,
> HAIL, HAIL, GROOVY DADDY!"]

## *Chapter iv*
### *Chuck Wagoneer*

We spent our Mr. Chuck Wagoneer breaks smoking cigarettes together on the loading dock and Steve would have been there too, smoking and trying to get warm with coffee and hot chocolate, but he was off frolicking mit den Mädchen in Germany. It took longer to get to know Keith than it would have if Steve had been there.

Keith Buck was the king of the Ice & Cold. Looking like something out of Wagner standing high and golden on the huge machine, he'd fork these massive plywood crates – noses, fins and tails of frozen tuna poking through breaks in the sides and threatening to spill from over the top. Towering forklift pushing out the portal with the blast of a huge white cloud when minus 30 embraces plus 50, from one side of the plant to the other. Checks his clipboard. Then back with a pallet stacked high with canned crabmeat – crescent-moon-cardboard-boxed and bound for Vietnam.

[THE SCORE:]

High-pitched shrieking whine of the electric forklift eeeeeeeeEEEE EEEEEEEEEEEEEEEEEEEEEEEEEEEEEEEeeeeeeeeeeee; the grind and cram and roar of the opening portal; skitter of hard rubber wheels through puddles; the howl of wind; the explosion of mist.

♪ *Mississippi Queen*, Mountain

Nordic, stoic, native of Eureka, Lutheran by mother. Looking into those deeply set eyes you sensed he was a man who had endured much and would no doubt endure much more with no complaint. A champion in heavy gloves, fur-hooded thick coat with cigarette drooping.

The picker ladies with their white babushkas and jeans tucked in rubber boots were all so in love with him and just a bit afraid. Keith didn't smile at them, just drop that pallet. He'd be back when it was full.

Sometime later, it was Keith who brought up the idea of the three of us, Groovy Daddy, me, and him, putting in together and renting a big enough space to work in.

"Good... good," said Groovy Daddy. He'd been making some minimalist, installation type work out of chain link fencing in a small dark room Lazio's lent him in one of the old wood waterfront buildings they owned. He'd just about installed himself out of space, just about fenced himself out.

"Yeah, maybe we could find something big enough and halfway habitable. Make a real co-operative studio. I don't want to be staying at my parents' house. And Kento, he's got that little place on Harris, but maybe he'll wan..."

"Yes and soon!" put in Keith, cutting me off. "I haven't set up my loom for years. Not enough room at my mother's house. Something habitable, yes! We need someplace to live too." He always looked intense, serious, but then relaxed into a huge smile after a long drag on his cigarette.

"I'll ask my father tonight whether Lazio has any buildings we could rent." Groovy Daddy's father was the bookkeeper for the fish company and knew where every skeleton, with fins or otherwise, was hidden.

**ART IS NOT A MIRROR TO REFLECT REALITY
BUT A HAMMER WITH WHICH TO SHAPE IT**
*Bertolt Brecht. Hand lettered on the front of Keith's forklift*

## Chapter v
### My Ship

So I stepped across that threshold like walking up a gangplank and embarked on my much-desired adventure to sail the mysterious seas of creativity in an ark of art. I did not know at the time and still to this day find it hard to understand that I climbed those musty wooden stairs and surveyed the vast open second floor not as lowly scrub but as master.

Are those glass jars for bait? Are those piles of old hemp rope available? "Are you the owner, sir?" I asked.

"Supposing I was, what would you be wanting of the owner?"

"I, well, me and my friends, were thinking about renting this place." I was taken aback by the situation, since I thought someone, most likely he, would be expecting me. The front door had been open, all was arranged, I thought.

"You were, were you? Do you have any experience in the renting and

operation of a 30,000 square-foot warehouse such as the one in which we now stand?"

"I have rented apartments before. Two in San Diego. Also rented a twenty-one foot trailer and its parking spot, well, I went in half on that, but I did rent a house once."

"Don't speak of apartments and rental houses to me, laddie! This be serious industrial property we are negotiating! Trailers! Tomfoolery…"

[FADES TO MUTTERING.]

I heard a toilet flush behind a rough redwood wall and immediately another man, very similar in dress, appeared, walking toward us.

"Hello, hello, you must be Peter." Similar in dress, maybe, but considerably different in manner was this new one.

"I'm Roger Bildad and the fellow who's been yelling at you is Don Peleg. I spoke to you on the phone. Peleg/Bildad Property Management. We're handling leases and rentals for Lazio," and he reached out to shake my hand.

"Don't be too upset by Don's attitude. He still hopes for a serious manufacturing business to take the place. I spoke to Lazio and I understand this is different – the whole starving artist routine, ha ha!"

Roger looked to be about half of Don's age and while also dressed in a suit, he had soft, damp eyes, a wispy moustache, slightly elongated sideburns and a hair or two creeping over his collar.

I'd already seen enough but wasn't clever enough to hide my enthusiasm.

"It's perfect!" I exclaimed. "We'll take it. Where do I sign? How much a month?"

"We were discussing terms back at the office," said Peleg. "Considering the square footage, comparable rentals in the area, $777 a month."

"That's a lot more than I had tho…"

"Blast you, Peleg," cried Bildad, cutting my meek response. "Dost thou intend a swindle?"

"7, 7, 7," repeated Peleg. "A nice easy sum to remember."

"Wait," interrupted Roger Bildad.

[SOTTO VOCE TO PELEG:]

"Remember the talk I had with Lazio, Don?"

Roger turned to me, returned his dewy eye contact and said, "We thought $100 a month would be fair."

"That's great, thanks."

"Oh, there is this one little thing," said Roger. "A fisherman who delivers

to Lazio stores his crab gear here. Would it be okay? Just until he finds another spot? Just..."

"Sure, fine," I blurted, excited about the rental price.

"...downstairs in the back you won't really even see him. Great! Oh, and there's this other guy who has been wanting to rent the place. He's an artist too. He'd fit right in. We can set that rent if you are willing to give this guy some space, as part of your *co-operative*."

"Huh. Who is he?" This I hadn't seen coming.

"What kind of artist? What kind of work does he do?"

"You probably don't know him. Just moved up here from Oakland. He cuts up old wine barrels and makes them into artistic chairs and tables. Very beautiful, elegant, or so he told me. Really a very nice guy. Name of Charles. He prefers Charlie, Charlie Cain."

"Yes, Cain," said Don Peleg, with a little smirk, "like the brother."

♪ *Seemann, deine Heimat ist das Meer*, Lolita

## Chapter vi
### Characters

Once Groovy Daddy, Keith and I had a look at the place, we realized bringing in some other artists would not just be a good idea, it was key to having WACO function as a real co-operative studio.

"Not just anybody," said Keith, and I agreed.

"I know this guy David, a student up at Humboldt State. Great guy. A painter, I think. I'm pretty sure he'd be interested in renting some space," Groovy Daddy offered.

Hmmmm, David McStubb. I remembered him from high school. A year younger than Steve and me. Always pleasant and friendly with one of those handsome wide-open smiling faces the girls all seem to go for.

♪ *Ooh La La*, Faces

He looked a bit like the young Rod Stewart of the *Faces* period, same poofy hair but with an almost invisible thin droopy moustache and a quick laugh of dismissal if you tried to get too serious.

"Man, I just don't know what to do! Advice?" I might ask while sitting hungry at the kitchen table worried, anxious about... something. David, turning pirouettes in front of me with his ever-on professional roller skates, would reply "Hah! That sounds like a personal problem! Hah hah hah!" while skating off.

Maybe the thing that kept him in good spirits was his friend, his pipe. The pipe that was constantly jammed tight in a corner of his mouth. At the dawning, when he lifted head from pillow, a pipe, freshly tamped full, went in and a lit match found it quickly. David kept a row of five pipes, in different shapes and sizes, on a little wooden shelf low on the wall next to his mattress; each cleaned and ready to be loaded and lit. We were told it was an over-the-counter Captain Black vanilla mix and it did smell that way, indeed, sweet like a summer cookie, not at all harsh like cigarettes can sometimes.

♪ *You're So Rude*, Faces

We all assumed he augmented the tobacco with a just hint of the local sensimilla, and called him Happy David.

## *Chapter vii*
### *Characters & Characters*

Scott Gerard, or F. Scott, the guy I mentioned earlier who'd castrated the telephone, lived in the warehouse also. The rent was cheap and he needed a garret-like atmosphere for writing his version of The Great American Novel. College done – degree in English – all set! Now he was going to stun the literary world with a gritty workin' class adventure about tough talkin', cigar chewin', foot stompin' truck drivers caught in a web of existential incidents involving tits 'n liquor and always wonderin' 'bout what it all meant, and all them gerunds wit' no g. 1970, 1971, he was a good five years ahead of the big truck driver craze. If his book had been on the shelves when that song Convoy hit, man, it would've been an easy best seller.

**NEVER PUT OFF TILL TOMORROW WHAT MAY
BE DONE DAY AFTER TOMORROW JUST AS WELL**
*Mark Twain. Posted in hallway*

I wasn't a writer then any more than now but I did make paintings and drawings with words in them and I found the practice of calligraphy enjoyable, spending many happy hours lettering pieces of found cardboard, or the occasional purchased matte board, with clever aphorisms and witty quotes. That Mark Twain thing was an example, pinned up in the hall near the kitchen.

Here's another:

**DON'T LOOK UP HERE FOR A JOKE
YOU'RE HOLDING IT IN YOUR HAND!**

*Unattributed. Posted in bathroom above toilet*

That one was eye level above the toilet. I admit I just copied it from the restroom of that cafe in Laytonville, but it did look nice in pen and ink on white Bristol board with a very thin, crisp, inked border until ruined by errant (?) spray.

If you asked for a description of F. Scott, I would say this: Picture the young Errol Flynn of Robin Hood standing there smiling in front of you, shit-eating grin. Then take off his suede booties and green tights and replace them with Vietnam era combat boots and knee length plaid shorts, dirty T-shirt tunic. And oh yeah, stick a smoldering, Swisher Sweet® skinny turd cigar in his mouth.

Pretty remarkably close, I tell you. Anyway, his eyes are very big, clear, green, and set off by dramatically thick eyelashes. Those eyes make him look clever, a bit mischievous, always twinkling.

Twinkle, twinkle.

F. Scott was a very local guy. Raised by bona fide Bohemians in a wild windswept Victorian farmhouse out on that lonely one lane road to Table Bluff. Along with scouring the house's clapboards to a paint-free grey, the constant wind had turned all the surrounding spruce and cypress into spooky topiary and given his childhood a howling, haunted soundtrack.

The parents, both heavy writers and serious drinkers, surrendered over the upstairs of the house with its bathroom and three bedrooms to their children – Scott, Wendy and Duncan. None of them wanted to go to school so it wasn't insisted upon. Instead, an early form of home schooling was imposed. Basically, first learn to read and then start reading. Then, here's some more books.

The children read upstairs. And they did whatever else they wanted upstairs: cut passages between the rooms; built rope ladders and elaborate forts; put together model rockets and small bombs; carved the woodwork; painted murals; used mirrors and lenses to construct death-ray beams – death for spiders and insects, anyway.

The parents stayed below never venturing up those stairs for any reason. An intercom was set up by Scott for the minimal necessary communication:

[PUSH TO TALK]

"Hey! We need TP up here!"

[PUSH TO TALK]

"All the fixings for tacos are hot on the table!"

F. Scott's actual first name was Flask, decided upon just after the birth by his father while taking a long draught from one. Everyone just called him Scott and he was fine with that right up until he decided to start writing. I sometimes made an effort to go along with his evocative re-naming request, but more often than not, I ignored it.

He was frustrated with this writing thing, not much ever got on the page. Instead he took a truck driving course out at College of the Redwoods. He became a *tough talkin', cigar chewin', foot stompin'* truck driver who didn't give a shit about the meaning of it all. Got a night job hauling tank truck loads of *product* up and down the county.

♪ *Drug Store Truck Drivin' Man*, The Byrds

F. Scott called it *product*. I thought that was so funny and always laughed. Maybe it was a truck driver's professional way of referring to whatever they were hauling. Maybe they taught him to say that in truck driving school or when he took the job with the distributor. Never gas or gasoline but always *product*. I found it so amusing. He didn't give a shit about what I thought, so naturally when he asked why I laughed, I told him.

"Well maybe, Scott, maybe it's because we don't normally conjure up a fireball and burning people and their faces are melting and great slabs of crispy flesh are sliding off and they're running away screaming waving their arms and dying, when we think of *product*," I said.

He looked at me with a *what the thank are you jabbering about?* look.

F. Scott didn't give a skinny rat's ass shit.

What he did give a rat's ass shit about was getting his sleep. I didn't tell him to get a night job. We're living in WACO. I didn't tell him he had to live here either. WACO, a state of mind, an old warehouse on Second Street in the bad part of Eureka. Industrial, not a home-sweet-home in the quiet suburbs.

Never was the easiest place to sleep even at night. Truck and car traffic in the street all day and the Northwestern Pacific train a block away

hauling lumber up and down First Street. Mendenhall Moving & Storage Company across C Street was always working on some kind of equipment with those annoyingly loud, whirring, compressed-air tools. Kitty-corner across Second, The Ebony Club, a topless bar that had full blast music from early afternoon until 2 a.m.

And inside WACO, there was constant noise. After closing down the bar, some of our fidgety, creative types built strange and noisy artworks until dawn. And in the daytime records playing, hammering, people yelling. And right next to F. Scott's room – just outside his thin door – hung our official Pacific Bell® pay telephone. Always ringing. You have to pay a dime to make a call. But it doesn't cost anything to make it ring.

Night shift truck driver F. Scott decided pretty early on in his residency that his day-sleeping was more important than the rest of us being able to get telephone calls. At first all he did was take the receiver off the hook. Pretty easy, but he was careful and clever. F. Scott wedged a little lump of clay (pinched from the ear of Happy David's latest work in progress) into the space under the handset holder. The arm sat down on the clay which was just enough to keep the weight of the handset from pushing on those contacts. It was off the hook – a busy signal to anyone calling. To a person glancing, to the passerby, it appeared to be hung up and in fine shape.

Elizabeth ▮▮▮▮, my girlfriend at the time, called to ask if I wanted to go see a movie, and the phone was busy. She kept on trying for a couple of hours, still busy, and then started to worry. Why not worry? Everybody else in this town worried about what was going on in this old warehouse. This was long before the whole "loft" thing got started.

On the cutting edge, WACO got featured in a Bay Area weekly newspaper story about audacious artists moving into old abandoned industrial buildings. Project One and Artaud in San Francisco; WACO in Eureka, but *no one* actually lived in old warehouses. I mean who knows what could be going on in there. Ten odd-looking people hanging around, sleeping in there, calling it a studio, a co-operative studio.

*"Officer, they refer to it as a studio... a co-operative studio. It was the use of that suspect term 'co-operative' with its ugly Socialist connotations that alerted me. I felt it was my duty as an American to report my suspicions."*

Ye Gads! – anything could be going on in there! What did that black paint job mean, *exactly*?

**WELCOME ALL AXE MURDERERS & SATANISTS!**
**SUNDAY BRUNCH HERE –$4.99– BOTTOMLESS MIMOSA!**
*Imaginary banner hanging on WACO exterior wall*

And that name WACO painted white high above the door, the black door in the black wall. Drawing them in, drawing them in, man.

Once, middle of the night, a drunk from Texas, quite a drawl and not just a drunk drawl, rings the buzzer. I poke my head out of the second floor window above the front door and yell,

"WHAT! Yes? What?"

"Whaaah did y'all paint the name of mah hometown on th' side of yer buildin'?"

"Sir, I did not paint the name of your hometown. I painted the name of this co-operative studio, WACO. It's not Waco (WAY-co), it's WACO (WACK-oh)."

So Elizabeth tried a few more times. Worried a little more, then called the operator who rang the phone. They could do that, you know. Override the *off-the-hook*.

The frustrated truck driver writer got woken up again. Later that day, I had a little chat with him.

"So look, Scott, you're not the only person living here, understand? Maybe somebody else might be expecting a call. Maybe something important. Just leave the phone hooked up. I'm sorry you get bugged by the ringing, but..."

"Okay, okay, that's true," he said.

## *Chapter viii*
### *Characters & Characters & Revenge*

I should add this in: F. Scott and Happy David didn't get along. Big surprise? Probably not. I never knew what really started this, but I can speculate. Whilst creating, Happy David did like to play music on his little record player. F. Scott was sleeping days and Happy David was playing that first Yes album, the one with Roundabout, a lot, kind of loud. Rolling around on skates, smoking his pipe, humming along to the music.

That would do it.

♪ *Roundabout,* Yes

I didn't actually ever see a physical fight, nor any sort of fight between them, but at some point there must have been a confrontation with a puffed-up F. Scott bumping his chest into Happy David's, waggling his

finger in his face, complaining about the noise and how the working man and his need for sleep must be respected by the lazy student, the lazy long-haired art student, no less.

Happy David would have backed off (rolled off) apologizing, even been a little scared. A little fear turning into a little anger and then, maybe next day, inspiration!

Like I said, I never knew what started it but I did find out later what Happy David did to get even. Pretty funny, actually. A well thought out solid gag. But much like in the Middle East, Sicily or West Virginia, one *gettin' even* must beget a *gettin' even* for the *gettin' even*.

So later, what F. Scott did to get back at Happy David, well, *thankin' aye!*, F. Scott's revenge was a masterpiece.

A very long, nasty, funny and inspired *gettin' even*.

But let's start with Happy David...

## *Chapter ix*
### *McStubb at the Rise*

Happy David knew F. Scott always got back from his product run at 7:00 a.m. and hit the rack for some down time as he would have made a point of saying. He also made an evocative point of saying he was hornier than a three-peckered goat when trying to sweet-talk some chick at the Ebony Club last call or that it was time to feed the fishes whenever a bowel movement summoned.

I was most likely up and on the boat hours ago. Trini and Charles Motherthanker III, the lovebirds, were way at the other end of the building, half a city block away, entwined and snoring all naked and sweaty under piled up sleeping bags in the warm workroom nest Charles had built against the west wall of the second floor.

Keith Buck – Wise Keith the weaver – had his sleeping and workroom more in the center of the second floor to be able to use one of the skylights. Keith had become *Wise* since the new Keith, Keith Walden, arrived that first summer. To keep the Keiths in order, this new one became Sweet Keith. He was the only one of us who slept down on the danker and seemingly much colder concrete first floor (except maybe the troglodytes; no one ever saw them). Sweet Keith was certainly passed out in what amounted to his

cardboard and sheetrock bunker near the front entrance.

None of them would have been much bothered by the phone ringing at this early hour even as loud as those pay phones ring, ringing right next to F. Scott's room, just outside his thin door.

Happy David rose up from his mattress-on-the-floor bed in his tiny, rough redwood room next to the kitchen and quietly headed down the old wood stairs and out to Peggy's Cafe.

> **IF YOU WANT TO TELL PEOPLE THE TRUTH,
> MAKE THEM LAUGH,
> OTHERWISE THEY'LL KILL YOU**
> *Oscar Wilde. Posted on kitchen wall*

## Chapter x
### Peggy's Cafe

From the outside, the corner building at 2nd and D (a block east of WACO) looked beat. Flaking lead paint chips exposing greyed redwood siding. Nothing special; not in a section of town filled with degraded three-story Victorian buildings. Its exterior decay just added to the wonder of pushing in through those double doors.

In the thousands of times I walked through those doors, I never once felt, "Eww, too hot," or "Shit, too smoky," or "Thank it, too noisy." I pushed through those doors under that black-on-white hand-painted PEGGY's – almost looking like a professionally done sign but not quite enough room for that cramped lower case s – and it was always just perfect. Perfect in its welcoming thick steamy heat, reek of the deep fat fryer, cigarette smoke and noise.

Built as an Oyster Palace during the boom times in Eureka, the interior survived in full patinated glory. Protected under a thick coating of chicken fried steak and nicotine goo, the fluted redwood columns supported a fourteen-foot multi-vaulted plaster ceiling. Upper walls, covered almost completely in posters, framed black & white photographs, met by high intricately carved wainscoting along which were arranged the many booths and banquettes. Nothing had been altered for a hundred years, or cleaned. On the exterior, the end of the post-war lumber boom and devolution of 2nd Street into Two Street into Eureka's Skid Row had allowed time and

weather to wreak havoc on the building that now housed Peggy's Cafe. There was no money for upkeep. That same lack of money had saved the interior from the sad dishonor of fashionable "updates" and "remodels."

An original brass five-light (gas, now adapted for electricity) chandelier hung in each of the twelve vaults of the ceiling. Under them, small Carrara marble-topped tables with two or three old chairs of the type that make a solid grinding squeak when moved. The tables were rarely used. We sat either at the massive mahogany bar polished glossy by a hundred years of rubbing hands and faces, or in the booths.

O! the booths! I can't even begin to tell you about Happy David's phone calls until I speak about the booths. The cafe opened at 6:00 a.m. and closed at midnight. I am confident that between May of 1970 and the end of 1973 there was always at least one odd person with some kind of an association to WACO sitting in one of those twelve beautiful booths. Ancient leather on the banquettes and the wall behind covered with an old-growth fir flame veneer that had been shellacked and rubbed so many times over the past hundred years that it glowed and seemed to put out the heat of real flames. I had once remarked to Marianna that it resembled the flames in the image on the back of that Leonard Cohen album and she, sitting across from me, was quick to oblige my vision by raising her right hand to her breast and stretching her left toward the ceiling, tossing her long, wavy black hair and looking with those perfect blue eyes to God or the ceiling. I could see the chains hanging, really.

♪ *Suzanne*, Leonard Cohen

Happy David went straight through the double doors not even glancing sideways at the booths; he headed at a hard clip toward the bank of pay telephone cabinets on the far northeast wall of the cafe. John and Peggy, behind the bar and not too busy at the grill to pause and watch, sullenly, warily, the determined march of this suspicious hippie/artist type.

Peggy was *the* Peggy. Five feet of bowling pin with a spatula, stained apron and eyeglasses so thick I would mention Coke® bottles here if that weren't such a cliché. John, over six feet with short grey hair, a cigarette dangling above a slack scrubby chin and tattoos that told of Navy service peeking out from under the edge of his no longer white T-shirt. Oh, also a soiled apron and a spatula, but he could drop that spatula and have his hand on the baseball bat behind the counter before you, or Ramón, could say, "I'm on time!"

Things were more than just beginning to fall apart even then. The racks where newspapers from around the world once hung on their poles for the perusal of the cafe's patrons – next to the telephone cabinet Happy David chose – empty now for the most part excepting two or three rumpled and

disheveled copies of the *Times-Standard* and *Tri-City Advertiser*.

No *Chronicle*? Happy David thought to himself as he reached in his front jeans pocket for a dime and closed the mahogany accordion door sealing the silence within.

With the handset to his ear and the dial tone mournfully sounding, Happy David slowly dialed the memorized number for the WACO pay phone and waited through what seemed a dozen long rings until finally the groggy voice he recognized as F. Scott's answered, "Hullo?"

"Huuuuuuuuuuuuhh…uuuuuuuuhhhhh…huuuuuuuuuuuhh…," Happy David breathed deeply and slowly into the mouthpiece until finally he got his desired answer after a few weak whats? and whos?

"WHO THE THANK IS THIS!?" screamed F. Scott. "Who are you? You mother thanking PERVE!"

Happy David hung up after another ten seconds of loud breathing into the mouthpiece and curse-filled screaming coming back so strong he could hold it at arm's length. Smiling ear to ear he had been barely able to keep from bursting out laughing. Now he went back across the room to the counter, hopped up on a stool and said to Peggy,

"Coffee please," with his big smile, "and I'll have the French toast."

He spun around once and shifted on the stool to get his right hand down into the pocket and pulled it back out full of dimes. "I'll wait ten minutes," he thought, looking up at the clock.

And then to Peggy again, "Hey, is there a *Chronicle*?"

♪ *Sugar Magnolia*, The Grateful Dead

## Chapter xi
### His Mark

He's back! He's down! Grounded safe and sound! Trailing clouds of glory, Steve is down! I'd have to explain the Firesign Theatre reference later, after all, Steve had been so far away across the pond in Deutschland über alles for what seemed like much more than a year (probably was less). I'd missed him so much. Thanking shit, he'd missed so much... I even had to explain the context and usage of the slang term heavy!

♪ *Don't Crush That Dwarf, Hand Me the Pliers,* The Firesign Theatre

"*Ein klein maus... ein klein maus!*" I was jabbering. "Stevie, it's so great to see you! I've been practicing my *Deutsche* so I can communicate, hah ha!"

"Very nice, *ein-ah klein-ah Maus*. Very nice to see you also."

June of 1970 and pleasant weather, if a little foggy, on the waterfront of Eureka, now made perfect by Steve's return. I was so excited, I wanted to show him everything at once! Peggy's, WACO... where should he stay? We'd build him a little nest upstairs someplace, wherever he wanted. Thankin' Aye!

A year ago, Steve and I had been climbing mountains all summer. He was working in his father's machine shop, ▮▮▮▮ Engine; me at the Ice & Cold. Every Friday as soon as we got off, we headed out of town – east to the Trinity Alps, exploring every trail we could find, climbing every granite peak from every possible route we could figure. East on 299 to climb in Castle Crags – learning the value of the rappel! Shit, once, we came down out of those Crags and into a liquor store looking for beer and chips only to see men walking on the moon! East to Mount Shasta, the Queen, the mountain of our dreams! Climbing from the south, from the east, and most loved, from the north. Lassen... McLoughlin... Thielsen... Three Sisters... Jefferson... Hood... and always back to work on Monday morning.

When it stopped, when Steve headed for *Rothenburg ob der Tauber*, when I headed back down to *San Diego*... it really stopped.

## Chapter xii
### Ramón

Ramón lived in a tiny single room above the Buon Gusto at Maria's 123 – a boarding house, one of Eureka's many SROs common those days in that part of town.

I only ever saw him on the streets down around WACO and Two Street. Always shuffle-walking from one bar to the next. Someone told me he was Portuguese. A former Merchant Marine sailor. I also heard he was of Mexican background. He did have a thick accent every time I heard him speak his three words:

"I'M ON TIME!"

Sometimes as an announcement and sometimes with a hint of questioning like, "Am I?" but that difference may have just come from variations in his accent rather than intent.

Worn out looking, like maybe he was eighty or more like fifty with some hard bottle time. Couple of dirty coats, couple of dirty pants all on messy with some shitty shoes down there and a greasy watch cap on top.

If I passed him on the sidewalk and said, "Hey, man. Morning."

"I'M ON TIME!" all covered in phlegm would come back at me with his eye contact, red and runny.

More than once we'd be sitting around in Peggy's Cafe when he'd push his way in and just as the doors were squawking, slamming shut, he'd announce,

"I'M ON TIME!"

More than once I saw John behind the counter reach down, perhaps pretending, reaching for that baseball bat and yelling, "Get out of here, Ramón."

So, it was a surprise in mid-December when Steve and I were heading, smoking, up C, coming back from time sitting around the table at Lazio's with Dave the Skipper. Too rough outside to go crabbing, we'd spent three hours drinking coffee and eating table oyster crackers, talking Dungeness lore and electrolysis with a couple of other skippers who delivered to Lazio's.

The two of us heading back to WACO and here comes Ramón.

"Morning," says Steve.

"Morning," says I.

"Shipmates, are ye boat pullers on that there LADY-FAME?" asked Ramón, pointing back to the dock and boat.

Even though we were both taken aback by this question from a fellow not known for conversation we managed to say we were indeed.

"And ye have been out in her?"

"Yeah... why?"

"And so ye know The High Liner then?" asked Ramón, with a hint of mischief.

"What are you jabbering about, old timer?" I replied with a hint of irritation.

"Your skipper, sonny lad! Your captain. A hard charger, a high liner, I say."

"Oh, you mean Dave. Yeah, he's a hard charging kind of a guy. But he's all right, I mean, he took me on when I was totally green last season. Hadn't been to sea, hadn't been on a boat," I said.

"All right, ye say, ALL RIGHT?" Ramón's head was shaking. "Sonny lad, whenAve ▉ is all right, then these rags of mine will be as silk, and champagne will flow from the tits of two redhead tarts on my arms."

"C'mon Pete, let's go. This guy is talking gibberish. I'm getting cold."

"Wait a sec.

"Look, Ramón, I've seen you around. You know me. If you have something really important to tell us about the LADY-FAME or Dave, then just say it. But if you're only looking to thank with us, in some kind of gag..."

Ramón looked at me hard with his bloodshot eyes squaring, squinting, brow furrowing, "Hard charge he will, shipmate, and hard charge ye will, and at that time when ye find the new number seven *a-ringin'* then God and all shall find ye be on time... ON TIME!"

I felt that chill, you know, and stood back.

Ramón leaned forward, all smelly, ruddy gin bloomed and spewed:

"Ye be on time!"

♪ *The Parable of Ramon*, Richie Havens

## Chapter xiii
### F. Scott Castrates the WACO Telephone

The day after having his rack time ruined by perve-breathing phone calls, F. Scott castrated the WACO telephone. Not one to be concerned with consequences or explanations to Pacific Bell®, he... wait, let me cast further light on his personality. In his world, rules and locks alike were talismans set as a soft message: It is our preference that you do not open this, unless it's important to you; or, Please do not enter here, unless you really want to. Messages intended to deter only those little people without manly reason for opening or entering. For F. Scott, a lock or rule of any kind was merely a bump in his path; the supremely important F. Scott Gerard whatever-I-want-to-do path.

"If your skipper really didn't want anybody to get inside, it would be all three-inch thick welded, case-hardened steel, Pete," F. Scott explained as he wielded the hacksaw against the small Master® lock on the wheelhouse door of the LADY-FAME. I was getting a little nervous looking at the tourists on the dock above heading to the door of Lazio's for their breaded Petrale sole filet, pausing to drink in colorful dock culture, eyeing us.

I had finished an hour earlier, finished with my days' worth of chores on the boat in preparation for tomorrow's early start. Went to hang the key back in its hiding place in the head and came up blank in my pocket.

Through the window in the wheelhouse door I could see the key sitting pretty on the galley table. *I am THANKED!* I thought to myself. Don't even know whether Dave carries a spare with him. He'll get here at 4:30 in the morning and be so pissed at me. Can't call him. So thanking stupid. Maybe F. Scott, he certainly knows his way around a lock, maybe he can easily pick it.

"Scott, I'm getting a bit nervous somebody might call the cops."

"So what? You work on this boat don't you? Just say, I work here, mother thanking pig, go get an éclair or something," and he laughed.

"I think it might be... might get a little more complicated than that," I said.

"Well, I can't get this thanker, anyway. THANK! Case-hardened steel."

He said pretty much the same thing in answer to my challenge a couple of weeks later when, alerted by the hacksaw sounds, I'd found him happily

wrestling with the lock Charles Motherthanker III had put on the door to his love nest.

"My brother needs a place to stay," F. Scott said, his playful eyebrows now shrugging. "Charles and Trini are away in L.A. for a couple of weeks. They won't mind. Why would they?"

F. Scott, whether with hacksaw or pry bar, somehow got the telephone box open and clipped the little striker ball off its rod with a pair of linesman's pliers. Without that striker ball the phone would only sputter, like geldings everywhere. And like it sputtered now. Not very loud either, sometimes you couldn't even hear it if you were on the other side of the building, but I can hear it now.

I just got the cup of coffee in my hand! I just got the TV set tuned in nice and clear! They were just tossing the coin! I know that with the air so cold in here today, I'll be able to get to half-time before this thanking thing starts rolling. Then maybe if I turn it off during half-time, try not to make a big deal of it, maybe, maybe, it'll cool down enough to make it through the third quarter. Three whole quarters seen on this piece of shit TV!

[WE HEAR A QUIET, ALMOST MUSICAL SPUTTERING. EERILY PREDATING THE TELEPHONE RING IN TERRY GILLIAM'S "BRAZIL"-1985.]

The telephone sputtered once more.

## Chapter xiv
### The Apostle

Apostle pressed the talk button on the doorbell/intercom at 202 C Street, cleared his throat, straightened his suit front and awaited a response.

"Yes?" came a thin static-filled disembodied voice.

"Good afternoon. Mr. Ronald Apostle, City of Eureka, Department of Health and Human Services."

"Yes?"

"Our Department has received information concerning this property I wish to discuss with the owner, lessee or renter."

"Is there a problem?"

Apostle cleared his throat again and pressed the talk button,

"Are there farm animals... chickens, specifically, being maintained on this property?"

"Ummm... maybe."

"If there are chickens on this property, within the city limits, then we do have a problem."

"Ummm... hold on, I'll be right down to let you in."

Back up in the kitchen – only Kento and I were around that day and he was in his room – I did my best to be a good host.

"Something to drink, Mr. Apostle? Coffee? A beer?"

"No, thank you. I don't drink alcohol or use caffeine."

"Oh, okay. A glass of water?"

"No, thank you. I had one earlier."

Apostle moved stiffly about the kitchen examining our filthy sink and counter; table piled high with books, magazines, used plates and utensils; smoldering pyramid of cigarette butts. His slow movements carefully avoiding contact with any surface – *vertical* or *horizontal*.

"Now, I understand that everyone here is an artist," ventured Apostle just as Kento's door creaked open and he came into the kitchen.

"Are you an artist, too?" he asked Kento.

"I am not an *artist*," Kento said. "I am *an fartist*." He reached out to shake the hand of the unsuspecting victim. As soon as flesh met flesh in the traditional greeting, Kento let go with a loud, brief, flatulent event.

"I see," said Apostle, a bit on the back foot.

"No, no, you don't *see*. It's... *invisible*," he whispered with a finger to his lips. "But you did *hear* and in just a second you *will* smell!"

> [THUNDEROUS LAUGHTER AND APPLAUSE AS KENTO EXITS STAGE LEFT WHILE MIMICKING THE SIDE-SHUFFLE MADE FAMOUS BY CURLY JOE OF THE THREE STOOGES.]

## *Chapter xv*
### *The Blacksmith*

We didn't see Charlie Cain, wine barrel entrepreneur, at WACO until later that first summer of 1970. I knew he was black and since I had spent all that time in Oakland working for and with African-Americans, I naïvely thought he would be politically and socially progressive. Upon our meeting, his admiration for Richard Nixon, unwavering support of the Vietnam War and adherence to Chicago School economic principles, came as a shock.

As I understood it, Cain had been a very successful member of the emerging black middle class no more than five years past. He'd been fooling around with blacksmith work as a teenager and found himself in just the right spot when the first wave of the "back to the land" movement hit the Bay Area in the mid-sixties. First it was just repairing old plows and hinges but soon he was working all the time making elaborate wrought iron gates and chandeliers; running a crew of ten from a workshop in Emeryville. His fame spread, the business prospered and he met and married a beautiful young woman from a good family. They bought a little house above Lake Merritt and soon enough there were two children.

But one night a horrible thief slid into his happy home and stole it all away. To make it worse yet, Charlie Cain himself had foolishly invited that thief into the heart of his family. The fiend of Colombia!

When that tiny spoon found itself at Charlie's left nostril, out flew Candy Cain to shrivel up his business, his home, his family, his life.

When all is lost there's this period of hanging around at the bottom in the same place you used to know from the top. A self-loathing punishment seeing those same sights, same people from this new, lower angle.

But friend! That is why there are places such as this one. A place apart! A place of redemption! The Humboldt! Eureka! You cry out the name when, like a meatball of enlightenment striking your forehead, you realize there is a place for you after all.

So, in the spring of 1970, a clean and sober Charlie – *don't call me Candy* – Cain made his way up Highway 101 to WACO in an old Ford® flatbed with a load of used wine barrels.

"I buy the barrel for $2, cut it in half and sell each half as a planter to some gardener lady for $10!"

"Very nice," I said. "Very artistic."

"Hey, I'm just looking out for the people's business, brother," said Charlie Cain.

♪ *Candy Man*, Roy Orbison

## Chapter xvi
### *The Blacksmith Again*

But Charlie, if it were really working like you say it does, these inequalities would be diminishing. Instead it just keeps... the gap just keeps getting wider. You're setting up two extremely different classes all over the world. The tiny one with huge amounts of everything – way more than they could possibly ever need – defending it with barbed wire and guns. Passing it along to their spoiled offspring. Leaving the majority, what maybe ninety, ninety-five percent, everybody else, with just barely enough to survive."

"You are forgetting the middle class, as so often people of your ilk do," said Cain.

"Oh, yeah right! Them. Ever shrinking, paycheck to paycheck. Looking at the people living in cardboard boxes on the street and saying, 'Well, I'm not as bad off as they are. Those are the *real* poor. I must be *the middle class*.'"

"And so they are! The solid bedrock of our great nation."

"That's what the rich keep saying, Charlie. And people believe it, even you, man." I was pacing around with coffee in my left and a cigarette in my right.

"They got this vision for America that was formed on some junket to 1950s Guatemala, sitting around the pool at the club being served cool drinks by defeated locals. *I like this*, they said to themselves as they puffed on their fat Cubans. *Now, this would be real nice up in the States*," I was ranting now. "They are never going to let you in that country club, Charlie."

We were in Charlie's studio downstairs by the massive fourteen-foot high sliding garage door. This part of the building had never been very desirable. Dark, dank and cold it had been shunned by the artistic types when space was divided up. Most everyone was drawn to the light upstairs filtering through double hung windows on both the north and east walls and the skylights, which cleared of their roofing material, leaked like sieves but brought in welcome light. Most everyone except for the married couple Dave and Phyllis Sweasey (troglodytes! I think they were still back in there; nobody ever saw them).

Charlie liked this spot because you could get a big truck in here. Another of Charlie Cain's get rich quick schemes had been to siphon up all of Eureka's used newspapers with the idea that they could be recycled – turned into pulp and used again for something. Get them for free and sell them for easy money, but the buyers needed quantity. So, this mountain of wet moldy newspapers continued to grow until the day, Charlie never specified which day, when they would fill a semi-tractor trailer and be hauled off to Oakland for the big payday.

I was kicking old *Times-Standard* newspapers from 1970, 1971 and earlier this year out of the way as I paced. They flowed like grey lava from up near the ceiling, covering half of Cain's old wine barrels. With the garage door open, enough light drifted in to just barely illuminate the strange troglodyte domain deeper back in this section.

For more than a year now, Dave and Phyllis had been copping Charlie's newspaper and making it into wheat paste papier mâché. They'd started on the back and side walls, covering the old redwood foot by foot in the hopes of keeping the space a little warmer. Obsessively, they'd built up a layer almost two-feet thick on everything, fourteen feet up to and including the ceiling. All soft and grey now, you could just barely recognize the rafters. Wispy mâché stalactites hung above the rolling thick carpet of forgettable, pulped Humboldt County news stories extending fifty feet towards the garage door. It looked like they were about halfway done with a brand new wall of the soft mash which would close off their space from the world completely. In the dim light I could see a large lozenge-shaped central structure behind the new wall. Kind of looked like a huge wasp's nest. Circular entrance, there... a tunnel.

I'll have to go in there and talk to them one of these days.

"You believe it, Charlie," I continued, "you believe it because all of

society's mechanisms, the media, advertising, all of what you see and hear every waking day, tells you that it's true. But who controls all of that? Who pays for all that media?"

"Rhetorical question?" asked Cain.

"Right, anyway now the country's re-elected Nixon and this place is going to head so far to the right. You know, it worked pretty good for a long time. A little *quasi-socialism*, excuse me for swearing, but you know it is. All the Roosevelt New Deal stuff. Dismantle that and well..."

"Nixon's okay, but he won't get the job done. I prefer having our own state's governor in the White House," interrupted Charlie Cain.

"Reagan!? Awwww, thank me... thank me dry."

"It would be a good choice," Charlie added. "All about the good choices, making the right decision in life. Good life choices."

"Yeah right. Right choices. Good choices. Like that really important first choice, that decision which determines all that follow: *Hmmm, let me think... which womb shall I pop out of?*" I said hoping to end this.

**THE RICH WILL DO ANYTHING FOR THE POOR BUT GET OFF THEIR BACKS**
*Karl Marx. Posted in bathroom under the mirror*

## Chapter xvii
### *F. Scott & the Bad Penny*

F. Scott was sitting at the counter in Denny's®, maybe a week after the telephone business. Hunched over the counter at three in the afternoon eating breakfast and fiddling around in a notebook with this idea for a short story involving Steve and me and some crabs escaping from a burlap sack in Denny's® at three in the morning.

"What do *you* think, Mr. Bubbles?" came the voice of a child on the stool right next to him. Startling because he hadn't noticed anyone sit down in his just-awake state, his distracted state.

"I think that's a fine idea, young lady. A fine idea," said the voice of a big man, possibly black man; a voice with the unbearably majestic beauty of Paul Robeson.

F. Scott peeked up over his notebook and saw the sole source of this dialogue. It's that same girl who'd wandered in off the street during the WACO art opening just two weeks prior. He remembered her well. He and Charles Motherthanker III were the ones to remove her after it became clear she was something quite different than just a little drunk or stoned.

"Oh! My! Look at *who* is here, Mr. B.," said "Shirley Temple" when she noticed Scott's stare.

She still had that dirty Charlie McCarthy ventriloquist's dummy, resting on the counter next to the coffee, her right hand up inside.

The girl's mouth moved a little while the dummy, its shiny face aimed now towards F. Scott, said in that same Robeson tone, slowly, deeply, "Yes. Yes... I *remember* you."

F. Scott felt the hairs go up on the back of his neck, never had the word remember been pronounced in such a menacing way.

"Oh, hey there. Hi... Penny, right?" said F. Scott.

"What do you know? Do you know?" said Penny ▬▬ with a smile, and her eyes got a little too big.

♪ *Do You Know What I Mean,* Lee Michaels

A Dutch girl, Penny had been on the road since the fall of 1968. Sliding in a haze with the wave of Northern European hippies on over to Afghan-

istan and India for all of those reasons; Thailand and the dope beaches; Indonesia and more drugs. In Australia she actually held a job waiting tables at a comedy club in Melbourne. That lasted six months, and when she left the ventriloquist comic she was thanking, she took one of his old dummies as a *thank you* gift. South America was about the same, except for Brazil. Brazil felt different than anywhere she'd been and Penny thought she might stay awhile in Manaus, until that one night at dinner in the Donald Duck Hotel.

"I might be crazy, but I'm not that crazy," she had said to herself, or so she thought. Like most of Penny's inner conversations, everybody else standing around on the street watching the restaurant owner mop up the blood, heard her quite clearly.

It was possible to travel by gypsy riverboat for days in the Amazonian jungle for about the same money as that coffee and pie in front of her now, and that river could lead to the USA.

"I had head lice the size of kittens when I got to the border," Penny said to F. Scott, and she seemed genuinely excited to share this information.

Then she frowned and turned to her dummy, speaking again in the voice of that cute curly-headed child star, "We still can't get rid of those other itchy little crabbies *down there*, can we, Mr. Bubbles!"

F. Scott looked at her more carefully now than that night he'd first seen her. As she rearranged sugar packets, he realized she wasn't completely unattractive. A bit disheveled, true, but tall, thin and ready for either Jesus or an institution. What's not to like?

"Hey, Penny? Can I buy you dinner?" A sick and wonderful plan was starting to pour over F. Scott's brain like a warm syrupy blend of spermaceti and blood... of revenge.

They moved to a booth.

F. Scott spoke calmly and rationally about WACO and the group of artists there, our aspirations and dreams, while Penny across from him ravaged the patty melt and strawberry milkshake she had requested and he had ordered. Mr. Bubbles now lay abandoned, close by there on the Naugahyde®; lifeless eyes staring up at one of the orange and brown plastic chandeliers.

He remembered that his current nemesis, David McStubb (F. Scott had quickly figured out the source of the prank phone calls) had not been at the WACO event during which Miss Penny ███ performed. A performance which necessitated her abrupt assisted exit.

Happy David had been camping in the Trinity Alps with that cute, mousy little girlfriend he'd been dating. How convenient, thought F. Scott, not at all disturbed by the animal-like, open-mouth chewing going on across the table.

"Say, Penny, you know, there's this one real handsome artist there, really a great guy. Oh, and he's a real good artist too. Really! A painter! He was pretty interested, I mean, attracted, I mean, really attracted to you at that party. Made a point of mentioning it to me. We're very close, you know. He and I, very close. Really."

"Glumpf, schlurp."

"David's his name. Hey! Maybe I should play cupid, eh? What do you think? I'm sure he's home. It's only a two-block walk."

"I like to thank!" sputtered Penny spilling out chewed fries. And then after a heavy, noise-filled swallow, "I REALLY like to THANK!"

The waitress on the other side of the counter filling ketchup squeezers frowned over at the two of them and F. Scott smiled back, with a twinkle in his eyes.

♪ *Venus*, Shocking Blue

## Chapter xviii
### The Capstan Winch

"It does make a difference, Dave," I tried to argue, emphasizing this time the word *does*. "People, especially black people in this case, take huge offense at things which maybe seem to you or me, like nothing, no big deal."

"Well, that's what they're called!" Dave shouted. "My dad called them that, *ever'body* in the fishing fleet calls them that, *ever'body* working in the woods. I never heard this *Captain's Winch* before."

"Capstan Winch, *capstan*."

"Yeah, well," Dave said. "They don't even look like nobody's *head*. Why's anybody gonna get offended?"

"Look, it probably comes from the bad old days when everybody was really, really racist. Probably still that way, lots of places. I don't have to tell you how people talk back in Arkansas. You know, it probably had something to do with lynching, or for all I know, with that hobby of towing around some poor black guy behind the pickup.

"But, letting you know, next time you tell me to 'take a couple of wraps around the *niggerhead*,' I'm just going to *look* at you. Words matter. Just say 'winch' or, 'capstan'."

"Yeah, well, I might," Dave started to chuckle. "I sure don't want to get that *look*. I was just talking the other night to Fame about that look of yours."

He really laughed loud and Steve, who'd been keeping pretty quiet reading there on the padded bench that ran along the starboard side of the wheelhouse, looked up and smiled.

## Chapter xix
### *The Ship's Prow*

There was standing built at that time the prow of a sailing ship, scrabbled together from bits of detritus found throughout the building. Sailing out westward from a twenty-foot diameter hemisphere of soft grey blue ocean sky painted on one of the only un-windowed, un-broken interior walls the second floor offered.

Constructed crudely and quickly by your narrator in inspired-response to the shockingly exciting revelations as to the very nature of art contained in an *Artforum* review of the conceptual work "Seed Bed" by one Vito Acconci, artist of New York City.

In January of 1972, at the prestigious Sonnabend Gallery, Acconci built a ramp of plywood and then hid underneath it for the entire duration of the exhibition, masturbating while listening and talking dirty in reply to the sounds of the viewers above.

Now, for most rational humans and actually for most of the artists involved with WACO, this work became the epitome of what was wrong with Art in the contemporary era. For some reason, with me, it was like an epiphany. The closest I had yet come to actually knowing the sound and song of angels floating on clouds playing their golden trumpets. (Closest until that much later moment in Switzerland surrounded by the Art Brut Collection in Lausanne.)

About my prow:

This *ship* consisted of a keel-like arrangement of heavy timber tied back into the wall by thin strips of found redwood lathe set to resemble the lap strake of a hull. A deck of sorts, gunwale and rails and all finished with a lovely bowsprit that tapered out quite a distance. And rigged she was! This being the sort of warehouse used for years by fishermen of all sorts there remained tossed away scraps of rope, net and line from polyester to the antique hemp. I had run line from bowsprit back to the wall, rope from the rails to the open beams of the ceiling. A short set of stairs heisted from a platform on the first floor – its function long forgotten – allowed me or anyone else access to the deck where one could grasp a rope, bend into that wind and shout out a rhythmic shanty or sea curse.

*Bend into that wind*, ye ask? Yea, there was a wind provided. How could it else be? A large floor fan I found at the neighboring we-buy-junk-yet-sell-antiques shop. Jammed high into the rafters upside down and between it and that bowsprit, a large glass bottle just like those from an office water cooler, no, not just like one, it was one, fitted with a hose tipped by a shower-head. And I must add, that water came not from the tap. Nay, I brought it home from the deep blue sea in plastic gallon containers enduring the raised eyebrows of my skipper on more than one occasion.

All was set above a Fellini sea of three mil black plastic sheeting which rippled and glistened with the wind and spray and I, clad in my Helly Hansons® with Sou'wester pulled down tight, screamed out above the roar of the fan:

"*Oh, the rare old Whale, mid storm and gale*
*In his ocean home will be*
*A giant in might, where might is right,*
*And King of the boundless sea.*"

♪ *Willie the Pimp*, Frank Zappa (Captain Beefheart vocal)

**BY HAMMER AND HAND ALL ARTS DO STAND**
*Motto of the General Society of Mechanics & Tradesmen,*
*chiseled (over the course of two years) into a fourteen-foot long*
*ceiling beam in the open second floor work area*

## Chapter xx
### Frank Gabriella & The Jungfrau

Frank arrived quietly at WACO sometime that first year. Lanky, mid-twenties; I can't remember if I ever saw his full face as he felt the need to wear a thin, gauze surgical mask at all times in public.

"I spent some time in Japan and Korea," he had explained.

A US Navy Electronics Technician while in the service, Gabriella had spent his days and nights "messing around with wires and circuits rather than boats and bullets."

Toward the end of his tour, the Navy had stationed him at the remote and very secret facility it had out at Centerville Beach. The Navy's Sound Surveillance System, or SOS-US, listened for trace sounds of Soviet submarines sneaking around deep in the Pacific.

"You'd be surprised at how much we heard," he sipped his beer then lit a cigarette. "Got interested in sound. Very interested in sound."

"Have ye listened upon any that ye might call 'Art'?" I asked.

"Yeah, man. Listen to Alvin Lucier's *I Am Sitting in a Room*. Anything by Terry Riley."

♪ *In C*, Terry Riley

"But look," he continued, lowering his voice like he was going to impart a secret, "the thing that's really got me, man, the thing that I'm really into, nothing to do with sound, well, slightly, music does help it – this memory thing."

"Huh? What do you mean, *memory?*"

"I mean a way of, of electronically, like with a computer, electronically enhancing, finding, bringing forth – controlling our memories."

"I suppose..."

"It's a ways off. Years and years. Some guys in Special Ops were playing with it. Everybody got really sick, I'm not supposed to talk about that. I'm convinced that if it were safe enough, just think how old people, like people in their forties or fifties, want to relive their memories. There's a big wad of them getting to the right age at about the time I'll get this all figured out. The *baby boom group*, demographics people call it. There'll be these places set up, like bars, where people can come and maybe there's some kind of

little electronic device to stimulate, you know, tune in the year you want, put it under your tongue close your eyes, *close your eyes and I'll kiss you, tomorrow I'll miss you remember I'll always be...* There'd be these MEM-lounges™ outfitted every way imaginable. Not so much here in Eureka, but in the big cities. Every way imaginable. Sounds and smells of the Forties, the Fifties, the Sixties! You could choose the *Grateful Dead* – body odor, skunky dope, patchouli oil and boiling lentils; across the street *Loretta Lynn, Buck Owens* – whiskey, cowshit, old leather rubbed with saddle soap and yeah, body odor. It would work like that cookie, man you know, *madeleine*, yeah like there'd be just the right smells and sounds for, what's that guy's name... for *prousting*, that's it Prousting™..."

"Hey, look I really like what you've got going on with this Cube Room," I said, trying to shift onto more stable ground.

"Smell!" Frank almost shouted.

I liked Frank a lot even though I never felt I got to understand him that well. I also have to admit to being very distracted by the girlfriend he brought to WACO: Marianna; the untouchable Marianna Jungfrau.

I, and most every other WACO guy, really wanted to touch her.

## *Chapter xxi*
### *Communication Breakdown*

A cube room, twelve by twelve by twelve, all white. No windows. The only light comes from above. A decrepit skylight, glass half-blocked by sloppy tar repair jobs. Entry via a small door in the south wall which, when closed, becomes almost invisible. A thick, near sweet smell of fresh latex paint.

In the center at the base of each wall:
- a portable stereo
- platters turning
- on each, Led Zeppelin's first album
- volume knobs turned up as loud as possible

The artist and three assistants drop the needles simultaneously – third track, side two:

♪ *Communication Breakdown*, Led Zeppelin

"I told you," says Frank removing his earmuffs when it's over. "No drugs necessary."

"What?" I say.

"No drugs!"

"What?"

## Chapter xxii
### The Quarter-Deck

In 1971, political criminal and President of the United States, Richard M. Nixon removed the country's economy from the gold standard and set the price of an ounce of that heavy metal California-creator at $35. Zipping up its fly, the United States of America slipped out of the Bretton Woods and into the sunlit meadow of decline.

My rich Auntie Helen, the painter, and her tycoon real estate investor husband, Uncle Poo-Poo, had given me a coin for my birthday. Not just any coin but a one troy ounce pure gold Krugerrand. Uncle, looking more like his true Monopoly® character than ever, had flipped the thing to me doubloonishly from the passenger seat of their dove grey Jaguar® whilst Auntie said, "Shit, man, do something arty with it," then let the clutch out.

Folding and rolling the coin in my left hand I paced back and forth in the confined floor space of my sleeping cabin high in the rafters.

Spend it? Change it into real money? Hide it? Pure and heavy and warm. The floorboards creaked above the kitchen.

"Do ye hear him, Scott?" said Happy David in a whisper across the table. "That little baby chick inside him pecks at the shell. Mark ye my words, somethin's a hatchin' out."

Short time passed before the crashing of my sliding drop down the ladder from my cabin shook both Happy David and F. Scott.

"Call everyone together!" I shouted to them rushing through the kitchen and out onto the second floor's open space.

"I gotta big announcement!"

[THE MEMBERS OF THE CO-OPERATIVE ASSEMBLE
AT THE FOOT OF A ROUGHLY CONSTRUCTED SET OF STAIRS
WHICH RISE THROUGH THE RAFTERS INTO A DIRTY SKYLIGHT.
THE AFTERNOON SUN POURS CLEANLY THROUGH AN OPEN
HATCHWAY WHICH ALLOWS ACCESS TO THE ROOF.]

### ★STAIRWAY TO THE STARS★
*Posted on stairs to skylight*

When all those of WACO were assembled at the foot of Stairway to the Stars, I bellowed from the top,

"What do ye do when ye experience the aesthetic?"

"We sing out!" responded the troglodytes, Dave and Phyllis (there they are!).

"That's right!" I said. "We sing out. We tell each other about it. That's what WACO does. That's how we help each other.

"Every day we be bombarded with sounds and images which serve only to confuse the masses. Tricks created with the primary goal of extracting money from one's pocket to place it in the ever-doubling larder of the few. Music. Movies. Television. And even the so-called 'Fine Arts', much of it mere decoration. Decoration and distraction masquerading as the aesthetic, as culture. Decoration in the traditional visual fashion with its eye-candy surfaces, devoid of content. Now..." I lowered my tone for dramatic effect, "...ye even find its more pernicious cousin, *cerebral decoration,* assaulting our battlements!"

"There's lots of nice enjoyable decoration out there, Pete," said Happy David. "Nothing so wrong with someone picking out a landscape for over the couch. And, I don't mind spending a couple of bucks at the Minor for two hours' distraction by some *Colossus: The Forbin Project*. Doesn't always have to be *Five Easy Pieces* especially if I'm making out in the balcony."

"Did you get any on ya?" laughed Sweet Keith and several others joined in constrained giggling. The group seemed to welcome the chance to escape yet another of my rants about Art with a capital A.

"A couple of those easy pieces."

"Okay, okay, look, serious now, mates. Here's a piece for ye that's easy," and I held the shiny Krugerrand up into sunlight, turning it slowly between my calloused thumb and forefinger for maximum golden glint effect.

That got their attention.

"Huzzah!" shouts the group.

[A SHORT MACHINIST'S HAMMER AND A CUT NAIL
ARE REQUESTED AND APPEAR.]

"I nail this chunk of gold to this uppermost rafter and I lay down the challenge to all of ye as I do so:

"Create now something of value to the world. Something that adds to that vast stream extending from the Willendorf to the Acconci.

"Make something that will last, that people will care about in a thousand, nay, ten thousand years.

"That be my challenge, and I say he or she that first shows that Art to me shall hold this gold!

"Now we drink on it!"

"Huzzah! Huzzah!"

[A ONE GALLON GLASS JUG OF CARLO ROSSI® RED MOUNTAIN LEFT OVER FROM A RECENT WACO FÊTE IS PRODUCED AND PASSED AROUND.]

[SINGING TOGETHER:]

*"Farewell and adieu to you, our own garish ladies!*
*Farewell and adieu to you, oh ye ladies of gare!*
*Our captain's commanded that -*
*We grow our beards an' grow our hair,*
*Laugh an' sing an' thank an' swear,*
*Oh, we are artists an' we don't care.*

*Farewell and adieu to you, our garish ladies!*
*Farewell and adieu to you, oh ye ladies of gare!*
*Our captain's commanded that -*
*We seek an' make the fine artwork,*
*Paint an' chisel an' thank an' swear,*
*Oh, we are artists an' we don't care."*

## Chapter xxiii
### Lake Anna

"Steve's the Daddy, Pete's the Mommy and I'm the little... the little Pip!" exclaimed Sweet Keith after some deliberation. Bouncing around using arms and hands, throwing them out there with each popping thought. "The little PIP!" He had been fairly quiet since the drenching – unusual for his motor mouth to be so stilled – and this new pronouncement didn't exactly make me feel his near-drowning had knocked any sense into him.

Steve, on the other hand, was satisfied to play along with Sweet Keith's absurd idea that the two of us, Steve and me should guide his every move through life. "You two are the only two here at WACO with their shit together," he'd said.

Snow camping and a mid-winter climb of Gibson Peak was the first lesson. Sweet Keith stood, awestruck, still shaking from the cold unplanned drop through the thin ice of Lake Anna, while Steve built a campfire under a wide snow-covered Ponderosa pine using nothing but his Buck® knife and a chunk of flint he always carried at the bottom of that knife's leather holster. We warmed ourselves about that roaring fire and Sweet Keith, when at last calm and not shaking anymore, announced to us:

"I'm gay. What do I do now?"

"Well, now, that's a step," I said perkily, with no tint of disdain.

"That will come," Steve said professorially. "That will come naturally, but not with either of us. We're your guides, remember, and besides, Pete and I decided years ago that we would only gay up if we gave up hope of ever finding that hetero soul mate. Then we'd partner together in some little cabin on Mount Shasta, grow beards, fingernails and run around with automatic weapons shaking our willies at unwanted guests."

"Okay," said Sweet Keith thoughtfully.

"Yeah, these days, tits and pussy are doing it for me, for me and Steve," I said, adding to the scholarly discourse. "We seek that glowing bush – maybe a little labia majora peeking out – looking like a resplendent grail hovering there, lighting the sky above the mountain top."

"Okay," said Sweet Keith.

Steve amplified Sweet Keith's schooling over the next six months, advising on attire, style, social events as well as the eventual explanation to and breakup with his girlfriend, Flower, down in Cupertino.

♪ *Come and Get Your Love*, Redbone

Another climbing adventure – again led by Steve but this time involving most of the WACO members – took place later that same spring. Mount Shasta somehow got into the conversation over a group spaghetti dinner I had put together. Steve and I both waxing on a little too red-wine-long about the joys of climbing that volcano. Most likely foolishly, the group piled into three cars for a four-hour journey through the night, and arrived in sneakers and street shoes, sweatshirts and Levi's® in the snowbound parking lot of the Ski Bowl Lodge. The sun was coming up to reveal... nothing. Clouds so thick we couldn't see the bottom of the chairlift. Thwarted, we opted to head into the village of Mount Shasta for a hearty group breakfast. Found the only cafe open this Sunday morning to be filled with church-going-families having the Lumberjack special. All eyes turned to examine us as we examined the hand-lettered sign on the door:

**WE RESERVE THE RIGHT TO REFUSE SERVICE TO ANYONE!**
**NO SHOES, NO SHIRT, NO SERVICE!**
*Unattributed. Posted in cafe, Mount Shasta*

The overheated dining room stayed quiet long after we were seated and ripping into our own Lumberjack specials. Famished, we were on such good behavior that the locals eventually relaxed and went back to their chatter about trailer hitches, laundry soap and tumors.

I asked the waitress if I could get another piece of French toast, "this time with whipped cream, and just like the picture in the menu, could I have a..." Charles Motherthanker III – huge and hairy in cut-off Levi's® jacket, motorcycle boots, fulfilling every church-going-family member's vision of the outlaw Hell's Angel® demon – chose that moment to noisily push back in his chair and respond to a short humorous story told by Sweet Keith with a loud guffaw followed by an even louder:

**"THHHHAAAAAAAAAAAAAAAAAAAAAANNNNKKK!"**

The room was filled with that particular, atonal cacophony of dropping silverware. I persisted in my order, "... a cherry on top?"

I did my part, as best I could, in the ongoing *tell-me-what-to-do* by defending Sweet Keith, helping him cope during a difficult mid-summer visit to WACO by his very Mrs. Katzenjammer mother, the dramatically overbearing Edna Walden.

"And *where* is the picture of Keith Walden?" she needled as Sweet Keith, during a tour of the WACO kitchen, pointed out the wall of snapshots celebrating members and events.

"Mom... it isn't really..." he was fumbling and stuttering when I, careful to first put on a shirt, slid down from my Captain's Cabin and charmed her with great stories of the group and her Keith's contribution to our artistic growth. Introduced as the founder, my oil lubricated and she left happy.

## Chapter xxiv
### Sweet Keith Walden

When painting these wall-sized acrylic on canvas works, Sweet Keith covers his studio floor with a nine-by-twelve foot carpet of ten-ounce cotton duck canvas; disrobes; coats his body with thick acrylic paint (primary colors); rolls around naked as a jaybird on the floor trying to keep a hard-on going. That boner shape seems to be his leitmotif.

Sweet Keith is also writing and illustrating a comic book (pen & ink and gouache) about the adventures of a superhero of his own creation *The PIP*. From what I've been shown in private viewings, his dark eyes burning the back of my neck through those askew black-rimmed glasses, *The PIP* is a small picked-upon fellow who has a psychotic break and runs around killing those he considers to have tortured him. Much hacking with a hatchet, lots of beheadings. *The PIP* also has an erection (huge and constant) which he uses as his backup weapon – a powerful bludgeon of vengeance.

♪ *Whole Lotta Love*, Led Zeppelin

Sweet Keith had arrived in the first days of WACO and chose, I'll never understand why, to take as his work and living space, the large showroom at the front door. This space, which had probably once served as the office for whatever manufacturing business occupied the rest of the vast building, had its own filthy bathroom and was glassed in on both the Second and the C Street sides by near floor-to-ceiling picture windows. To solve the problem of low-life peeping toms disrupting his creative bliss, Keith set about immediately constructing a system of free-standing sheetrock walls. While it would have been simpler to just paper the windows, these new

walls gave him the opportunity to post works of art and spray odd bits of graffiti:

**WACO RULES!  O! THE WHITENESS OF THE WHALE!**
*Odd bits of graffiti sprayed on Sweet Keith's walls*

The addition of these walls also made the process of getting from the front door to the main set of stairs more like a maze – apt preparation for what the innocent visitor would find beyond.

## *Chapter xxv*
### *WACO & the Virgin*

"What's that she's got there?" asked Wise Keith as he watched Marianna walk from her work towards the spot where he and Happy David now stood together below the skylight.

"Is she coming to borrow more precious turps again?"

Happy David now directed his gaze towards Marianna and took in the object she carried.

"No, no, Keith, sir," said Happy David. "Clearly she carries some fresh coffee just this minute brewed up for our drinking pleasure. The sweet thing!"

"Thank with me not, young David. For that is most obvious a gallon can. Whether it be empty or not, I cannot say. I can say, 'tis not a coffee pot, leastwise not of a sort I've ever laid eyes on."

As Marianna headed toward the two chatting there so speculatively, she framed herself in one of her large canvases propped against the wall. From Happy David's and Wise Keith's point of view, there finally was something to gaze upon in one of those six large paintings.

[DAVID McSTUBB SINGS:]

"Diamonds, daisies, snowflakes..."

♪ *That Girl*, Theme from Marlo Thomas TV sitcom

[HIS SONG IS DIRECTED WITH A WINK TO THE READER, AND NOT HEARD BY MARIANNA.]

## Chapter xxvi
### The Gilder

Marianna Jungfrau spent the majority of her time at WACO dedicated to these six canvases and their elaborate frames. When not socializing, eating or charming the others, she could be found here sanding, wiping... sanding again. Building and gilding the complex and elegant frames that surrounded canvases of an almost remarkable plainness. Sliding tiny amounts of what, from a distance, looked to be a uniform grey oil paint onto one or the other of the picture surfaces. Only on the closest inspection could the trained eye see, rather almost sense, the slight variations in color and tone. *Loveliness unfathomable...*

While painfully lovely at the near view, step back a meter and all six canvases quickly receded into identical – in all manner of identification – grey planes of six feet by four feet. Step back another stride and the show really began. At that point, the magnificent frames dominated the eye. *Loveliness unfathomable...*

Hundreds of hours had been expended in building up the elaborate compo filigrees and decorative extruded swirls and rosettes. And then the laborious priming and gessoing. All the meticulous sanding and leveling only to be hidden forever under the coming red clay bole. I had spent many hours myself watching from a respectful distance as Marianna laid sheet after sheet of 23 Karat gold leaf. Watched her burnish each of those frames with smooth agates found locally on the beach. *Loveliness unfathomable...*

The overpowering brilliance of the gilder's craft was impossible to replicate with any simpler, quicker technique. *Loveliness unfathomable, as ever lover saw in his young bride's eye.*

"Keith?" said Marianna in her sweetest way and with a quick flash of those large blue eyes. "Can I borrow just a teensy bit more of your thinners?" holding her thin elegant forefinger to her thumb in front of her melt melt smile.

♪ *Groovy Situation*, Gene Chandler

## Chapter xxvii
*A Groovy Daddy Amongst the Doukhobors*

From the first moment he chose his work area in the vast open loft space WACO's second floor provided, Groovy Daddy was preparing to leave.

His goal, explained and discussed many times, nearly non-stop, you might say, was the wilds of Eastern British Columbia.

Groovy Daddy had – during an exploratory trip to the region several years earlier – discovered the Slocan Valley and a tract of land close to the spot where the Kootenay River fed into Canadian reaches of the mighty Columbia. A parcel of land suitable for his setting up of the perfect self-contained house and home.

"So, tell me more about these Dooka... dooka...?" I had asked last summer.

"Doukhobors," Groovy Daddy corrected. "Really nice people and willing to let me settle and stay on this one little parcel of theirs. Well, they were originally from Russia and a bunch of them immigrated to Canada a hundred years ago."

"Cult, huh?" I said.

"No, they are not like a cult," Groovy Daddy said.

I was laughing, this was something I'd been giving Groovy Daddy a hard time about, in a kidding sort of way, ever since he first brought up the idea and these people.

"More coffee, hon?" said Connie looming over our booth.

"Yeah, thanks." It was probably my fifth refill. We'd come down to Peggy's to warm up on a particularly cold morning.

Groovy Daddy said no to the coffee and Connie sashayed her way back over to the counter. For the *ass tippers,* I thought. As I watched her move, I was careful not to be seen by her father (one hand on spatula, one on baseball bat), John.

Groovy Daddy lit another Winston® and said, "But they are religious. Christian, in an odd way. It's why they got so persecuted in Russia."

"They're pretty ardent pacifists, I heard."

"Yeah, yeah. So I can stay up there until the war is over or they stop the draft. They have these plots of land all around there and they're willing to

let me build and live there."

"I'm sure they're really nice and all, but I don't get it. They can't take in all the Americans wanting to avoid the draft."

I pulled out my smokes, lit a Camel® and tossed the half empty pack on the table.

"It's probably 'cause of *that*!" Groovy Daddy laughed pointing his finger at the image of the camel on the cigarette pack. "Just a fluke. They have one."

## Chapter xxviii
### *The Needle*

A simple plan and design had been taking up most all of Groovy Daddy's artistic efforts since he first crossed the WACO threshold and stepped aboard this ship of sorts.

"It's just a needle," Groovy Daddy said. "But a big one."

"How high?" I asked.

"Tall, *tall*. A hundred feet more or less, depends on the radio tower I find. I've seen used ones advertised, people are always upgrading, radio stations get bigger, need taller towers. I can buy a used one for under two thousand, just have to build a pad."

"The Doukhobors love this idea so much, they're willing to help out. They've got excavators, cranes, all the stuff. That's what all this aluminum sheeting is for, all this I've been cutting."

He had been cutting up a lot of thin aluminum over the last couple of years, *a lot*. As he explained, "this will be riveted on to form a smooth shiny skin around the central armature of the radio tower. Kind of like building an airplane, but vertical. Most of the skinning will be done when the needle is down on the ground as the pad is being prepared and then..."

"And then what?" I asked.

"Well, if I get it just right, the aluminum needle, smooth and shiny will rise straight up," he gestured now, getting a little animated, making the motions of a crane lifting and positioning. "Straight up and with the eye right there at ground level, looking like it's halfway jammed into that concrete pad and that eye is going to be big, man, big enough..."

"Big enough to get that camel through, right?" I said taking another drag and letting the smoke slip out slowly.

"Yes, yes!" Groovy Daddy was really getting worked up now.

"My Doukhobor friends said they want to advertise, build a visitor center, fix the road, try to get hundreds of rich people to travel there, pay a set fee, and then lead the camel on a rope right through. I told you they have a camel already, right?"

## Chapter xxix
### An Aside Concerning F. Scott & Happy David

Feeling sweet vengeance, and seeing Happy David approaching there, F. Scott launched forth a little tune:

> "Old Mac Stubby had a crotch, ee-i-ee-i-ooo.
> And in this crotch, he had some crabs..."

"Thank with me not, lest ye be thanked with," was the interrupting reply from Happy David without loss of stride across the wide workspace.
"Yeah... okay," muttered F. Scott.

## Chapter xxx
### The Claim

Awakened I was, and dark the night with dawn not being even a faint glow in the future. I struggled to find the tiny push switch on the cast brass ducks-in-flight light that hung near my pillow. Up on one elbow I groggily demanded the reason for this slumber interruptus.

"I come to claim that gold," beamed Happy David, his head having a pronounced surreal quality owing to it being the only part of him protruding up through the hatch into my warm and formerly private cabin in the rafters.

"Can this wait until morning? Perhaps this notion will fade with the morning light."

"Some things cannot wait and you were the one who nailed that coin, so you must be the one who first sees."

"Sees what, David?" I asked, getting a cigarette lit.

"I just finished these four paintings! These four works of art! Art in every sense of that word you hold so dear." Happy David was clearly very excited. He must have been at this a while, bouncing around down there before finally deciding to make his claim.

I was sleepy but my eyesight was fine and truly astounded at what awaited me when, after partially dressing and descending, I laid sight on these four impressive works hanging in Happy David's workspace.

"Am I right? I lay claim. None may dispute it."

Happy David had, as I understood his explanation and was able to decipher the process myself, laid out four large sheets of the very heavy rag paper he and I both used in our work. This paper, of high quality, was only available in large rolls, six feet wide by some hundred yards in length. We had over time developed a system for buying a roll and then sharing both paper and costs. I used it for my drawings, graphite only, and he for watercolor and more recently, these acrylics.

For these four, *what an inspiration*! Happy David had roughly brushed simple forms in heavy, bright acrylics, then and before this under-painting had a chance to set, he'd poured a thinned roofing tar – probably left behind from one of many roof repair attempts – along one edge and then using a crudely fashioned rubber squeegee, had pulled this tar out over the bold color. Grabbing, skipping, blending as it went. The result was just beautiful. Simple yet transcendent.

"Yeah, you really have done something nice here, David," I said taking another cigarette out of the pack and looking for a match.

"So... now we get the gold?"

"Uh, well... you are certainly at the top of the list but we have to wait until everybody is up and around. Only fair, you know."

"I guess they do have to dry still."

"David, what I would suggest is that you borrow a good camera and get these well documented... in the morning, man.

"But also make a lot of notes. You want to establish *primacy* on an idea as good as this one."

"Primacy?" Happy David asked.

"Oh, you know, who does something first. Big deal in the art world. Right now, I think you got Gerhard Richter beat by a few years."

"Who?"

"German artist, painter. Nobody in America is really aware of him until like the 1990s"

"The 1990s? What are you talking about, Pete?"

"Uhh... thank, I'm sorry David, I'm not thinking clearly. Must still be half asleep. And I'm going back there now, back to *whole asleep*."

## Chapter xxxi
### 1968

I first met Rich Mapple in 1968 because James Earl Ray shot Martin Luther King Jr. A fluke, I suppose. James Earl Ray fired his rifle in the spring of 1968 and Big John ▇▇▇▇ said, "I'm glad somebody finally killed that nigger," and I quit my job as an apprentice electrician to a cocksucking asshole racist Texan, on the spot.

I looked level into Big John's eyes and said, "Man, I can't do this anymore. Work for you... do any of this... I quit."

"Now wait a minute, Pete. I didn't mean it to come out like that," Big John tried to pull back but he couldn't, he didn't have his cowboy boots with the three-inch heels on and he wasn't so big like he wanted us all to call him.

A fluke, I suppose. But it was the bamboo stick that wacked across the back of my head and I could no longer be this way, could no longer stay in school, could no longer be II-S in the draft, could no longer just – with head down – just go along with it, try to work it to my advantage.

The next day I called my fiancée, ▇▇▇▇ ▇▇▇▇, to tell her I could no longer marry her, I was sending in my draft card and everything, *everything* was going to be different.

I could no longer continue our plan of my finishing college with the help of the US Navy.

- 💣 **Could no longer** continue with the fantasy of serving my required time in the military as a dashingly romantic jet pilot in Southeast Asia, landing on that carrier sending home letters and souvenir photos to our happy little home, where she would wait so faithfully, and perhaps my parents would visit and my father would look at the pictures, smile and say, "Well, I would have preferred Pete as a pilot in the US *Army*."
- 💣 **Could no longer** live out my fantasy of being William Holden in that ditch with Mickey Rooney (long green scarf, tall hat) at my side holding off, with only my trusty service .45, wave after wave of unstoppable and very angry Asians firing AK-47s – Buddha! Buddha! Buddha!

- 💣 **Could no longer** work for a smooth talking thirty-five year old unlicensed electrician from Texas who paid me five dollars an hour (a noticeable jump from my previous job washing buses for eighty-five cents).
- 💣 **Could no longer** work for Big John driving his '53 Jaguar® XK-120 that he said was mine to use as I wished for *whatever* and for work, and oh, by the way, if I could just *ever' once in a while use it to pick up that twenty-one year old sweet li'l' piece o' tail college gal, drive her on over to the motel there by the airport and keep the mouth shut as regards the wife, y' know?*

I could no longer... the wife! His wife Felina. How could she have ever been with that dickhead? So beautiful, innocent and kind. She'd put her arm on my shoulder and grasped my neck and looked straight into my eyes, her brown eyes red and face flushed from crying, when she told me how grateful she was. I was the only one that dark dinner party night willing to take Big John's loaded and cocked Smith & Wesson® .44 out into the yard and hold like a vise with my thumb and finger onto the hammer and slightly, gently, pull the trigger just a tiny, careful, to get it to release and allow the gripped hammer to slowly, gently, return to its safe un-cocked home.

"I just wanna try it," he'd said during dinner. "I ain't never smoked it before."

"I just wanna show it to them!" We'd all heard him scream from their bedroom soon after dinner and his first joint. "Just *show* it to them! *Dirty Harry*, DIRTY HARRY!"

Felina had somehow been able to get the .44 out of Big John's excited sweaty grasp just as he'd cocked it.

"Pete," said Felina, still sobbing, "please get that shit dope out of my house and never, ever let Big John anywhere near it again."

Some people don't react well to psychoactive drugs.

I sent in my draft card that next day, that next day after I quit, with a politely worded letter, almost a letter of resignation, explaining how I felt I could no longer participate in this system, this war that I considered unjust.

When I was sixteen, my career Army retired Lieutenant Colonel father had driven me to Santa Rosa for an interview before a panel of retired Admirals and Generals in an effort to secure my Congressman's nomination to the United States Naval Academy in Annapolis.

Returning to Eureka, riding in the car in the late summer sun, the heat near Ukiah making me sleepy, there was a story on the radio about *Operation Starlite*, the first offensive action in the Vietnam War by a completely American military unit.

♪ *Here Comes the Sun*, Richie Havens

[A LETTER, HIGHLIGHTED BY MAGICAL GLOW,
WINDS ITS WAY THROUGH THE POSTAL SYSTEM:
PICKED UP FROM A MAILBOX IN SAN DIEGO;
DROPPED AT A SORTING CENTER;
TRUCKED TO SAN FRANCISCO;
MORE SORTING;
TRUCKED TO EUREKA;
BAGS OF MAIL POURED OUT
INTO THE CENTER OF A TABLE;
THE LETTER IS PICKED OUT
AND STUFFED INTO A PNEUMATIC TUBE
ABOVE THE TABLE, SUCKED, FLIES EVER SO BRIEFLY
A SHORT TEN FEET TO POP OUT INTO THE HANDS OF…]

…my father's good friend and golfing partner, Sam ▇▇▇, Chairman of the Local Draft Board. Years later, down at his antique/junk store near WACO, he told me how he had broken the news to my father about it, that moment when the letter arrived, about my disgrace/honor of being Humboldt County's very first Draft Resister.

## Chapter xxxii
### Oakland & Resistance

"Who should I talk to? I want to be involved but doesn't make sense any more to be talking about getting some kind of Conscientious Objector status. I mean I just turned in my card, man."

"You didn't burn it for the news people?" laughed Jim.

Jim ▓▓▓ ran the Bay Area Center for Conscientious Objectors on (seedy) Market Street in San Francisco. I'd been calling him and asking questions over the past couple of months since the very first inklings of a feeling that something wasn't right began to creep in during early 1968, right after watching Walter Cronkite squirm during the Saigon reporting of the TET Offensive. "No," I said.

"Well, you really ought to be talking to The War Resisters League, I got the number here. Or maybe you should just talk to Sandy ▓▓▓, she's great. She'll steer you in the right direction."

He picked up the phone and dialed, soon having a conversation with this Sandy person.

"Good luck!" Jim said brightly, handing me an Oakland address. "You'll like Sandy, she's a Quaker! Very energetic, *very*, and she knows everyone and everything to do with Draft Resistance."

> [HERE, WE PULL BACK TO VIEW A SERIES OF PERIOD MONTAGES, SAN FRANCISCO IN THE LATE 1960S: MARKET STREET BUSTLE; THE GREYHOUND BUS STATION; HARE KRISHNA CHANTING DANCERS, ORANGE ROBES WITH TAMBOURINES. WE WATCH PETER SANTINO THREAD HIS WAY ALONG THE CROWDED SIDEWALK, SMOKING, AN ENORMOUS RED BACKPACK ON HIS BACK.]

I headed out onto Market Street, lit a cigarette and walked to the Greyhound Station on Seventh, caught the next bus – just barely – for Oakland.

> [SOUNDTRACK MUSIC COMES UP AS THE SCENE CHANGES – THE UNFORGETTABLE FIRST NOTES INTRODUCING "ASTRAL WEEKS" BY VAN MORRISON.]

♪ *Astral Weeks*, Van Morrison

## OAKLAND & RESISTANCE

[Ticket counter; rush to catch the bus;
greyhound bus from high above crossing the bay bridge
— a view and feel similar to the iconic overhead highway
shots of Benjamin traveling to Berkeley in his red
alfa romeo® spyder, midway through "the graduate."
Oakland! a grittier streetscape, still we follow from
above the same solitary figure walking,
while the music transitions to "cyprus avenue,"
also from the "astral weeks" album. ]

♫ *Cyprus Avenue,* Van Morrison

There was activity up ahead. It had been a long walk from the stop, but I was pretty sure that had to be the house (right address); old Chevrolet® station wagon out in front and all the action seemed to be people jamming boxes and pieces of furniture into every open space in and on the car.

As I stepped onto the driveway, a tall, distinguished looking black man came out the front door, hefting a cardboard box. Not seeing me while turning quickly, he stepped backward, calling out:

"I fare thee well, O Queen Mab... 'til next we meet in my dreams!"

He continued back into and onto me dawdling there, smoking next to the car, recovering from my long backpack lugging walk.

"Oh, I'm so sorry," the man said, "please excuse me."

He smiled a broad smile, perfect white teeth framed by goatee, and placed his box of books into the back of the wagon before heading across the street.

I continued up the walk to the porch, to a pixie of a woman who held her hand out with a smile and said,

"Welcome weary traveler, you must be Peter Santino, who I heard so much about from Jim ▓▓▓▓. I'm Sandy ▓▓▓▓"

I answered that I was and that I was happy to meet her and while acknowledging me, she kept looking after the man who'd just left, as his car turned the corner.

"Do you know who that was?" she asked. "That was Eldridge ▓▓▓▓, Minister of Information for the Black Panther Party. You were almost knocked over, squashed by a great man!" she laughed and I felt immediately at ease.

"Man, you just made it! We're almost done packing and then we're headed to the new digs. Another fifteen minutes and you would have never found us."

"Lucky for me," I said. "A fluke that I made that last bus. Who's Queen Mab?"

## Chapter xxxiii
### Queen Mab & the Black Panther Tribe

"Oh, Eldridge ▮ calls me that, Queen Mab, from Shakespeare, you know, Romeo and Juliet? I think it's because he finds me tiny and sexy but George says it's probably because I flit around filling people's dreams with wild fantasies," Sandy said as she drove the big station wagon along Lakeshore Drive.

Sandy, George and their three boys were moving to a bigger house, up above Lake Merritt, up on Cyprus Avenue, and I was moving with them.

▮ Cyprus Avenue was a huge two story brown shingled Craftsman not much more than a couple of miles, as the crow flies, from where my mother had been raised in Piedmont.

"Full circle, for this crow," I had said when she had pointed it out on the East Bay map.

George and two of their sons were already at the new place unloading the U-Haul® truck when we arrived. We barely got the furniture in when the Panthers started coming by for meetings with Sandy.

"One of things I do is to counsel prisoners out at Santa Rita (the Alameda County Jail). Prisoners are allowed visitation from clergy and since we're Quakers, well, in the Quaker tradition there are no designated *clergy*. Everyone in the meeting house is *clergy*. So, through Eldridge, I advise every Black Panther arrested to list their religious preference as *Quaker*. Then I'm out there every day meeting with them. There's a lot – advising, counseling, and watching out for their rights... hey Pete, why don't you paint this place for us? You can paint can't you?"

Years before, Kento and I had rolled and cut our way through a couple of the little apartments that his dad owned up on Humboldt Hill, so... "Sure!" I said.

That would have been a disaster if not for Clarence White and his wife coming to dinner.

Mr. White was a licensed painting contractor and offered to take me on the crew to train me for a while when he heard Sandy's plan over lamb chops and peas. That following Monday I was learning how to be a house painter from a black man named White in the hills and flats of Oakland all the time trying not to make mistakes that would make his son Clarence Jr.

any madder at me than he already was.

"Move it, boy!" Clarence Jr., who preferred to be called "Not" when his father wasn't around, yelled from eight in the morning until quitting time.

"Not Clarence?" I had foolishly, jokingly asked.

"NOT WHITE!" he'd yelled and then told me to finish all the closets. I always had to do the closets.

"It's because you're small," said Not.

"Not white?"

I painted  Cyprus and lived in the basement with the litter box until Sandy and George advised me it was time to go back South.

"You can have an effect," they told me. "Counsel other students – *that's* relevant!"

Sandy told me I should set up a chapter of the Resistance, maybe even on campus at San Diego State. I'd been convinced that college couldn't matter less, why return to continue something I didn't believe in. I knew I couldn't go home. My mother told me that my father's reaction to my last phone call (when I *dropped the bomb* in my mother's parlance), telling them I had turned in my draft card; intended to drop out of school; and was preparing for life as a political prisoner... was not good.

"Maybe after a little time has passed," Mom had told me. "Your father can be very dour, which he tries hard to hide. He is pure Sicilian, remember, so right now, you don't exist.

"You, fortunately, are only half Sicilian, that gloom and doom nature moderated by the mix of happy-go-lucky always upbeat Scot genes I have contributed," she chuckled.

♫ Something in the Air, Thunderclap Newman

# Chapter xxxiv
## The Jeroboam Story

I was sitting on one of the kitchen counters I'd recently painted in Varathane® orange. Sandy liked the color and Mr. White had assured her that with proper preparation, the plastic coating should hold up almost as well as the old linoleum underneath it. Next to me, close next to me, is Angela ▆▆.

H. Rap ▆▆, Minister of Justice, James ▆▆, Minister of Foreign Affairs and Bobby ▆▆ seated around the little breakfast table built-in nook under the west window with two padded green vinyl benches. Sandy won't allow any smoking in the house, no exceptions, not even for Huey P. ▆▆▆▆, so he and George are out on the front porch smoking and talking about California geology and the Gold Rush of 1849.

We're drinking beer, Sandy's making snacks. She keeps talking about the *Sixth Point*. The sixth point in the Black Panther Ten Point Program: *We want all black men to be exempt from military service.*

It's a way of drawing me, shy and feeling paler than normal, into the conversation.

"Pete's resisting the draft," Sandy said. "Heading down to San Diego to help organize."

I'm trying to chat up Angela ▆▆, she's *so* beautiful, if a little old for me.

"I spent a lot of time down in that strange white town, UCSD," she giggles between sips of Budweiser®.

I pull together nerve and say, "You know, I went to Humboldt. Didn't you go to Humboldt?" (I read this someplace.)

"Really? When were you in Berlin?"

"Uhh, ahh..." I felt that nervous lost-for-words-not-sure-where-I-am feeling which she picks up on and saves me by saying,

"Humboldt University in East Berlin. I did my Doctoral work there."

"Oh... right, right. Stupid of me, I just saw that name Humboldt somewhere reading about you. I went to Humboldt State up north there, where I'm from," and I gestured toward what I thought was north.

I can hear the other conversation, everybody else louder now, more animated, laughing, something about *station wagon*.

It's still about San Diego, and this road trip to visit Angela ▇ at UCSD that the group had made last year.

"Sandy was, yeah it was you, Sandy, always telling me that I had to drive a boring car, like you – less hassle from the pigs," Bobby ▇ said.

"Tell it, Bobby," somebody pitched in. "Tell the story! Hah Ha!"

"Alright, alright. My Auntie gave me this car." He pronounced it *Ahhhn-ty.* It's always fascinated me that many people who curse readily and speak in the most grating and coarse manner in normal conversation (except in this house, best behavior for Sandy, always), or out on the street spew harsh words easily – an automatic weapon of stinging power – interrupted only when time to put name to sister of one's mother or father and then, like a fluff of soft cloud, comes the word *Auntie.*

"My Auntie gave me this car, her old car, a 1958 Dodge® station wagon the color of what, flesh? Well, honky flesh! Hah hah ha, no disrespect, Sandy, but it's what you always told me to get, *the polar opposite of the gold Caddy with tinted windows.* It's so big, so big, Eldridge ▇ calls it *The Jeroboam* when he sees me driving up!

"Yeah, *Jeroboam,* I had to look it up, hah hah ha!"

[HERE, BLACK PANTHER PARTY CHAIRMAN, BOBBY ▇, TELLS THE TALE OF THE JOURNEY OF THE JEROBOAM FROM OAKLAND TO SAN DIEGO IN 1967:]

*"We set out in the Jeroboam at midnight, casting off Oakland to find a fine following sea and breeze out of the Northwest which stayed our companion through the foothills and on South to near San Luis Obispo. On first stop, for fuel, food, drink and restroom, it was noted by several of the crew, a slight hiss emanating from the rear passenger tire. Along with gasoline to the tank, air, from the station's compressor, was added to that tire in particular. Concern was minimal and certainly seemed a worry not enough to forestall our plan of arrival at the feet of the beauty, Angela ▇, now dominating all of the University of California, San Diego, with her exalted presence.*

*H. Rap ▇ felt that perhaps a puncture of some type had occurred on the road where such hazards were common and that with the attention we were all capable of, we would not find the need to abort our plans and turn tail, returning to Bay and port.*

*But what sort of puncture? James ▇ inquired as our course continued toward Goleta and the coastal paradise of Santa Barbara. This simple question began a debate that continued to our next fueling. A nail? A shard of glass bottle broken on impact with the hard asphalt, thrown by restless and bored young people from an overpass as a hopeless gesture of defeated rebellion against an overpowering, oppressive state?*

*A check of the entire tire was held during the stop, the sun almost fully risen over the Oxnard hills. Initially to no avail, but upon the return from a neighboring* Denny's®, *three coffees in hand, H. Rap* ▓ *pointed out something overlooked in the thin tread, 'Is that some kind of a small stick?' asked our Minister of Justice.*

*Yes! The source of the leak which while having increased the slightest, still seemed manageable in its slow constant hiss.*

*'Touch it not!' I spoke aloud, and with some force, fearful to dislodge and thereby cause a full flood of trapped air to rush forth ending our journey in such a location, so very far from any known or familiar civilization.*

*Both I and James* ▓ *leaning in close, realized it at the same bright moment, Aye! Some kind of beak!*

*Even more excited discussion. A beak, you say? A sad and suicidal end to the fine free life of a winged comrade. Flinging himself in grief and solidarity with the masses from heaven's cloud to earthbound tire. Be it bird or... nay, not avian, nay, it can be no other, for I have seen just this sort of protuberance before, on several occasions.*

*The sharp, spiny tip of the swordfish nose!*

*It seemed so ordained for our group, we black-leathered young warriors on a quest to sit in the glow of our glorious Angela, so just for our vessel to be attacked by and dealt a suffering blow by the sword and sword alone!*

*We continued on, stopping only again for the necessary nourishments and eliminations and this one exception: a purchase in Oceanside at a shop along the road carrying the attractive moniker of* Pep Boys® *for a compressed air can of* Fix-a-Flat® *and a small foot operated air pump, just in case.*

*On to the treed campus of the University so sought for and we now find! In lofty halls of learning above La Jolla, the cherished one is busy. Not expecting our marvelous quest and devoid of spare room in her dormitory residence, we satisfy ourselves being in her glow and consider the journey a fine success just in receiving her blessing.*

*"Back the same path?' asks she, and on the spot, I say,*

*"No, Beauty, for where be the joy in that? None here have yet seen the desert.'*

*After minimal gathering of supplies and a quick survey of our tire situation; still she leaks but slow and calm. So, off then to the mysterious East! And the fabled desert.*

*Our plan, hastily but wisely formulated through Mission Valley and El Cajon, was to stick with the trade route we hold fast to now and then venture off into the more exotic and inspirational, the Anza Borrego! From there North again, somehow finding again the main trade, the Five as it is known, for our tack North and home port with no diversion 'cept a short run to pass by the surely fortified compound of white country singer Buck Owens in Bakersfield. Ask and plead as we might and did on more than one occasion, H. Rap* ▓

would give no further clue as to his obsession with this music, what truly could be called honky-tonk. We as his comrades of the road, could find no reason to steal from him this one favor, this one wish.

♪ *I've Got a Tiger By the Tail*, Buck Owens

But that would be for later and for now I guided the Jeroboam, fine stout vessel, filled now with the thick sweet smoke of the local herb gifted us by our Angela ▮▮▮▮, along the seven nine route and North to Julian then, at last! East and down the Banner-Grade.

I pulled the huge flesh wagon off on the side of the road for what we laughingly called a 'pit stop' and a chance to check our sad tire; off on a turnout that, if anywhere else would have been just that and that alone. But it was here and now that it happened: We were in shade and could see beyond that shadow extending far and below and across the land so dry and the color so distinct, more hues than I had ever seen in a green brown, red brown, yellow brown. Where did these colors come from? And everything placed! Placed! No rock or tiny succulent just happening there but so perfectly arranged! My heart beat fast but not with a fear, but as when a boy I had first touched my lips upon a sweet girl's lips. I felt the tears running down my cheeks and there he was, so proud, so beautiful standing strong on the rock, his long tail full and slightly moved by the timid breeze. Coyote! He made me full eye contact. Coyote. I looked into those, he into these and it felt... Coyote... we knew each other more a thousand years and we were, not in first meeting but in long awareness saying,

'My dear friend,' each to the other."

"Are you through?" asked Angela ▮▮▮▮, quietly.

## Chapter xxxv
### Richard Mapple

Gary looked dismissively, pityingly, at me over the top of his Ray-Ban® Wayfarer sunglasses, "Gandhi was doing his thing in India, man. And up against a very civilized British Empire. Army and police from a land where even the cops on the street were without weapons. Try to imagine how difficult it would have been to shoot an unarmed protester sitting in the road, even if they did think of that protester as a wog."

I tried to defend the idea with a weak, "But, history... the tide of history."

"Man, our situation now, the thing for the *Movement*, the historical situation we should be thinking is not India in the '40s but Germany in the '30s and I don't intend to go quietly to that camp, that gas chamber."

This Gary ▆▆▆▆▆ with his floppy thin red afro and dark glasses was not the same Gary ▆▆▆▆▆ Sandy ▆▆▆ knew from just last year. True, she was consorting with the Panthers in Oakland but her Quaker nonviolent ethics were much stronger than the brief flirtation with Satyagraha that Gary had recently left behind in his rush to the more romantic dark glasses and guns side of the anti-war movement.

He pushed back his chair from our small table in the corner of the Campus Activities Center, rose and said, "I'm not the least bit interested in organizing a nonviolent draft resistance presence here at San Diego State. In fact I've been thinking there's good reason for minority and disenfranchised people to get some military experience. Weapons training is going to come in handy in the coming... the coming street theatre."

As he got up to walk away, Gary stopped and looked back, "Hey, man. You might want to talk to this guy, Richard Mapple. I just had the same conversation with him two, three days ago. Here's his number."

♫ *The Rapper*, The Jaggerz

Rich, as he asked me to call him, was slight, a few inches taller, a year older than me. He seemed so academic, dressed in a soft brown corduroy suit at our first meeting there under the banana tree. No tie but then it was San Diego in the 1960s. We spoke of all things people might speak of when weighing a new acquaintance; the question's answer and how that answer

is delivered leading to one of a number of possible next questions and how comfortable I or he felt with those answers leading on to liking someone very much.

How similar our backgrounds! He also was the child of a military family (Navy, not Army like me). Both spent our young childhood on foreign soil. I was raised from age two until eight in Argentina and Colombia; Rich spent that same period and a bit longer in even more otherworldly Japan.

Rich Mapple told me he was studying journalism, but his true love was film and in particular Ingmar Bergman. All this on our first meeting. He spoke in a soft voice and ever so slowly as though measuring the weight of each syllable for intellectual correctness:

"W...h...o...? W...h...a...t...? W...h...e...n...? W...h...e...r...e...? W...h...y...?"

It was mutually determined that we would organize and run our little chapter of the Resistance together and equally as a blow against the notion of one leader, one captain, one chief, that spoke so of the old order, The Establishment. He was confident, in that pure wisdom at twenty-one, that there was nothing better than a drawn out consultation in decision-making under pressure, a back and forth discussion where all viewpoints are given equal weight; and I nodded.

**TO RUN A CON REQUIRES BOTH A CON-ER AND A CON-EE**
*Not posted anywhere, not a quote... a lesson*

Our ad in the *Daily Aztec* announcing the formation of an on-campus group advocating the principles of draft resistance brought us John ▮▮▮▮ (John V) and his roommates Jeff ▮▮▮▮ and Gino ▮▮▮▮. It also inspired a very formal letter from the San Diego State College administration telling us we could not have an on-campus charter as a chapter of an organization at the top of J. Edgar Hoover's *Enemies of the American Way* list.

Thus, with the addition of the three girls, and some relatively clever nomenclature, we became "Friends of the Resistance."

*The Three Girls:*

Ω  Leda ▮▮▮▮ – my girlfriend since the day I stood up in a political science class and announced my decision to return my draft card and refuse induction. After that class, we attended a rally featuring Mary McCarthy, daughter of the presidential candidate Eugene McCarthy. Then to her dorm room where I first heard the song *Time Has Come Today* by The Chambers Brothers and first learned the pleasure of pretending to be her swan. Leda turned on her heels six months later when she took that first gander at me after I had shaved my head in solidarity

with conscripted inductees. A former professor also saw my shiny white pate, and yelled across the courtyard, "What's next, self-immolation?"

Ω ███ ███ – a friend of Leda's who became radicalized in that year of 1968 and was looking for a nonviolent, anti-war organization. I was very interested from our first meeting, but it was John V who fell in love with her first and gave her the nickname, Li'l Miss Goodvibes.

Ω ███ ? (Allison Wonderland) – I never knew her real last name. A childhood friend of Li'l Miss Goodvibes. Incredibly beautiful, pale with curly strawberry blonde hair down to her butt.

♪ *You Ain't Going Nowhere*, The Byrds

♪ *Time Has Come Today*, The Chambers Brothers

## *Chapter xxxvi*
### *Graphically Described Sex with Li'l Miss Goodvibes & John V*

**W**ould you care to join us?" Li'l Miss Goodvibes asked while putting her cigarette in the ashtray and pulling open the covers. Patchouli oil scent roils out and over me. I'd just come into the bedroom. John V lying on top of the Indian print, his long lanky sides a little damp, hair matted, his cock still fat and slick.

I slipped my T-shirt off without even setting down the plastic bag of frozen peas and pork chops. Unbuttoning my Levi's® as I sat next to her, picked up the cigarette. John V reaches over and puts his hand on my shoulder. Tough to get my underpants off when my cock is as hard as all get out.

John V does have a bigger cock than me. He's also taller with incredibly smooth blemish free olive skin. But I don't go flaccid after that first cumming and I look a lot less like Howdy Doody.

♪ *Raga Kausi Kanhara*, Ravi Shankar

## Chapter xxxvii
### John V

John V's real last name was so familiar in American popular culture that anytime he gave it at the counter or over the phone he was always ready with a clever response to the inevitable question. Something he'd been doing since grade school.

"No, I'm his nephew." "No, I'm his uncle." "No, I'm his granddaughter."

Everyone just called him John V. I like to think it was me who first started saying that capital V as a Roman numeral five, elevating him into... A Pope! The Pope from mysterious Byzantium! John the V!

John V had been the one to have gone before and had the good sense to know that we would require assistance in our psychedelic plan. Guiding Li'l Miss Goodvibes and me, when as a couple we figured nothing could bind our romance tighter than opening those doors of perception. He found the perfect medium: 500 micrograms of Owlsey pharmaceutical grade lysergic acid diethylamide obtained from the Brotherhood of Eternal Love.

John V chauffeured the two of us as we began rushing in the mountains east of town, everything beginning to crawl in a Julian roadside organic produce store, standing over as we peaked in a clearing somewhere near the Banner-Grade. We lovers stepped through arm in arm, all melty and woozy-like; born again in a clarity, but the death and birth were no walk in the sunshine, orange or not.

They should have never done what they did. The FBI, I mean, they could have just called him on the phone and said, *Come on in John.* Cock-thanking bite, this was the most nonviolent person they'd probably ever run into. Three agents in two all-black Ford® sedans with red lights flashing for the neighbors. Hard pounding and dramatic announcements at the door of his parent's house during a Sunday evening visit and family dinner. Cuffed him, marched him, pushed him into the back seat... Thank, his mother! His father too, but his mother. It broke John V and I suppose that was part of the fun for them.

We found out later that night from a halfway sympathetic desk sergeant down at the county jail that, it being a federal arrest, John V was being held in solitary confinement. No visitors, no contact. Military town, Republican San Diego 1969; Draft Resister was the worst thing possible. The FBI could understand and possibly even relate to kidnappers, bank robbers, interstate child molesters, regular American guys all. Hoover inexplicably hated this Resistance and so did they. A last name ending in a vowel, maybe they thought he was Mexican. Bonus!

♪ *Morning Glory*, Tim Buckley

## Chapter xxxviii
### Graphically Described Sex
### with Li'l Miss Goodvibes & Allison Wonderland

Kento and the recently bailed John V were listening to Hendrix in the living room of that little rental on Amherst Street. Li'l Miss Goodvibes and I had wandered out and into Kento's Dodge® van, laying on the mattress for a little privacy.

♪ *Bold as Love*, Jimi Hendrix

When the side door creaked open, I figured it was Kento and time to head out but it was Allison come to find us, come to cuddle. We had all three been doing strenuous research in the altered reality field since morning, and just lying together in the fading Southern California twilight felt so comfortable.

"Take off your clothes, too," said Li'l Miss Goodvibes and Allison did. Giggling the whole time until we were all three naked. Me there fetal on her starboard, Allison, still laughing quietly, left-side, squashed in against Li'l Miss Goodvibes in the center pulling us into her little tits and cooing,

"Oooo, my two little babies. So safe and close with me."

I was inside Allison from behind, pumping slowly while she slurped and nibbled at Li'l Miss Goodvibes' clit. I would come too soon, if I couldn't distract myself. The smooth soft round warm porcelain butt... warm, warm... I'm going to come too soon. *Rommel drives deep into Egypt!*

Going to come too soon.

Li'l Miss Goodvibes wasn't helping the situation, pleading, kidding and playing with the Bard's tongue:

> "Come, night, come... Peter... come, thou day in night;
> For thou wilt lie upon the wings of night
> Whiter than new snow on a raven's back.
> Come, gentle night, come, loving, black-brow'd night,
> Give me my Romeo."

And reaching up to tickle her Romeo's balls... pulling...

♪ *Draft Morning*, The Byrds

The drizzle was constant. Greyhound® bus windshield wipers pulling back and forth at the same slow rate with the little pause. Started in Marin I think, but maybe earlier. I don't think I slept. Across the Bay Bridge after the transfer and still that same back and forth... back and forth... the little pause.

♪ *Wasn't Born to Follow*, The Byrds

Sometime in the middle of January, 1969, can't remember the exact date or day of the week and I really ought to. In a cold, gusty, early morning drizzle, I walked from the bus stop to the doors of the Oakland Army Induction Center and was stopped by a guy my age with really bad acne perhaps aggravated by the chilly rain.

"You don't have to go, man," he said, and I think it really put him back when I said, "I know, I know. I'm going to refuse induction."

*Back and forth, rhythmically...* he stepped aside, smiling.

Inside it all seemed quiet, grey, dim grey, methodical, bureaucratic. None of the drama. Nobody screaming, "NO!" Nobody screaming, "HUZZAH!" *In and out, in and out...*

That screaming stuff started when the group I was standing with was given the first memorized orientation speech and I stepped forward to the young Lieutenant right after he asked, demanded, "Do you understand?" and I said, "I am here, Sir, to refuse induction."

His face got close then back, back and forth, as he was yelling... did I know what I was saying and did I know that I was committing a felony, and *back and forth and in and out...* did I know that I would be punished with a sentence of up to five years in Federal Penitentiary and a fine of up to five thousand dollars, "DO YOU UNDERSTAND!?"

His face kept getting redder and his yelling faster. Close, very close to my face and then back, then close again. All with his neck, like a turkey.

The Lieutenant stopped and I was ushered away from the other fifty guys, taken out of that big hall and into a tiny room, maybe six by eight feet with two chairs separated by a small desk.

*In and out, slowly in and out...* after what seemed an hour, a man – grey tweed suit, sky blue shirt, narrow black tie, short grey hair – came in and sat across from me in this blond wood-grain Formica® tiny room.

"You know, Peter, Pete, you can't go through life always being a nice guy," FBI Agent Mr. ▓▓▓▓ told me, almost philosophically, his parting remark after our short interview. Lifting his left hand as he stood by the door, he flashed me the peace sign then the finger as he opened it and stepped through.

I came all over Allison's back, a lot, and couldn't keep from laughing. It just felt so otherworldly, so good, so nice.

*Chapter xxxix*
*In Which Coyote Explains the Reason
for this Book's Existence*

"Here we are, Pete," my sister said as she pulled the big Chevy Suburban onto the turnout. Here was the side of Interstate 8 about an hour east of San Diego, near Jacumba, near the Mexican Border and right at the spot where the old railroad tracks headed north under the freeway and down through the Carrizo Gorge to the Anza Borrego Desert.

"You sure you don't want to just spend Christmas in Chula Vista with me and John?" Mary asked.

"No. Nope, this is what I'm doing. This is where I want to be for the end of 1969, the end of the '60s."

I suppose I could figure out all the events that worked together to get me to this point. Lay them all out for you like in a list. Aye:

➢ I, no, Steve goes away to Germany.
➢ I still want to be in the mountains, so I start going alone.
➢ I like being alone in the wilderness.
➢ I buy that Colin Fletcher book, *The Complete Walker*.
➢ I spend a week alone traversing the Trinity Alps during the Fall.
➢ I attend a Ray Bradbury lecture at UCSD and overhear two girls discussing the Tate/La Bianca murders in Los Angeles.
➢ I watch as the girl I love falls apart.
➢ I watch as my friend John V is arrested and falls apart.
➢ I watch as my ~~friend~~ associate Rich *really* falls apart.
➢ I buy quadrangle maps for the Anza Borrego Desert.

Colin Fletcher taught me about walking alone in the desert and it seemed to fit with everything I understood about the search for an answer to a completely thanked up situation. Less than a week ago I had been sitting across from Li'l Miss Goodvibes in a pleasantly appointed, modern campus reading room, both of us chain smoking. I was trying to figure out something to say that would make her feel better... something that would make me feel less depressed.

We had awoken in the middle of some horrible sweaty collective night terror. A vivid dream in tones of black, grey and... dark grey. A vision of utter hopelessness stretching out into the future as far as we could see. John V, always our guide for LSD sessions, seemed a bit steadier, but in my heightened paranoid senses even he felt to be close to the fall. John V tried to reassure us that much of what we were experiencing was a normal aftereffect of the drug. And then suddenly John V was gone, arrested at Sunday family dinner.

Rich was really starting to flap around all bug-eyed. Some people don't react well to psychoactive drugs.

When you are trying to only see the good in someone and working so hard not to make what seemed old-fashioned value judgments, someone like Rich Mapple can slither through. Speak slowly and softly about Gandhi, throw in a few well-placed Zen tokens and some black & white Bergman quotes... it was my fault really. I wanted him to be the pal and partner I was missing.

Kento wasn't looking for a pal and wasn't fooled.

"Rich is pretty much jive," he'd said and didn't have much to do with him. I should have listened. Instead, I enabled.

"Let's use some of that money for a good thing, Pete, a nice thing for the girls. A present for Li'l Miss and Allison who are working so hard," Rich had suggested when we were wandering around in a bookstore on El Cajon Boulevard. I still had a hundred dollars saved from the Ice & Cold Storage plant back up in Eureka and thought it would be sweet to surprise both Li'l Miss Goodvibes and Allison Wonderland with beautiful art books – one about the photography of Ansel Adams and the other a large color-plate overview of Magritte – that Rich was paging through. Of course, like several times before, a few days later he told me he felt it would be better if perhaps we bought the girls something different... *something more special for them...* as he had really grown to love the books and was now going to keep them.

"Rich is pretty much jive, Pete," Kento said. "Remember his idea for a girlfriend?"

Oh, right. We'd never much seen him with any girls, but Kent and I were both around when he explained how he was interested in this new girl he'd met in a journalism class.

"I plan to ask her out to go and see *Wild Strawberries* and I am confident she will say 'yes' because she has a withered arm," Rich announced.

"What?" said Kento.

"What are you talking about, Rich?" I asked.

"She's very beautiful, clever and smart, and is perfectly normal in every way except that her left arm is tiny, withered – only about a foot long and very skinny." He used both his hands to form out the length and shape of this limb in the air in front of us.

"A birth defect, I think. She probably feels it keeps guys from asking her out, but I will tell her that it doesn't bother me one bit and she'll think that I am better than all those other guys and want to be my girlfriend."

"I don't see what you see in that guy, Pete," Kento had said later when we were back at the trailer. "I don't think there's anything solid there. Kinda creepy. Gotta make value judgments sometimes, and Rich is pretty much jive."

Rich did everything according to some sort of imaginary guide for successful hip living for the woefully un-hip. I can't describe it any other way. At times it got to be embarrassing, but I was still at a stage, a naïve stage of trying to see the good, only see the good in people, and didn't call him on it. I probably enabled his condition.

He rented this little cabin out east in Deerhorn Valley an hour-long winding narrow road away from campus. Bought a little dog and a set of clothes straight from some *Melody Maker* article about *The Beatles Magical Mystery Tour* – this massive thick sheep woolly vest!

The VW® bug, sickly green and barely running, should have been clue enough that Kento was right. Rich had an old aunt who died and left him her 1965 Dodge® Dart. Just like in the car collector's wet dream, this Dart had been garaged in Kensington, having amassed only 9,000 slow and cautious actual miles back and forth to the hairdresser's on that slant six. Rich traded it straight across for this piece of shit '59 VW® bug with twenty times the mileage and thirty times the abuse. How that hippie shyster must have laughed driving away with the Dodge® pink slip.

"It's a much groovier car, man," Rich said. "Girls don't want to be with a guy in an uptight establishment type car."

I hadn't seen a car of any type since I left my sister two days ago up on 8, although I did find a reference, to my surprise, in the middle of a solitary clump of brush, in the center of a vast plain of fine gravel and sand. I could see the bush from miles away and something within it picking up and reflecting the bright sun. As I approached, a white business card pierced by a thorn in its very heart, dazzling though tiny:

**BUY A TOYOTA® – GET A LEMON**
*Anonymously posted on bush in desert*

# IN WHICH COYOTE EXPLAINS THE REASON

On the third day, middle of the Carrizo Badlands as the sun set, from my sleeping bag I saw him there not twenty feet away – big clear eyes glued to mine and a slight warm breeze just rippling through his full tail.

"Hey little buddy... *tich tich*. Can you tell me... can you...?" I said so softly.

His coyote nose ticked up, and:

*"What? You think I got something for you, Thankface? Some natural wisdom? Shit!*

*Get the thank out of here, you thanking little human asshole!*

*Get a thanking job, you pussy! A real job where you sweat and all your muscles feel sore and connect you to the real thanking world.*

*Get the thank out of this thanking desert where you don't belong and get your sorry thanking ass back home.*

*Stop feeling sorry for your thanking sorry ass and stop... STOP!... being such a thanking pussy.*

*'OOO Boo HOO, I'm so sad... my whole life is falling apart... Boo HOO,' Jesus! What a thanking crybaby! Shithead!*

*Go the thank home and get to the thanking opposite of where you are right now... this thanking dry pile of rocks and dirt. WATER! The Sea!*

*Get a thanking job on a thanking boat.*

*Yeah, mother thanker, a thanking BOAT!*

*GO TO SEA!*

*Get some thanking fresh sea air into that thanking brain... get a cold hard splash of seawater in your thanking face! Work up a sweat for once!*

*Get dirt under your fingernails and a tattoo on your arm.*

*Just get the thank out of here... this ain't the place for you... but first, throw me the last of that reconstituted chicken fettuccine with the green peas there... you're not going to finish that, are you?"*

♪*Abba Zaba*, Captain Beefheart & His Magic Band

## Chapter xl
### *Bird & Life*

When a storm rages at sea, seagulls fill the courtyard, seeking a calmer spot to ride out the storm. But why come these ravens? I almost stepped on a dead raven on the sidewalk, perfectly wedge shaped like a sideways Maltese Falcon. Looked up and half the courtyard was filled with them, sitting on fences, benches, tables, bicycle racks, looking at me. Where's that storm?

Li'l Miss Goodvibes's eyes were steady, almost cold as she stared over my shoulder in the reading room.

"Why did they have to put *that* picture on the cover?"

Behind me, and facing her as if a contrived tableau in an art house experimental film, six other students on couches, at tables, in chairs – each with their face buried deep in the December 19th edition of *Life* magazine. Buggy eyed Charlie Manson leering six times, twelve crazed eyes drilling into Li'l Miss Goodvibes' two foundering eyes, announcing:

> *Behold! My visage heralds the end of the Happy Time!*
> *The time of youth, of innocence; the sweet and perfect time.*
> *My eyes, gateway to my soul, your soul, our soul,*
> *guide you and all you love and hold dear,*
> *into the coming really bad time.*
> *Make ready!*

## Chapter xli
### Bird & Death

When a dead robin was found perfectly arranged on their doorstep, she felt a return of the old paranoia and told me nervously that Rich Mapple had finally tracked her down. I thought it more likely a fluke. After all she was tucked away in small town Oregon with her grade school-through-high school sweetheart who had waited, steadfast on the sidelines for her experimenting with the rollicking summer of love-not-war, to be over. She was far from the Southern California turf Rich haunted, literally.

Li'l Miss Goodvibes was trying to smile but it was that clenched and holding back tears kinda smiling.

"Burp and me, we're going to move. Not far, I just can't handle seeing Rich." (Burp was the petit nom d'amour that her now husband carried, gamely, from the sixth grade.)

"We'll stay near Roseburg. But just more out in the woods, and off the grid," she said.

It seemed a little extreme and I tried to notch it back.

"C'mon, Rich is a wimp. He's not going to actually hurt you, unless you consider listening for hour after hour to that slow, s l o w, s l o w telling of the many tragedies... and then hearing him repeat the s l o w, slow... well, I was going to say moving would be a bit much, but now that I'm thinking about it, have you considered moving to any countries that require passports and visas?"

That got a little laugh out of her and her eyes had that look I remembered. In only a couple of years we had transformed from sweaty naked bodies intertwined to a young farmwife thinking more about grocery gardens than sex and enlightenment, visiting a commercial fisherman thinking more about crab gear and art.

"I'm kind of surprised by where you live, this building, and this kind of art you're working on," she said brightly in a manner to change the direction of the conversation. We were standing in my workspace at WACO in front of a recent drawing: A six-by-nine foot pencil-on-paper rendering of a very hairy, very close-up Karl Marx, with the text TIMES ARE TOUGH! floating through.

Li'l Miss Goodvibes' surprise was most likely because everyone else we knew from the Friends of the Resistance days (our own San Diego Resistance Family) had run as quickly as possible from any association with anything that seemed even a bit like the radical lifestyle. Had run to straight jobs; gotten their hair cut; gone back to school; gotten married; moved off the grid. Run like rabbits ahead of the blade. Afraid of losing their minds. Insanity! O! what a sharp and unforgiving blade that be! That's what the really bad time did. Brought that swift blade. Made us all very afraid of losing our minds.

"Well, Li'l Miss..." I began, but she interrupted.

"Pete, these days, I'm, we're trying to move beyond that nickname."

"Oh okay, ▮. Speaking of names, you know the name WACO comes from me and John V. It was one of our little catchphrases like 'See you at the beach!' Comes from *Midnight Cowboy*. Remember? Dustin Hoffman, as Ratso, is crossing the street in Times Square – almost gets hit by a cab! Slams fist down on the hood and screams, 'I'm walkin' here! I'm walkin' here!' Cabbie yells back: 'Get a job, wacko!'"

I took a breath and stopped pacing.

"So, we were always saying that: 'Get a job, wacko,' whenever it seemed right. As a joke to each other. Somebody bugged us, maybe. Whatever. Under our breath. Whenever."

"I remember," said the former Li'l Miss Goodvibes with a hint of smile.

"When we first set this warehouse up, I wanted that for the name. Just changed the spelling and figured out an acronym, you know. Western Artworkers Cooperative Outlet, or some people say, Organization. So, WACO."

She really smiled now with those clear blue eyes and seemed genuinely happy with what must have been a brief pleasant memory of those days with John V and me.

"Look, ▮, if he shows up around here, I won't give him any clue to where you guys are. I can handle dealing with Rich. That guy doesn't shake me up these days. Not... in... the... least... Remember, I've been at sea for years now. Commercial fishing, the work – maybe just the salt air, I don't know. Tough guy stuff! I've never been more mentally stable, more capable of dealing with adversity. And I am stronger than all THANK! I can just BOP! and no problem," I said jokingly making a jab with my left fist.

## Chapter xlii
### A-200®

Happy David popped his head up into my tiny captain's cabin sanctum sanctorum looking a little off his normal game of mirth and frivolity. I was about a third of the way through that Herman Hesse followup to Siddhartha: Magister Ludi. Wasn't doing it for me. I had liked Siddhartha. "What's up, David?" I said, setting the book down and waking Albert Einstein from his lap nap.

"Do you know about... well, this A-200® stuff. I mean does it work? Or is there a better way... I mean, shit... how do I get rid of these... these...?"

"Oh ho! Ho Ho.... ho." I couldn't help laughing even though it was obvious this was very upsetting for Happy David. Thinking about it later, I realized that a little chuckle was nothing. If I'd been a real asshole I would have answered in the way he always responded and said *Gee, David, that sounds like a personal problem* and then gone back to reading. Albert Einstein sleepily wandered over to his original master for a little affection, maybe sensing Happy David needed his services. He stroked and the cat purred.

"But, David, I got the sense that that girl was almost virginal. So pure and cute and young."

"I didn't get crabs from ███," he said. "I got them from that other girl, the creepy Dutch girl with the dummy."

"The shitter! You thanked the shitter?"

"C'mon, Pete, gimme a break! I didn't... I didn't know about the incident... the performance. I wasn't at that party."

"Oh, that's right. That was that first camping trip with the new little mousy mouse. But you heard about it now, right?" I asked.

"Yeah, I heard she got up on the table and crapped," Happy David said as he filled his pipe, tamped and lit it without missing a stroke on Albert Einstein's back.

"Well, yeah, but that was like the finale, David. That girl is very bent. There was a lot of... you know... dancing? Hippie arms flowing, full body spinning, strange guttural animal noises. I thought it was going to get all naked and sexy when she got up on the table and that ventriloquist's dummy started to pull her skirt up. But then what's her name, Penny, yeah Penny, just squats and shits.

"Right on top of my cheese ball, which I spent quite a bit of time shaping and putting little stick pretzels into.

"F. Scott and Charles Motherthanker III escorted her out of WACO. She wasn't too happy about that. You had sex with her?"

"Yes, Pete, I had sex with her. It was weeks after that party. Remember I didn't know. I got seduced... couldn't help it."

"Yeah, yeah, keep going," I said.

"So she was just very friendly over at the Ebony Club and we came back over here and we're drinking wine in the kitchen. I went in the bathroom and when I came out, she's gone. Not here. *Penny? Oh, Penny? Where are you? I'm in your room, David.* So, I go in and she's lying there naked on my bed, writhing, and reaching out to me... she had one of my pipes... and was putting it up inside her... you know, her... in and out, in and out..."

"Okay, I understand. Could have happened to anybody." I shifted around in the bed to try and dislodge my erection, jammed as it was by the bed cover. "You're sure you have crabs?"

"I saw a couple. Yes I'm sure. Very itchy."

"Okay, forget about all that pharmacy crap. You would need fifty bottles. First thing in the morning, run down to Englund's Marine Supply and get two gallons of kerosene:

- ✓ Kerosene (2 gal.).
- ✓ Big plastic or metal tub (big enough to just barely sit in).
- ✓ Put kerosene in tub.
- ✓ Take all your clothes off.
- ✓ Sit in tub with kerosene.
- ✓ Don't smoke (not flammable, but it is combustible; if you were flapping around you might aerate it enough).
- ✓ 1 hour! Sit there and contemplate. Read or something.
- ✓ Don't masturbate!
- ✓ Make sure all pubic areas have been well soaked in kerosene.
- ✓ Exit the tub and then,
- ✓ Nice long hot shower – soapy and scrubby!
- ✓ Throw underpants away – far away from here!

"And that's it! Should take care of the problem, little mousy will never know. My lips are sealed."

"Thanks, Pete," Happy David said, his mood much improved by our informative chat. He set Albert Einstein back on the bed and turned around to climb down the ladder.

"Oh, David, by the way," I asked just as his head was disappearing through the hatch. "Was it *that* pipe?"

## Chapter xliii
### Mackenzie & Mona

I can't remember ever seeing Mona in anything other than a tight, long haired cashmere sweater. Since I know she didn't have any money she must have searched every thrift shop in every town she ever passed through; or maybe she kept some sugar daddy sweater salesman hard in hopeful anticipation, somewhere in L.A. Frayed, faded jeans, crappy shoes, and a tight, tight, soft, smooth, furry sweater. Mona had short brown hair, a sort of a chipmunk face with wide blue eyes, slight overbite over a weak chin and a guttural giggle. I got a boner whenever she giggled, especially if I was close enough to sense her cashmere tendrils. It was so easy to drop my gaze down from that weak chin to her strong, standy-up tits with those ever perky nipples.

"I'm not that kind of girl, Pete," she chuckled lowly, even though lying close next to me under a blanket on my mattress for warmth, watching a movie on my – the only – TV.

Mackenzie, who everybody just called Mackie, and Mona had come into the neighborhood in the summer of 1970 and taken up living in an old basketball court on the second floor of the building adjacent to The Ebony Club. They never could get that place warm and spent most of their time hanging around WACO where there were a few pockets of warmth and a lot more warm bodies.

I never could warm up too much to Mackie even though she was always mentioning how *wearing these tight Levi's® with the buttons rubbin' on my clit all the time make me wanna thank all the time.* I asked her once whether she and Mona, since they were always together, did other stuff together like with one guy but I think that was only to try an' get into Mona's pants. Could have been her love and admiration for Charles Manson keeping even this horny boy at bay.

♪ *The Ballad of Easy Rider*, The Byrds

"You only get the media shit, all lies," Mackie had said. "Charlie was the sweetest guy, really talented, an artist like you, Pete. That should make a difference."

"Oh, come on Mackie! That Manson shit was completely insane. No

way it's just some exaggeration by the press. I mean, I don't believe that Bugliosi stuff straight. He's a DA looking to advance, playing the hippie fear card, but the guy whose word I *do* trust is that Ed Sanders, you know, one of the original Fugs, '*Nothing, nothing, nothing, nothing...*' you remember.

"When the whole trial was at its height, the *Village Voice* back in New York appoints Sanders, the undisputed *hippest of the hip* to go to L.A. and find out what the truth was. They all figured it couldn't possibly be true, what the cops were saying," I took a breath.

"Just read his book, *The Family*, for thank's sake!"

"Yeah but," Mackie came back with, "I lived with them all out at the Spahn Ranch for a couple of months."

"Thank! No shit?" I said, pretty shook. "You weren't around in the fall of '69, right?"

"No, no... I... well, me and Mona had left way before that."

"Maybe people change dramatically. I gotta few old *friends* that would qualify for that." I picked up the pack of cigarettes, offered one to Mackie and lit one for myself.

"I knew about the music connections, the song writing. Pals with the Beach Boys. That Terry Melcher thing."

"Terry Melcher?" Mackie asked.

"Doris Day's son, Hollywood producer... besides the Beach Boys, you know he was working with one of my favorite bands, The Byrds.

"Key thing is, Mackie, at some point there, Manson met with Melcher and pitched his music, his philosophy. And Melcher turned him down. Charlie might have gotten very pissed off, I don't know, but I do know that Terry Melcher was living at that house and then left and rented it to Sharon Tate."

"So, not good to piss off creative types, I mean *short* creative types?"

"Yeah, right," I said, looking at her in a way that let her know I got the jab, however ▮.

♪ *Have You Seen Her Face,* The Byrds

"Do you all have some nells I could have? We're putting up some boards," Mona asked one afternoon.

"Nells? What do you mean?" I was puttering at my workbench and Happy David, eating a sandwich out in the adjacent kitchen, was eavesdropping.

"Nells, you know, nells to hammer in and hold the board up there on the wall fer a shelve."

I could hear Happy David out there laughing and that's pretty much how she got that nickname. Nobody around WACO ever called her Mona again after Happy David got the word out.

## Chapter xliv
### O Irony! The Apple!

If ever there were a garden. If ever there were two naked innocents with genitalia waking and beginning the throb, the throb that, if ever it was, leads into, and out, in and out, up through, and up out, and up down through thousands of generations. And throughout history all the stories of The Fall caused by that fruit, that solid nutritious fruit (so maligned) working class healthy fruit, the Apple. And the sad misunderstood underfoot serpent just doing as it was foretold delivering to First Mother: Knowledge! Understanding! Science! And She passes it, offers that same hard fruit to First Father and it does with the eating thereof, cast them each out, cast them out of the bliss garden of stupidity, out of the calm eternal joy of ignorance.

None could say that Apple was the destroyer, rather more the creator itself of everything all potential built atom upon atom, molecule upon molecule, over the eons reaching the highest point, and on that lofty point at last with clear wise eyes able to see back, back, back through the blackness to the very beginning.

Then, as that fully realized wise humanity stands at the brink of understanding true Oneness, it is only then that the jokester, the wily coyote comes visiting; sidling up on the *sinistra* saying:

"Hey, lookie, lookie, try this," and then laid out on upturned paw offers forth the tiny fruit, glistening, glistening, dripping, dripping and more beautifully sweet and deeply saturated red than anything in nature naturally achieves:

The Maraschino Cherry!

Man nibbles, and hands half with sticky fingers to her open mouth.

They embrace the sweet irony.

After long searching in each other's eyes, they dismiss the difficult Apple, with,

"Meh... whatever..."

♪ *Happiness Runs*, Donovan

**IRONY IS WASTED ON THE STUPID**

*Oscar Wilde. Pinned above the opening of Steve's tent*

## Chapter xlv
### Times-Standard

Steve came into Peggy's about a half hour after me and I'd had plenty of time to read the Times-Standard and finish my French toast. "Did you see the paper yet?" I asked just barely able to contain my glee.

"I don't need to waste my money buying the paper to get lied to, I've got lots of friends who'll happily lie to me for free."

"Well, this little blurb here," I pointed to a short article on the third page and handed Steve the paper across the table.

"This is pretty entertaining."

### WOMAN ARRESTED IN OLD TOWN

Eureka, CA (AP) – EPD arrested a woman yesterday morning at the 2nd and E Street location of an antiques store. Witnesses told the Times-Standard that a naked young woman was found squatting in a front window display at ▌ Antiques by the store's owner upon his arrival to open the store. She had apparently broken in and made herself a nest in some hay being used as part of a display of vintage farm tools. Owner Sam ▌ was quoted, "She was naked as the day she was born, squatting there in the hay making chicken noises. When I told her to get out of my store, she clucked a lot, said she was hatching an egg and then threatened me with an old Charlie McCarthy ventriloquist's dummy. I called the cops." Police have not yet released the name of the woman described only as a disturbed Dutch national.

### WATERGATE HOTEL BREAK-IN

Washington, DC (AP) – Five men, including one who says he used to work for the CIA, were arrested trying to bug the offices of the Democratic National Committee at the Watergate Hotel and office complex.

♪ *Sin City*, The Flying Burrito Brothers

## Chapter xlvi
### The WACO Meets The RogerT

Jolly enough it was in the days following that first celebration in Old Town. Flags and pennants still flew from the lampposts and an unusual warmth filled the days; and even stranger for Eureka, the evenings.

The buzz of the doorbell/intercom came as no shock as we'd been having a number of visitors, afternoon drinking sessions and small gatherings for dinner; much seeming to have stemmed from that open house we'd thrown together for the July 4th Old Town Festival.

With Trini at his side holding a tray of tiny Dixie® cups full of red wine, Charles Motherthanker III in faux tour guide outfit with cap and armband, had led group after group on these very popular "walking tours of the artists' abode."

"And here we see where they cook and eat their meals," he said with an open palm directing the gawkers pushing forward right up to the red velvet rope that cordoned off the kitchen.

I got no response to my intercom greeting and so headed down the stairs and through the Sweet Keith maze to the front door.

A slender young man, looking slightly older than I but boyish with wispy beard, smiling warmly, holding up both arms as if intent on hugging. Upon seeing my unfamiliar face produces instead a small printed card:

**HELLO FRIEND!**
**MY NAME IS ROGERT AND I AM ON A SPIRITUAL JOURNEY OF SILENCE!**
**PLEASE ASSIST ME ON MY PATH BY LIMITING YOUR**
**QUESTIONS TO THOSE WHICH MAY BE ANSERED BY A "YES" OR A "NO"**
*RogerT's calling card*

"Hey, hi," I said. Then studying the card in my hand, asked, "Umm, isn't there a *w* in *answered*?"

He quickly grabbed the card back from my grasp and after deliberate study mixed with some frowning, nodded fully at me and broke into a wide smile.

I will not bore you with the long process of elimination – *yes* or *no* – that led me to understand that he had been a college friend of Happy David's,

had been in touch by letter, and was hoping to visit for a while. A similar game of questions, aided by information that arrived later, allow me to explain that his name was pronounced row-JER.

He had taken only the first letter of his family name, appended it onto his given name and because of a year in Europe pronouncing stuff, made it silent. *Et voila!*

Very pale in complexion with long blond, I should say *dirty* blond, hair. Like-colored eyebrows above his wire rim glasses, good smile, easy laugh, RogerT was dressed from head to toe in what looked like full *Chichicastenango* including huaraches, which would be expected but also a rough wool head wrap which would not be. That wrap along with the drapery of bright wool layers gave him the look of a Middle Eastern Pharisee. There had been rain that morning while he'd been out on the road with his thumb and all that patchouli oil didn't completely cover the wet dog smell or the body odor. (Actually, that combination... that particular reek, somebody really clever – like Frank! – could make it into a kind of perfume; pop lots of people right into a Woodstock acid flashback with just a little spritz.)

"Well, come on up," I said as he jammed that little calling card back into some section of the bright woolen hand-woven shoulder bag.

"David's here someplace."

RogerT hitched the big backpack up and followed me through the maze of Walden to the stairs and up into the kitchen.

"There's the bathroom, if you need it," I said pointing into the little room next to the kitchen that had been plastered with found billboard posters artfully torn and collaged floor-to-ceiling, turning what had been a dark, sad, small room into something visitors regularly photographed.

"Steve, he's another guy here. Real master worker, he can do most anything. He and I just finished putting in a hot water heater and a shower, so there's *that*, if you are interested..." I hinted.

Happy David spent several hours with him, did the twenty questions routine multiple times and tried to square the whole spiritual journey thing with the Roger ▆▆▆ he had known three years earlier in the Art Department back at the University of Illinois, Champaign-Urbana.

Apparently, Roger had dropped out and gone to New York City to try and make it in what he would later call *the real art world*, got pretty connected, spent a bunch of time in Europe and wandered the world, while Happy David had moved back home, back to Humboldt State to finish his degree.

Even though RogerT, as he now called himself, never opened his mouth, never spoke a word, he and David managed to have more than just a few disagreements about art and how to live one's life that first afternoon.

"Thankin' asshole," Happy David had muttered to me while RogerT was out of earshot. "I hope he leaves right away."

RogerT stayed for most of two years and after that first month with the little calling card and the spiritual journey thing, he finally spoke:

"Mother thankin' cocksuckers! It feels great to have the words coming out! Let them come on out! SPEWING, THANKING OUT! Gimme a thankin' beer!"

The very next day he was guffawing at poor Happy David for having the temerity to suggest he was planning to sell the new squeegee paintings.

"You might be able to ask someone to help you out with the cost of materials, David, but you have no track record. No sales in a properly accredited gallery, no reviews by an acknowledged critic. Art of value doesn't just pop out of nowhere, it has documentation. Provenance. Real art has papers, man."

His near yearlong vow of silence ended with a curse and he wasn't kidding about how good it felt because once RogerT started having those words come spewing out, he never shut up.

## Chapter xlvii
### *A Second Aside Concerning F. Scott & Happy David*

Happy David wandered out into the kitchen looking for coffee, sleepy-eyed, not initially seeing F. Scott there at the table with the newspaper.

"Bwoka, bwoka, bwoka... bwaak!" clucked F. Scott.

"Thank with me not, lest ye be thanked with," said Happy David not even turning to acknowledge F. Scott's presence.

"Yeah... okay," muttered F. Scott.

♪ *It's A Shame,* The Spinners

## Chapter xlviii
### *The Scraping*

RogerT's body odor and general greasy appearance had come up as conversation amongst the rest of the group and I, since I had let him in, was asked to have a word with him.

"Thank that shit! He's David's old pal. Have David talk to him!"

"David's not talking to him at all," said Wise Keith, looking up at me over the loom. Glowering in that powerful way that his deeply set eyes only allowed. "You let him in."

"Yeah, okay."

"Okay RogerT... ya know Steve and I set up this pretty nice little shower system in the bathroom... I mean, *if* you were interested," I prodded forth using the words as a little stick.

"It's unnatural, *un natural*," answered RogerT.

"Really?" I asked.

"The human body produces oils to naturally cleanse itself of the toxins that are expelled through the skin's surface via the pores."

He lowered himself down on the one rug in my workroom.

"On occasion, ceremonially, I scrape my skin to collect and dispose of these pollutants."

"Scrape? Ceremony?" my eyebrows were raised.

"People have been doing it for thousands of years. It's only in the last few hundred and only really in the West that we have this love of immersing our bodies in water. Up until recently, most bodies of water were such repositories of filth that the idea of even dipping a toe into such was thoroughly disgusting. Yes, *scrape*. Do you want to see?" He pulled the filthy stiff caftan over his head and tossed it aside. It landed with a heavy thud and eye-stinging waft.

"Uhhh...."

RogerT reached into his dirty, bottomless hand-woven smelly Guatemalan bag and pulled out a long knife-shaped object.

"It's made from a baleen plate, from a whale. That might be of interest to you, Pete."

As he scraped and as I watched, RogerT began to trace his intellectual, his philosophical, his artistic path from the strictly rational and conceptual

to his latest position and that which he considered the eventual position, the final enlightenment of all seekers who wish to explore fully, as he had.

"*Solipsism*," he pronounced as he finished a long run up the back of his calf and wiped the blade on a hand-woven rag.

"Just as I control everything you now witness here, everything you think about now during this very contrived scraping scene." RogerT moved his hands and arms with a flourish as he repositioned himself for the next leg to be scraped. "You will one day control the entire universe you create for your reader in telling this amusing little scraping story."

RogerT smiled up at me from the floor, and he did have a winning smile, blue eyes bright behind those antique wire rim glasses.

"Make me attractive; interesting and attractive."

"I'm probably going to make you smelly; interesting and smelly."

## Chapter xlix
### Does Art's Magnitude Diminish? Will it Perish?

[Rogert is speaking:]

Couldn't do the con. Couldn't look into their eyes no matter how disgusted I was by their wealth and micron-thin intellectual rigor. I couldn't continue with the hustle that their purchase of a painting or drawing I had made, would give them what they so desperately sought:
Cool. The Coolness.
The Miles Davis Coolness.
'Everybody cons, RogerT,' my gallerist had scoffed. 'Honestly? I'm conning you right now with this meaningful discourse.'
'Not everyone,' I had insisted. 'Not me.'
'Those people all fail, RogerT. Failure not just in the arts, but in any form of human – social, political, whatever – human interaction. They inhabit the periphery, wander the streets, stumble the gutters of New York or Nairobi, sleep in the rescue mission and culvert, live in some backwater burb and procreate with their cousins, they always have, since caveman days,' he laughed. 'And when they do get their voice heard? Well, it's so very easy to dismiss genuine honesty as the blathering of an idiot or the immature pronouncements of the naïve.'"

RogerT's revelations on why he had left The Art World that most of us here at WACO considered our destination, his long conversation with me that night on the roof with the chickens snoring and the Chianti soothing, was certainly an eye-opener. Not only in that simplest of terms, the understanding of the complex workings of the Art World at its highest levels, but also in what it revealed about him. The man I had considered so thoroughly cynical was as much a romantic as I.

"Keith, that RogerT isn't as thanked up as I'd first suspected. I was up on the roof the other night talking with him and he was making good sense... about the Art World, anyway."

Wise Keith looked up from his weaving, fixing his eyes on me as he reached for another cigarette, "I haven't felt that from him as of yet. While I don't know RogerT very well, I got the notion from some of his pro-

nouncements... he's certainly free with those... that he is still very tied to the traditional model of the Art World, with a dose of cynicism thrown in to seem contemporary. Both you and he have that quality in common, I would note... if I can be a little free with my pronouncements as well."

"Well, if you mean that I acknowledge the existence of the Art World and want it to acknowledge me..."

"That," said Wise Keith, his deep eyes drilling, "*is* what I mean, what I consider this soft blasphemy."

"Talk not to me of blasphemy, man! I'm fully willing to destroy all of that structure: galleries; museums; collectors; all... all struck through that fatuous mask they wear..." I yelled but then caught myself. Wise Keith and I had always, even back at the Ice & Cold, been able to speak freely and without falseness with each other.

"But look, Keith, friend Keith, that which is said in heat... that thing unsays itself. I meant not to incense you."

Wise Keith stretched back from the loom, arching and rotating his back, his neck. Slipping the cigarette into place on the ashtray, he reached for his mug (covered with cartoonish renderings of cats, *CAT LOVER* printed in blue). "Let it go, let it all slip away," Wise Keith said gently.

I spoke again:

"You make all these beautiful weavings, tapestry really. Wouldn't you wish for a system, a system more fair and open that would allow you, *recognize* you and all your hard work, allow you to actually make a living from this, this beauty, rather than the shit manual labor that might pay the bills?"

Wise Keith smiled as though taking my words as a compliment and also as a sign of my ignorance, two for one.

"Pete," he said, "this, these material objects, the weaving, the macramé, these, this is my craft. A separate thing. My Art, my Holy Thing... of that you know nothing:

"*I began early, in grammar school still. Living as I was in a less than smiled upon environment: single mother; food stamps; subsidized housing... out where the Eureka Mall, Sears®, now stands, you remember... there was not much extra for the purchase of frivolous art supplies, but I could read and I could write and I could find a notebook now and then. So I began to write out full and detailed descriptions of the paintings I would paint, the sculptures I would sculpt, the movies I would make... and this will probably amuse you: full and complete descriptions of the books I would write, including careful explanations of the choices for punctuation, tone of voice, et cetera. Hah ha!*

"*By the end of high school, my room looked a mess! Not a spare inch, crammed as it was with stacks of paper, high piles of inspired-project-filled spiral notebooks. I needed to make a change and that change presented itself in the*

form of a chance encounter with Tibetan Buddhism. I had hitchhiked to San Francisco and wide-eyed rube from Eureka, was just wandering Chinatown hoping to find a meal I could afford.

Naturally, I got quite lost and rounded a corner to find myself in front of a sign which read:

**TIBETAN MONKS SANDPAINTING! YOU ARE WELCOME!**
*Unattributed. Signage in Chinatown*

*Inside the quiet dim temple six robed monks were splayed out around a four-foot by four-foot partially completed mandala. Reaching in and over, they were adding little lines and shapes, a grain of tinted sand at a time!*

*A steady and almost rhythmic chirpa, chirpa, chirpa, came from the rubbing of the brass tubes holding the sand. The rubbing stick caused a vibration to move the grains along to the end of the tube as well as the beautiful chirpa, chirpa, chirpa sound.*

*I was astonished, never having seen anything even remotely similar. The colors! The intricacy of the design! Inquiring of guide/interpreter nearby, I discovered that upon completion, after more than a week of intense labor by these six, the work, all loose sand I remind you, would simply be swept away.*

*Returning to Eureka, returning to my room, I simply swept it all away. My mind felt clear for the first time I could recall, and from that time forward, anytime I completed one of my written planned projects: of the paintings I would paint; of the sculptures I would sculpt; of the movies I would make; and of the books I would write, out to the burn barrel in our yard I would go with the notebook or handful of papers, much to my mother's amusement."*

Wise Keith paused and stood as if to stretch even more. The studio, like the rest of WACO, was always cold and it's hard to imagine how that chill and the long hours at the loom could not have caused gripping cramps. There was a cleaned-off skylight in this room and it was up into that glass and the thin grey overcast light that Wise Keith looked as he pulled his shoulders back and his Tam o'Shanter down.

"I'll tell you something I found to be true, Pete. That *Great Artist* thing you have going... that connection with the stream of Art from the Willendorf to the... whomever. That *Art is my mother, Art cares about me...* that, all that. That's an illusion, man."

"You really think that, Keith?" I didn't want to argue, figured it'd be one of those *agree to disagree* things.

"Art isn't a loving friend or Mother or... God. It doesn't like you or love you or hate you. Not out to embrace you or out to get you. Art is just a force... just creativity rolling along... it doesn't even know you exist. But don't feel bad about it, it doesn't know *anybody* exists, it doesn't know

*anything* exists... Art doesn't know *it* exists.

"Recently, these past few years working at the Ice & Cold," Wise Keith started again after lighting a new cigarette, "I've stopped even writing the ideas down; feeling that *that* act, the writing, the notebook, was tying the work, the pure idea, too much to the material world. Holding me back, still. The True Art, the Pure Art, the Holy Art cannot be made material in any manner; cannot be documented or even discussed."

"Can it even be thought of... contemplated, Keith?" I asked in all seriousness.

"So it would seem, but Art is a fleeting thought. That's why we must satisfy ourselves with this craft work," he said, gesturing to the rough bright cloths, soaring clusters of knotted wool, all the beautiful weavings that hung, filling the walls.

And it was true, what he'd said earlier, of this Holy Thing, I knew nothing.

♫ *Cross My Heart*, Phil Ochs

**ART IS THE ONLY SERIOUS THING IN THE WORLD**
**AND THE ARTIST IS THE ONLY PERSON WHO IS NEVER SERIOUS**
*Oscar Wilde. Posted above entrance to Santino work area*

## Chapter 1
*Are We to Presume Then, That the Seed of the End of All,*
*Is to be Found in One of Those Late Night Discussions With RogerT?*

"History is not truth," pronounced RogerT. "These writers/comedians at National Lampoon, while thinking only to make a clever joke, are actually, most likely accidentally, putting forth one of the more recent contributions to the study of history by the postmodernists. We cannot accurately write anything about an ancient culture without tainting that description with our own contemporary prejudices and our own viewpoints, making a truthful rendering impossible."

Steve tossed the magazine back onto the kitchen table and lit a cigarette before saying, "History's *Truth* has always, since Ugg slew Dugg with the donkey jawbone to have full access to Juggs' pussy, been laid down by whomever was the Ugg of the battle. But with film, photography... video... wouldn't you agree civilization is getting to a point where some kind of accurate, unbiased chronicling of *Truth* can occur?"

RogerT shrugged, and got up from the table to search for more coffee, finding a few fingers worth of sludge in the coffee maker.

"Sure, maybe in some rare instances. But so what? Even if you were trying to tell the story of something as recent as last month, or, ten years ago or twenty, thirty, *even forty years ago*, hassle, hassle, hassle. Maybe you have to start tossing off some of the effects, *affectations,* of all those history classes Steve.

"Stop worrying so much about Truth, that Truth that dances there in front of your mouth with its capital T so proudly erect."

"I wouldn't say... *I was worried*," Steve said slowly, deliberately and delivered almost in the manner of John Wayne in *The Man Who Shot Liberty Valance* (1962, Paramount Pictures, John Ford Productions).

"*I wouldn't say... I was worried... pilgrim.*"

RogerT finished his thought, "Stop thinking: *Hey, is this story true?* and start thinking:
*Is this story any good?*"

## Chapter li
*Moby Dick*

Within a day of Steve's return to these shores and my Willkommen, he had found his spot to pitch the large Army tent purchased for a pittance from Palmer C. Berg Army Navy down around the corner on Broadway.

Capable of protecting a full platoon during the harshest of conditions, Steve's new room-within-a-warehouse stood a full ten feet tall and was easily that much again in width; in length, another yard or two. Made of heavy dark olive canvas and soaked in fish oil for water repulsion, it could have stood stiff on its own without the poles and lines to the rafters. It emitted a consistent, not displeasing odor, friendly to the nostrils of fishermen from all parts.

A crimson Persian wool carpet from the back room of the antique/junk store, a California King mattress, oak roll top desk and chair, and flickering candles, gave the interior an inviting, womb-like quality.

Whether it was the odor, that womb-like quality, the size of the mattress or size of Steve's cock, I never was told, but Nells found her way into that dark and calm tent, room-within-a-warehouse, soon after Steve set it up. I wasn't the least bit jealous, feeling actual satisfaction during his description of the event. We were very close.

"She said, *'All I am to you is a fur-covered jock strap,'* and then took off."

I made a couple of fur-covered jock straps after Steve told me the story. Those jocks hung on the wall above my bed, bookends to a tiny photo of Méret Oppenheim's fur-covered teacup, for as long as I stayed at WACO… but never succeeded in pullin' Nells in.

Mackie and Mona, I mean Nells, left in the spring for Alaska and some scheme involving the pipeline.

Early on in that '72 summer, Steve and I were in Chico after a hard run down from the summit of Mount Shasta. A wedding looming.

*For what is wedlock forced but a hell,*
*An age of discord and continual strife?*
*Whereas the contrary bringeth bliss,*
*And is a pattern of celestial peace.*

Steve was spouting Shakespeare again. "Henry VI," he answered when I asked.

"*Do you know where hell is? Hell is in hello,*" I started singing, laughing.
"*Heaven is goodbye whenever it's time for me to go!*" Steve finished the couplet in perfect Lee Marvin basso profondo.

♪ *Wand'rin' Star*, Lee Marvin (from the 1969 film, *Paint Your Wagon*)

Wise Keith didn't marry Mary ▮▮▮▮... probably the best for all if I leave it at that. Still it didn't seem right to leave the liquor and hot weather go to waste so Steve and I and the Maid of Honor headed deep within Bidwell Park for the afternoon, drinking and swimming naked.

Those two fell hard in love. Steve and Jan ▮▮▮▮, the spark plug! Venus of the Peninsula, the Madonna of Millbrae. The two... a force of nature entwined and I was happy enough to play Puck:

*How now, spirit! whither wander you?*
*... I do wander everywhere,*
*Swifter than the moone's sphere;*
*And I serve the fairy queen,* and her new made King!

Steve's dank tent wasn't the honeymoon bungalow most would conjure, not that Jan was complaining. Dale ▮▮▮▮, nice guy trucker and next door neighbor to Steve's parents, stepped in fluke-like, and offered his retired 1950 Ford® F-6 delivery truck. Big and white, it cried out for a nickname and soon got one. Little more than a minute was spent spraying that white whale's name in four-foot high letters on the side of the box. Shaking that spray can, clickety-clackety, for a prescient graffiti tag homage to Melville.

A frenzy of cutting and nailing turned the interior of that cargo hold into Juliet and Romeo's dream summer cottage, outskirts of Verona, lined in Indian bedspreads, thick with incense.

Charlie Cain had left WACO and his moldering mountain of newspapers behind (a boon for the trogs!). Through the massive garage door, into that newly available parking slot, slid MOBY DICK.

## Chapter lii
### The Carpenter

Comrade, if it were possible to place thyself high above the plane of Earth and consider the perfected concept of a man; he seems now a beautiful wonder. But then, take a turn around in place, refocus... and survey mankind as a whole and it seems a mob of simple animals, mired in mob's rule, repeating the same wrong actions and courses over and over.

There was some wisdom within the walls of WACO, no doubt, but most was the new-minted wisdom of youth, shiny still and unsullied by experience. Wise Keith Buck would certainly qualify as being wiser than most of us. With those piercing eyes and a good five years more of life and work to draw on, few would challenge his advice.

And yes, RogerT offered intelligent, if a bit cynical, understanding of the processes of the Art World at its highest levels, but I turned to neither of these two for clues as to what Art was; what it was and would be to me.

I turned to Bill ▇▇▇▇: not a *beautiful wonder*, but also not a man mired in any mob's rule. A near obsessive/compulsive perfectionist working with wood for many projects (sculptures of doors, ladders, brooms) and now bone, finely shaped into letters. For all these reasons, he earned the nickname "The Carpenter." *Carpenter*, a trade name I hold in highest respect.

## Chapter liii
### The Carpenter & Me

[Evening. The last nearly horizontal shafts of sunset streaming in from the north windows. Bill ▮▮▮▮ whittles down the rough-cut bone with a scroll saw forming another sans-serif M, and sets it in line with the others, the 30 other m's.]

"Why 'M' Bill?"

"Why... just the most perfect of the letters!" with just a slight lilt in his voice.

"All the power and sexuality of the 'V' and the added benefit of legs to stand on!"

"And no pesky inside 90's, no troubling curves... speaking from a scroll saw's point of view, of course," I said.

Bill ▮▮▮▮ raised his eyebrow slightly in a way that conveyed full awareness of my gentle mocking as he looked at me and continued:

"Always remember, Peter: *Take an object. Do something to it. Do something else to it. Do something else to it.* That's what Jasper Johns said."

"Uh huh... those bones are really big. Where'd you get them?"

"Not just bones, *whale* bones, Peter," he said hoisting a large nearby chunk and stifling a sneeze. "Also quite dusty when cut.

"I've been getting them from the Eureka Fisheries yard in Fields Landing. The last whaling station in North America. Quite a pile they have out there. Delight told me a gardener friend had been getting some to grind up for soil amendment. Seems sad to just grind them up. Some are big enough to carve into substantial objects. I'll polish them up later, like scrimshaw."

Now he let go with a huge sneeze.

"Bill, I feel like you're the art teacher I never had. The only actual instruction I ever had, that would, I guess, be considered an art class was that class in photography at Humboldt State, Tom Knight's class."

"Oh, yes! Tom Knight, *Tom Knight!*" Bill ▮▮▮▮ transitioned into a near perfect impersonation of the beloved professor's eccentric speaking style as he leapt over to a mounted photograph and began "cropping" it with his hands and forearms.

"And what are we saying with the image when the object is sitting thusly in the plane of space?" Cropping more from the left and top now, leaning in to obscure more and more of the photo. "Better. Yes, yes, better! But perhaps, perhaps, a little more over here! Yes, yesssss! There!" Finally completely blocking the photograph with both hands and most of his upper body.

I cracked up. Even though I had seen the routine before, it didn't get old.

"Carpenter, you smooth that bone so fine with rasp and paper, planes and blades. Is there no bone you would fail to smooth?"

"None, save the one," Bill ▬▬▬ replied with a dismissive noise.

"Then can you just smooth this one?" I pleaded as I passed my hand across my troubled brow.

"Hmmph," he said with that same dismissive tone, "that be the one I mentioned, but here, hear:"

Though I had also heard *El Paso* before, I never failed to get carried away when he picked up his guitar and began to play those first few notes. Bill ▬▬▬ was the consummate showman and knew every verse. All sixty-eight lines, all fourteen stanzas. Each note rendered perfectly, every word sung as it should be with the correct feel...

♪ *El Paso*, Marty Robbins

He'd put together his own rock band when he was thirteen back down in Fort Bragg, where he grew up. Son of the mayor and not going to stay.

"You know, Pete," he said, "those big drawings you're doing have as much right to be exhibited in art galleries or museums as any of the other stuff I see out there in the art world."

I hadn't really thought much about that possibility until Bill ▬▬▬ said it that night. I mean, I felt like I was an artist, at least pretending, but the idea of actually exhibiting and selling work? Well, I hadn't really considered it. There was a bit of the cocky youthful idea merged with some leftist political notions that all of the art world was decadent; a playground for the rich. A clever, unregulated system for moving and laundering ill-gotten gains.

My thinking at the time was to do work so great, so impossible to deny and yet completely separate from tradition that – oh, and keep doing it, regardless – the Art World would eventually bend to me. It would just have to.

"Thanks, Bill," I said. "You realize, I hope, how much your opinion means to me. One of these days, maybe, I'll show, exhibit. I'm serious about you being like a mentor, man. Your *lessons*, well, you really give me a leg to stand on in the Art World."

Bill ▮▮▮▮▮ smiled, his eyebrows raising, eyes tightening to slits, and he sneezed.

"Can I buy you a beer?" I asked.

♪ *Uncle John's Band,* The Grateful Dead

**ART IS WHAT YOU CAN GET AWAY WITH**
*Andy Warhol. Posted in The Carpenter's rafters*

## *Chapter liv*
### *Charles Motherthanker III*

"Really? Is that your real name or is it a taken name, you know, like an artist's nom de plume?" I'd asked a couple of weeks after he'd arrived, after I'd slowly realized he wasn't an outlaw-biker-killer on the run after all; instead a kind and gentle fellow of great wit.

"Real. Quite real. My father and his father before him were both Charles, a family tradition. First born son. That's why I'm Charles the Third." Charles had replied with a little deep chuckling.

"Yeah, right, very funny, like you haven't pulled that one before."

Charles stroked his goatee, pushed his thick, long hair back, looked me straight in the eyes and laughed his strong, honest laugh.

*"Yes, okay, quite real. Charles Motherthanker was my grandfather's name... also my father's. The way I heard it, it was because of one of those Ellis Island immigration incidents that are probably responsible for many, many, strange names in this country.*

*My grandfather left Belgium in the early years of this century, mainly, my father explained, because of the Congo. Grandfather was only a teenager when he boarded that ship for America. Scared, but it seemed to him so much better than condoning King Leopold's horrible colonial policy. My dad had saved a Belgian anti-colonial poster that had been among his father's possessions and he showed it to me around the time we were having our big discussions about me*

trying to get Conscientious Objector status. It was a straightforward composite of ten or twelve black and white photos of the wives and children of Congolese workers. Seated in formal pose stoically showing their arms with the hands cut off when their husbands and fathers had failed to meet their rubber collection quotas.

It was very effective; I've never forgotten it. I referenced it in one of my rambling letters to the Selective Service when I was applying for CO status..."

Charles stretched and shook himself at this point as though bringing himself back from a distant thought.

"Anyway, the name thing. My grandfather's name and what he gave to the Immigration Control Officer on Ellis Island was Charles Mothreé Fuchs. He wrote it out and also pronounced it much to the amusement of the asshole immigration guy. After howling a bit and laughing with his fellow officers he wrote down: Charles Motherthanker. Grandfather didn't get the joke for a while and didn't really care when he did. It was an American sounding name and that was what mattered.

And yeah, it was a hassle in school for me but fortunately since there weren't too many other Charleses around, most teachers and school officials could just avoid using it... using my last name, that is. But for me really, it became like that Johnny Cash song, actually helped me."

♫ *A Boy Named Sue*, Johnny Cash.

I loved visiting Charles Motherthanker III while he worked in his nest. No exterior windows but his skylight might have been the best one in the building. He'd replaced glass and re-puttied after cleaning off the tar; no leaks thus far. The high wall of the neighboring Rescue Mission blocked harsh direct sun, on those rare sunny days, so the skylight provided an even, steady light sought by Rembrandt, sought by Vermeer, sought by Motherthanker III.

His canvases were always prepared in the most traditional manner:

- Sizing with rabbit skin glue.
- Smoothing with a pumice stone.
- Multiple coats of *gesso* until an even, smooth surface ready to accept the oil paint was achieved.
- Dead Coloring, nowadays called under painting if remembered at all; sadly forgotten by so many of Charles's contemporaries.

The paintings themselves were the most perfectly rendered odd juxtapositions of touchstone cultural elements. Mickey Mouse® might find himself wandering and whistling along the smooth, tan stomach of a reclining nude laid out in front of a magnificent Sierra Nevada background.

O! The smell! Fine oil paint, linseed oil and real turpentine so fresh, so pungent I half expected to find a crusty Maine lumberjack crouching in the corner squeezing it with vice-like hands from pitch-rich pine boughs. Not some odorless paint thinner from the local hardware store.

Smell matters.

None of these canvases were insignificant in size, the one he was working on being ten-feet by twelve-feet. Its tableau: a blonde, ample-bosom, bikini-clad beauty apparently having stumbled on a hot and sunny beach, glancing with slight anxiety over her shoulder, careful to appear as attractive as possible in case a talent scout – tight, grey warm-weather suit, light blue shirt, thin tie and dark glasses – also stumbles on that same beach. She's looking over her shoulder at a fast approaching MiG-15 on a strafing run, Chairman Mao clearly visible through the glossy cockpit Plexiglas®, right hand on the joystick, eyes on her, thumb enlarged, engorged, throbbing, twitching on the crimson trigger button.

## Chapter lv
### *The Giant Crab*

Giant amphipods have been pulled up from deep-sea trenches scaring the shit out of fishermen opening their traps. Relatives of all crustaceans, these things are normally tiny, about the size of the sand fleas common on beaches around the world. Pale, waxy and quite scary at twelve to fifteen inches in length, this giant-size flea raises questions about the possible existence of other large-scale crustaceans.

Lobsters live to be 150 years old. They gain in size and weight with each molt attaining as much as 45 pounds. And these are just the normal garden-variety lobsters caught in those beautiful, worm-infested, wooden traps off the coast of Maine. How grow the pale and waxy ones in the trenches?

[A VIEW OF MOONSTONE BEACH FROM ABOVE,
STEVE AND PETE ARE WALKING ALONG THE SHORE
DRESSED IN ARMY KHAKIS, CARRYING RIFLES.
THE SCENE IS IN BLACK AND WHITE AND THEY APPEAR
TO BE SEARCHING:
"DAVE! DAVE! WHERE ARE YOU?" PETE CRIES.
"YOU LOOK IN THOSE DARK, DAMP CREVICES OVER
THERE IN THE CLIFF, PETE. I'M GOING TO HEAD DOWN
THE BEACH. HE MUST BE HERE SOMEWHERE," SAYS STEVE
AS THEY TAKE A BREAK AND BOTH LIGHT CIGARETTES.
THERE IS BARELY ENOUGH LIGHT TO SEE
PETE'S FACE IN THE DARK, DAMP CREVICE.
HIS VOICE ECHOES COLDLY AS HE CALLS OUT:
"DAVE! DAVE! WHERE ARE YOU?"
"I'M RIGHT HERE, PETER," A STRANGE DISEMBODIED
VOICE CROONS AS A GIGANTIC CLAW REACHES OUT
FROM THE BLACKNESS AND GRASPS PETE AROUND
THE MIDDLE OF HIS CHEST. HE IS ONLY ABLE TO EMIT
A FINAL TERRIFYING SCREAM AS THE CLAW CLOSES TIGHT,
CRUSHING BOTH AIR AND LIFE OUT OF HIM:
"THAAAAAAAAAAAAAAAAAAAAAAAAAAAANNNKKK!"]

## Chapter lvi
### *Albert Einstein, Cat of the Future*

- Right up here is his little black nose, always cold and a little damp. Up so high now because he's sniffing in anticipation.
- Albert Einstein's ears, larger than most with plenty of long strands of fur.
- His perfect big eyes. Green and bright. Always looking for something interesting to do.
- Mouth: Teeth good, but he's still young; breath could use some help but Happy David can brush his teeth, not me; yowls in some Asian language (part Siamese) issue forth from here.
- Skinny neck. Wiry tough.
- Chest: Very light grey with some white patches.
- Tiger! Handsome; well-defined black on grey stripes all over his back and sides.
- Legs: Scrawny but quite muscular.
- Front Feet: Paws are huge! Opposable thumbs!
- Tip of his long, long skinny tail is black.
- End of his slinky back where tail connects above his hips.
- Here, his li'l butthole *.
- Strong! Upper legs like rabbit. Hoppy like kanga.
- Feet and paws pretty much normal size in the back, wouldn't you say, Happy David?
- His tiny yet sharp claws, just barely visible, ripping into my cornea.

♪ *Back in the Saddle Again,* Gene Autry

## Chapter lvii
*Pete! Don't Get So Thankin' Bent Out About Religion*

[STEVE:]

Pete! Don't get so thankin' bent out about religion without even considering for a minute the benefits it brings. This country and pretty much all the rest of the world is filled to the brim with semi-literate cretins, all of them armed to the teeth – if not with sophisticated weapons then at the very least, with pointy sticks and rocks – and each and every one of them filled with a seething rage to lash out in revenge. Revenge for the unjust death of a loved one, for a perceived affront to honor, just for payback, or... for stepping on my shoes, for cutting me off in traffic, for the cut of your jib, for the size of his nostrils, for the smell of her... her...

"And the only thing that's *holdin'* them back, the only thing that's *calmin'* them down, is this profoundly idiotic belief that an invisible, old white man with a beard who lives in the clouds is saying, *Do not do that, my child, for it is an abomination in my eyes.* Rather than: *It would please me if you would drown your infant in the sink,* or, *Bring me his head on a stick.* What difference does it really make *what* people believe, if at the end, it all ends like you say *back into the pudding* right?

"Show a little compassion and let them die seeing a vision of their long-dead loved-ones smiling with open arms from that warm brilliant light instead of what... your more realistic *cold black empty nothingness*?

"Since nobody knows they've died, since *knowing* ends, maybe what you're concerned about is that when they die they won't know they were wrong and you were right!" Steve laughed as he finished his thought.

**WE ARE AS GODS AND MIGHT AS WELL GET GOOD AT IT**
*Stewart Brand. Posted on wall at the top of the stairs*

## Chapter lviii
### Ramadan

I had not seen Steve for an entire year. A year he spent in Germany studying under a Goethe-Institut program in Rothenburg ob der Tauber holding one of those heavy ceramic lidded beer steins raising it over and over above his head to the repeating chorus of Drink! Drink! Drink! from the Student Prince (MGM, 1954).

A thousand student princes in powder blue tunics adorned with brilliant medals and ribbons seated at long tables in a huge beer hall and those steins keep going up and down and up and...

*Hier ist Greta mit mehr Bier!*

*Eins zwei drei vier*
*Drink! Drink! Drink!*

<span style="font-size:smaller">*Steve's strong singing voice replaces Mario Lanza's*</span>

What follows is important, and it was not something that I was witness to. Steve had mentioned only the surface of the incident during a drunken reverie that included talk of women and their vaginae. But it was not until quite a while later that I ran into one of Steve's student prince *Goethe-Institut* cohorts, Lynwood ▓▓▓▓, down at a local dock bar, The Vista Del Mar (The VD ha ha) and it was this same Lynwood who described in detail the incident in Frau Hussey's boarding house.

"Look, I probably shouldn't be telling you this, but I really like ol' Doc. (Lynwood called Steve *Doc*, something I never did; since we were in third grade Steve's dad was *Doc*.) I know you guys are best buddies, fishing together and all... what did he tell you about that tattoo?"

"Not much," I said. "He did tell me the typeface was called *Fraktur*... frak-TOUR, a German medieval style thing."

"Yeah, well he did it himself and it wasn't pretty."

Lynwood began:

*"It was Ramadan, the Muslim time of Fasting and Humiliation, and we were studying Comparative Religion at the Goethe-Institut. It might have been because our teacher was from Tehran and a stunning beauty... well, we all got very taken by Islam; its subtleties, mysteries. Steve immersed himself more than anyone else; caught up in its strictures, rituals and meditations.*

*So I didn't think too much of it when Steve disappeared for a couple of days.*

'I'm going to go do a little fasting and meditating,' Doc... Steve had said to me.

A couple of days after that, ▮, his girlfriend, ran into me in the hall and asked if I'd seen Steve. I told her no, he was off doing a fast and meditation project for Religion class.

'Oh, that's good,' I remember she said. 'I was a little worried that he might be... he was a little upset when we broke up... I guess maybe more than a little.'

A couple of more days went by and still no Steve. Now it's getting to be a week since I saw him. A week since anybody saw him! I admit, I started to get worried and began checking around. This breakup thing... I knew he was really crazy about ▮. He'd acted like they were going to spend the rest of their lives together, after Rothenburg, back in the States.

Nobody had seen him in the dorm rooms so I went around the neighborhood, visiting the Gästehauses, little boarding houses where students sometimes took rooms off campus. Just by chance I see this sign: Hotel Tilman Riemenschneider. Now this Tilman Riemanschneider was Steve's absolute favorite. No greater cheerleader for a German Gothic sculptor has ever existed. Steve loved his work and in particular the altar in the church of St. Jakob in Rothenburg... the Holy Blood Altar... an amazing piece of wood carving from 1500..."

Lynwood must have noticed my eyes glazing over since he seemed to hesitate for a second and then got back on track and away from this digression.

"I found the concierge of this little Hotel, a Frau Hussey, and asked in my best schoolboy German about Steve. She knew exactly whom I meant from my description and said she was glad the school had finally sent someone over to deal with the situation.

Steve had been locked in the small room he'd rented for a week now, not venturing out even to eat as far as Frau Hussey understood. I banged on the door for some considerable time and called out his name long and loud enough to attract concern from neighboring rooms.

'Steve, Steve! It's Lynwood. Why don't you speak?'

No response from within save for the repeating music, that saccharine English tune of the '60s... Peter & Gordon or Chad & Jeremy, I can't remember which... not that it really matters... I've always melded them together in my memory.

♫ *A Summer Song*, Chad & Jeremy
♫ *A World Without Love*, Peter & Gordon

Finally, desperate, filled with concern, but also keenly aware of the peeping eyes from cracked-open neighboring doors, I sank to my knees to see what I might through the keyhole.

That keyhole offered a crooked and sinister view of only a small low section of the tiny quarters. A sallow window, I assumed, was allowing light the color of thin poultry broth in from the left; straight in front, what seemed to be a small fruitwood end table with a portable record player on it. I could see the disc spinning, source to the sound.

A little more to the right and what looked like the very messy edge of a bed and there... there on the floor, a naked foot, toes jammed to carpet!

I jumped up and ran down the stairs finding first a timid chambermaid to whom I screamed,

'Key! A master key! Or, failing that, an axe!'

She ran to find Frau Hussey, not fully comprehending me.

'What is the matter, junger Mann?' said the concierge, wiping her hands on her apron as she came down the hall. Trying to calm myself with deep breaths, I told her my concerns and that we must at once open the door to the room Steve had rented; that something was dreadfully wrong; that he may have harmed himself.

'Oh, Mein Gott!' she cried.

Then to the chambermaid, 'Fetch that sign painter, what's his name, on the top floor, and have him paint me a sign at once:

**NO SMOKING IN THE PARLOR & NO SUICIDES.**'

Together we made a hurried return up the narrow stairs to Steve's floor and while her master key opened the lock it did nothing to slide the deadbolt Steve had placed.

'I'll have to force it. I'm sorry for the damage,' I said and she nodded.

Running full force from a ways down the hall, I dashed myself upon the door. With a huge bang and shaking the door flew open. I rushed immediately to my friend's side.

The constant music had been masking the thick and heavy noise of Steve's prodigious snoring, but when Frau Hussey lifted the needle, it became the only sound in the room and quite profound.

Face down on the floor he was, but with some gentle shaking of his shoulders and calling of his name, I was able at last to rouse him. He lifted himself up on an elbow, turned his head in my direction and said, 'Hey Lynwood. What the thank's up?'

It wasn't Steve's use of foul language that made both Frau Hussey and me gasp. It was the 2 inch high, 6 inch long homemade black tattoo that completely dominated his large forehead.

# ich liebe dich

*Posted on Steve's forehead*

*There was still the red trauma around each letter and bits of dried blood flaking there.*

Steve turned over and lay there half raised on his elbows, almost completely naked save for a pair of filthy white boxers. Lay there amongst many empty little bottles of Jägermeister®, and many empty big bottles of Grolsch®. Behind him, propped against the wall, three or four local postcards of Tilman Riemenschneider sculptures, the mirror taken down from the other side of the room, and a color snapshot of ▮▮▮, signed, 'ich liebe dich', the three dots above the 'i's replaced by little fat hearts.

'What the thank is up, Lynwood?' he asked again, this time with a lusty smile.

'Not much,' I said. 'Glad you didn't do the hearts.'"

## Chapter lix
### Trini & Babydoll

Charles Motherthanker III built his nest in the nether reaches of the WACO far west end; as far as one could go from the front door, and as far as one could get from my room in the northeast corner of the second floor. An area little used for the making of art or other projects since there was no natural light; the skylights had been tarred over to prevent water leaks from the near constant rain. Dozens of clip-on floodlights mounted in the rafters provided lighting for events and exhibitions whenever someone got the energy and desire to rig up such a thing. A thing that involved running hundreds of feet of homemade patched together extension cords, cleverly dividing the wattage load amongst the breakers, the fuses; and hoping for the best.

Over the course of his first month at WACO, Charles had single-handedly dragged back a suburban home's worth of scrap and abandoned lumber from the surrounding streets: waterlogged beams and poles from the shore of Humboldt Bay; *abandoned* plywood from construction sites; and two-by-fours from neighboring empty lots.

Since legal dumping required a long drive in the country and a small fee at the gate of the landfill, Second Street teemed with detritus ready for re-use. Entrepreneurs had set up small dark shops full of it, unregulated fly by night second-hand stores, junk stores. The more clever capitalists then perused those sloppy stores, high-grading choice crap to fill their own shops, rather *shoppes*, with glass in the windows, lights, locks on the doors. Placing that same junk on shelves, and having paid attention to articles in *Sunset Magazine*, they used the word *antique* in their signage.

That same Sam ▮▮▮▮▮▮▮, golfing friend of my father and Chairman of the local Draft Board, had partnered with his wife to set up such a business just beyond Peggy's Cafe, and it was there Charles Motherthanker III found and purchased the needed final components: huge nails (spikes, more accurately) and a four-pound sledge hammer.

This time it was Happy David who got robbed of sweet sleep. Charles Motherthanker III decided it would be much less disruptive if he did his building work in the middle of the night and he was convinced that hitting those spikes with sledge at a slow rhythmic pace would lull rather than irritate.

So, like a massive six-foot, two hundred pound, swarthy faced Bower bird, wearing motorcycle leathers and a rough goatee, he set about building his nest to keep his mate happy and by his side.

"CHARLES! Please! FOR GOD'S SAKE!" Happy David, in his briefs with tousled hair, wailed from the center of WACO's second floor.

We didn't ever refer to it as the Motherthanker Nest since no one ever used Charles' last name, but rather as Babydoll-land (never to his face) as that was how Trini ███, Charles Motherthanker III's full, and richly vibrant girlfriend, always called her man.

"Ohhhh, Babydoll, oh... BAAAAAYYYYYBEEEEEEEE!!!!... DAAAAAAAAAHHHLLLLLL!!!! EAT!!!! OH BABYDOLL, EAT!!!" Shrieked so loudly across the open second floor from the door of the kitchen, aimed toward the nesting box, and rattling the north side windows on its way. Trini had cooked up some hamburger along with its helper in the GE® electric skillet I had borrowed from my mother to serve as our stove and oven. That skillet and the coffee maker were the only appliances. Even in the warmest times of summer, a refrigerator wouldn't have made much difference.

Coming home in the middle of the night, I once glimpsed the two of them entwined, upright and slowly moving, dancing, to the sound of *We Belong Together* by Robert & Johnny, under blue light from one of the floods.

I was a little drunk having just left the Ebony Club, and leaned for support against the door jamb at the top of the stairs watching them dance. I couldn't hear any other sounds, not in the building, nor out on the street. Only plaintive voices on the 45, distant, with a hint of echo. The sound floating on the blue light barely showing edges of rough flooring, rafter beams and support columns; just enough to reveal the enormous size of this place as it drifted toward me in the doorway. So far away.

♪ *We Belong Together,* Robert & Johnny

Trini told me that all her problems with boyfriends disappeared on the day she decided to stop dating boys and start dating men.

"I met Charles that same day, and we've been together since," Trini smiled, looking up from the enormous smile she was painting.

There were quite a number of these smile paintings now, all about two-feet by five-feet, oil on canvas, presented horizontally.

Since I was standing next to Trini as she brushed and we talked, I could see the image now as vertical and most likely closer to what she was actually painting all this time. Faint hints of labia in these full lips.

## Chapter lx
### Musings on the Religiosity of Contemporary Art

RogerT was alone at the bar talking. How long he'd been talking to himself I had no way of knowing. The other few patrons were as far away from him as they could get; more interested in sucking on their beer than engaging in a stimulating art history lecture from RogerT. I say lecture and not discussion because I can't remember an instance since he began talking, a month after he arrived at WACO, when anyone got a word in. Unless it was a word he wanted you to get in.

"Peter!" he said, looking genuinely pleased to see me.

"Hey, RogerT. Buy you a beer?" I was working; RogerT not. I liked to come into the Ebony on the way back up from the dock. In the afternoon no one was here and the sun would stream in, in just the right way, like today.

"Today, Peter, I have been considering how important religion is to art. Have you considered this, Peter? Considered how important religion is to art, today?" His voice was a little slower, with an alcohol drawl.

"Okay, I'll bite," I said.

The Ebony Club was fairly quiet. Sly & The Family Stone on the jukebox and the air had that afternoon stale bar smell. I ordered two beers and RogerT began to talk:

♪ *Thank You (Falettinme Be Mice Elf Agin)*, Sly & The Family Stone

*"I had advanced myself well in the European Art World. Certainly had attained much higher status than one would normally expect for someone of such humble origins. The man here in front of you at this bar, this Ebony bar, has chatted with the crowned heads of Europe, you realize. European governments, particularly Northern Europe, in an effort to pull themselves out of the post-World War II abyss, chose to pour large portions of their budgets into the Arts. We have nothing like it here in the States. Americans know full well how to treat the creative types... like shit! True, we shower something that resembles honor on musicians and movie stars, but in Europe they treat artists, painters and sculptors, like gods and goddesses. I couldn't believe it when I got over there. A fellow artist from my gallery in New York, a strong champion of my work, made some introductions for me, and things really took off.*

*I suppose it may have helped that my work was quite unique and very inex-*

pensive to create and transport. Only loose sand, cheap and easily available from a local building supply yard anywhere in the world. Curators, museum staff and gallerists loved the fact that they need only pay for my personal expenses and not the massive shipping bills, not to mention the creation of heavily-insured shipping crates, which usually accompanied most artists traveling the circuit. And it was a circuit over there. Certain museums, certain cities, certain grand exhibitions, all had their appointed times and one could attach to this artist-cluster, swimming from one to the next, ad infinitum. This had been going on since the very early 1950s, and was now well developed. A large, very happy group of comfortable artists; completely off the radar of angst-ridden starving American artists. Young art students would complete the Academy work in their respective countries; immediately be subsidized; and join the circuit, into the stream. Jeez, I had often said to myself, if American artists ever found out how it is over here...

At some point early on, if I remember correctly, my work caught the eye of one of the most respected curators in Europe, a Belgian naturally, and he took me under his wing. Soon I was seated high in the order at the seven-course dinners and the multinational exhibitions. My work didn't sell, how could it? Nothing but sand and I wasn't interested in selling documentation: photos or drawings. This added to my aura of mystique! There was no need for money in any case. Everything – and Peter I do mean EVERY THING – was taken care of and at the highest comfort level.

Now this Belgian curator, head of a huge museum, was also 'old money' and very schooled in the ways of society. So I learned which wines and which families. And I learned how to maintain myself long into the night in discussions, arguments, primarily about art and culture. Sessions that took until dawn and drained every available bottle. It was toward the finish of one of these marathons that I made a small remark. A remark that not only taught me the importance of religion in contemporary art but also caused my downfall. And a swift one it was."

RogerT excused himself to head to the bathroom and I ordered another round of beers. Five o'clock had come and there were now more patrons than just the afternoon sleepers. I left money on the bar and headed back to a small table where I thought it might be quieter. I didn't want to miss this coming climax.

♪ *Brandy (You're a Fine Girl)*, Looking Glass

"'Fluke,' I had answered. 'An American colloquial term, I don't know if they use it in England or Europe.' My Belgian friend-curator-mentor had looked strangely at me. We were both deeply drunk, but this was not one of his... not a look I had ever seen from him.

'I am suspicious of you!' he screamed, eyes ablaze. The ten other artists, writers and cultural types in the room had audibly gasped, those who were still alert enough to gasp, that is.

My clever, I felt, explanation of how the simplest of random accidental events might change the course of an artist's career and therefore the entire course of art history had apparently struck a nerve the size of an anaconda and that snake was headed for a harsh embrace of my skull.

Here's what I said: 'A gallerist is dining with friends. One of those friends sees a cab approaching and decides on the spur of the moment, to leave in order to catch that cab and get home before midnight. Big job interview in the morning, so sorry, better to go now, it's been wonderful... oh, please finish my beer for me, don't let it go to waste. Our man wasn't planning on drinking any more but once the cab has been sent on its way, he empties this extra beer into his glass. Another good draught. Bladders being finite, this extra liquid is just enough for him to need a trip to the restroom, which he would have otherwise avoided since he has hated using public restrooms since childhood. While standing at the urinal he sees a small blue oil painting mounted at eye level, which he finds attractive, no doubt the warm release and pleasure of pissing heightens his appreciation. Later in the week, he passes the desk in the gallery office reserved for an intern to have a perfunctory glance at the hundreds of submissions and reject anything from anyone whose name the bored twenty-two year old doesn't recognize. Our man's eye is caught by a half-covered photograph of a familiar little blue oil painting sitting on top of the pile of rejects. Stops in pleasant foggy memory and picks up the folder with the rest of the artist's submission, taking it back to his private director's office. Looking through the folder, he sees a number of works he finds to be of great interest and takes it upon himself (very rare) to telephone the number listed. The ringing telephone startles the artist and she takes the revolver's muzzle out of her mouth to say 'hello'. The exhibition sells out, naturally, as do the next two or three and the major retrospective is already in the works and all because a fellow wanted to catch a cab...'

'This is not right! I don't believe this!' he screamed at me, pointing his finger in my face, his eyes bulging. 'I AM SUSPICIOUS OF YOU! When the work is great it is always found. Such things are destiny! Greatness is not determined by whether a man needs to pee!'

'Fluke is always in play,' I said and I knew then I shouldn't have. I should have been back in the hotel hours ago, sleeping or watching Danish pornography on TV. Should have let one of the other artists have the argument that night.

'This is not true, this fluke! If I knew you believe such nonsense. I would never have looked to your work, never have tried to help you.'

And that was that. Everything ended for me in the European Art World and I headed back to the States."

♪ *Brandy (You're a Fine Girl)*, Looking Glass

That insipid song came on the jukebox again just as I said to RogerT, "Quite a story. Any moral?"

"Yes," RogerT said quickly. "*Don't fluke with destiny!* And how about: *Flukes can thank you in the ass!*"

After we both stopped laughing, he added, "The thing is, Peter, the Belgian curator was a very sensitive guy and well aware of how much his help could change the course of an artist's career. That's a load of pressure, a huge responsibility to know that a simple *yes* or *no* from him... well, better to form a belief system that relieves that pressure, a system that says ultimately, success or failure is predetermined by some quasi-metaphysical *destiny*. God decides, moment to moment, or decided at the beginning of time, who wins, who loses. It doesn't matter if you destroy someone because you make a faulty decision after having a shitty lunch that gives you heartburn and upsets your stomach.

"Doesn't matter because you didn't. God already decided."

## Chapter lxi
### On the Roof

"Can we just have a look at the alleged weapons, please," asked the young Eureka Police officer. Neither of them looked to be much more than a few years older than Happy David and I and neither of them seemed the least bit worked up about what was probably their most trivial call of the week.

A Friday evening, summer boring. I was working on a drawing when Happy David popped in carrying two assault weapons; tossed one to me saying, "Let's fill 'em up and get on the roof! Lots of geeky old tourists walking down to Lazio's out there!" The plastic AK-47 looked as real as it could, the only giveaway being the fluorescent orange filler plug where he wanted me to put the water in and that thin plinking sound it made when I caught it.

I was willing to put on the black beret he gave me, but Happy David, thankin' aye, he was all in: black turtle neck pulled up over his chin; black fatigues; black combat boots; black shoe polish covering half his face in a sort of zebra camouflage look. And the beret!

On the roof, we drank beers, targeted tourists and Happy David shouted out orders to me in some kind of made up language that was a halfway pidgin Spanish/Vietnamese, but spoken by a pirate.

"ARRRGGGH! El baldo, EL BALDITO! AIYEE! Aiyee! La corpes-ka! Git-em, git-em, numba one, numba one, git-em, arrgh! NUMBA WHAN ARRRGGGH!"

I squirted my share. There was some screaming.

It really didn't last long, and the cops had this wonderful way of behaving professionally while rolling their eyes.

## Chapter lxii
*Albert Einstein, Cat of the Future (RIP)*

The Keiths and I were sitting at the kitchen table sometime after five, drinking coffee and talking like we did most all the time about some thanking artsy concept:

"When Magritte paints those words there he sets up the double bind," I said, and then we all heard the front door open and slam hard.

"Double bind?" asked Wise Keith.

"You know it's a pipe, but then you're reading those words telling you it's not a pipe."

"What if you're not a Frog? What if you can't read French? What if you think it's just a copy of a picture from a children's French language book teaching the little Froggies that it *is* a pipe?" Said Sweet Keith with a laugh, just to stir it up, I suppose.

At that moment, Happy David, not looking happy, face flushed, came through the kitchen hardly pausing at the table on the way to his room.

"Could someone please bury Albert?" he asked, more in my direction than the others, his voice hesitant and broken. I hadn't ever seen this before... he was crying.

I picked up Albert from the street just outside, near the gutter on C Street. He'd been hit pretty hard. I don't blame Happy David for not wanting to do it. Sort of had to push him into the small box I'd brought down. Not in the kind of shape for a last hug or caress.

I buried Albert Einstein, Cat of the Future, in the empty lot west of the Rescue Mission. He loved playing in that lot. Like a vast sports arena for him to show off how good he was at retrieving any little ball Happy David or I might throw. Bouncing off of dumped broken toilets, jumping through piles of busted bottles and rotten shoes, tufts of grass in the clay dirt amongst the used hypodermics and condoms. All the time holding that little red or blue ball in his front paws.

Opposable thumbs, you know.

## Chapter lxiii
*Success as an Artist*

"True, very true, I've sought it in my past as much as any of you here before me now," RogerT replied, looking about him, acknowledging the turnout for this, his announced Salon d'Art WACO, 1971. Almost all members and hangers-on of the WACO group were here, jammed into my workspace, chosen for its relative comfort and seating options.

"But I have since come into contact with the work of Jacques Derrida, Michel Foucault, and Jean Baudrillard; re-examined all I strive for and come to this conclusion: failure and hopelessness are the correct and natural positions of the contemporary artist."

Both Sweet Keith and Happy David were pumping their right hands in the air looking for a break, a crack to wedge in a thought or question.

"Can't we still hope for success? The possibility of making something so wonderful that we soar on the covers of the glossy art magazines into the Pantheon of Art History?" Happy David finally managed to squeeze out and in. Marianna turned around to try and settle Happy David, hoping for a bit of decorum, respect for the lecturer.

"Hah hah!" RogerT laughed dismissively. "So very like you David. Sweet, kind, naïve... and so very *1960s.*" He reached for his beer, took a long swig from the bottle's neck and wiped sleeve across wispy blond beard, still sniggering, "Remember that painting back in college:

*"...what most puzzled and confounded you was a long, limber, portentous, black mass of something hovering in the center of the picture over three blue, dim, perpendicular lines floating in a nameless yeast. A boggy, soggy, squishy picture truly, enough to drive a nervous man distracted. Yet was there a sort of indefinite, half-attained, unimaginable sublimity about it that fairly froze you to it, till you involuntarily took an oath with yourself to find out what that marvelous painting meant? Ever and anon a bright, but, alas, deceptive idea would dart you through; 'It's the North Pacific in a midnight gale! – It's the unnatural combat of the four primal elements! – It's a blasted Redwood glen –*

*It's a Hyperborean winter scene – It's the breaking-up of the icebound stream of Time!' But at last all these fancies yielded to that one portentous something in the picture's midst. THAT once found out, and all the rest were plain. But stop; does it not bear a faint resemblance to a gigantic crab?...*

"We have to put such paintings and thoughts out of our minds now. No one seeks meaning. We seek the wink, the ironic wink that pulls us into the cool private library of detachment, fruitwood-paneled blasé."

## Chapter lxiv
*Success as an Artist: The Original Thought*

It's like a cone of sand. Maybe more stable to think of it like a pyramid of cannon balls. In any case, there's always the first one and that one sits alone, a first layer, the original idea, breakthrough thought. That's you, baby. You've just popped out a Art. A ART all capital letters because it's something original. A new idea popped out into the pool of human culture. That pool that stretches back through time thousands of years, lost in the misty distance, back to the Venus of Willendorf, the Lascaux Cave paintings."

"*An* ART," corrects Marianna.

RogerT nods at her, eyes over the top of his glasses, and continues: "Pretty soon you've been able to explain it or do it or create it and show it to a few others. And even if you don't mention it there are those few around in that rarefied spot where you are that just get it and not much explaining is needed. See that's the next layer already, under you. Four more cannon balls. See them, now? Under the first, under you, under the original thought, the original thinker, the pure new idea."

This was yet another of RogerT's many lectures as to the nature of art in the contemporary world. This time, several of us were grouped in one of the booths at Peggy's Cafe, drinking coffee, smoking cigarettes and arguing.

"That's all fine, being the original thinker, all that. But there's no market in it. No sales. No money," RogerT had the ladle of molten iron in his hand, filling the molds and fully in control of this pile of cannonballs as it grew.

"Your four cannon ball supporters are just as broke as you are."

Happy David, Sweet Keith, Wise Keith, me, and Marianna fanning the smoke away every few minutes, all there to listen, learn at the feet of the master.

"It's a simple mathematical idea called the *Square Number Progression*. Art, new ideas anyway, really become marketable at about the 100th layer; 10,000 people aware of it. Those lower layers grant nothing, perhaps bragging rights. Now, clever artists, those who wish to do well in the marketplace lurk about smaller exhibitions, the more esoteric art magazines, looking for those ideas which have stalled below that layer.

They understand all that is missing is perhaps a pretty face, a charming manner, social connections, witty cocktail party banter... sexual desirability, perhaps. All of which they are more than willing and capable of putting into the mix.... *et voilà!* The next cover of *Artforum*, the next great artist!"

"That's probably the most cynical explanation of... of anything, I've ever heard," Marianna exclaimed. "No wonder you took a vow of silence."

Wise Keith made eye contact with her across the table, raising his eyebrows in agreement.

"Yeah, come on, RogerT," Happy David said. "What about *primacy*? I mean if somebody had done a body of work, say ten years earlier and it was all documented, you just show it, prove it, and..."

"And what?" said RogerT, obviously relishing this discourse. "I'll tell you, David. You discover the fascinating concept of *prescient derivation*. Your work would be seen as derivative of work done later by the fabulous artist of the moment. Nobody asks, *how did he pull that off?* A wild outsider critic, not caring about career advancement, might well give you a few lines. Those critics are few and far between and for the most part you risk being dismissed as just another sour grapes failed artist. Sad, sad, sad."

"Thank!" I said, not that loud but loud enough to get Peggy to raise her eyes from the grill with a chilling look in my direction.

"I have to say, RogerT, I agree with Marianna. It's just too hopeless, your cynicism. Maybe we're talking about two separate and distinct things when we each use that word, Art."

"Pray continue," challenged RogerT, straightening his back, his smile wide, "tell us, Peter."

"It's like Christianity, Judaism, Islam, any of them... all from the same source, all the God of Abraham... so thoroughly distorted, managing to twist themselves into a worship pretzel as far from what must have been the original spiritual feeling as possible," I took a breath, not completely sure of where I was going. Lit a cigarette and sipped a little coffee.

"Not this shit again," Sweet Keith jammed in the break.

"We were talking about Art, Pete," said Happy David.

"So I am... as I am," and continued.

"Organized religion makes me feel that, if I believed in such notions, that in some masterful move Beelzebub kidnapped the God of Abraham, tied Him up in a back room and has been out there parading around on the stage of Heaven saying all the things his devout worshipers want Him to say, rewarding those who go along, stomping on the... the heretics. Deviousness is His specialty, after all.

"Listening to you, RogerT, seems like the same exact thing has occurred in our beautiful Art World. And I think that if we go along with it, obey it, we have to go against ourselves, disobey ourselves; and it is in this disobeying of ourselves, wherein the hardness of success in the Art World consists."

"What the thank are you talking about?" said Wise Keith, Sweet Keith, Happy David, Marianna and RogerT in unison, the chorus loud enough to raise another chilly glance from Peggy.

**EVERY NATURAL FACT IS A SYMBOL OF SOME SPIRITUAL FACT**
*Ralph Waldo Emerson. Posted on wall near quotation by Jean Baudrillard*

**THE SIMULACRUM IS NEVER THAT WHICH CONCEALS THE TRUTH**
**IT IS THE TRUTH THAT CONCEALS THAT THERE IS NONE**
**THE SIMULACRUM IS TRUE**
*Jean Baudrillard. Posted on wall near quotations by Ralph Waldo Emerson*

**I HATE QUOTATIONS, TELL ME WHAT YOU KNOW**
*Ralph Waldo Emerson. Posted on wall near other quotations*

## Chapter lxv
### *The Encounter with The Schooner*

I was just crossing Second, headed for a shower after a day chipping paint and squirting Ospho® on rust bleeds along the LADY-FAME's hull and there's Ralph yelling "Hey!" from across C Street.

I just got my hand on the door and he yells, "Hey! I wanna talk to you!" Oh shit, thanking shit, he's found out! I think.

Always a gruff looking guy, Ralph is the owner/bartender at The Schooner and father of hot little Gail, the fifteen-year old trying to get into Steve's pants. Maybe around forty, big and balding, he's got on his customary long-sleeved white shirt and a damp white apron.

He's never talked to me about anything before, even during our visits to The Schooner. He's looking for Steve! Probably wants to kill him. Shit, thank, thank, cock... thank! I wait for Ralph to cross the street with nothing but dread.

Steve hasn't ever thanked her. That's what he told me anyhow. They went out a few times, kinda like dates. Very pretty, Gail, tiny. Steve liked to squash her head under his armpit, laughing like, with lots of sexual... nice little tits and a very firm looking butt, coming home from school with those books held tight by her crossed arms under, lifting and amplifying those breasts. Lots of bad girl makeup. Nasty! Eyes heavily outlined, pimples toned, and light pink, pouty lipstick. Brown French roll cocked just right and she'd smile that *come-here-lookee-what-I-got* to every guy, not just me and my boner.

♪ *Use Me*, Bill Withers

It was Steve who took her to that Thanksgiving Rock & Roller at the Municipal Auditorium. Skating around arm-in-arm. Skating amidst fifty other rolling, staggering couples, slowly, being passed on both sides by the Pooner twins going like fifty right into solid objects: Larry into the wall; Tom into one of the posts that support the balcony where I was sitting, smoking a cigarette next to Fred the DJ.

"That was "Use Me" by Bill Withers," said Fred into the PA, then added, resonating, "it's Thanksgiving roller skating time, turkey time... and I bet you'd like to stuff that turkey, wouldn't you Steve?... *Steve?*

"Now here's the Raspberries."

♪*Please, Go All The Way,* The Raspberries

"Steve, you don't gotta be scared of my dad. He don't care. My last boyfriend, he was twenty-five," Gail, the little San Quentin Quail, said as she squeezed into Steve, rolling in rhythm to the scratchy, modulating song...

Ralph tells me I won the football lottery.

"What?"

"Last week's Football Lottery," Ralph says. "I suppose I gotta to give you the money..."

We walk across the street to the back door of The Schooner. Behind the bar he hits NO SALE! Bing! and takes some money from the till. Only two very tired old-timers with their faces down close to their beers at the bar, so it's easy for me to announce:

"The next round's on me! Me, the winner!"

"I suppose I have to give you this twenty-five bucks even though I don't much agree with this Vietnam thing I heard about you.

"You know there's lots of really fine boys getting themselves hurt and killed over there doing their duty, doing what the country asks and I don't know whether I much like the idea of you dodging the draft," Ralph says, but not in a particularly confrontational way. If I think about it, if he really hated me he wouldn't have given me my *fine* winnings. Two month's rent at WACO, man.

"I don't feel like I'm *dodging* anything, Ralph. I was dodging it when I took that II-S deferment in college. Lots of other guys don't have that college option. Lots of other guys don't have a well-connected dad to pull strings and get them into the National Guard.

"You know, I did get drafted and I went down to the Oakland Induction Center on the day I was supposed to. I, very politely, told them I refused to be inducted."

"Yeah, I heard about that," Ralph said.

"But I didn't run away to Canada... not that I feel there's anything wrong with that. Don't really feel there's anything wrong with just about anything somebody does to get out of going over there to that mess. That war is just completely wrong. It's not the guys going, it's the guys sending."

"See now, that's where you're wrong! Duped by all that Commie propaganda," shouted Ralph, gesturing and pointing. "I know that the Nixon

people, the people high up have all kind of information, they can't tell us for security reasons... all kind of information about what's really going on..."

One of the barflies lifted up, sat up straight with Ralph's raised voice. The Schooner was normally a very quiet bar. We came over once in a while when the Ebony Club just got too packed and noisy. Now *that* was a real wild bar when the girls were dancing in their cages and shaking their tits, stompin' their boots and people were on the dance floor howlin'. Nothing like that ever happened in The Schooner, in fact it was never even dark in here like you might think a bar should be, but always brightly lit from a half dozen eight-foot long double fluorescent light fixtures. Never a band or jukebox, but twenty-five cent beers and two full-size pool tables, no waiting. Mostly, the only sound was clacking pool balls and that buzz from the lights.

"The government knows what it's doing," he continued, a little quieter now. "Can't have the soldiers deciding when to attack, when to fight or not. If you want to change that, it should be through the ballot not... not..."

"So, sort of *my country, right or wrong*?" I said.

"Yeah, but we're not wrong," Ralph answered swiping the bar with his towel.

"Okay, so go along with me a bit, a hypothetical situation."

"A what?"

"Like an imaginary situation."

"Okay."

"We just had this election in November, but in this imaginary situation, my hypothetical situation, McGovern won, by a landslide."

Ralph laughed, "Now, that's some imagining!"

"I know. Okay, McGovern is the president and right away those dang froggy Québécois decide they want Quebec to secede from Canada. They close the borders, masses of cheese farmers attack English speakers with axe handles, pitchforks. They got quite a platform lined out: full blast Socialism; free cradle-to-grave healthcare; legalize pot; free abortions; French language only... French food only! Homosexuality and bisexuality not just tolerated, but encouraged... I can go on.

"Canada flips out and sends in troops, the whole thing, air power, tanks... strafing civilians, bombing hospitals... those poor Québécois are getting creamed... hundreds of thousands killed or injured... and then..."

"What?" asked Ralph, actually paying attention, hands on the bar.

"Our McGovern, our President George McGovern, normally thought of as a peacenik, gets on the TV, speaks to the nation, his voice quavering a tiny bit with emotion: *...cannot stand by if we choose to call ourselves a civilized people, a peace loving people. So, my fellow Americans, tonight I*

*am announcing the United States has entered into a formal alliance with the People's Republic of Quebec..."* I imitate the presidential voice a little, with a quaver.

"What?"

"We declare total war on Canada, two-hundred-thousand troops roll across the border from British Columbia to Newfoundland."

"Ah, c'mon," says Ralph.

"Still, *my country, right or wrong,* Ralph?"

> **NO EVENT IN AMERICAN HISTORY IS MORE MISUNDERSTOOD THAN THE VIETNAM WAR.
> IT WAS MISREPORTED THEN,
> AND IT IS MISREMEMBERED NOW.**
> *Richard M. Nixon*

> **THE MARK OF THE IMMATURE MAN
> IS THAT HE WANTS TO DIE NOBLY FOR A CAUSE,
> WHILE THE MARK OF THE MATURE MAN
> IS THAT HE WANTS TO LIVE HUMBLY FOR ONE.**
> *Lyndon B. Johnson*

## Chapter lxvi
### *The Telephone Rang, Yet Again*

The telephone rang. No, no, not exactly. It sputtered...
"Hello?"
"H e l l o... i s... t h i s... P e t e ?"
"Yeah, this is me." Uh Oh.
"T h i s... i s... R i c h... um, R i c h... M a p p l e."
Oh shit *thank*, why did I say it was me? Why? Thankin' aye, I knew it was him the minute... the instant... I heard that voice. Thank... what a thanking idiot I am! Stupid, stupid, stupid.
"Oh, hi Rich."
"I'm just passing... through town... and... I thought I would... call you and then come over... and... maybe... we could rap."
Rap? Thaaaaaaank, am I in a time warp or something? He still uses the same words from years ago, and still talks so slow, so... thanking... slow.
He talks so slow that we all used to believe that his speech, along with his other slow habits, all meant something. That they were manifestations of his inner serenity. Hah! Well, everybody (except Kento) gets fooled once in a while.
"Hmmm, okay, Rich, uh why don't you come over? You... ah, y-you know where I live here at, at the wa-warehouse... at... at WACO?" Thank, I better light a cigarette. Starting to stutter.
"I know where it is. I was there once, but you weren't home. Last summer sometime. Second and C Street... right?"
Oh, yes, I *was* home when he visited last summer. Sort of. I was coming home from work and I saw his car there. Rich Mapple's old unmistakable mental-institutional green Volkswagen® Bug. I saw it and I hid. I saw it there in front of WACO and I backtracked and went up the back street to Peggy's and sat there drinking coffee and smoking cigarettes until I was sure he was gone. My timing was a little off (I always underestimate the thickness of Rich's skull) and even though I hid for two hours at the cafe, I got back just in time to see him driving off, rounding the corner.
Groovy Daddy told me that Rich had sat in my room for those two long hours; waiting, refusing conversation or refreshment; generally acting distant, spaced-out and weird. Nobody had been forewarned.

Groovy Daddy and the others working at WACO that day, they all thought he really was an *old friend*. Thankin' shit, all that explaining to do.

"Well... uh, okay, I'll see you in a little while then, Rich."

"Good-bye."

"Yeah, bye."

"SHIT," to the dial tone. Just when I was starting to feel stable, a bit sure of myself. It always thankin' happens. Thank. Always when I forget to worry about possible disaster... it happens.

Even when I was a kid, I knew that if I worried enough and in minute enough detail about the worst possible consequence of whatever action I was doing, it would always, always, turn out okay. But the minute... the instant... I relax and allow myself to think I'm in control, that it would work out, that I'd get away with it... MASH! THANK! Right in the face comes the old worst possible.

So here I am mashed in the face by the mere presence of this guy, just his presence, in the same town. I haven't even seen him yet and I'm shaking. My stomach is doing that crazy crawling around, the back of my neck is getting tight, adrenalin is pumping by the gallon... and I haven't even seen him yet. Thank, I can't watch three quarters, I can't even watch any of this game. I can't even sit down. Why am I pacing? Sit down, sit down. Smoke a cigarette. Shit, this guy really has me all thanked up. All those bad memories he brings with him. Bad memories are Rich's clothes. He wears them and they stream out from him. They're his aura.

He scares me. Thaaank. I know I could beat the shit out of him, not that kind of fear, not physical. Not a standard threat to my territory or my possessions, but a threat to my mind. My fragile mental health. You can hate in your mind somebody who threatens your body, but shit, you can really hate in your body, your guts, your whole being, someone who threatens your mind. Thankin' aye! Look at me, shaking here. Thank. Look at yourself, Pete. No. No don't go looking in any mirrors now, asshole. Jeez, thank, slow down a little.

Guilt. That's what he is. Guilt for not being able to help him when he needed it. Where was I, his *trusted comrade*, his friend, when he was losing control and needed me? Me? Shit, I was losing it too, we all were. All of us losing control. Nightmares every night... so real... no sleep... my stomach so tight, my neck so strung. And the girl I loved so scared. She knew before anyone else. She knew we had pushed it too far, played on that edge too long. And me trying to fight it, trying to hold out... Rich looking to me to hold him up. Sorry, Rich, I know you didn't understand, but how could I look into those landed-fish eyes of yours?... thank, I couldn't even look into Li'l Miss Goodvibes' crazy eyes; I couldn't even look into my own. How was I supposed to stand up, hold onto you, tell you it would work out? Tell

you, "I understand. You're not alone."? I couldn't even say that to myself.

Maybe he's recovered; maybe he'll be like he was when I first met him. Maybe we can talk, communicate, and I can apologize for my failings. Maybe he'll understand and then leave, really leave. Shit, no way. You heard his voice on the phone, he's still way the thank out there, Pete. That's the reality. You have to deal with it.

If only I'd realized that the worst possible thing that could happen on this cold but pleasant Saturday, two days before Christmas, the thankin' one thing that could really thank up my life, would be a phone call right out of the worst time of my life, a phone call from Rich Mapple... I know I would have handled it differently:

## Chapter lxvii
### *The Alternative Scenario*

[OUR NARRATOR IMAGINES AN ALTERNATIVE SCENARIO:]

"Hullo?"

"H e l l o... i s... t h i s... P e t e ?" says a slow voice that I, in my wisdom, immediately identify.

"Who? Who dis Pete ah? I no knowah him," in my best imitation Grandpa Sicilian accent.

"Oh, uh, this is an old friend of his from San Diego, Rich Mapple, I thought that you might know him. I thought that since I was in town I might call and then maybe come over and we could rap, we went to the same school together, San Diego State and we were real good friends... (prolonged pause), who is this?" (He suspects!)

"Uh... Paul, (think fast!) yeh... disah Paul Lazzaro." (Nobody thanks with Paul Lazzaro! A nickname given me by Kento, from Kurt Vonnegut, Jr.'s *Slaughterhouse Five*. Lazzaro is the over-the-top macho, fellow POW so offended by Billy Pilgrim's weakness in the face of Nazi capture that he vows revenge, even if that revenge should take a lifetime to realize. What? Did Kento bestow the nickname because he felt I was over-the-top macho? Or, did he feel I was the guy who would quietly spend twenty years plotting the perfect revenge? Or maybe the guy who would be coolly capable of cutting up the spring of a watch and feeding it to a dog in order to enjoy the slow, agonizing death of a poor dumb animal? That guy who would have

explained, "Hey, the stupid dog barked at me, man... seems fair, right?" Or simply because of the Italian-American name thing.)

"Oh. You don't know who Pete is?"

"Ah... nope ah."

"Well, this is his number in the phone book. I would think that you would know him. We're really good old friends and I was just passing through town and I thought I would call him up and then maybe drive over and visit, for a while."

Oh, for thanking sure! For a while, my ass... meaning three hours, meaning overnight, meaning a couple of days meaning a week meaning three weeks meaning three months meaning three years. Thank that shit.

"Lookah... my frenah, me I justah work here. Disah big ol' thankin' warehouse wit many peoples ahcomin' ahgoin'. I no knowah this fella youah lookin' forah. I got me some work to do. Good-bye to you."

"Well... bye."

[END ALTERNATE SCENARIO.]

## *Chapter lxviii*
### *The WACO Meets the Richard Mapple*

It might have been a little easier that way, but then I'd always be looking behind me when walking the streets. In a sweat whenever the phone rang. Panicked that anytime I turned around a corner, he'd be there waiting. God only knows how long he'd stay in town trying to find me. He has such a thick skull. He wouldn't just leave town. Rich would hang around, parked near WACO for weeks hoping to catch a glimpse.

Eventually I have to confront him. It's better this way on my own ground at least. See him. Talk to him. Explain the situation, calmly... very delicately tell him.

Say:

"GET... THE... THANK... OUT... OF... MY... LIFE!!!"

I can hear him knocking. Tapping. From my window here, I can look down on anyone at the front door. And looking down on Rich, I'm losing any feeling of confidence that I might have tried to convince myself I had. I mean I'm melting. I mean quaking knees, cold chills, and the whole thing.

Pushing the heavy double-hung window bottom up enough to stick my head out, "Ah... h-hi... uh, hi Rich, I'll be, r-ri-right down to open the door for, uh, you."

Rich looks up and... there are those eyes. He's got a Clint Eastwood hat but those are Lee Van Cleef's eyes! At least they're not all bugged out like last time I saw him. Thankin' aye! I'm going down there to let him in? Open the door to all that past shit? And I still think he's the crazy one? Down the stairs, breathe deep, must ease my stomach cramps, must stop my hands from shaking.

Open the door and,

"H e l l o P e t e."

"Yeah, uh, hey hi, Rich. Look, uh, come in. Well, look, let's go up to my room, it's a bit warmer there. We can talk there."

"Oh kay," says Rich. He... talks... so... slow.

Even okay becomes ohhhhhhhhh... kaaaaaaaaaay.

He's wearing the standard let's-go-mellow-out-in-the-country attire: work boots (never done an honest day's); Levi's®; wide leather belt, heavy brass buckle; heavy shepherd's coat, hairy wool inside spilling out onto fat lapels. Oh yeah, the cowboy hat. I don't think he was trying for Eastwood's *Blondie* look, don't remember him ever embracing those Sergio Leone movies, it was all Bergman for Rich. I'm pretty sure it's a John Lennon attempt what with his round wire rim glasses and short scruffy beard. However the flat top black hat makes not *Imagine* but Robert Mitchum in *The Night of the Hunter* jump to mind.

Back up in my room, and maybe it's not so bad now that he's really here. He does seem harmless, even pleased to see me. I can handle this. No sweat... maybe. "What have you been up to?" I venture.

"My mother died. She had cancer and she died, just a few weeks ago. They let me out of the Army because she died. I, ah... I was in the Army down in Texas somewhere and they let me out because she was so sick... she had cancer. They didn't really want me in the Army very bad... they, uh, they couldn't train me very well. I was at an Army base in Texas and they were trying to train me in electronics or some other thing... they just let me out to go home since my mother was so sick. I went back to San Diego and when she died I inherited some money and that car, the Mustang®... that was her car. They let me out of the Army when she died. I was in prison, you know, in jail at Lompoc... they let me out of prison because I said I would join the Army. I worked in the garden there at prison, the farm that's there... they let me out to join the Army. Boy, I really want to sock that David Harris in the mouth for telling us all those lies... all that stuff he said about non-violence... all that stuff about resisting the draft... the Resistance... all those lies he told us... it was all wrong... everything was

lies... I didn't like prison at all... I was at... Lompoc? You knew that... didn't you? They let me out to go join the Army... I was at a fort in Texas... Fort ... uh, I can't remember the name. All those lies David Harris told us... I didn't like prison at all."

Rich takes a brown paper bag out of his coat pocket and sips out of the pint bottle of amber liquor half hidden inside. He talks in such a monotone and so slowly, that it seems like hours before he's done with his first long self-absorbed lament.

"Huh."

"Do you remember, Pete," Rich starts again. "Remember when I had the little cabin out in Deerhorn Valley, and you used to come out there to visit all the time and we'd sit around the pot-belly stove and talk about whatever we were doing... talk about films, talk about Eastern philosophy, talk about the draft... talk about anything and everything... remember... we would go for long walks in the woods there and ask each other questions and answer back... sit down by the lake and talk... asked who we are, what we are, where are we going, why are we going, what are we going to do when we get there. Remember, Pete?"

He's back there by the lake near his cabin right now; this is going to be harder than I was hoping; he doesn't even know I'm here.

"Remember, you and ▓▓▓ and ▓▓▓ (Li'l Miss Goodvibes and Allison Wonderland) always came out to the cabin in the valley... and John (John V) too... always came... there, the house at Pooh Corners we all called it (no we didn't) and we'd go for long walks with the dogs... (I suppose)... my dogs... they shot my dogs... did you know that? They shot them. They didn't want me in the cabin anymore, the new people moved into the big pink house and they didn't like me so they... didn't want me there... and they shot them. Did you know that, Pete?"

God, this all happened three years ago and he's still living it. He's stopped there. Decided he liked it better there, shut down the equipment and there he is. And goddamn it, he thankin' wants company.

I know it was a mistake back then, so I'm at least trying to move on a little. Remember, remember, remember... those were mainly bad times, really bad times, that last few months of 1969. Rich pisses me off because he's always trying to bring me back with him to the bad old days. And he scares the shit out of me because he succeeds.

Now he sips again from the bottle. He does look a little healthier, not so pallid with his beard grown back. No, he's the same.

"I sip bourbon... makes me feel calm."

"Huh," I said, "that's new, isn't it?"

Rich doesn't notice my question about the liquor, just continues his remembering.

"Remember the big Resistance Family party we had out at my cabin in Deerhorn Valley? Everyone came... you and ▓ and ▓ (Li'l Miss Goodvibes and Allison Wonderland) and... and Kent (Kento) and John (John V) too. Our Resistance Family. Our family. We all brought food and ate... then when it got dark... after the hiking, we sat around the stove and sang songs and talked about everything for hours and hours and..."

"Rich, uh..."

"We played music... everyone sang along... boy..."

"Rich!"

"Gee Kent was funny that day, Kent's always so..."

"RICH!!" I screamed his name now. "RICH THE DIFFERENCE BETWEEN YOU... (calmer, calmer), the difference between you and me is that you're living in the past! That all happened three years ago! It's all over with! ALL OVER WITH! You've got to realize that! I'm trying to live in the present! Right now! I recognize all that past, but I don't keep living it! THANK, Rich, that's all over with! Done! Thanking shit, man!"

Rich looks afraid for a second, then his eyes go back to blank, like he didn't hear me.

"Gee, that was a nice day. We were all together. Our Family." He says it so sweetly, so calmly.

He didn't hear me. Wasn't even rattled by my tirade. Why should I give a shit whether he heard me or not? Let him live in his little dream world, I don't care.

I'll get rid of him in a few minutes and I'm not scared of him anymore... so thank it. If he wants to be that way, that's his problem... and the State of California's if he ever makes the mistake of telling his story to some shrink on his lunch break in a cafe.

I don't have to always be my brother's keeper, he's not my brother. I can't even stand him.

"Do you know Les and Jeff's address?"

"Nope." (I lie.)

"Gee I thought they lived up here somewhere."

"I don't know, maybe they do."

"What about Kent, he would have their address. I'd like to look them all up while I'm here." (Not with my help, I say to myself.)

"Nah, I don't know where Kento, Kent is these days. We don't get along. Don't know where he lives." (I lie without hesitation.)

"Gee, you guys were best of friends, you used to live together in San Diego."

"Yeah, well, times change and people change, Rich. Do you know what I mean?" I hinted but with little hope of him getting the hint.

"Well... what about ▓ (Li'l Miss Goodvibes)? She lives up in Oregon

doesn't she? I'll be going up that way on my way to Canada. I'd like to stop by and visit for a while."

"No, I don't know where she is now, Rich. We never write, never talk. Last time I heard she was up in some town near Portland. She's married. I don't know his last name." All lies, but the idea of giving Rich a lead to the very fragile ▬▬ (Li'l Miss Goodvibes)... thank no.

"What was the name of the town?" Rich asks, excited to get a lead, a hint of any kind. All his *old friends* seem to always be out of town, always so hard to find.

"I don't know."

"Gee..."

This guy's skull is incredibly thick.

The only other person, besides the two of us, in the building right now is Groovy Daddy Johnny. Not the same John from San Diego that Rich was referring to. That's John V.

But this local Johnny has run into Rich before, spent some time in San Diego, dealt with Rich during that odd visit last summer. He was well aware of my dislike for him. He would never invite Rich to stay. He would never blow my plans to get this idiot out of here as soon as possible.

Rich has lapsed into silence, into the same silence that I used to believe meant important thoughts were being mulled over. I used to believe that wise answers to the human race's most eternal questions were being figured out and refined during those long silences. I also used to believe in Santa Claus, Jesus, and that just a little dose of LSD-25 would give each and every member of the human race – regardless of race, creed, color, sex or prior political views – knowledge of the true nature of the universe, and bring about peace, love and truth everlasting, for all the world, forever and ever, world without end, amen.

I found out different during the really bad time, the last couple of months of 1969. Two men, both with landed-fish eyes: one running helter skelter through Los Angeles; the other kicked out of his cabin in Deerhorn Valley east of San Diego. They proved me wrong, opened my eyes, enlightened me.

But that doesn't mean I have to be obliged to either one of them. I don't have to be obliged to Charlie Manson for the lesson or Rich Mapple for flipping out and helping to show me the error of my ways in one traumatic shit bit enlightenment. Thank that shit.

Live and learn.

So, here comes Groovy Daddy back from cutting up his aluminum flashing out in his work area. Stomping across the rough wood floor and through the kitchen.

I hope I know what he's going to say because that's my plan for having to leave.

*Oh, so sorry, but really must go. See you some other time then. Pressing engagement, you understand.* Some of the other people that work in the warehouse here are having a get-together over at their house. So now I can tell him to get lost, tell Rich to leave. Tell him that is, if Groovy Daddy doesn't blow it here.

"Pete, it's time to go we were supposed to be there an hour ago. Oh, hi," Groovy Daddy adds when he sees I have a guest.

"Johnny this is Rich. You *remember* him from San Diego *don't you?*" I say in my best warning tone, drawing the words out and raising my eyebrows. "Remember, Rich was here *last year.*"

"Hi."

"H...e...l...l...o...," the word comes out slowly as Rich tunes back in.

"Pete, we really have to go. Everybody else is probably there already. They said there'd be lots of food and eggnog, so why don't you bring Rich along too."

WHAT!? OWW! Thank me dry! What did you say, Johnny?

*Thank thank thank thank thank thank thank thank thank thank...*

"Yeah, okay Johnny... Okay."

It's not Groovy Daddy's fault. I have to actually tell Rich to get lost, no easy way out. Shit, but now I have to inflict this guy on all those innocent people at the party, my Christmas present to them!

Rich has perked up so much at the thought of free food that there's no way I can tell him to get lost now. He even feels he's invited.

Shit thank cunt piss.

We drive in Groovy Daddy's car. Drizzling a bit now, and Rich sits completely silent in the back seat.

Now that is a possibility, Rich could just keep his mouth shut at the party. Maybe he'll just be quiet and then he won't make everybody uneasy with his monotonous mindless rambling.

Rich is so quiet at the gathering that he makes everybody uneasy. Thank, he doesn't even say hello to anyone (maybe he nodded).

Everyone is pretty close, you know, that comradery that comes from working together under strain, doing the same thing together. It's usually a social blunder to bring a person who is not involved with the group to this kind of gathering. In this case it's a disaster.

My comrades were looking forward to a friendly evening of talking, eating and drinking. And here I show up in a terrible mood and with an odd acquaintance who just sits and stares.

But what can I do? I can't stand up, tink tink on a glass and say:

*Friends, this asshole here, this uninvited guest that I brought along with me... is no friend of mine. I don't have friends like him. Good heavens no, not me! I'd have to be completely crazy! True, I used to think he was an interesting fellow and spent lots of time with him... but, that was so long ago, so very long ago, a lifetime ago. No, no, wait. In fact I've never seen this asshole before in my life! Please believe me! I'm sorry! Please believe me... please, please.*

Can't say that. I'll, we'll, just have to suffer through this.

But, thankin' aye, Groovy Daddy, let's not stay too long.

♪ *All the Tired Horses,* Bob Dylan

## Chapter lxix
*Spooks of Hawthorne Street!*

Shit, what's everybody talking about now... poltergeists? Oh, thank me dry. Great, just what I need in the state of mind I'm in. Thank, why does the talk always turn to the occult stuff when I'm feeling so mentally shaky? Ohhh, so this house is haunted? Marianna, sweetie, you are so right, right now, more than you know.

"...saw the book move, nobody around it though. It flipped open, man... picture of a ship at sea... a storm... then slowly, slowly spun upside down, by itself, man... nobody touched it! And then there was this cold chill... like..."

TTTTTHHHHHHHAAAAAAAAAAAAAAANNNNKKKKKK.

Yeah, like the one dancing up the back of my neck, right, okay, okay, I'm a believer. Cock-thankin' bite me, let's talk about minimalism, performance, conceptual art... anything more rational. I just can't handle this thanking conversation. I'll just kind of chuckle here, cross my arms for protection and try not to look at Rich over there. Certainly not into his eyes.

"...apartment over there on Myrtle Avenue. Bill used to see all kinds of strange things happen. Once he..."

This wine isn't working either, my heart is really pumping. Thank.

"Where's Steve tonight?" Marianna asks.

"Yeah, Pete, where's Steve. He should be here, after all, he's lived down there at WACO a long time... Pete?"

"Huh, what?"

"Steve should be here, where is he?"

"Oh, yeah. Be good to have him here. I'll call him."

That is a good idea. Steve. I'll get him over here, maybe that'll make it easier to be tough with Rich.

Even from the kitchen at the phone, I can still see Rich sitting there staring. I can see him through the pass-through hole in the wall between here and the dining room. He's just staring straight ahead, expressionless.

Next to him, Bill Bulkington and Corrina are really getting soused. Inseparable, they might get married, I heard. Marianna passing chips across Groovy Daddy to the troglodytes Dave and Phyllis, looks like they've also

had more than a few of the eggnogs.

Trini and Charles Motherthanker III, making out, shamelessly. Bill ▇▇▇▇'s eyes are real squinty even in the low light. There's a group chuckle at RogerT's new "word of the day" *simulacrum...* "No really, pay attention," he says, but he slurs the last word, *al len lun...*

The receiver to my ear I hear the phone ringing at Steve's parents' house.

"Hello?" It's Jan's clipped voice.

"Hello out there, this is Pete. Is Steve there?"

"Hi. No he's not here. He just got a '58 Chevy® and I guess he's out test driving it."

"Oh. Uh, okay, well thanks, I'll see him later anyway." Test driving a '58 Chevy®? Thank, I really am in this alone.

"Are you guys going fishing in the morning?" Jan asks.

"Umm, I don't know yet, I'll call him later or in the morning. I have to talk to Dave first."

"Okay, I'll tell him you called. Bye."

"Bye bye."

So, no Steve. So none of that support that helps you be a tough guy. Just me and Rich to face off with no back-up. I have to get rid of this past... tell him to leave... try to calm down.

"Is Steve coming over?" Marianna asks when I get back to the table.

"No. No, he's out test driving his new '58 Chevy®, maybe he'll stop by later. He knows about this thing, I think."

"Did he buy Keith's car?" asks Groovy Daddy.

"I think Keith just gave it to him."

"That must be where Keith is."

"I would assume," I say. And the small talk continues. RogerT tries drunkenly to pontificate. Everybody avoiding thinking about the general uneasiness.

Rich has succeeded. Probably never notices the change in the way people act whenever he's present. How could he? He's not there when they're in a normal mood. When he's there they act this way, the Rich way. His skull is so thanking thick. Back in San Diego, back when we were closer and he wasn't noticeably crazy, I can remember once trying to explain to him that I didn't appreciate the fact he used me, took advantage. I didn't like the way he'd suggest lunch and then after eating, suggest that he was broke. I remember he paused, said something about this being important, *that we must bare our souls and express our inner-most feelings... continue our very real conversation* over lunch.

I know he succeeded with me and now he's succeeded in spoiling this party too.

"Look everybody, I have to get going. I've got a couple of things I

wanted to do tonight and I have to get up really early tomorrow," finally I said what I should have said an hour earlier.

"Oh too bad, party's just getting started. Don't be a party pooper." (Me?! Are you blind, Bulkington, or are you just being nice?)

"Nah, gotta go. Johnny do you think you could give me and, ah, Rich, a ride back to the warehouse?"

"Sure, sure, sure. I ought to get going myself anyway."

"Awwww," from the group.

"Well, goodnight," everyone says as Groovy Daddy and I are putting on our coats and milling around. Rich still sits there at the head of the table. He never took his hat or his coat off.

"Yeah, yeah, well goodnight everybody. See you all soon. Merry Christmas. Real nice party." (That's just being tactful.)

"Merry Christmas. Goodnight Groovy Daddy. Goodnight Pete. Nice to have met you, Rich." (Now that there's a bald-faced lie.)

"Goodnight." Rich sort of mumbles, but to his credit, he says it along with a nod or two.

Relief! Out of there! Is that an audible sigh from the house too? "*Awwwwwoooooooooooooooooooooooooooo...*"

Thankin' aye, this is a cold drizzle. Must be why I'm shaking. Groovy Daddy drives so slow, I could run faster than this. I know I could tonight. I could run down to the boat, lock the door and hide until morning comes. But then he'd still be waiting... stay in town until I tell him. I have to tell him. I can't run away from it this time. Not like I ran from San Diego. The whole thing I ran from is here now, embodied in Rich Mapple. I have to face him and just tell him... just tell him. Leave. Go. Don't come back. Don't call me.

♪ *Rainy Night in Georgia*, Brook Benton

Back at the warehouse, back in my room, back where we started. It's a little better now, here on my home ground.

"Do you want some coffee, Rich?" What a phony I am, what a pussy.

"No thanks, Pete, I'll have another sip of my bourbon it makes me feel calm, it..." (Yeah right, it complements your image of mellow-down-home-cowboy-wise-man.)

"Yeah sure, Rich."

"Do you know of any land for sale cheap around here? I've been thinking I'd like to buy some land around here, settle down up here in the Redwoods near all my friends. You and Kent (Kento), Les and Jeff, even ▓▓▓, she lives up north a little... in Oregon... doesn't she?"

God, what a horrible thought. Thank, Eureka is my home, where I was

raised. Where can a guy go to hide if not in his hometown?

If he moved here I'd have to run somewhere; back to San Diego? Thank no. No way, he's not moving up here to spoil my little hide-out. He can thanking well go back to Southern California where he belongs, where he doesn't stick out like a sore thumb.

"Look, uh, Rich, I don't think there's any cheap land around here, this is still California, and you know, there's no cheap land anywhere in California. And look Rich, like I said before, times change and people change, maybe it's possible that none of your *old friends* as you call them, maybe none of them want you around here. Maybe that's why your *old friends* are always so hard to find. Did you notice? Did you ever think about that?! Understand? Understand what I'm trying to say?"

Rich looks at me with those sick cow eyes that say he doesn't understand. He doesn't comprehend, can't comprehend. So he changes the subject:

"What are you up to these days, Pete?"

"Huh? Fishing. I've been working on a boat for a couple of years now. A commercial fisherman. We're crab fishing right now, although we've been spending a lot of time on the beach, what with the storm this last week. But look, Rich, that's not what I was talking about."

"Just you... alone?"

"No, two other guys and me. The skipper, and another guy, Steve, who works on the back deck with me. Look, Rich…"

"Isn't that dangerous, now, in the winter?"

"No."

"How big is the boat?"

"Forty-eight feet. Hey, look, we were talking about something else!" I was at the end of whatever patience I'd started with.

"Crab? Fishing for crab? For food? Food that people eat?"

## Chapter lxx
### His Righteous Rant

"But that's detestable," said Rich.

"Detestable? Crab fishing is detestable?"

"Listen," he said, pulling out a worn black Bible, finding a marked page and reading. While he read, his voice changed, soared with inflection... even sounding like Robert Mitchum:

" *'These may ye eat of... all that are in the waters: whatsoever hath fins and scales in the waters, in the seas, and in the rivers, them may ye eat. And all that have not fins and scales in the seas, and in the rivers, of all that swarm in the waters, and of all the living creatures that are in the waters, they are a detestable thing unto you, and they shall be a detestable thing unto you; ye shall not eat of their flesh, and their carcasses ye shall have in detestation. Whatsoever hath no fins nor scales in the waters, that is a detestable thing unto you...'*

"That's Leviticus," Rich said slowly, in his own slow voice.

"Kinda thumping it pretty hard there, Rich," I said.

"Thumping it? Thumping it? Is it this good book you now blaspheme?" Rich demanded, showing signs of life and a fine new turn of language.

"Where'd this Bible thing come from, Rich? Years ago, when I told that writer that our Resistance ideals of refusing to participate in the whole Vietnam thing were more in line with the teachings of Jesus than... than burning down villages, killing innocent women and children... you got all puffed up saying you didn't want the readers of that magazine to think that you were some kind of Christer.

"What happened?"

Rich stood, reached into his coat pocket and took a long swig of bourbon, and got animated in a way I had never seen before. Striding vigorously about my quarters making little whimpering moans, he headed to the kitchen. I followed behind trying to keep up and trying to make sense of this new behavior.

"What is the lesson Jonah teaches?" he asked, not really directing the question towards me, just holding his hands out, gesturing.

He strides past the sink, the wood stove, through the door and into the open workspace of the second floor.

"Jonah!" loud now.

"What is his lesson?"

"WHAT IS THE LESSON?" Rich said again, loud enough now to attract a glance from Groovy Daddy out in his spot cutting up sheets of aluminum.

I was close on Rich's heels and shot a quick raised-eyebrow shrug over to Groovy Daddy.

Richard Mapple saw my ship's prow construction ahead, approached it with curious resolve, curious for him, and climbed on board, heading straight to the bowsprit which offered some altitude and the chance for his voice to carry.

Out came that Bible again, and Rich began to read.

He's done this before, I thought, but offered no resistance.

He read well; loud enough and with fine articulation:

"*Jonah. Chapter One:*
*This is the word of the LORD that came to Jonah, son of Amittai:*
*'Set out for the great city of Nineveh, and preach against it; their wickedness has come up before me.' But Jonah made ready to flee to Tarshish away from the LORD. He went down to Joppa, found a ship going to Tarshish, paid the fare, and went aboard to journey with them to Tarshish, away from the LORD.*

*The LORD, however, hurled a violent wind upon the sea, and in the furious tempest that arose the ship was on the point of breaking up.*

*Then the mariners became frightened and each one cried to his god. To lighten the ship for themselves, they threw its cargo into the sea. Meanwhile, Jonah had gone down into the hold of the ship, and lay there fast asleep.*

*The captain came to him and said, 'What are you doing asleep? Rise up, call upon your God! Perhaps God will be mindful of us so that we may not perish.' Then they said to one another, 'Come, let us cast lots to find out on whose account we have met with this misfortune.' So they cast lots, and thus singled out Jonah.*

*'Tell us,' they said, 'what is your business? Where do you come from? What is your country, and to what people do you belong?'*

*'I am a Hebrew,' Jonah answered them; 'I worship the LORD, the God of heaven, who made the sea and the dry land.'*

*Now the men were seized with great fear and said to him, 'How could you do such a thing!'*

*They knew that he was fleeing from the LORD, because he had told them.*

*'What shall we do with you,' they asked, 'that the sea may quiet down for us?' For the sea was growing more and more turbulent.*

*Jonah said to them, 'Pick me up and throw me into the sea, that it may quiet down for you; since I know it is because of me that this violent storm has*

*come upon you.'*

*Still the men rowed hard to regain the land, but they could not, for the sea grew ever more turbulent.*

*Then they cried to the LORD: 'We beseech you, O LORD, let us not perish for taking this man's life; do not charge us with shedding innocent blood, for you, LORD, have done as you saw fit.'*

*Then they took Jonah and threw him into the sea, and the sea's raging abated.*

*Struck with great fear of the LORD,*
*the men offered sacrifice and made vows to him.'"*

[SILENCE. THEN:]

Groovy Daddy, who had been half-listening and surmised it was a performance, gave a short bit of applause before returning to his cutting work.

I was cold with anxiety. A tightness in my neck and that familiar knot in my stomach. I admit I have never been very comfortable with crazy people.

I know, I know. I've heard all the arguments:

*They are more aware. They see things more clearly. It's the only rational response to an irrational world.* Et cetera. *As an artist, you must surely appreciate...*

Yeah, yeah. Thank that shit.

For me, this anxiety? It's from not having any idea what's coming next. I like sameness, repetition. I enjoy boredom and seek it out at every chance.

No, that's not really what scares me. What scares me, what gives me this knot right now, is the knowledge that all he has to do is look at me in just the right way, touch my shoulder in just the right way, and I'm right in there with him. And it's not a happy world of marshmallows and tangerines. It's as scary as the scariest nightmare ever. Black and white, strobe-lite on, off, on, off... piano wires being scraped with a serrated knife.

"Thanks, Rich," I say, careful not to make eye contact. "Right, right. Hey, wasn't there something about a whale?"

"A whale?" said Rich, his eyes lighting up a little.

"Yeah, a whale, true. God sent a whale to swallow the *detestable* Jonah up."

He emphasized detestable.

"And Jonah was in that whale's belly for three days and three nights – until he got right with Jesus – and then he got spewed out."

♪ *Spirit In The Sky*, Norman Greenbaum

## Chapter lxxi
### Get the Thank Out of My Life!

"Time to leave, Rich," I said.

"Wha...?"

Rich had calmed as we walked back into my room, taking several more swigs, maybe to soothe his throat. My words seem to shock him.

"We were talking about maybe you should be going. Going back down to San Diego. Maybe right now!"

"Gee, I, uh... I can't go. I, uh, need... a... place... to stay," so slowly.

"Well you can't stay here, impossible, landlord won't allow it. Nobody's supposed to sleep here. This is a warehouse and it's against the zoning ordinance for anybody to sleep here." (That is sort of true. But who cares if I have to lie to Rich, I'm saying it at last, telling him to go.)

"So you can't stay here, Rich, and I've got a hot date in a few minutes, (that's a lie) so you'll have to leave now." I'm sort of edging him out of my room into the hall as I'm talking, talking faster and faster because if I slow down now, if I stop, I'll never be able to say it. I'm physically helping him along! Thank, look at this, I'm finally actually throwing him out of my house! Not touching him, edging him out with my force-field shield!

"But... I need... a... place... to stay, I, need a... can you tell me what Kent's address is? I... could... stay over there. He's an old friend of mine."

Through the Sweet Keith maze with its sprayed slogans.

Opening the front door for him now, "I don't know where Kent lives. I told you that. Sorry Rich, but I don't know where you should stay. I think you should just go!"

"You know Les and Jeff... remember, they live up here somewhere too. I could stay with them, where do they live?"

"I told you, Rich. I – DON'T – KNOW!!"

"Where should I stay?" So meekly now, "Awooooooooo," he moans.

"Look there's a KOA® campground about five miles north of town, right on the highway. You can stay there," I said (for all I care, I thought).

"But it's raining."

"That's too bad, I can't help you, not anymore. You can't stay here. Go back home. Maybe that's the best. Sometimes moving to a new place isn't the right thing to do. At least you have some history in San Diego, some

reason to be back there. Some right to call it home."

GET THE THANK OUT OF MY LIFE!! I yelled at him in my mind, but I couldn't say it. Not out loud. Not to his face. Not to his eyes. I should have. Should I have? Yeah, I should have.

"Well... goodbye... Pete."

"YeahbyeRich."

I shut the door and watch him walk to his car. God, he walks so slow, so thanking slow. Even in the rain, he's still just barely moving. He can't see me here, because of the glare from the streetlight on the window, but he's not looking back anyway, just sitting there in the car idling the engine. Shit, a Mustang® doesn't take that long to warm up. What's he doing? Is that really his mother's car? I don't know what of anything he said is true.

Last year when he was calling my parents' house all the time trying to find me, I told my mother not to talk to him, just say you don't know where I am and hang up, I told her. But... she talked to him. Sometimes for hours on the phone. She was a registered nurse years ago and she told me the way he was talking, something in his quaking voice, she was worried he might hurt himself if she'd just hung up. He told her back then that his mother had just died that week. Total bullshit. He didn't tell her anything about how he was in prison or in the army. I tried to explain, convince my mother that I was sure Rich had simply become one of those contemporary hippie con men who'd figured out it's basically difficult for most people to say *No*. All you needed was a sob story. Mix into that the new thinking about how *we shouldn't make value judgments like The Man does*. Thankin' aye! Sprinkle in a strong ego telling you that you're special, shouldn't have to work to support yourself like the straight people... thank.

I'd heard from John V in San Diego that after the really bad time, Rich had moved back into the garage of his folks' house in Coronado and stayed there taking hit after hit of acid. Maybe they finally kicked him out. Gave him the Mustang®, a tank of gas and pointed to the highway.

I remember Rich telling me way back when we were more like normal friends, that his idea of the perfect life would be to just sit in a warm room, thinking, reading, meditating. His every need provided by loyal acolytes.

Maybe Mom and Dad got tired of wearing those robes.

He's still sitting out there in that car. Staring straight ahead.

He's planning some kind of horrible revenge, I know it! I must have gotten through to that hard little lizard nugget at the bottom of his mushy brain and now he really hates me. Thank, he might come back in the middle of the night when I'm asleep... alone. Shit! I better lock that sliding garage door, he could get in that way, could sneak up the stairs, tippy-toe like a ghost up my ladder with a bread knife in his grinning mouth! Calm down, calm down, calm the thank down. Think, think. If there's one thing that

Rich is not, it's violent... or crafty enough to figure out how to get in here... but he seems really crazy. I could have pushed him over the brink. Given the last little peck to hatch an axe murderer.

Why's he still sitting there?

Maybe he's putting some kind of curse on me. Maybe like the Sicilian curse that Joe Siculiana put on the LADY-FAME!

Shit, that was more than a week ago, the last time we were out, the last time we delivered. Not much of a curse if it hasn't worked yet.

So what? I don't give a tiny thank if Rich does curse me, I don't believe in that shit and that's the big trick, you have to believe in it for it to have any effect.

Right? Am I right or am I right?

So that's the way it goes and there goes Rich.

Bye bye... so long... hope I don't see you later.

The Mustang® slides around the corner. God, a little relief now. A little thankin' relief!

♪ *What's Going On*, Marvin Gaye

## Chapter lxxii
### *The Sicilian Curse of Joe Siculiana*

My stomach's still in a knot, my neck too, but I'm not shaking anymore. Good. I better have another cigarette, this little Camel® here, the poor man's drug, the working class tranquilizer.

Thank, Rich is really gone. I really threw him out. Boy, oh boy, *weird*. I think I survived.

What was that curse I was talking about? Oh yeah, I should probably explain. The last time we were out, more than a week ago – been that long since we've fished – that curse was administered at the dock when we tied up to deliver.

I'll step back for a couple of chapters because this is a book about crab fishing, and this is a really great crab fishing story:

## Chapter lxxiii
### Fast-Crab & Loose-Crab

The LADY-FAME, with Dave at the wheel, Steve and I smoking out on the back deck, coming back in. Cruising up the bay at twelve knots on a chilly, sunny December day. Steve and I had gone through all the gear, two-hundred and seventy pots. Well, except for the ones we couldn't find, about twenty in our southern-most string. Some idiot had run down the string, cutting off buoys, either unknowingly with his wheel, or intentionally with his knife. Twenty pots at... shit, about fifty dollars apiece with the lines and buoys. Thank.

I threw my butt into the wake behind us just as we passed the F/V BACHELOR with those two fat Bunger brothers on the flying bridge, laughing and pointing like always. Steve and I got out of the cold wind and were just kind of lolling around in the wheelhouse reading and shit. Dave was plenty pissed off and talking on the Citizens' Band radio, the C.B., the Mickey Mouse® radio, the *mouse*.

"Yeah, that's right, that's right. Twenty. *OK*."

"Jesus, that's a shame. Probably one of those goddamn tugs. They don't ever stay outside when they make their turn for the bar like they're supposed to. The buyers signed for the nickel raise. Did you hear? They signed that thing this morning. They signed. Anything will help this season. *OK*."

"Yeah, that's right, that's right. The new price starts tomorrow. We might just have to hold these couple of crates we've got until the morning, heh heh," Dave looked over at me and winked.

"Like you said, anything will help this season, heh heh. *OK*."

"Yeah, Roger that. They're your crab 'til you sell 'em. They can't tell you when to sell 'em or where to sell 'em. No argument there. *OK*."

"That's right, that's right, the difference might pay for one of those pots today. I gotta do something, I'm going out of business here, heh heh. *OK*."

"Roger that, hah hah. Well, good fishing to you and your crew there, I'm out. *OK*."

"Yeah, I'll talk to you on the beach. *OK*. I'm clear."

Dave hung up the mic, "Any more coffee there, Peter?"

"Yup, the last cup here."

"How much do we have out there?"

"Two full and one about halfway. About, oh, I'd say eight-hundred pounds."

"Okay, then that's... uh, forty dollars extra if we hold them until tomorrow, right?"

"Yeah, but..."

"No sense in throwing away forty dollars, right, Peter?"

"Right, Dave."

"Spread them out even and put the other crates over them. It'll be cold enough tonight, they'll survive... but squirt 'em real good with the deck hose before you cover them up, okay? Do you have the tires out?"

"Uh huh."

"You don't think that's wrong do you?"

"Uh... Huh?"

"Forty dollars is forty dollars, right?"

"Right, Dave. Right, Skipper."

"They're my crabs... our crabs, and we can sell 'em when we want, right?"

"Yeah, but... right, Dave."

Steve had gone out on the back deck with the hose spraying water all around to clean off the pieces of seaweed and the chunks of crap that litter the deck after a day's work.

"Stevie, help me get these crates up here next to the hatch. We're not going to deliver tonight."

"Oh yeah? How come?"

"The nickel a pound raise goes into effect tomorrow, so... well, you know Dave."

"Ooooh, fireworks on the dock," Steve said grinning, blue eyes wide.

"Buy, howdy, no kidding, you're right there, old buddy." After watering down and covering them with wet burlap sacks, we deftly hid the crab crates under some other empty crates. The only people who'd really be fooled were the tourists, and there weren't any of them around this time of year.

Dave dropped back on the throttle and the boat idled past the unloading dock where Stan Drogosz, Lazio's dock foreman (former professional wrestler and no tourist) was waiting. Looming above the LADY-FAME, Stan bit down on his cigar butt, raised his thick eyebrows and put his hands on his hips as he watched us slide by, sliding towards the small floating dock at the foot of C Street where we always tied up. He turned and walked quickly into the plant.

Uh Oh, he's going in to tell Joe (no tourist either).

The engine revved up again loudly, as Dave stuck it in reverse. Steve threw the bow line down to the dock and jumped after it, and the stern came in for me. A little bumping and a little screaming later, we were tied up. Dave always wanted us to be the best at even the simplest things: tying

up; delivering crab; getting fuel; everything.

The BACHELOR also delivered to Lazio and was just outside of us maneuvering, back and forth to try to get into position under the crane on the unloading dock. Rodney, the younger of the Bungers caught sight of me and did his cute new catcall, "Charlie... Charlie Manson."

I'd had a buzz-cut and beard for years now but there'd been some new photo of that Manson asshole so Rodney started up with this routine every time he saw me now. Mother thanker. His older brother Bobby had the wheel and almost put the stern through a piling they were both laughing and bouncing around so much.

I'd already cut the stove off, so all we had to do was kill the engine, flip the circuit breakers, lock the door and we were off the boat and up to Dave's truck. No hanging around tonight, no small talk on the dock, we were trying to go unnoticed.

"See you in the morning, Dave," Steve said.

"Yeah, same time. After we deliver, we'll still be able to get out and get a day in. Goodnight, boys."

"Goodnight Dave," I said as he drove off.

"Let's get the thank out of here, before we have to lie to somebody," Steve said. "We can go up to Peggy's and eat. They're open late."

"Yeah, I am really hungry... Cheeseburger *deee*. But I want to stop by the warehouse and check the mail.

"Nothing but excitement when you're working on this boat, huh? *Fun fun fun in the morning time*, huh? Hah ha! Shit!"

We walked to WACO, two blocks south on C Street. There's nothing better than waiting for something to come in the mail and then it finally comes, and it's more than you ever dreamed in all your waiting. The manila envelope was thicker and filled with more stuff than I expected. Getting it made me feel like I was really close to leaving. There it was in the upper left corner of the envelope, *Office of the Consulate of the Republic of Colombia*.

"Cock-bite, Steve, look! There's all kinds of stuff in here. Let's go up to Peggy's and spread 'em all on a table. Shit! They're in color too!"

We walked the block east on Second Street to the restaurant as the sun was setting. A few minutes later and the entire Republic of Colombia was spread out over the corner booth table, along with two cups of coffee.

"Getting close now, Pete. A couple of weeks more and you'll be right there dancing with that sweetie there in Cartagena," pointing to the brochure's rich color photo of a *Colombiana*. "On the beach in *exotic ancient Cartagena. Caribbean breezes* will be breezing on you, Pardner."

"I know. I know. Boy, oh boy. I can't wait, but I should wait until after Christmas, so I can spend it with my folks. What the thank, huh? I've been waiting for six months now. Saving. What's another week or so? I think I'd

like to cross the border at Mexicali on the first day of 1973. There's a train from there that night. And then... heat! Heat, Stevie! Just lying around soaking it all up, all that sun. Ha ha."

"I don't know about all that below Mexico though. Tom Wolfe calls it all the Rat lands until you get past Panama."

"You were sick when you were in Mexico City, remember, and besides, I'm just going through that way because it's the cheapest way. I'll zip right through the Rat lands and into Colombia. That'll be great, to go back to the neighborhood I grew up in, in Bogota."

"It'll be smaller than you remember, it always is," Steve said between sips of coffee.

"Well whatever, then comes Rio. Thank, that'll be great. Sitting in a sidewalk cafe on the beach at Ipanema in a white linen suit, sipping tall cool drinks, and I'm going to spend all my time writing postcards to you guys freezing up here, hah! Shit, I wish the stuff from the Brazilian Consulate had come, that's what I really want to see. Boy, oh boy."

Those bursting breasts of Connie came between Steve, me and La Republica de Colombia.

"Cheeseburger deee... cheeseburger deee... here's your burgers," Connie said. "Where should I put them?"

"Great, I'm starved. Here, I'll move this stuff. What do you think's going to happen in the morning, with Joe I mean?" Steve asked between sliding some fries in.

"I guess we'll find out then, along with everybody else within three blocks," I laughed, through a mouthful of burger.

"Did you see Stan on the dock when we came in?"

"Yeah, he knew. So Joe knows too."

"Hoh ho ho." Steve shook his head, long black hair across the tops of his shoulders, popping out from under his watch cap. A few pieces of burger bun flew out with his laugh.

## Chapter lxxiv
### The Fecal Material Impacts the Rotating Helical Blade

In the morning, we untied and slipped the boat back the hundred feet or so to the unloading dock. Tied up with just one small piece of crab line, amidships, to the piling. Dave and Steve climbed up to run the hoist and get some pallets ready for the crates. Somebody was already there because the hoist had been turned on and the door to the plant was open. So we hoisted the crab up onto the dock and wheeled it over to the scales. Dave stood there by the scale waiting for Stan or Joe to show, and Steve and I went into the restaurant to take advantage of the company policy of free coffee to the fishermen (and oyster crackers... well, maybe we weren't supposed to eat so many of those).

For the edification and entertainment of the diners and tourists, Lazio's restaurant is separated from the rest of the processing plant by large plate-glass windows. A lady from Iowa can sit in comfort at her table and watch the workers, cigarettes dangling, rubber boots up to the ankles in blood and guts, removing the head and offal from the very same species of fish she is eating.

Steve and I got our cups of coffee, said morning to the couple of other fishermen sitting around, and sat down at a table next to the windows. I don't know whether we talked about anything or not, we didn't have time.

I just sat down. I just got the cigarette lit. I just got the cup of coffee to my lips. And Steve was up, staring through the window, then headed off through the kitchen at a jog. I looked through the window and could see Joe, Stan and Dave moving their hands and arms rapidly. I couldn't hear but I saw their mouths moving, muted yelling and their faces turning red. Dave was wheeling the crab away from the scales and towards the hoist. Stubbing out the smoke and clanking down the coffee, I ran after Steve, through the kitchen and out onto the plant floor. Now I could hear. Incredible swearing. Really loud swearing:

"LISTEN YOU SONOFABITCH! THAT'S THE WAY IT IS, YOU THANKING ASSHOLE!!"

"I'LL TAKE 'EM SOMEWHERE ELSE! I DON'T NEED YOU GODDAMN COCKSUCKING CHEATERS. GODDAMN IT!!"

"THANK IF YOU DO!!!! MOTHER THANKING DICKHEAD!!! MALOCCHIO!!"

"SHOVE IT UP YOUR THANKIN' ASS, JOE!!!"

"YOU SHOVE 'EM UP *YOUR* ASS!! THEY'RE YESTERDAY'S CRAB AND THEY GET YESTERDAY'S PRICE! SO... THANK YOU!!"

"THANK YOU! ASSHOLE! THEY'RE MINE AND I CAN SELL 'EM ANYWHERE AND ANYTIME I WANT!!!"

"YOU'LL SELL 'EM... YOU'LL SELL 'EM IN HELL! I SWEAR IT! IN HELL!!! MINCHIA MOTHER THANKER"

"THANK YOU, JOE!! AND YOUR THANKIN' LAZIO SHIT!"

"YOU'LL SELL THOSE CRAB IN HELL! MALOCCHIO!! I SWEAR IT! IN HELL!!! I SWEAR!!!"

Steve and I have both been working for Dave long enough to have developed the necessary I-just-work-here attitude and facial expression. He's always yelling at somebody. We walked around this mess careful to avoid eye contact, hooked the crates up and lowered them down, one by one while the shit was flying all around us. Sitting down on the back deck of the boat, we lit cigarettes, just listening and waiting.

After a few more minutes of vitriol, Dave came down the ladder, missing a rung but making it to the deck.

"UNTIE US!" His face looked like a beet. A big beet. A big throbbing, sweating, red beet.

As we let go the single line, Dave crammed the throttle wide open in forward. Cranked the wheel hard to port and the boat banked away from the dock like a ski boat. Stan was the only one left on the dock, and from the back deck I shrugged my shoulders and half smiled at him. To show me that he didn't take it personally, not against me anyway, he scowled and flicked his cigar butt into the wake of the boat.

"HE SAID OKAY AND THEN... and then he was writing it up at yesterday's prices... YESTERDAY'S PRICES! It's not yesterday! Today, it's today... TODAY! Jesus Christ, that Joe is a liar! Sonofabitch liar... cheater! Thankcuntshitpiss!! Twenty years delivering at the same company, and then they try to cheat me! That thanking *Eye*-talian... sorry Pete. That Joe always was a cheater. We'll take it to Humboldt Seafoods. We don't need that cheater."

But they wouldn't take the crab at Humboldt Seafoods nor any of the other big buyers. The guys on the dock all had a story, of course, but it was pretty obvious that Joe had just called them. This is a small town with an even smaller waterfront.

For a while there, we were like the man without a country, a boat without a dock. What the thank huh? Forty dollars is forty dollars. Right?

We did finally find a buyer, NorCal Seafoods, the Young Turks of the bay who would take the crab later that morning and our crab in the future.

It's been stormy, rough and windy so we haven't been out since then. We still tie up at the same dock at the foot of C Street, right next to Lazio's. That's kind of awkward since the company we used to deliver to owns it. Dave helped build the floating dock five years ago, so he figures he can tie there if he wants. Nobody has squawked about it yet.

♪ *It's Gonna Rain (Part 1)*, Steve Reich

[END DIGRESSION]

While Rich Mapple was sitting out there in maybe-his-mother's Mustang®, motor idling, sitting there in the dark, maybe cursing me, Bernard Herrmann's soundtrack from *Psycho* soft and low in the background; those paranoid thoughts reminded me of Joe Siculiana swearing that we'd *sell the crab in hell!*

Shit, I'm not superstitious or nothing, but what the thank, huh? Why take a chance. I did hear a couple of nasty Sicilian curse words peppered in there. That character with an arrogant dismissal of the irrational is always the first to get it, in those horror movies.

Best to play it safe.

I'm not in the best of shape mentally right now and these things seep in. Besides, you know the rules:

- ☠ No women on board.
- ☠ No bananas.
- ☠ No suitcases.
- ☠ No whistling.
- ☠ No flowers.
- ☠ Never start a fishing trip on a Friday.
- ☠ Never step on board with your left foot first.
- ☠ Never start a fishing trip while having sex with a redhead.
- ☠ Never say the word *drowned*.
- ☠ No extra person.
- ☠ Never say it's your last trip, last day, last time.

All that stuff. May as well be on the safe side, pay irrational thought its proper respect. You know what happens when you start feeling sure of everything.

Always better to worry a bit.

Play it safe.

♪ *Safe As Milk*, Captain Beefheart and His Magic Band

## Chapter lxxv
### *Gandhi & Delight*

Rich is gone. Maybe I don't have to deal with that shit again. But his skull is so thick! I don't drive around bothering other people when I'm thanked up, so why should he get any sympathy? His greatest success is his ability to make people like me realize how far from Gandhi they are. Thank Rich, I got more important things to do: smoke this cigarette; drink this coffee; and maybe go out and talk to Groovy Daddy. Maybe he can make this headache and these stomach cramps go away. I gotta get out of this place for just a little while. I wish I did have a date like I told Rich. Shit, that wouldn't do any good. I thought I was going to feel all kinds of relief when I finally got rid of him. Why do I still feel so guilty? Why do I still feel so anxious?

Groovy Daddy's still here. In a pool of light. Underneath the one light on tonight in the whole open space of the warehouse's second floor. A quarter of a city block of roofed space, broken only by support posts set in a twelve-foot grid to hold up the rafters and fourteen-foot ceiling.

He's sawing up pieces of redwood to use in his Needle – struts or something – making notations in that ever-present notebook.

"Ah... Santino. What's up?"

"Well, I just threw that Rich guy out."

"Funny person, funny person," Groovy Daddy says turning the table saw off.

"Yeah, real funny. *Haw haw.*"

"What did he say? What were his... his big problems?"

"Shit, I don't know, Johnny, I just don't know. Oh, he wanted to stay here for a day or two. Shit. No way. I'm not that stupid, he'd be here a month at least. Spoil the party and all like he did, thank, why does he have to pick me to be his prey, his host? Thanking trematode."

"Heh heh, relax Pete, he's gone."

"Probably already sucked everything out of... yeah, I know but, shit, he's got me all shook up, just generally spoiled my day completely. THANK, thank, thank."

"You just need to get out. Delight invited us over for hot toddies and tea. Still early, just past nine. Why don't we go over there?"

"Delight? Haven't seen her for months. When? That'd be really nice. I'd like to get away from the building for at least a while."

"Oh, she didn't care when, anytime we feel like going over there."

"Okay, let's go now!" I stubbed out my smoke and turned toward the stairs, zipping up my coat.

"Wha...? Heh heh, that guy really has you on the run."

"Huh? Him? Yeah, I guess maybe he does. Let's go now though, he may come back."

"Heh, I thought you got rid of him."

"Jeez, Johnny, I didn't kill him. I just threw him out. He's pretty crazy, he might have thought it was my way of showing affection. He's pretty thick. Thick and crazy. He once broke into this bikers' house in San Diego, across the alley from Jeff and John V's place... you remember them? And then he tells the guys, these bikers, that the door was open, so he made himself at home. Can you believe it? Now they almost did kill him. But I'm too much of a pussy for that."

Groovy Daddy picks up his notebook, and we walk across the room to the stairs.

"Well... okay, okay... lights out. I've got everything here. Let's go."

Down and out to his Volvo® 544, ivory and sparkling with raindrops under the streetlight.

It's stopped raining and is starting to clear up, along with the temperature dropping again. Saturday night and it should be noisy out here what with the Ebony Club across the street. But the drinkers and fighters and stabbers and gutter pukers will have to wait until the day after Christmas; the bar is closed and dark. The street is quiet... too quiet.

I feel uneasy. I wish I could slow down my mind just a little, stop thinking about all these weird things for a while. Everything outside here looks too crystal clear... like edges too well defined... too... crisp... like the sounds from the cars going by... amplified... they're too obvious. The adrenalin pumps must still be on. I wish I didn't feel this way. I felt this way before, and I didn't like it then either. Thank, the really bad time lasted months. I hope Rich didn't bring all that back with him. He was central to that last time. But I recovered from that and this time it'll be easier... I know, I know... I think...

♪ *Heart of Gold*, Neil Young

## Chapter lxxvi
### *Ray Bradbury & The End of The Sixties*

I can tell you the moment the really bad time started: Wednesday, December 3, 1969, around 9:00 p.m.; the Revelle Cafeteria on the campus of the University of California, San Diego.

Ray Bradbury is one of my favorite writers of all time and I don't blame him even the slightest. I had read everything he'd ever written, pedaling my Schwinn® down to the Eureka Public Library and spending hour after hour going through every book in the science fiction section.

Ray Bradbury was giving a lecture, a very upbeat lecture about how we shouldn't be so worried about the end of the world, shouldn't live our lives as though we were all going to be blasted into nothingness tomorrow by the Commie missiles with their International Socialist warheads. In fact, he assured us, we college-age worriers, that all of us would live to a ripe old age and it probably would make more sense for us to be thinking about how to spend all those years wisely.

I don't blame Ray Bradbury, but I do associate him and his upbeat words with the words of the two girls talking in the row ahead of me.

First I wanted to *shush!* them, but when I began to grasp what they were talking about, their words began to fold together with Mr. Bradbury's like a deck of cards being shuffled.

"... a family... all living together, like out in the desert, hippies... calling themselves a family... all taking LSD... commune... acid... family..."

"About fifteen years ago I wrote the screenplay for John Huston's *Moby Dick*, which was a wonderful experience..."

"... Manson Family... he controlled the girls like zombies... they cut Sharon Tate's baby out..."

"... been going through this fantastic period where there's been a revival of interest in faith with the arrival of the 'Jesus Freaks' on the scene, with the reincarnation of interest in all kinds of spiritual things, indication of a of revival of some kind of faith in something..."

"... you see the photo of him? The photo when the cops arrested him... those eyes?"

"... curiosity that makes us hungry for answers. So, I can foresee in the next forty or fifty years – if you want a prediction from me – the end of this gap between Science and Theology, between reason and the occult..."

"... a cult... hippies... murdering... knives... Acid..."

## Chapter lxxvii
### Tea & Delight

Gahh, shit. Just when everything was going so good. I've got plenty of money, no women problems, all ready to go on the vacation I've been thinking about for... seems like years. All set with the suitcase packed, my passport and twelve hundred dollars in Travelers Cheques® tucked away in it. I was going to leave in a couple of days. Now I don't know what to do. I gotta work this shit out of me, I know that for sure.

So you got yourself feeling confident, and now you got taught a lesson. That's all it is, Pete, a lesson in the mysteries of the universe. That's all. It's over with now, so forget it, quit going on and on about it. That's where you're thanking yourself up. He's gone. Rich is gone and it'll be nice and quiet over at Delight's.

Delight lives out on Old Arcata Road, ten miles? Then why are we here so soon? We just got in the car. Thank, Groovy Daddy must think I'm crazy or something, I didn't say a word coming out here, did I?

"Jeez, Johnny I'm sorry, I was so quiet this whole time, my mind's not working that well right now." The headlights bounce along the steep hill we're climbing, the gravel road off Old Arcata that Delight lives on.

"That's alright. I didn't have anything to say anyway. That guy's pretty spacey, huh."

"Yeah, yeah... it isn't even him so much as it's what he brings with him. All that past stuff I didn't ever want to think about again. Let's forget it and have some Christmas cheer here with Delight."

"Okay, here we are," Groovy Daddy says as he pulls off the hill and onto the driveway.

The porch light goes on when Groovy Daddy knocks. A second later, Delight is at the door.

♪ *Here Comes My Baby*, Cat Stevens

"Hello guys. I didn't think you'd make it, come on in, it's too cold to stand out there."

Into her little house, and it's nice and warm. Plants in the kitchen and at every window. We go on into the living room and sit down and Delight asks us what we want to drink, the water is hot for toddies, she says.

"Yeah, I think I'd like a hot toddy," says Groovy Daddy.

"Delight, could I just have some coffee? Is it all right if I smoke?"

"Oh sure, here I'll get you an ashtray, it's only instant coffee, is that okay?"

"Sure, great," I say lighting up another cigarette. Jeez, I haven't seen Delight since the summer, not since I was drinking a whole bottle of wine alone, sitting listening to sad love songs. Not since that day at the river. Boy was that stupid, she just wanted to be a friend. I feel comfortable now, she's just so pleasant to be around and maybe that's why my unrequited lust popped up last summer. Jeez, I hope she doesn't hold it against me.

"What have you guys been up to lately?" Delight asks.

"Working, aheh heh. Down at the plant... everyday just about," Groovy Daddy's laughing a little more than usual now with the drink in his hand.

"I've been bringing Groovy Daddy all his work. Bringing him all those crabs to unload and cook."

"Have you been doing any more of those drawings like the ones this summer?" Delight asks me.

"Oh yeah, some. Maybe not as much as before, but I have one now I've been working on. It keeps me busy when we're not fishing. Keeps my hands busy. It's just therapy anyway, what the heck, huh?"

"Well it's so nice to see you guys. I never get down to the studio anymore, don't hardly leave the house except to go to school. I'm glad you could make it over for a little Christmas cheer."

"Boy, Delight, you don't know how nice it is to come over here. Jeez this is the first time all day that I've been able to relax. This old *acquaintance* from the past showed up. It's been, as they say, a tough day."

"Aheh heh," Groovy Daddy giggles. He's on his second toddy now.

♪ *Hot Fun in the Summertime*, Sly and the Family Stone

We'd all gone skinny-dipping a bunch of times down on the Van Duzen River this last summer. Eureka never gets hot in the summer, so one of the regular WACO field trips was to a secret swimming hole around forty-five minutes east. Always eighty or ninety degrees there and crystal clear water pounding through these massive granite boulders, some little pools and sandy spots. Everybody naked and splashing around with copious amounts of beer and weed. Delight wasn't really anybody's regular girlfriend then.

She hung around at WACO as much as she did because she was trying to get regular with Bill ████████, The Carpenter. I hadn't paid too much attention to her, she was always so quiet, sitting patiently at his feet.

We wandered off together one time on the Van Duzen looking for a different spot around the bend and were back in the woods along this shady

trail. She turns around and offers her hand to help me over a rock. Heat and grasshoppers chirping... so I got a boner. It's natural, it's natural. We're both naked and she did have quite an attractive body. Slim, full high tits, nice pink nipples, light brown bush... not overgrown, I wonder if she trims it slightly... "Huh?"

"I said, are you going fishing tomorrow? That's Christmas Eve. Surely you must get some days off." (She's not reading my mind.)

"Well, I don't know yet. I'll find out in the morning. We had all this last week off because of the storm. We're real hard chargers, you know."

"The high liner boat, The LADY-FAME," Groovy Daddy chuckles and raises his toddy in a toast.

"Yeah, right. I'd like to get out tomorrow anyway, since it'll be my last day. I'm going to leave for South America right after Christmas."

"Yeah, somebody told me you were going down there. Going to bask in the sun, eh?" Delight is laughing. (Did she remember? Did she read my mind?) And now Groovy Daddy is laughing, and me too.

Feeling a lot better, thinking about my plans and talking about them. There are not many things nicer than thinking about future plans, since they're always nothing but good. Nice future plans are sort of a dreamy drug.

"Uh, what time is it, Delight?" I ask.

"Oh, let's see," glancing at the clock in the kitchen, "it's a little past eleven."

♪ *Hot Burrito #1,* The Flying Burrito Brothers

## Chapter lxxviii
### The Death of Peter Santino

At a little past 11 p.m. on December 23rd, 1972, my grandfather, who had the same name as me, died. He had locked the door to his room – the same room I lived in until I was eighteen – and was taking a sponge bath. There is a sink in this room, and a mirror, both built into a small cupboard behind the redwood paneling which covered all the walls. I loved that redwood paneling and I loved having my own private boy bathroom so I didn't have to compete with my three sisters in the morning. He was standing naked in front of that sink when he died. The unmistakable deadweight sound of his fall was heard by my parents, who unlocked the door and found him there. My father attempted to revive him with mouth-to-mouth resuscitation, but he was gone.

My mother tried to call me, but I wasn't home. I was having a little Christmas Cheer at Delight's. Those days, fishing, even though it was a Saturday night, I would have always been home at WACO trying to get a few hours' sleep before the 4 a.m. get up. I should have been at home but I wasn't.

"He wanted to go when Harry Truman went," my mother said later. "He always liked Harry Truman. I always thought Grandpa looked a lot like Truman, didn't you?"

My grandfather, who had the same name as me, had his heart attack too soon. I was just getting to know him, just starting to be able to talk to him about things. In the last few years since my return to Eureka from San Diego, on visits back to P Street, I'd often see him sitting out in front of the family house, in his little sky-blue Ford® Falcon. Listening to *music for the adult, and the mature young adult* on the radio and smoking Pall Malls®. I was just getting to know him after a childhood of being afraid of him and an adolescence of being stupidly ashamed of his inability to speak understandable English. I sat out there in the blue Falcon with him more than a couple of times, smoking cigarettes and trying tentative conversations about Sicily, about fishing. I should have been home, but I had to get out, to shake off the dread that Rich Mapple had dumped over me like a bucket of knotted muscles.

Actually, *that* Peter Santino did look a little like Harry Truman.

Harry Truman died two days later.

## Chapter lxxix
### All Astir

Still... Delight. Even though I enjoy being with Groovy Daddy, and seeing Delight; even though her house is so nice and warm and the conversation pleasant; even though... I want to go home and sleep.

If I can just get to sleep this anxiety will leave. It'll be a new day tomorrow and I can start all over. The sun will come up and this feeling will have left in my sleep. When it got dark in those really bad times in SanDiego, I just had to hide and wait for the chance to sleep, for the nightmares to come. In the morning it was always better. It can never be as bad as that again, because I recovered; I handled Rich; I told him to get lost. I'm just talking myself into this mood. When I get to sleep, the sleep will cure. Relax.

"Ahh well, Delight, I think we should probably be going now, it's eleven-thirty and I've got to get a bit of sleep, I don't know about Groovy Daddy, but I do. I gotta get up to check at four even if we don't go fishing. And I'm pretty tired after dealing with all that shit today."

Groovy Daddy's giggling from the rum as Delight stands up and we reach that stopping point in conversation where people shuffle and gather up their things to leave.

"I guess it is rather late," Delight says. "It's been so nice seeing you both, I haven't noticed the time passing. But it has passed hasn't it? We don't get together enough. I'll have to start coming down to the warehouse more often."

"Yeah, I wish you would. I'd like to show you what I'm up to. Don't hesitate to drop by anytime," I say standing up, reaching for my jacket.

"Okay then, Delight, come by, come by, when you get a chance, heh heh hee, anytime, anytime," Groovy Daddy talks quickly what with the drinks.

"Thanks a lot for the warm house and the coffee and conversation. I hope we see you soon, so... Goodnight, Delight... oh... have a Merry Christmas," I say.

"Goodnight, goodnight, Merry Christmas, hee heh hee," Groovy Daddy says at the door.

"Goodnight, guys," Delight says as we all stand by the open door. "Oh, just a minute... there." The porch light comes on giving some illumination

across the yard and bushes to the parked cars.

"Merry Christmas, ho ho."

"Merry Christmas, you guys. Drive carefully now, Johnny."

She closes the door and it's really cold out here. Quiet with a completely clear sky. The stars are only a few feet away up there. The ground crackles under our feet so it must be cold, but there's no wind at all. Inside the Volvo®, it's colder than it is outside, or so it seems.

"Johnny, get this thing started. It's thanking freezing in here. Cock-bite, it feels like working down at the ice plant."

"Hee heh hee, it's good for you, makes you tough, ready for the Yukon, heh heh," as he gets the key in the ignition.

"Yeah the Doukhobors," I laugh.

"It's not a cult," says Groovy Daddy.

Then we're quiet just trying to get a little warm.

"Boy, it's really cleared up, and that thermometer is through the floor… maybe the storm's over. If the wind stays calm, we might be able to get out in the morning. That'd be great."

"I don't know. Swell's pretty big still," Groovy Daddy says.

"Yeah, but that's not so bad, a big swell. They go down fast. Anyway, it's not bad fishing with a big swell. Just as long as the bar's not closed out. Tomorrow will be my last day, it'd be nice to get out there and splash around a little, especially if it's sunny."

"How am I on that side?"

"Just a second," rolling down the window and craning my head out.

"You're okay on this side, Johnny."

The backup lights show the driveway and its junction with the road. The driveway is level, but the road is very steep. Groovy Daddy keeps backing until the car gets most of the way onto the road, and the car twists dramatically, leaning heavily down on his side. The springs are making all sorts of groaning and popping noises, but he gets the car out, straight up and down the road after a bit of jockeying around. It still leans very heavily to the left.

"Something's wrong with the car, it's not level. It doesn't feel right," Groovy Daddy says.

"Oh, sometimes the shocks will stick like that if they get overextended. It'll drop down level again in a couple of minutes," I say confidently, as we steer down the road.

We drive through the trees down onto the old road, once the main highway. Still leaning, the car isn't easy to steer.

Groovy Daddy drives across the cutoff road to the freeway, driving even slower than usual. Then we creep along 101 towards town.

"All the eucalyptus trees died from the cold," Groovy Daddy says when we pass the row of trees.

"Huh, yeah they don't look too healthy all right. Jeez, this has been about the coldest ever around here. I thought I heard the weatherman say something like that today. This is supposed to be sunny California. The idea of fishing out there with ice all over the decks isn't appealing. Did I tell you about that trip to Astoria last year? I was ready for that though. God, it's been freezing here for two weeks now. Steve and I were pulling the gear one day in the snow. The snow! It's not supposed to snow around here. I could see it crabbing in Alaska, but then those guys up there have the right mental attitude. Boy, I don't."

"Heh hee, just think about all the money you're making. Those crabs are like gold, Pete. Gold! Heh hee."

"Yeah, sure, I'd be rich if there were any out there. There aren't many left. I have the distinct honor of helping to wipe out the Dungeness crab as a species. I think a guy gets special Karma for doing stuff like that."

"Hee hee, they'll grow back," Groovy Daddy says as we cross the slough bridge.

"I suppose... Hey, stop at this gas station here. We can check the shock. Something must really be wrong, this thing is still listing, I mean, leaning just as much."

Into the Shell® station with all its fluorescent lights blinding. I think they put all those lights in these places for the same reasons they put them in fast-food restaurants; they're supposed to make you uneasy, so you get out of there fast, don't linger, don't get in the way. The fluorescent lights of a gas station at midnight do their job well.

"Hey, you can't park there!" yells the attendant.

"We're just going to be a second, just want to check our problem here."

"Do you want gas?"

"No, I don't think so. Nope."

I jump up on the left rear fender and start bouncing, hoping it'll pop back into place.

"Well, then move it," says the attendant.

"It's not popping back into place, Johnny. I don't know what's going on here."

"Hmmm, oh no, I hope the spring's not broken," says Groovy Daddy looking under the car.

"It looks like the spring's busted," the station man says. "I can't fix that though, you'll have to go to the dealer to get the part. Probably pay through the nose too. You'll have to go to the dealer."

"Sure, look, we just wanted to use your lights. We don't want you to fix it," I say.

"Shoot, well, let's get going, Pete."

"Okay, thanks for the lights."

"Shoot," Groovy Daddy says as he pulls the leaning\listing Volvo® out onto Fourth Street.

"Well, what the heck, huh? This is just one of those days we all should have stayed in bed. Even if I had stayed in bed, the roof would have probably fallen on me. Never a dull moment, right?"

"Shoot."

"Aw, it probably won't cost that much to fix, Johnny. Twenty or thirty bucks, don't worry about it."

"Problems, problems," he mutters.

We turn the corner at C, with the Volvo® cartoonish, so exaggerated in its angle, looking like it's going ninety, and head down the street towards the bay, towards the warehouse. Nobody around, all is quiet. No white Mustang® lurking on this street. None down this one. God, he's not here. He wouldn't be coy enough to hide the car somewhere else and then walk, so he's not here. Yay! Groovy Daddy turns around in the intersection and pulls to the curb.

"Well, thanks for taking me over there, Johnny. It was really nice to see Delight again. Kind of just what I needed. Well, you take it easy now, and I'll probably see you tomorrow sometime, tomorrow night if we decide to fish, I don't know whether we will or not. Anyway, thanks for the ride."

"Oh sure, sure. It was fun. So, sleep well, and I'll see you tomorrow or sometime. Goodnight."

"Yeah, goodnight, Johnny," I say getting out of the tilted car. Groovy Daddy pulls away, and I walk over to the door. Peek around the corner, but it's clear. Nobody anywhere. Stop sweating it, he's gone. Shit, he'll never be able to find me tomorrow on the boat. Maybe he's already left town. Thank him. I gotta get some sleep.

The front door really echoes when I shut it, must be the cold. *Sound is more intense because all the air molecules are tighter packed and...* why do all these pieces of worthless information stick in my mind? Why can I figure out quasars and pulsars but not this black hole I'm sucked into?

It's just as cold in here as it is outside. There's nobody else here, I gotta get some sleep. Sleep will cure it, it always does for a while.

Passing through Bulkington's studio, onto the stairs...

## Chapter lxxx
### The Lee Shore

Who should I see there, standing dimly lit in the center of the concrete floor in that frigid space but Bulkington! I looked with awe upon Bill, he was so devoted to his pure vision. He had heard me come in and turned to acknowledge but made no effort to speak or turn on the lights. Bill Bulkington was at his best in this space, cold as it was now and so dark one could not make out the labors to which he devoted so much of his being, the huge stretched canvases that covered its western wall.

I write this short chapter in lieu of a granite monument. These works he created were wondrous and must be spoken of! That they are not is testament only to the sad worm maneuverings of the Art World, and for him 'twas better to be dashed in the storm of failure and sink in that howling infinite, than land, crawling, upon the lee shore, on his knees before the self-righteous and moneyed.

I ask no special treatment, not for me nor Bulkington. Only this: that the Art World conduct itself with a modicum level of honor. If this were to pass, and only this. This and merit alone would suffice.

There had once been many of these great canvases, but now that wall held but three. Only three on a wall of fifty-foot length and height fourteen! Yet they dominated, leaving space for none other. Powerful they were, and handsome as their creator. Layer upon layer, thicker and more convoluted with each additional mass of color mixed heavy with wheat paste. Thrown against the willing, groaning woven cotton plain with mason's trowel, brush, broom and Bulkington's bleeding torn own hands.

My favorite and one that had consumed three months of the man's sweat and heart, was green in final tone. But to try and invoke in that simple manner is akin to describing Mount Shasta as *pointy, white, with some clouds in a blue sky.* Twelve by eighteen this beauty had, and we must ne'er forget its advance from the wall! Indeed, layer after wheat paste-caked layer had brought its jagged surface out a foot in the calmer passages, other sections blossomed forward even more and the work culminated in a massive burst of jade green that pushed forward to attack the viewer then drooped from its own weight, landing moist, tired and still panting – a full three feet from where it last tasted canvas – on to the concrete.

Take heart, take heart, O! Bulkington! They will thanking remember you now!

## Chapter lxxxi
*Meanwhile, In Dreams...*

Upstairs in my room, I built this tiny loft, this Captain's Cabin, more than a year ago. It's a winter necessity in this building. Tight enough to be warmed by a small electric heater. At least there's one place of comfort I can go to. Hide in if I was disposed to hiding. And I am. I should've been hiding in here today.

What the thank, the drama of life, it's entertainment of a sort.

I can see stars through the skylight I put in the roof right above my pillow. One of these days a seagull, or more spiritually apt an albatross, is going to drop an oyster with Norden® bombsight precision right through it, and I'm going to end up with glass and oyster shell all over me, picking it out of my face.

Better smoke a cigarette. I know that clown Rich is going to thank up my plans to leave somehow, just when I was almost on my way. How does he time it? Thanking shit, he must be cognizant of my dislike for him by now. He must think... no, I don't know what he thinks, maybe that's most of the problem. Drugs can really screw some people up. God, his brain must be fried.

At least Rich believes in something, he can formulate arguments no matter how absurd. I can't even argue with him. Maybe believing in something would make it all easier... believing in *anything*: Religion; the Democrats; ███ ████; International Communism... thank, then I could have lots of pat arguments and answers for everything. Chant some chant to myself and the soothing dogma flows. Rich's appearance would transform into a life lesson for me to get a better understanding of the human condition. Hah. He is human, a person, and I just threw him out. Oh, sure now, start that Gandhi stuff again.

He's so much like me with just the slightest... get to sleep, in the morning I can talk to Steve about the whole mess, he'll understand. It's not really Rich's fault. He just happens to personify all those times that scare me, those faults of mine that scare me.

Think about something else, about the sailboat I can build. Just like the *America* only much smaller. Just big enough for me to slide inside and be able to run the lines and steer. I can use the plans for the model to figure it out. Miniature. Everything the same, only small. Only about fifteen feet. Lots of room downstairs to do it and it wouldn't cost that much, not if I use that old pile of lathing strips and then fiberglass. It would work... my

head would just stick out... and my arms... everything small... but perfect. All the fittings... sails and masts... perfect... Rich is just the same as me. He is me with all the same fake wisdom shit and... wait, wait... maybe a battleship would be better? Sailing yacht, even a small-scale one, has that inherited hassle of the tall mast... a battleship sits so much lower and why do it from scratch? I could easily get an old canoe or kayak, something seaworthy and just add layers on top... all the superstructure and guns!

Should be able to rig up something to work as... as big deck guns!

Rows of three steel tubes... maybe some kind of firing mechanism... yeah, like a weak shotgun shell, lots of smoke and noise...

down the bay I could cruise...

yeah, down the bay...

♪ *The Juggler's Song*, The Incredible String Band

**ART IS ALWAYS AND EVERYWHERE THE SECRET CONFESSION AND AT THE SAME TIME THE IMMORTAL MOVEMENT OF ITS TIME**
*Karl Marx. Posted on wall in main stairwell*

## *Chapter lxxxii*
*Meanwhile, In Heaven...*

Meanwhile, in Heaven, an angel, one of an infinite number tasked with assisting Death, mulled over all the possible natural accidents ze could conjure. Ze thought over the things that could happen to a commercial fisherman in the course of a normal workday, trying to think of something interesting, something to break the boredom of this not-too-busy Saturday night.

The angel thought of having a huge whale swallowing this guy's boat as it left the dock. A witness with a Super 8 camera on the shore. A massive black shape the size of a factory breaches from the still bay surface trailing Niagaras of frothy water. High into the chilly predawn air, a yawning chasm-mouth opens wide, rimmed with brilliant white tree-sized teeth daggers! Yes! On a morning so close to this religious holiday and all, it could be quite moving. No, it'd be stupid. All the other angels would laugh. Too theatrical.

The guy could just fall off the boat, "Oops, I fell overboard." That would be a wonderfully dumb way to do it. So simple, but then, everyone might read the newspapers and think, "What a fool, he fell off the thanking boat!" Nothing here indicates he should go dishonorably; or sluff off the mortal coil as a fool. Sad, that's almost as bad as getting hit by a station wagon while jaywalking to the Post Office to get that phone bill paid before 5 p.m.

♪ *Long Cool Woman (in a Black Dress)*, The Hollies

[DEATH IS A NATURAL AND NECESSARY PART OF THE CYCLE. DEATH'S NECESSITY DOES NOT PRECLUDE ONE FROM MAKING IT AN INTERESTING AND SATISFYING UNDERTAKING.]

The angel had recently attended a showing of Bernardo Bertolucci's *Last Tango in Paris* and while ze had felt it was probably the best film of the year, a trailer for the upcoming *Poseidon Adventure* had been the most memorable part of that evening.

"A rogue wave!" ze shouted though no one could hear. Such a beautiful way, beautiful image and that name, that word: *rogue!* The angel set things in motion with small manipulations in the Gulf of Alaska all the while thinking of that wonderful word and of greasy-haired juvenile delinquents leaning against chain-link fences picking their fingernails with long switchblade knives while sweet *doo-wop* music sprang from a quartet lit by the streetlight.

♪ *You Send Me*, Sam Cooke

## Chapter lxxxiii
*Write What You Know;*
*What You Care About; That Which Moves You*

I don't really know what to say about the veracity of this book. Some of it, like that last chapter, I admit I made up. In a junior high school English class, the assignment was to write an original short story and I chose to write what I loved to read, what I cared about: Science Fiction!

I remember it was some kind of tale about wise, misunderstood aliens, a cure for mankind's ills revealed after a tortuous, convoluted plot. When we got the papers back, our teacher, the highly regarded tough but fair Mrs. ▓▓▓ had written on the top of my first page in red pencil: "C-, Boring, average technique."

I remember feeling initially disappointed, thinking I'd written a fairly interesting story but also happy to just be done with it and not to have failed. Strangely and quickly that feeling was replaced by intense jealousy and envy when I saw the paper being handed back to Gary ▓▓▓ who sat next to me. Gary looked at me with a little smile to mask his shame, like he'd just farted. Mrs. ▓▓▓ had scrawled, "**F!!! ABSURD!!!**" in ALL CAPITALS in that same red pencil across the top. And the red on Gary's paper was not just bolder, but deeper, richer, more vibrant. Each line in each letter had been gone over three, four, five – ten times and there were multiple exclamation marks! The pencil had been jammed hard leaving a deep imprint and almost breaking through the surface. I saw it and knew immediately with my every fiber: I wanted *that!*

Maybe this applies. Maybe every time I do a drawing or painting, I remember that lucky guy next to me in my ninth grade English class.

So I bought this typewriter, a very stylish Olivetti® model on sale at Eureka Business Supply, took an adult education course on how to type using most of your fingers, and here:

A fairly good tale. Just to be done with it, is something in itself.

Like I've been saying, the incident, the main event coming up and most all of the other shit, really happened. They are true. They can be verified by the newspapers: *San Francisco Chronicle*; *Sacramento Bee*; front page of the local *Times-Standard* (went out on the AP® wire), all with my name spelled wrong. Lots of other things wrong too, but my name?!

Thank! They took my Sicilian Heritage from me when they spelled my name wrong. In the newspaper, because of the misspelling, I come out Portuguese. I have nothing against the Portuguese, but what if I'd been killed? You wouldn't be reading this stuff, true, but thankin' aye, some guy in San Francisco would've picked up the *Chronicle* and said, "Aw, look, some poor Portagee bit it up there in Eureka."

The reason, the only reason, I'm writing all this down, is to finish with it. To forget it. If it's all written maybe I won't have to constantly think about one or another aspect of that twenty-four hour period. Thank, it's almost been two [42] years, it's about time to *complete the gestalt*, as the therapists say.

About time to get on with a few other things that might be more interesting. Maybe even more enjoyable.

Oh, yeah. The rest of the story has less sex, drugs and art-babble, but plenty of action. I'll tell this story as best I can. I remember this particular morning very well. You already know what kind of a story it is.

I'll tell this story as best I can, constrained as I am by the Truth.

## Chapter lxxxiv
### The Chase, First Part

I can see all the way to the Humboldt Bay entrance from here high on Table Bluff. I can even see clearly deep into the water. And there, must be five miles distant, there bobbing at the bar are all my friends floating together like a cluster of flotsam. ▮, Elizabeth, Marianna, the Keiths, Johnny and the troglodytes. They seem happy and I am certain they are headed my way, until... I can see it coming under the water but can't yell, too far. It's bigger, a thousand times bigger than a Great White, several of which are spinning circles, orbiting around it like those small pilot fish that swim about the huge sharks as if to illustrate the size difference. Right into them! Right into the cluster of friends and I feel the panic. Body parts and even a head... a girl's head! I see it all sliding down through the water to the sea floor. Don't make so much agitation! I'm trying to warn them. But they can't hear me. The thing, huge and bulgy, and hardly a sleek sea creature, all covered over in skin dark grey blue black... except that face! I see it so clear now as if I can zoom in. Very light buff-grey, the massive face of a camel! A smiling camel face!

"Man the mast-heads! Call all hands!" I scream out, raising my head and flailing my arms madly.

"Okay, that's it, shithead, you are out of here!" says the barkeep and he slams his fist onto the mahogany next to my ear.

Outta Jimmy Dunn's... owwww, the squinty sun, soft legs rolling kitty-corner zig and zag over to... to Roy's Club.

"HEY! GET THE THAnk outta..." screaming voice, Doppler® fade, thanking driver, I'm walking here.

"Yeah well, thank you asshole, thank you too," but I can't see him no more, where'd he go? "Ahoy, the Roy!" I say cheerfully pushing through the glass doors and leaning left into the bar. What's all this shit? Full of suits, dames with colored cocktails getting all quiet and giving me the stink-eye. Best not set gear, keep away from the anchor block, barman is doing that motion with his head toward the door as he's wiping that glass... stink-eye too.

"Like I was sayin'," as I turn 'round muttering the notion.

A hard South then tack Sou'west through the shoals of parked cars to Shanty, to Schooner.

"Ralph, I just wanted to say... Ralph."

"Look, why don't you finish your beer and call it a day, Pete," Ralph said, not really in answer to anything that I'd been spouting.

"Fine and dandy," I reached to find my smokes but only a crumpled empty pack came back. Maybe home port, maybe to Buon Gusto. Yeah.

[Pounding sound]

"Um, um, um. Stop that thunder! Plenty too much thunder up in here. What's the use of thunder? Um, um, um. We don't want thunder; we want rum; give us our tot of rum, um, um!"

A pounding sound like a Chinese opera drumbeat from overhead.

"Avast!" I cried. "Look aloft! Look aloft!"

A pack of Winstons® taste-good-like-a-cigarette-should, bouncing just there in the air. Right out of reach, ummm, bounce and hop, ummmm!

Can't get um. They're dressed like in a commercial: top silver foil opened and splayed back; five little friends coming out of the pack like members of a pipe organ choir with their matching little faux cork headdresses on.

I stab again to heaven and again my reach falls short.

"Blast ye!" I cried. "Let's have fair play here, though I be the weaker side. Blast it! Have mercy on us all."

[Happy david, on the roof of waco, beating a bucket, barely restraining his laughter, bounces the pack of cigarettes suspended on invisible fishline just out of grasp of his drunken friend below.]

♪ *Dixie Chicken*, Little Feat

**THE DIFFERENCE BETWEEN A WISE-ASS AND A WIT IS MONEY**
*Unattributed. Posted above kitchen table*

## Chapter lxxxv
### The Telephone Rang

The telephone rang. Sputtered. The ring worked into the dream, became some noise heard by the dreaming me. The other part of me is told what it is though, and I'm pushing the covers off and stumbling out of the loft before the second ring sounds. Jumping down the ladder in two steps (too fast); one of these times I'm going to trip (broken neck), but I get to the phone by the end of the second sputter.

"Hullo?"

"Morning, Pardner. Are we going this morning?"

"Huh? Steve? Boy, I'm still asleep. Shit, I...uh... overslept. What time is it?"

"It's about 4:15, did Dave call yet? Any wind down there?"

"Nah, I... uh... don't know. I haven't looked out the window yet, I was sleeping like a baby there. Dave should call in a minute or so... Cockthankin-bite, Steve, that's the first time you've ever woken me up I think. You're the one who's supposed to oversleep. I'm always waking you up."

"Huh, I know, I know. Hey, look out your window there and tell me if the wind is blowing at the stacks."

"Yeah, uh Dave should call in a minute, so how 'bout I call you back after he calls. Then we'll know for sure," I yawned. "Look don't go back to sleep, now. I'll call back in a few minutes, don't go letting the phone ring and wake everybody up out there, ha ha."

"Okay, call me back, bye bye," Steve says.

"Uh huh, bye bye."

I finish pulling up my pants, zipping the zipper and buckling just in time to unbuckle and unzip. Thank, the toilet's frozen. There must be a quarter inch of ice on the bowl water. My piss melts right through after a little splashing. A small hole right in the center, hah. Steam all over the place. God, it's so thanking cold. At least I can still aim, right in the center there. In the mirror... blagh, I look the same as every thanking morning. No hair to comb, hardly any teeth to brush... haaaahhhhh, into my palm, doesn't smell bad. Forget it. What difference does it make? No little sweetie is going to be smelling my mouth today. Coffee's the important thing right now. Coffee, coffee and a cigarette.

Where are my smokes? Oh, yeah, up in my cabin. I gotta turn the light off, anyway. Back up the ladder, through the trap door, and I grab my cigarettes and shirt. Flip the light off. Coffee. I gotta get woken up here. Down again, nice and slow, with care. Plug in the lower half of this coffee maker we use to boil water for the instant shit. I put in just enough water for one cup, and this thing can get it hot in only ten or fifteen seconds, which is really important at 4:15 in the morning. What time is it? Oh, Jeez, it's almost 4:30. Where's Dave? He always calls by quarter after. Man, I gotta wake up here. Hurry the thank up water. Was I completely asleep when I came down? I better call Dave. Ah, hot water, yay! Coffee! A couple of cigarettes and a cup of this stuff and I'll be ready to go. I gotta call Steve back. But I have to wait for Dave first. Maybe Dave's already looked at the ocean and decided it's too rough still. Yeah, but he would've called still. He's probably sitting there in his kitchen drinking coffee, but he would call even if he didn't want to go. I'll look at the wind situation.

If I press my face against the glass of the window, and strain, looking as much to the west as I can out of a window that faces north, I can see the smokestack of one of the pulp mills across the bay. It's not really a smokestack, I've been told. No smoke, just steam. Stinky, rotten egg steam. Anyway the steam is rising straight up, no wind. Not a breeze. These stacks are a time-honored method of fishing weather prediction. Some of the guys even know the calibrations needed to tell the speed of the wind from the way the smoke… steam, whatever, runs off the top of the stack. If it eddies down the lee side two of the painted rings worth, then that means thirty knots. That's the only one I know. The smoke right now is rising straight up, swaying around a little, but it is dead calm. I wonder why Dave didn't call, it sure looks good to me. The first morning since this storm started that there's been no wind at all. Huh. Shit, this coffee's cold all ready. If the swell's dropped any at all, it should be nice weather outside. Cold, but clear and calm. Maybe I should call Dave. Maybe I should go back to bed. Why should I go out there and freeze my balls off just for twenty bucks worth of crab? Ah, shit. It would be kind of neat to get out and work, spend the day with Dave and Steve. Splash around. This'll be the last possible day for me to crab with those guys before I take off. I better call Dave.

"Riiing." He should answer right away, the phone's there in the kitchen.

"Riiing." Hurry up, Dave.

"Riiing." Oh thank, he must be outside doing something. Now it's going to wake everybody up and Dave's going to get pissed at me for calling when I know he'll call in a minute, I better hang…

"Ah… uh, huh… hel… hello?"

"Dave? It's Pete."

"Oh, uh hello Peter. Wh... what time is it... wh... what does the weather look like?"

"Well, it's after 4:30, and no wind down here. Clear as a bell and not a breath of wind. *Flat... cam...*"

"No wind, huh?" Dave says. "Well, I'll get up here. The alarm didn't go off, I remember setting it last night, just didn't work. I overslept, heh heh."

"What do you think, Dave? Do we go out there and get some crabs?"

"Heh, I don't know yet, Peter. I'll take a look at the beach on the way down there. With no wind it should be pretty good though. That swell went down quite a bit the past two days. We may as well meet at the boat, we can go up to Denny's® if nothing else. Get some breakfast."

"Okay, I'll call Steve, then. Five o'clock at the boat?"

"Yeah, fine, Peter, fine."

"Okay, bye Dave."

"Bye."

Dial again. This time the first ring doesn't even finish.

"Pete?"

"Yeah Steve, I don't know whether we'll go or not, but Dave wants us to meet at the boat anyway. He said he'd take a look at the ocean. Oh yeah, there's no wind at all. The stack's sticking straight up. Looks good from here, buddy."

"I just called the weather number," says Steve. "The recording said five to nine-foot swell, and five to fifteen knots out of the northwest. That's not too bad, huh?"

"Naw, it's really come down. That's nice fishing weather. Jeez, it's going to be clear and sunny too. That's great."

"Uh huh."

"Thaaaank, hey, you know what? I woke Dave up! Hah ha, that's a first. Thank, that guy is always up at 3:30 in the a.m. sitting around drinking coffee. Doesn't matter what time of year it is or whether he's planning to go fishing or not, he always gets up. Hah ha, his alarm didn't go off or something, he said. Hah."

"Yeah, that's weird all right. This is the first time you've overslept too, weird. Well, I'll see you on the boat in a few minutes. Bye bye."

"Bye, Steve." Click.

Uh Oh... don't start thinking about that kind of stuff now, Pete. That chill is starting to go up the neck. It's too early in the morning for thinking those thoughts. The cold is where that chill is coming from, put on your jacket. Odd; *weird* is what Steve said. Don't be running your imagination at this hour, Pete. But this is the first time in two years of fishing with Dave that he wasn't up on time. And I never oversleep. I'm always calling Steve and waking him up. Just a fluke, light a cigarette.

Ten minutes to kill before I walk on down to the boat... if I kind of breathe deeply here and conserve my warmth, I can get these shakes to go away. Drink the coffee... I'm not that hungry, there's those rolls on the boat I can heat up later, I think there's some tuna under the bench there for lunch. Thank, we probably won't go. That'd be nice I don't really feel like it. Probably be rough enough to get me sick. I want to go back to bed, sleep this off. Don't feel good anymore. I was up too late. Too much running around trying to hide from Rich. Thank, don't start in thinking about that asshole now, talk to Steve about it all later, when it's light and these shakes and chills have passed...

Okay, okay, lunch stuff all set, got plenty of cigarettes on the boat. Steve bought that case of sea stores. No tax. No reason to quit when you can smoke so cheaply. Winstons®, what the thank, they taste the same as these Camels® with filters, but the Camel® graphics are better. Why not enjoy looking at the pack when I see so many of them? I can take a couple of cartons with me to South America. I think that's how many they let you bring into Mexico, two or maybe only one... I can't remember. Then it's on to those rotten tasting... I can see the cartons sticking out from under some shirts in my suitcase there on the table. Passport, Travelers Cheques® all hidden away under things. I don't think anybody will get into my stuff. Two years here and no thefts. The thieves are our neighbors; they go into the suburbs to rob houses.

Huh? Wha... nothing. Just nerves. Nothing there.

Twelve-hundred big bucks there all saved up. Fighting all those fires for the Forest Service. I'd fight any fire. Then I wouldn't have any time to sit around the bar getting drunk like everybody else burning through their paychecks, and now I have enough money to go. I didn't have that much fun, it's true, but now in a couple of days the fun begins. Well, maybe. I don't really even want to go on this vacation now. Not a vacation, more like what, a vision quest.

Wha... what is that?

If I could shake this feeling, get back to how I was feeling before yesterday.

NO, no really... there's something there! Oh, thank, relax, relax. Oh, shit. You're just a little scared, relax. In a couple of days, you'll be sitting in the sun – right there in front! Shit I can see it and feel moving to my left now something darkly black a black man! The extra man! *Der Klabautermann!* He's sitting on my left side. Heart is pumping pretty hard. *He's smiling!* Another smoke... it'll pass. Relax, you're not feeling too stable right now because of yesterday, that's all. Nothing more. It's not an extra presence... it's just from the adrenalin, you know how that stuff works.

♪ *Sleepers, Awake!* Incredible String Band

## Chapter lxxxvi
### Relax

Relax. This is the hour of the wolf right now, the darkest hour before the dawn, literally. Go down to the boat. That's a nice solid object. Unchanging, solid. Steve will be down there in a couple of minutes. Unchanging, solid. This Rich-induced rush is fading...

I gotta get to the boat. Okay, jacket on and a look around to check that everything's all right. I switch off the lights. It's still light enough from the streetlight. Down the hall and then the stairs, all right still. Fine. Wrench the door open (one of these days I'll fix that).

Out to the street. Boy, *it is cold*. Frost and ice all over, glittering, like diamonds. I slam the door as hard as it's always necessary to do, maybe harder in the winter when it gets swelled up. Boy, *it is quiet,* too. Crunch, crunch across the street. Still a lot of snow. It's been so cold, the poor snow hasn't been able to melt, just get dirtier and dirtier until it loses all of its Santa Claus appeal. Every puddle in the street and on the sidewalk has a crust of ice on it. That's the only noise, no cars, nothing, only me walking. Walking and crunching through the puddles. Stars brighter than shit, bright enough to make a showing even with the streetlights.

But there's another sound:

A dull roar that I can barely hear when I stop walking, and hold my breath. Sounds like the surf, but then it's probably not. Not today, can't be big enough. It's two miles across the bay and the peninsula to the beach. Must be the pulp mills. It's only a mile to the nearest one and sometimes, when the wind is just right, I've heard men yelling over there. Workers barking instructions. They're probably running the last shift now, before shutting down for the Christmas break. Nobody in their right mind would work on Christmas Eve. Here I am walking down to the boat to go out in the ocean, freeze my ass, and on Christmas Eve. Shit, we won't even make any money. I can see being a hard charger when there's tons of crab out there just waiting to jump into the pots as soon as you empty them out. But this scratching for one or two legal males per pot, that's not the same. Shit, we have to pull the gear the same way whether there's one little thanking female in there or twenty jumbos.

Ah shit, you dummy, this is your last time out. Last day. This is for fun.

Another chance to spend a day with Dave and Steve, just messing around out there. Cheer up. There's no problem anymore, that's back at home. Working will make it easier to forget, like it always does.

Any trains? Thank, I should be able to hear one this morning, no there's nothing coming. Watch out for the tracks, Pete, slicker than snot. NO body around. The parking lot is deserted. One car on the far side by the boats, fisherman's car, maybe somebody's out on a trip.

Thank, here we have the most prestigious restaurant in the county. The one that tourists come hundreds of miles out of their way to eat at. The one they go back to Iowa raving about, and this place won't even spend the money to pave their parking lot. Gravel with potholes big enough to swallow small cars.

Nobody stirring at the plant here, but Joe or more likely Stan, will be here by five. Maybe not today. Sunday and Christmas Eve both landed on the same day this year. They might stay in bed for that.

Ah, at least the tide's not real low. I don't have to climb down the ladder. We left all the bait up at the other plant, so that doesn't make any difference there. Sometimes that can be hell, trying to wrestle that strap-box of bait down that ladder. Yeah, I'm sure it's all up at the plant. We had it all in the jars already, I think... shit, it's really been a long time since we've been out. Can't even remember where the bait is.

Yay, all right, no boat's rafted next to us. Thankin' aye, that's enough of a hassle without all this cold weather freezing the lines. And you gotta untie them fast, then retie them faster, and all the time they're pretending to be two-inch steel cable. So we got a clear shot out from the dock, at least. These lines are frozen. I figured they would be. The back deck is all nice and frosty. Get the door open and the stove going and the engine started, those guys will be here anytime.

I wonder why everybody puts their keys in the head, all the boats I've seen. If they have a toilet room closet, that is where the key goes. Do all the people who steal radios and other electronics know that? They must! Unlock the door, slide it back, put the lock and the key back... in the head of course.

Let's get some light on the situation here. Flip on the circuit breaker for the interior lights, also the one for the engine room, with its red warning light on, glowing there, telling me not to forget it. Get the stove going, get some heat in here, it's freezing.

Okay, so finally a nice puddle of fuel at the bottom of the chamber there. I have to stand here rocking back and forth rubbing my hands for... it must take thirty seconds for any fuel to make its way there... even with the pump. To make it there and soak into the soot and carbon residue, get it all nice and wet and ready to ignite. A match, a match... here, and some

paper towel to light. Okay, stuff it down in, flaming away... wait... turn the blower switch on. Ah, it's going. One of the rare first time lights. I've used up so many rolls of towels trying to light this thanker.

Okay, okay, get the engine going. I wonder if Dave will ever notice this nice new solid-brass pull ring I put on the engine room hatch. Cock-bite, those things cost four bucks! No wonder Dave was always yelling about being sure not to leave it pulled up. Not to leave it exposed to somebody's foot... but I didn't break it off. Must have been somebody else. Huh, it's not as cold down here. The water must keep it a bit warmer, water temperature can't be any less than forty-one or two.

Okay, check the dipstick, needs a quart like always. Jeez, I have to do something about these cans of oil. Get a box or something to stick them in. Rolling all around here... the empties still have just enough left in them to get it all over this spotless clean engine room. Thank, this stuff looks like ninety weight... hurry up. Shit this thing is going to be harder than thank to get started up. If Dave hadn't bought those new batteries, it wouldn't get started. Can't imagine Steve down here, contorting himself to fit... waiting for this oil to dribble in... he's got eight inches on me, and my back is starting to ache. Must be because of the cold.

All set, get the cap back on here, get rid of this can, get back up to the wheelhouse, it must be getting a little warm up there by now. Those guys will be here soon. It's always nice to have the boat running by the time Dave gets here, makes it seem like I'm concerned. And I am. Dave appreciates me coming down here a little early to get it all ready to go... I think. Naw, I'm sure he does. That talk Steve and Dave and I had the other day really means something. He said I was welcome on the boat anytime, when I get back from South America, *any time*. Feeling kind of bad about leaving right in the middle of crab season, but I really want to. I have to do it now or I'll never get the will power to do it again.

And Dave understood, he understood, so when I get back, I can go salmon fishing and don't have to worry about money or a place to stay... I can always sleep down here on the boat. He understands.

It's not any warmer up here yet. A couple of minutes more maybe.

Get the engine room lights off, this thing is going to need all the juice the batteries have.

Throttle's back, press the starter... crank, baby...

Oh thank, come on, come on. Thaaank, now it's not going to start... thank, we'll have to use the goddamn charger. Set it all up, hook it to everything... oh thank, slow us all down, and Dave will get pissed off at me for not running the engine enough to keep the batteries charged. Shit. Catch you thanker... there, there. Go. It's running!

Okay, idle it here at about five hundred turns. Great.

It must be five o'clock... this one's run down... that stupid clock on the wall, it never works. Just sits there pretending, with its ship's chronometer design, that it is a ship's chronometer. But it's a fake. I've taken that thing apart so thanking many times... tap the battery, flick the flywheel, and it'll run for a day. Then, just when you start to trust it and stop winding the little spare one here... well, who cares.

I'll get some water on the stove. Dave can have a cup of coffee by the time we get across the bar.

## Chapter lxxxvii
### The Chase, Second Part

Somebody's coming. I hope it's Steve, getting here before Dave. Naw, it's a pickup, Dave's big Ford®. Where the thank is Steve, he should've been here before the skipper. I better get out there and greet Dave, maybe he has something to carry down. Lemme get my boots on here first, all those puddles out there.

"Morning, Dave."

Dave is still shuffling around in the cab, but he rolls down the window.

"Morning, Peter." Nobody ever says *good* morning in this business. You learn early on, saying *that* can get your face bit off by someone screaming back *what the thank is good about it?*

"How does it look, Dave? Do we get our little crabbies out there today?"

"Well, the swell looked like it really came down. No wind. Maybe we'll run down the bay and take a look at the bar, might be able to get out. We need a boat ride anyway." Dave reaches over and gathers up his lunch, opens the door and steps out. "Where's Steve?" he asks.

"Ah, he should be here in a minute. He was up before me this morning. Called up and woke me. He should be here."

Dave slams the truck door and after the sound fades, says,

"Listen, Peter. Can you hear that?"

Dave and I were frozen still, listening in the sharp cold air.

"Yeah, it sounds like the surf on a big day, but I don't know whether it could be very big, Dave. I was thinking it was probably machines in the pulp mill over there."

"Well, it won't hurt us to run down the bay and look at it. Was it hard to get started this morning?"

"Naw, it started right up," I say as two other headlights come around the corner. It's Steve. That's his parents' Plymouth® crunching as the tires hit the gravel of the parking lot and right into the log there – *BOOM!*

There's a bunch of these good-sized redwood logs, bark still on them, laid out around in the parking area as a sort of cheapskate parking grid. Two-foot diameter, sixteen-foot long, pretty hard to miss seeing, pretty hard to run into. Lucky, he was only going about five. He could have really gotten hurt. Who's that there? Jan? And somebody else. Steve backs away from the log, and tries again. Making his way between potholes, to park next to Dave's truck.

The big Plymouth® stops in that way that huge American cars with power brakes stop. Sort of dips in the front and rises in the back. When Steve opens his door I can see Jan in the center, in her bathrobe. And on the other side – shotgun – oh, it's Gary. Steve steps out with what may be his lunch, Gary gets out of the other door... Uh Oh.

"Hi, Pete," says Gary, walking over to me.

"Hi, Gary. What's up?"

"Oh, I don't know. I guess I may go out with you guys."

Uh Oh. Steve gives Jan a kiss after she's slid over into the driver's seat, and shuts the door. Jan smiles and maybe she's waving there, I can't tell. The car backs away, and Steve is standing next to me. "Morning, Pete."

"Hey hi, Steve. What were you doing there? Having your own little destruction derby?"

"Hoh ho, I just missed my turn slightly. Those cars are a little difficult to maneuver at this hour. It doesn't hurt 'em though."

"Boy, you sure stopped quick. Looked like you were going faster than you were, I guess."

"Umm, I guess... Hey, where's Dave?" Steve asks.

"I don't know, he was just here. He must've walked on down to the boat. Probably didn't want to be a witness to that driving."

"Yeah, right... ahh hey, I have to ask him if it's okay that Gary goes. I got some film for the movie camera, and I borrowed this Instamatic®. I figured since it's going to be your last day, Gary could take pictures of us working the gear."

## Chapter lxxxviii
*Klabautermann!*

Uh Oh, the extra person. Klabautermann! God, how can I feel this way about having Gary go with us? What the thank is my problem? Starting to think all those weird thoughts I was sure I'd left back up at the warehouse. Stop it... it's Gary, good old Gary, not some spectre of doom.

"Um... Dave won't mind. He'll be happy to have somebody to keep his coffee cup full. I guess we should get down there and get untied."

Relax, it's just nerves. Nerves shot from yesterday. It'll be fine. Nice to get some movies of action on the back deck. That's all we lack, splice all those reels together for the epic 8mm crab fishing story. This is going to be the last chance, after all. No problem, no problem.

We walk down the dock and step down the couple of rungs on the ladder to the floating dock. Gary steps aboard the LADY-FAME, left foot first. Uh Oh. Relax, Pete, stop shaking. Stop thinking all this stupid shit.

I sleep, it's there in the morning. I go to the boat, it follows me there. Steve gets here, and it's still here! Thank, thank, goddamnit. Worry about it later, when the sun's up. Talk it all over with Steve then.

Climb over the icy rail and onto the deck. Dave's inside turning on the running lights, radios, radar and who knows what else.

Steve asks me, "What do you think, Pardner. We going to get to fish?"

"I don't know, Stevie. Dave wants to go down to the bar and take a look at it."

I turn to Gary, "At least you'll get a chance for a boat ride. A tour of the bay, if nothing more."

"That'd be all right," says Gary. "I've never been on a boat before."

"Really? Not even a little one?" I'm shocked.

"Yeah, but I mean like a fishing boat. I've never been out to sea in any kind of boat." (Oh No.)

"Huh, well it'll be a nice day for a first time. First time and well, a last time, for me, anyway. Sunny and all, if we can get out."

"Did you hear the surf over on the beach, Steve?"

"No, does it sound pretty big?" says Steve.

"Ah, I don't know."

Dave sticks his head out the wheelhouse door and says, "Well, let's get ourselves untied and go get the bait, boys. Got a full day's work to do."

"Oh, uh, Dave," Steve say, "this is my brother, Gary. Do you think it'd be okay for him to come along? I want to have somebody take pictures of me and Pete running the gear."

"Fine. Nice to meet you, Gary. Fine, when he's not taking pictures, he can be in charge of the coffee. Lots of room on this boat. It's fine with me."

Gary nods and Steve steps by Dave to set his paper bag down on the counter next to the sink. I turn to head for the stern line, Steve walks over the coils of line and other stuff along the walkway next to the wheelhouse and goes to the bow. This thing is really frozen solid, but with some kicking and cold hands, it comes loose from the cleat. Then jump over the rail to slip it from under the four by four. Smash it through there. Thank. Strain, push. Okay, there, it's free. Toss the line back onto the deck. Thank it, I'll coil it later, when it thaws. Wonder how Steve's coming with the bow? Yeah, he's got it, it's free. He jumps back, holding onto the pipe railing, then flips his legs over.

"All loose?" yells Dave from the wheelhouse. "Yeah, we got it," I yell back. Dave raises the RPMs and starts backing with the wheel turned hard, jockeying out from between the boats tied around us. Hesitate a second. We drift, then the engine cackles for an instant. Forward again, but now the stern sticks out from the dock at an angle. Drift slightly and then back, out alongside the boat that had been to our stern. Dave pushes the throttle forward hard, CACKLE! And with noise from the exhaust, we head east along the wharves.

## Chapter lxxxix
### Humboldt Bay

Under way, I light another cigarette, too cold to stand around out here. Must be nice and toasty in the wheelhouse by now, better get in there. Steve is clomping along the side of the boat that is fairly free of spare coils, weights and bait jars. The starboard side, the green light side, you know, all that nautical stuff. Anyway, he arrives at the door about the same time I do. Slide it open. Shit, it's eighty in here. The stove's still on pretty high, set it back to about 2. Steve smiles and gives me a slug on the shoulder. At least one of us is in a jovial mood... I'm sure not doing too good. Thank, what an asshole I am, thinking that poor innocent Gary there is a hex or something.

"How's it going there Mario Andretti?" I say to Steve, trying to fake a little good mood.

"Hoh ho, pretty good, pretty good. How's it going with you after your unexpected visitor yesterday?"

"Oh, you heard about that, huh? Yeah, I'm still a little slowed down from that mess."

"Hoh ho ho, yeah, I heard about it all right. Hoh! I called you back over there at Marianna's party, just a couple of minutes after you called, but you'd already left. Marianna told me you were with some real weird guy who just sat and stared. So I asked was his name Rich Mapple? Pretty good guess, huh? All the stories you told me about that guy, I should be able to recognize him the first time I see him."

"Pardner, you'll recognize him, but I don't really want to talk about that guy right now, Steve. Let's wait until the sun comes up and I feel a little more comfortable. A day at sea'll do it."

"There's nothing that a day out there pulling crab gear won't cure. It always works for me. Forget about everything except trying to get those pots on board and back in the water faster than the last time."

"That's true. Feel a lot better just being here on the boat."

"How's it going over there, Gary? You liking this seamanship stuff?" Steve asks.

"I don't know, it's not too bad here in the bay. I imagine it's a lot more fun out in the ocean, huh?"

"Yeah, well, this boat doesn't roll around at all. So, we'll be all right, just make sure you get your exposures right, that's all we care about, hoh ho."

Dave is his usual early morning quiet at the wheel. Doesn't say much of anything. He's probably still half asleep. And he's certainly not gonna wanna talk about his being awakened by my call this morning. Dave is not exactly very big on admissions of mistakes, it must have been the goddamn alarm, cheap rotten craftsmanship. Right. Regardless, Dave never says much of anything until after his second or third cup of Cremora®'d coffee. Whatever conversation there is goes on between Gary and Steve, with me trying as hard as possible to keep up an air of having a good time. It's always a lot easier to fool somebody else than it is to fool myself. I'm not doing too well.

Maybe we won't be able to cross the bar (too rough!) then we can come back, that wouldn't be so bad. A little boat ride, then a couple of hours of drinking coffee as the sun comes up. All this shit'll pass by then. It'll pass as soon as I open up to Steve, he'll understand. Better have another smoke. Six blocks east to the plant. NorCal, our new delivery point. The only plant gutsy or stupid enough to accept our day-old delivery that last time.

Cruising along so slowly past the moored boats; nobody else is going today. Look at that, there's no other boats getting ready (not a creature was stirring). They're normal, taking the holiday off like regular people.

Not us. No sir. Nope. We gotta get out there and be tough, work all day. Work our asses off for nothing; there's no crab out there! God, all those lucky boat pullers sleeping in. They're probably rolling over and stretching in a nice warm bed right now, thinking how lucky they are to have a normal skipper who would never take them out on a freezing day: The Day Before Christmas! Shit, they're not *lucky*. They're the status quo. The status quo isn't lucky when things go along as normal. It's me who'd be lucky if this thanking boat would stop right now. If the propeller would fall off. If the injectors would fill up with water and the engine stop.

Awww, too bad, I'd say. Too bad, I was so excited about going out there and freezing my balls off for twenty bucks. Hah!

I really blew it by calling Dave this morning. Could've done the smart thing, just sat there waiting for him to call like he does every other time. Shit, by the time he would've woken up, it would have been too late to go. Dave would've lied to save face and said the ocean didn't look too good, that he'd been up since three checking it all out. Would've lied and said that was why he didn't call me earlier. He would've had an out, an excuse. But no, not smart old me. I go and call him up like an idiot. Backed him into a corner. We had to go once it seemed to him that the wind was calm and that I (asshole idiot) wanted to go. Stupid. I could be back up in my warm cabin dreaming away if I hadn't called. Dreaming warm dreams, dreaming… yeah sure, nightmares about that asshole who ruined my day yesterday.

No wind makes the water like black glass, warping city lights.

All the way down here, we've been passing empty, quiet boats. All covered with frost, not moving at all until hit by our wake. Very quiet morning on the waterfront.

That boat has its lights on. It's getting ready to head out. Engine running, smoke from both the engine's stack and the stove's. At least we're not the only idiots in the bay. Not all of the fleet fishes crab, and especially not this season. Lots of the boats are tied for the winter, waiting for salmon season. You don't freeze your balls off during salmon season; you kill yourself instead by running up and down the coast, month after month.

Shit, it takes a long time to get up the bay here to our new buyer's place. This is going to be a hassle if we always have to do this every time we want to go fishing. Untying, going all this way up the bay, just to get bait so we can turn around and retrace our path, back to the place we were tied up. But still better than moving the boat up to the new plant.

Shit, I'd have to walk all this way then. Must be eight, ten blocks total from the warehouse. Get arrested every thanking morning looking like Mr. Burglar creeping in the dark. Dave would have to come down to the Courthouse and bail me out every thanking morning. I guess it's better leaving the boat where it is; Stan wasn't too happy about that, I heard.

Aww, shit, those guys will make up here pretty soon, stupid to keep this game up. We'll be back fishing for them in a while here, as soon as the necessary apologies have been made, the required loss of face. What the thank do I care for anyway, this is my last day, my last *get-up* is done. I'm on my way out of this town to see the warm world. Southern hemisphere, remember Pete? This is supposed to be a fun last day, right? Gary's going to take movies. Get into the spirit.

There's the dock now, finally. No lights on. Maybe there won't be anyone there and we'll have to wait and wait for somebody to come and let us in. Maybe by then it'll be too late to go, and Dave will say: *Too late to go now!* And I'll say, Aw, too bad, so sad, I was really looking forward to it... no, I better not say that. Dave might say: *What the heck, boys, if Peter was really looking forward to it, let's just go on out there for the fun of it! We don't need no bait!*

Gahh, for the fun of it. Starting the mental spinning shit again, you asshole. Time to get out on deck and get this thing tied to that dock.

Steve is already sliding the door open as I get up from the padded bench that I shared with Gary.

"Well, boys, let's get our bait so we can get out of here before noon. Is this clock right?" Dave says.

"Uh, the little wind-up one is pretty close, I think, Dave. I set it when I got to the boat this morning. Little after five? Yeah, that's about right. That one on the wall stopped again, I don't know what its problem is."

Moving by Gary, I reach out and poke his shoulder saying, "Now this is the fascinating inaugural ritual in the day of a crab fisherman, Gary, *the getting of the bait*, ha ha."

Gary laughs and follows me through the wheelhouse door. Steve is already trying to work his oversized frame along the narrow, crowded walkway to the bow.

"Hey Steve, let's just tie off with a piece of crab line. There's pilings here we can get next to. Shit, those big lines are still too frozen to be messing with just to get the bait."

"'Yeah, right," he calls back, and heads forward. By now Dave has slowed the engine to an idle. We drift, cutting through the water, straight for the dock's pilings. At just the right second, that *right second* learned over long years at the wheel of one of these things, Dave throws the wheel to port, and shifts into reverse gunning the engine simultaneously.

It's like *poetry*. This forty-eight foot, thirty-ton mass of boat just slips right up next to the pilings and stops. If you've ever tried it yourself, or watched someone who didn't have all that much experience try it, you know what I mean. The whole deal has zero similarity to parking a car. The piling is right there presented to Steve and me, so we flip the line around it, Steve throws a solid hitch fast, and before the tide's current can carry us, we're secure.

The plant is dark. Sitting by itself over here on the outskirts of this town's waterfront. No lights on the dock when Steve and I climb the ladder to it. All locked up. Aww, too bad, I think, letting sneak in the sweet notion of returning to our dock, returning to bed.

"Hey, it's all locked up," I say to Dave, who's now out on the back deck, looking things over.

"They said the night watchman would be here," Dave yells. "He sleeps in that room above the offices. You guys wake him up. He must have the keys. You wake him up!"

"Okay," we say, practically in unison. Great, how are we going to wake this guy up? Shit, he'll probably shoot us.

Steve walks over to the side door, the office entrance. Tries it. Locked. He looks around for some kind of a bell to ring, something to waken the watchman. Nothing. Maybe a more primitive system is what you're supposed to use, so we both yell, "Hey," but very quietly, "hey." Who (sober) can yell full blast in a strange place at five in the morning?

Shit, this guy might be dreaming about some murderer coming at him. He must be armed. Everybody is. Thank.

## FISHERMEN DIE IN CHRISTMAS EVE HORROR SHOOTING

Eureka, 12/24/1972. EPD reports two local fishermen died this morning, ripped to shreds in a hail of automatic weapon gunfire on a dark, cold and lonely dock – for no comprehensible reason – really stupidly. Young and vibrant, they were, full of vim and vigor, with the whole of their lives stretching out in front of them like...

SHIT, let's get the thank out of here. But I can almost hear Dave pacing around down on the boat. Steve picks up a few pebbles and starts tossing them at the window, behind which the guy sleeps.

Tink. Tink. Steve's not even the least bit concerned... Okay what the thank. I grab up a handful of gravel and start throwing rocks at the window too.

Ping! Pang! Tink!

A light! So this is the method, the elusive primitive wake-up system. The fish company obviously dumped this supply of pea gravel right here, just the perfect size and weight for tinking, but not breaking, the glass.

"Ah right, all right, I haar ya... I haar ya. GUUUMPF! I'm gettin' up... I hear ya, I hear ya," a voice from the room mumbles as a dim light behind a dirty shade comes on.

Steve and I shrug our shoulders at each other and kind of shuffle our feet around trying to stay warm. We wait, listening to all the muffled noises of somebody half-asleep getting dressed. Bumping into things, dropping shoes, muffled, but pretty obvious. And all the time, this voice going on about never getting any sleep... people always coming too early... no respect for an old man... where's my sock? gotta piss... and then the clomping down the stairs, the light goes on in the office, more clomping, clicking lock, and then... the door opens with this old watchman standing there looking at me and Steve.

"Well... ?"

"Uh, we need to get our bait," says Steve.

"Huh... well, let me get the keys here. Just woke up, ya know. Don't even have my shoes tied, ya know," as he steps aside to let us in.

The office is small, crammed with a desk and chair. Invoices and other loose pieces of paper are lying everywhere. And it's cold. Very cold. The old watchman, still mumbling to himself about sleep and respect, bends over and plugs in a small electric heater, then sits in the chair to tie his laces.

"Just a minute, just a minute. You guys are in a hurry every morning. A minute ain't going to make any difference in your day," he says, bent over, facing the floor. I don't think he's saying it to us, since we're just sort of standing there not looking the least bit impatient. I still can't figure out why he didn't shoot us. Why did he let us in? This guy's never laid eyes on us, he didn't even ask us who we are. How does he know we're on a boat?

Burglars can go out and buy boots like these, just like anybody else. Some thanking watchman.

"Now," he says, finished tying, "got to open the freezer."

He walks by us, kinda hunched over, through the door to the plant floor. Steve and I tag along behind. The watchman turns on lights as we march across the floor, still complaining to himself, loud enough for us to hear. Our footsteps and his complaints echo off the cold wet concrete around the storeroom. Up the short ramp to the freezer door. There, he reaches over to a nail in the wall, and grabs a ring of keys.

"Now, these here are the keys," turning to make eye contact. "This one opens the main freezer door, and this one here opens the little room inside there… but you don't see that. Now, they always, *always*, are put back on that nail there, ya see?" He points, finger shaking a bit from age and cold.

Either he now realizes we've never been here before, or he gives this talk to everybody, every time they come to pick up bait. I have to assume the second, otherwise, why would he have just let us in?

The watchman turns away from the freezer. He shuffles off still mumbling to himself; unlocks the heavy sliding dock door; opens it and flips on the outside dock lights; disappears into the office.

"Huh, how 'bout that?" I say.

"What can a guy say?" says Steve, pulling open the freezer door.

Inside, it's a little colder, but not much. I go in dragging the pallet jack. Steve's on the far side rummaging around in the fish boxes and cardboard cases of bait, all labeled with boat names.

He finds our strap box, half-full of bait jars, some full. Lots of loose bait, well, not exactly loose. The ten-pound boxes of squid had melted together the last time we were out into about a thirty-pound lump. It's all a frozen solid mess in the strap box now.

"How much bait we got there, Steve?"

"Oh, an easy thirty pounds, what with the jars already baited."

"Okay, I'll get another three boxes here. That should be enough."

"Plenty." Steve says as he drags the strapbox to the center of the freezer.

"Let's not freeze our little hands carrying that thing. Get it on the jack here." I stuff in three more boxes of squid from an open case.

"Hey, what do you think they keep hidden away in that other freezer?" I ask, pointing at the padlocked separate room.

"Ummm, the draggers probably hide all their halibut there, until they can find somebody they owe a favor, hoh ho."

"Yeah, right," I joke with Steve, "I can just see strange, dangerous looking men, prowling the foggy waterfront streets in heavy overcoats, wide-brimmed hats pulled low, whispering to pedestrians, 'Marijuana? You want dope? A girl maybe? Perhaps you want… halibut?' Then the dramatic

crescendo of music on the soundtrack!"

"Hoh ho," laughs Steve.

Lots of strange, dark-of-night assignations occur when a drag boat comes in to deliver. Big, low, American sedans idling softly, headlights off. A code phrase yelled to a friend on the dock, *Hopalong Cassidy!* or *Palamino!* or *Ambergris!* A brown paper sack, heavy and cool, passed slyly when no one else sees from one hand to another. But, so what? Petrale tastes better anyway, just the thrill of saying the name at the dinner table, I guess. *Halibut.* The forbidden fruit of the sea. Getting some friend a couple of pounds or even just a filet of the stuff does seem to have a lot of weight in the repayment-of-favors department.

"Yeah, well let's make sure we hang our keys back on our nail. Right Stevie?" I say while Steve is shutting the freezer door. He locks the padlock and carefully puts the ring of keys back where they belong.

Dragging the jack behind, Steve and I stop at the office door. I write down: 30 # squid – LADY-FAME.

"Hey, we took thirty pounds. I wrote it down on your list here. Is that okay?" I say to the watchman. He stops mumbling to himself about sleep and respect and looks up from his chair by the heater.

"Huh? Yeah... that's right... that list there. Boat name and what you took, yeah."

We haul the box out onto the dock, over to the edge. Gary's standing on the back deck alone. Dave must've gone back in to talk to somebody on the radio, maybe just to stay warm.

"Gary," Steve calls, "give us a hand here getting this thing down on the boat."

Gary gets over next to the dock, under us. The tide is still fairly high, so the distance we have to lower this very awkward box is only about eight feet. Steve and I each grab one of the rope straps, and swing it out and down to Gary waiting there. We have to drop down, get on our knees to get it down far enough for Gary to grab a solid hold of it, but it makes it. On the deck with no injuries and no broken jars. We usually use the hoist to avoid hernias, but that would mean asking the watchman to unlock the hoist and turn it on. Who wants to go back in there and get another lecture? The risk of a truss seems more acceptable. Steve heads down the ladder while I run the pallet jack back into the plant, park it without really thinking and get out of there. Make it to the deck, Dave's itching at the throttle.

"Get us free there, Peter. Let's get out of here before noon." Poking his head out the wheelhouse door for an instant, then back to the wheel. I just get the clove-hitch Steve tied, loose, as Dave guns it.

The boat pulls the line off the piling, I don't even have time to get it completely free. Another close one.

How does he know it's free?

He can't see me through the window. Jeez, he must just stand at the wheel, count to ten, or maybe three – probably tapping his foot as he counts – and then give it full throttle.

He's confident, I guess, but my hands are freezing. Not up to my best line-handling seamanship this morning.

Shit, one of these mornings a stuck knot and THANK! we're going to be cruising down the bay with half of somebody's dock dragging along behind us. Dave'll say: *Gee, we sure are bucking quite a current here, Peter.* And I'll say, Right Dave, lemme just fix that, real quick here, before running back out on the deck with the biggest, sharpest knife I can grab.

♪ *Grazing In The Grass,* Hugh Masekela

## Chapter xc
### Merry Christmas

How Now! Here and now at the very starting point of the voyage. All aboard that needs be and no other thing, nothing more to be got from shore. Steve and I take a last look around the back deck and decide, Anon! To the wheelhouse!

It's warm in here. Steve's toasting his hands over the stove. Now, that's a good idea. Thank it's cold out, maybe when the sun comes up.

"Hey Dave," I call, "they really have an interesting character up in the plant there. This old watchman guy is really something. I wonder if he works for the company or just needed a cheap place to live."

"Heh, yeah, I've heard about him before. Well, he'll probably be easier to get along with than Joe."

No lights on in the cabin, only glows from the radios (yellow) and the compass (red) directly under Dave's face.

The radios are buzzing slightly with static, but no voices, nobody going out this morning. Or maybe they're all waiting for somebody else to start the conversation. We pass by the same moored boats as on our way up. Going a little faster, with the ebbing tide. There's that same boat. The only one around looking like it's alive, the TOWN-HO, Ray and his guys. They probably don't want to talk on the radio, since then everyone would know they're on the boat. And if they decide to stay at the dock... ah ha, the guys who did go out would give them a bad time.

Commercial fishermen machismo, you can imagine. There's always somebody, who, regardless of how badly he and his crew are getting thrown around outside, will toss the old, *Come on out! Real fine going! OK,* to those still waiting in the bay. *Just a little roll-y pole-y on the ocean. OK,* he'll say to the cautious inside the jetties. *Just a little spit on the windows. OK,* he lures them with his calm skipper-in-command voice. *Just a little popcorn, a little popcorn upon the water. OK.* They can't see him wedged in there gripping the wheel, holding on for dear life. A hard charger skipper isn't about to admit that it may be a bit too rough for him.

That's the thing about working with Dave. Most of the time, he's the one saying *real fine going.* He may be that hard charger, that tough talker but he's also seen a lot of sea and respects the power, the speed of transfor-

mation. Spent World War II in the Navy as a cook in the Pacific.

I can't even imagine what that must've been like. He still likes to whip up biscuits and peach cobbler for us every so often in the little oven. Dave's seen a lot of blue water. Works with it, not against it. That old *man-against-nature* shit is nothing but foolish.

♪ *Jack Tarr the Sailor,* The Byrds

"Steve, when we get a little warmer here, we ought to get out there and put the block out. Then we can warm up again for a minute, before starting on that bait."

Steve nods and Dave asks, "What did you say, Peter?"

"I was just telling Steve we should put the block out... and cut up the bait."

"'Yeah, that's good. Don't cut up the bait though. We might just have to turn around and come back in. No sense in freezing out there for nothing."

"Okay," I say along with Steve.

Even though we might not use it, it's easier to get the block out while still in the bay. That thing is heavy and any swell, any rolling, makes locking it into position a nightmare.

Dave turns back to the wheel, guiding the boat along past the same moored boats, the same dark wharves... all the same as when we came up the bay. Still no lights, our wake the only stirring, our engine the only noise.

If there were any fishermen on the docks, they'd know what boat was passing just from its sweet cackle exhaust. Well, some would, and others might have to look up. But they'd know it was a GMC® engine. They'd know it was a 6-71®. Some of these things are so obvious. When they glanced, they'd see it was us. The LADY-FAME... hard charger... high liner. They might wonder what we were doing up at this end of the bay. No, they'd already know all about that mess by now.

Small waterfront, Eureka.

Oh, thank, I forgot to say goodbye to that old man at the plant. Didn't say, Morning to you, or Merry Christmas.

## Chapter xci
*Electrolysis*

Back to where we started. Passing by our old plant. Looks like there's life going on here. All the regulars are probably in the restaurant sipping hot coffee and talking about electrolysis. Man, I've spent at least twenty percent of my time fishing sitting in there, from five o'clock until eight or nine, even ten... until the waitresses come and sweetly push us all out to get the tables ready for the lunch crowd. Just sitting there drinking cup after cup of coffee, smoking cigarette after cigarette, listening. Only listening, you see. I'm just a boat puller, just a back deck worker. My place is to listen. Only to speak when asked to verify some situation: the size of a swell; the size of a catch.

"Ain't that right, Peter?" "Yes sir! Yes, sir, Skipper!"

Mainly just to sit there listening, listening to the skippers and old-timers talk about electrolysis, always electrolysis, eternal nemesis of crabbers. Electrolysis is the fast chemical corrosion caused by saltwater reacting with the combination of stainless steel netting and the iron rebar frame of crab pots. Lobstermen on the East Coast use wooden pots, they probably sit around every morning talking about worms.

All the activity going on around the plant here. If the big fight hadn't occurred, we could have been to the bar by now. Wouldn't have had to hassle with that guy at the new buyer's place. Jeez, it must be 5:30 or later by now. By the time we get out there it'll be really ebbing out, get bounced around if there's any swell. Shit! I'll get sick. We could have gotten our bait and been out of here a half hour ago. These guys were all awake and here by five. We never had to throw little rocks at any windows at this plant.

Thank, I wish we weren't going. I guess I got a little too much time on the beach this last week with no work (pussy). It'd be so nice to be sitting up there where it's warm in those comfy leatherette captain's chairs around the little tables next to the cocktail bar, talking, no just listening. A guy can never know enough about electrolysis, I always say. Or rubber wrappin'. *There is no object or tool in the work world known to man that is not improved by rubber wrappin' it,* so sayeth the Steve, backlit with his right hand up forefinger extended pronouncement-wise...

"Let's put the block out," Steve says, snapping me back to reality.

## Chapter xcii
### The Crab Block

The crab block is a hydraulic, high speed winch used to haul up the gear, the crab pots. Sits out over the gunwale on the portside just aft of the sliding cabin door. When not in use, it's swung in out of the way. Every morning, on the way down the bay where it's calm, Steve and I have to get it out into operating position. Not much of a job really, when it's not so cold.

I lift up Gary's legs to get to the tool drawer under the bench. Hope it's a nice day, so Gary doesn't get sick. His first time out on the big ocean... boy. It'll be sunny at least, hopefully not too rough. Can't have him lying in the wheelhouse all day, he's got to get those movies for the epic crab fishing film. He's just sitting there, smiling. Maybe he's having a good time. Doesn't seem nervous. Digging around for the wrench. I wish I was having a good time.

*Klabautermann!* Just because he's the fourth man... thankin' stupid. Here it is. *Klabautermann!* No don't think it. How come this crescent wrench, the most used tool on this boat... used every morning and then again every night, how come it's always on the thanking bottom?

[KLABAUTERMANN, THE EXTRA MAN;
FOURTH MAN ON A THREE MAN BOAT;
ABOARD ALWAYS;
VISIBLE ONLY WHEN THE BOAT IS DOOMED.]

"Be right back," I say to *Klabautermann*, I mean Gary. Steve's already through the door, and me right after him. He ducks under the stanchion that supports the top of the block's post. Working on a boat this size must be a bundle of fun for someone that tall. I can walk right under that thing. Steve steps through the array of spare buoys, coils of line, all the junk in the way, gets his end of the shaft and steps up on the gunwale. I pull the pin out so the block, on its arm, can pivot out from the boat. Steve gets his end secured to the wheelhouse roof and lifts the shaft out to me. I get up on the rail too. Lean out to stick the bolt end into this hole. Okay, get the nut on the end there. Tighten it up a bit with the wrench. Jump down and pass the wrench to Steve.

Glad it's nice and calm, that thanking rail is really slippery. A cigarette, that sounds like a good idea. Icky, they always get so wet from the moisture on my moustache. Taste shitty when it's this cold. Getting there, getting there… there's the boat basin. The docks really look white. Those new quartz-iodide lights, I guess.

"Let me by, I gotta piss!"

"You and your bladder, Steve. Thank, you always have to piss. Can't you rig a bigger one or something?"

The floodgates are opened, he must have been holding it for a while. Powerful stream. Steaming into the black water. We start around the corner. The dogleg in the bay. Heading south like we're supposed to in a bay that sits like this one. Maybe south-southwest. The lights of the small craft basin fading back there, but here comes the first of the pulp mills to brighten things up. No wind at all, still. Just like glass. Black to be sure, but with the reflecting lights of the mill making the bay look like one of those dumb experimental art films. Maybe it'll be glassy outside. Thankin' aye, that's so cool looking, the side of the boat showing in the water, the seagulls… you can see the underside of them when they swoop around like they do. It makes the ocean seem such a friendly place, instead of a threat. But what the thank, huh? I'm supposed to be in this thing for the money not for the art of it. Not going to make any kind of wages today. Probably spend the whole thanking day looking around for those lost buoys, then pull 'em and move the pots somewhere else. Great, what a thing to look forward to. I don't like moving gear around even when I'm in the best of moods. There's still a chance we might not be able to get out. Maybe no other boats will be going this morning, maybe no one'll talk on the radio then Dave won't feel he has to get out there with whoever it is. Maybe, maybe, maybe…

Shit, you're heading out Pete. Try to get a little more in the spirit, you're just going to make it harder, asshole. Try to pretend.

"You know, Stevie, one morning, early when I first got to the boat, nobody else around, I saw Joe Siculiana shuffling along the Lazio dock singing in his bag-of-gravel voice, singing *Everything is Beautiful*."

♪ *Everything is Beautiful*, Ray Stevens

Imitating that voice for a line of the song loosens phlegm and makes me cough in the cold air.

"Huh," mutters Steve.

"Look at the lights reflecting there, Stevie."

"Yeah, it looks like that one piece of film you shot. You know, the one of the bow reflecting, distorted, the water rolling back and forth."

"Yeah, I remember. That can be the arty part of our film, okay? Give

it a little class. We'll have the titles going by when that piece is running. Then cut to the boat in heavy seas bouncing all over the place. Turn this thing into a real winner of a home movie. Later, we could even blow it up to 16mm, add sound… cool, huh?"

"Maybe we should just stick with trying to finish a home movie," Steve says with a bit of a laugh.

"Yeah, maybe so. Look at that new ramp thing they have rigged up there," I say, pointing to the pulp mill.

"Huh, that *is* new. They just built it, eh? Must be for loading the pulp directly onto the ships. That'll put all the stevedores out of work."

"What do you mean out of work? You mean out of a job. You've worked with those guys, you know what I mean."

"Yeah, that's true. Remember though, Pete, you've never worked on the docks with those guys. Might be harder than it looks. It sure as shit is dangerous."

"Yeah, well enough of this folderol, let's get inside like normal people, where it's warm," tossing the filter and whatever else is left of the smoke into the bay.

## Chapter xciii
### The Chase, Third Part

"Right, that's right, Ray. OK." Dave is saying into the mic as we both get back inside, and next to the stove.

"Well, yeah, ahh, I was hoping to get a chance to talk to you. Get the inside scoop on that whole, ahh, thing. Stay with the people you're with now, Dave. They'll give you a, ahh, square deal. *OK.*"

"Yeah, that's right, Ray. Where are you now? *OK.*"

"Oh, I'm a ways behind you. I can see you up there though. I'm just passing the, ahh, boat basin now. *OK.*"

Dave turns around to face the door and Steve and I. Bobs his head a little as though trying to see through us. I take the hint and look behind us through the window in the door. Way back there I can see the red and green

lights of another boat. Must be Ray and the TOWN-HO. I nod to Dave.

"Yeah, I can see you back there, Ray. Have you heard anything about what kind of weather we're supposed to have? I haven't had the VHF on yet. *OK.*"

"The weather station says, ahh, the same thing they were saying on the recording you get on the phone, Dave. Five to fifteen out of the, ahh, northwest with about a six to nine-foot swell. Not too bad, if you can, ahh, believe those forecasters. *OK.*"

"No, that sounds fine. Fine weather. Fish that kind of weather all the time, Ray. Fine weather. Have you talked to anybody outside yet, Ray? *OK.*"

"Nope. Radio's quiet. I don't think any of the, ahh, draggers are out this week, Dave. I guess it's supposed to be pretty rough from, ahh hundred fathoms on out. *OK.*"

"Well, the wind is probably rising up and over us here, like it does sometimes. We should be able to get a good day's fishing in. I'm clear."

"Sounds good, Dave. The crew and I could use, ahh, a little something for this Christmas shopping. Been on the beach a long time. Start to get poor, you know. Morning to you and the, ahh, crew. *OK. I'm out.*"

I eyeball Gary and he raises his legs enough. Open the tool drawer and drop the wrench back in. Right on top, where it's supposed to be. Nothing to do now except wait and see what the bar looks like. Just relax and watch the mills go by. Try to get interested in catching crab. Try to think about going to South America. Don't be thinking of that what's his name... *Klabautermann*? No, that real asshole, what's his name. See you forgot already. (Keep pretending.)

Steve, he isn't worried. He's looking out the windows with interest, like I used to always do. I always enjoyed going out so early in the morning, everybody else still asleep. The whole town quiet. And here I'd be sailing out to sea to get crabs, in the romantic tradition of my forefathers... except my forefather, my Grandfather, wasn't too excited when I told him about this fishing thing. He came all the way over here to get away from fishing. All the way from Sicily where all my relatives could do was fish or maybe farm olives. So, he takes the boat to escape all that. Comes to America alone – in steerage at age fourteen – to America where his grandchildren can grow up to be businessmen. A banker or something. Thank, I come up and tell him that I'm a commercial fisherman. I thought he was going to cry. Maybe he doesn't understand how much more real, how much more satisfying doing this is. What a fool I am. Everybody back in Sicily didn't have any choice but to lead a *rich, satisfying life close to the earth, in communion with nature...* shit. They were all starving to death. They wanted a little less nature and a little more food on the table.

*Middle class revolutionaries* will never understand why Fidel Castro wants color TVs for the workers.

Hah. So here I am, his grandson, with the same name as his, telling him I've chosen fishing for a living. Stupid. But, also true that I'm getting money for participating in an activity that thousands of others would gladly pay to be able to do. Lots of fat cats would pay to be able to come out here and pull a pot... keep whatever crabs are in it. That could be a big-time money making scheme. I'll have to run the idea by Steve.

**EXPERIENCE THE THRILL AND DANGER OF REAL CRAB FISHING ON THE WILD NORTH PACIFIC COAST!!
BAG YOURSELF A LIVE DUNGENESS KILLER CRAB!!**

Steve and I could wear white coveralls and help the customers haul the gear aboard. At twenty or twenty-five bucks a head. Should be able to squeeze about fifteen onto this boat. God, I can just see all those guys trying to run the block. There'd be a big hole in the wheelhouse from all the pots flying into it. It'd be better than trying to scratch out wages like we are now. Guarantee the customers two or three crab. Big money, raking it in... where's a match?

"Stevie, you got a light?"

"Here, keep 'em," Steve says.

"Hey Pardner, I was just thinking about this scheme. We do a charter boat thing, only for crab. With the way crab are getting wiped out, in a few years they'll be real scarce. Your Hemingway types will all be itching to get a chance to bag one or two. So, we rent space out on the boat, they'll pay a lot when the Dungeness crab is as rare as white Indian tigers, right? Good possibilities? What the heck, huh?"

"Huh, pretty crazy Pete. I don't know whether a crab could ever give a guy the same thrill as a thirty-pound Chinook. Besides, it'd be in the wintertime, always rough. You know how much those tourists puke, even in the summer, when the ocean is like a lake. When I was salmon fishing, it'd be clear and calm... *flat cam*. And we'd see these charter boats with half its clientele leaning over the rail. Can you imagine in the winter?"

"Yeah, that's true. How do you think the crews on those puker boats stand it? Must get like a sadistic thing after a while, huh?"

"What are you guys talking about? Puking?" asks Gary.

"We're laying down odds on you, Gary. What is it now, Steve?"

"Five to three you won't make it across the bar. Hoh ho. No, we're just kidding. We were talking about some crazy scheme of Pete's."

"Not crazy. It's completely possible," I say.

"Oh," says Gary.

"Hey Gary, how come you're just sitting on the bench so relaxed? You're supposed to be pacing all over the wheelhouse. Rubbing your hands together and all that sort of stuff. You know, this is your first time out and all. If you were a smoker you would've smoked two or three packs by now. Hah ha,"

"Well, this is a good boat. You guys have been going out and coming back for quite a while now," Gary says.

I think that's the most I've heard Gary say all at once. He never talks much. I really don't know him at all. Jeez, he's quiet. I used to think I was the quiet type, huh. Oh, right and then there's Bruce, the third brother, the really quiet one, off in the East, off in India.

"Peter, is there any coffee made yet?" asks Dave.

"Naw, the water hasn't boiled yet, Dave. The stove must have taken a long time to warm up this morning. We'll get it ready for you in a minute here."

"What're you guys doing back there? Having a convention?" Dave says, glancing back.

"Naw, we're just talking about stuff. About setting this boat up as a puker. You know, like you were talking about before. Only you were talking about salmon fishing. I was thinking we could get 'em to pay to go crabbing."

"Sure, Peter. Well, right now, why don't we see how the new spotlight works. Switch it on over there, if that won't be too much of a problem."

I walk up to the front of the cabin, and feel around for the switch on the ceiling. Right there in front of the big radio. Throw the arm. A lot of light out in front of the bow. The new superpower light is hooked up with the other two old ones. Never seen it working before. The three of us spent a whole afternoon last week setting it up. Dave nearly blinded us with the arc welder. Only one mask on the boat. Maybe it wasn't worth it. Doesn't brighten things up that much more than before. Certainly not fifty dollars' worth. But it is quartz-iodide in a waterproof plastic case – sixty-million candlepower or something like that. Boy, it sure was cutting a beam through the dark night in the illustration on the box. These things always disappoint me without fail. Shit, Dave's crazy if he thinks we're going to be able to see the buoys before daylight with this thing.

"How about that! We'll be able to pick those buoys out from fifty yards away with that new light. No more having to wait until daylight," Dave says.

"Yeah, it really makes quite a difference, Dave." I lie, don't feel like an argument. It does make a statement up on the mast stanchion.

## Chapter xciv
### The People's Liberation Army of the People's Republic of China

The deck shifts a hair as we get into the small swells that creep into the bay when the bar is breaking. Rising and falling just slightly now. I walk back to where Steve and Gary are standing in front of the stove.

"Stevie, what kind of a deal did you get with Keith's car? Does it run?"

"Oh yeah, it works okay, needs a battery though. But it seems to run fair. At least in first and third, reverse is out too. It was free though."

"Are you going to fix it up? Make your hot rod finally? That thing has great flame potential. Right behind the wheel wells, intense hot white and orange streaming back, would look great. I'd even do something like that for free," I said.

"Yeah, sure. You'd probably paint another red star on the side, like on little Otto," says Steve.

"Did you ever see that star, Gary? Remember Otto, that little black cutdown VW® that Pete and I traveled the West in, climbing every mountain we could find?"

"Ummm... yeah, the one that got stolen, right? By that guy who said he was gonna buy it, wanted to take it for a test drive last summer, right?" Gary asks with a little laugh.

"Stolen, shit... well, shit. Anyway," Steve puts his arm around my shoulders affectionately, "this guy painted this big old star on the door... with a nice gold trim around it. And then, after the paint was dry, of course, then he tells me it's the symbol of the People's Liberation Army of China. Shit. I got him to paint an eye in the center to kind of disguise it."

All three of us are laughing now. Dave turns and asks, "What's so funny back there?"

"Nothing, Dave. We're just talking," I say, turning to yell forward over the sound of the engine, and then back to the joking. When I turn, I can feel that *whoop* as the boat slides up and down.

"Hah, and then Steve told these people we were talking to in some National Park, by the Tetons I think, he tells them it was an ancient Assyrian symbol for good traveling. They actually believed him, hah ha. Nah, nah,

don't worry, I wouldn't do that again Steve. Just flames, whatever kind you ask for. Show me some pictures. You know, the opportunity for painting up a hot rod like a '58 Chevy® doesn't come around much."

"Yeah, well, I don't know whether I'm going to keep the thing or not. Wouldn't start this morning. I think maybe Keith got the best of the deal by giving it away. Took it for a cruise last night though, maybe I can fix it up."

"You really need a hot rod, Steve. My first car was almost a '58 Chevy®, you know? Really, Louie ▮▮▮▮▮'s. Took it on a test drive, pink slip in hand and everything. $500. All the money I had saved. But then I found that MG®. When I get back from this trip, I'm going to save up and buy another sports car. Austin Healey® this time. Then we can cruise together down Fourth Street. Nice, huh?"

"Sure, but I don't think this Chevy® is the right car to really fix up. Maybe I'll find a '40 Ford® someplace. Now, that I could get involved in," Steve says.

"Hudson®! Hudson Commodore®!"

"Anyway, looks like we're getting there. Here's the Coast Guard Station. Must be a little rough on the bar. We're getting some swell even this far in. This is as rough as the first time we ever went out, remember Stevie?"

"Yeah, I wish I would've been working on this boat then. This is a real pussy boat, Pete. You don't realize how spoiled you are working on a boat that rides like this. Shit, on the LAREDO, Craig's boat, we'd be hanging on for our lives by now. Gary that boat really moves around, even in the bay."

"Didn't seem like we had any trouble, but then that was a year ago. I didn't know shit. So green, I didn't know I was supposed to be scared, hah ha," I said to Gary.

"Craig and I just barely made it out. Flopping around all over the place. His boat really rolls, Gary. Makes this thing seem like you're standing on the dock. So, anyway, there's Dave and Pete cruising out. Dave saying it's not too bad, *real fine goin'*, first one out, of course, talking on the radio, while we're covering the gunwales with water on every roll. Then poor Butch lost half his load of pots off the back deck. Boy! We just barely cleared the bar and it was dump the gear as soon as we could! Turned around and got back in. Hoh ho," Steve laughs and turns to me, "You guys kept on going way up the coast, didn't you?"

"Hah ha, yeah, we set gear all the way to the river, I think. Jeez, I didn't know it was rough. I thought it was always like that."

"That was a whole lot rougher than this though, Gary. Didn't mean to make you nervous," I say.

## Chapter xcv
### *The Coast Guard Station*

Dave's been listening to most of the conversation, he's laughing a little too. We come up next to the Coast Guard Station, the swell getting a little larger all the time. Starting to brace ourselves now. Usually it gets a bit rough from here out to the buoy we turn at. Nothing unusual. There's this part of the entrance where the silt builds up inside. Not the bar proper, but another raised area known to everyone as the Middle Grounds. When there's any kind of a swell, the waves break on this shallow part. Since it's close to the bay side of the entrance, some waves formed by this break rough things up from here until you get over to the channel. Then you head out to the bar where things get more action-packed.

There's no one standing around at the Station, but then it is a Sunday. Can't really expect those guys to be up this early after a big Saturday night, maybe they had a Christmas party.

"Well, what the thank, Gary. You'll get to cross the bar on a half-way interesting day. Make your sea voyage here more exciting. Never a dull moment in the world of commercial fishing, right?" I say.

"Oh, I didn't think it'd be dull," Gary says.

Through the window in the door I can see Ray's boat back there, still following. Maybe gaining on us. We're moving along pretty good, ebbing tide helps. There's that buoy. Red flashing one just after the Coast Guard Station. I don't feel so bad now. We're this far, may as well go all the way – that's what she said, ha ha ha – talking to Stevie sure can pull me out of depression. Sure is a lot nicer working on the boat with him around. It was great last year, but this is near perfect.

Dave's been in such good spirits. He hasn't yelled at us at all this season. *If you don't see me come screaming out the wheelhouse, you know you're doing okay.* Last year, thank, fifty... no, seventy-five percent of the time at sea, he was on the back deck yelling at me or Don or that other guy, for some thank up. I did thank up a lot last season, but working with Steve, I don't think I've missed more than one buoy in any given day this season. I guess all of Dave's training was for the best. We sure go through the gear fast now. It'll be fun today.

Shit, I can't understand why I was getting myself into that thanking weird frame of mind... crazy... stupid. Gary will get some great shots of us, and this is just what I need to forget all about that asshole Rich coming around bothering me yesterday. No sweat, it feels good to have the boat moving under me again. Here we are at the rocks already. Jeez, waves are bumping us pretty good. What the thank? We might not get out. Either way is fine... still a nice boat ride. Beautiful morning. So thanking clear. Who could ask for more? Ha ha ha. Good companions, a sturdy vessel under me. Okay, asshole, quit kidding yourself, a little nervous, huh?

"A slight bit of the sloppy stuff, eh?" says Steve.

"Yeah, not too bad though." It's not the right time. I can't tell Steve what's really in my head. Can't tell him how messed up I feel.

Relax, relax... that song... that song... it's a... it's a...

♪ *A Beautiful Morning*, The Rascals

## *Chapter xcvi*
### *It's a Beautiful Morning*

All those big rocks brought down here from a local quarry. Trucked down to the side of the bay at Bracut from up Jacoby Creek, and then barged across to this inside tip of the North Spit and nicely piled. Stuck there a hundred years ago so the tide rushing out twice every day won't wash away the corner. The corner that wary seamen aren't supposed to cut close, aren't supposed to cruise up next to taking the old short cut out the north side of the entrance. Dave did it a few times though. Just to see how easy or hard it would be; to see how much clearance he'd have. Not on a day like this one, no way. But on calm days, to find out for himself whether or not he could make it out that way. Why trust the surveys? The time saved can be a lot, depending on the workings of the tide. What the thank, huh? I had a fun time. I didn't know there was anything dangerous about it. I used to be very trusting. This morning, I'm kinda losing that trust. If I wasn't so depressed I'd be jumping around, all excited about getting to cross the bar on a rough day. Any other morning I'd be singing that song.

It's not any fun today... it's scary, actually.

*Chapter xcvii*
*The Bar: But First, a Lovely Poem*

*Crossing the Bar*
*– Alfred, Lord Tennyson*

*Sunset and evening star,*
*And one clear call for me!*
*And may there be no moaning of the bar,*
*When I put out to sea,*
*But such a tide as moving seems asleep,*
*Too full for sound and foam,*
*When that which drew from out the boundless deep*
*Turns again home.*

*Twilight and evening bell,*
*And after that the dark!*
*And may there be no sadness of farewell,*
*When I embark;*
*For tho' from out our bourne of Time and Place*
*The flood may bear me far,*
*I hope to see my Pilot face to face*
*When I have crost the bar.*

There's the end of the rock pile, the corner. If it wasn't so thanking dark we could see the bar conditions from here. Don't really need to see it though. Can feel it. Hanging on here. There's quite a swell. It may be as rough as that first day a year ago. Maybe a lot of the other guys trying to get out that morning felt like I do now. I didn't then. I didn't even know what the bar was then. All I was worried about was whether or not I'd be able to set the pots out without getting the lines all fouled. I did get a lot of the lines fouled later that morning... and the next, and right along. Am I a better fisherman now? I don't get the lines fouled and I'm scared of this thanking bar.

White water! A flash of it out there somewhere when the rotating light on the north spit comes around. Flashes across the mouth. Shows the foam for a split second. Something breaking out there. But it's always breaking, same almost every day. The size is what matters. Aw, if it's too big, we'll just turn around. Is Ray still back there? Yeah, there's the TOWN-HO closer now. Dave must've had the throttle back a little, he wouldn't have gained on this speedboat otherwise. Bob, bob, from his lights, it looks like he's moving around pretty good even back there. He's past the Coast Guard. Thank, this little one has some white stuff on top. Over it, whoop... huh, must be reforming inside here. The middle grounds must really be bumping around. Get over to the channel and this stuff will stop.

Everybody sure is quiet. Maybe Dave and Steve are concerned, but I hope Gary isn't. Nothing to worry about really, we've crossed this thing lots of times when it was this rough. Guarantees the ocean will be sloppy. Won't be very nice for taking movies. Or maybe it would be. Exciting anyway; *Victory at Sea* type stuff.

## *Chapter xcviii*
### *The Bar: Bowditch Says*

Red, Right, Returning. A handy mnemonic. Basically, in the standardized world of marine channel navigation, keep the red-flashing buoys, the even-numbered buoys, the triangular nuns, on your right side, your starboard side, when returning to safe harbor from the sea. It follows then, that when heading out to sea, the square cans, the green-flashing buoys, the odd-numbered buoys must be kept to the right.

One would never, never want to be passing on the wrong side of a navigational buoy in a narrow channel through the shallow middle grounds of a world renowned, dangerous bar on a rough, dark as a sailor's grave, predawn morning.

*What, never?*
*No, never!*
*What, never?*
*Well... hardly ever!*

♪*My Gallant Crew, Good Morning.* Gilbert & Sullivan

## Chapter xcix
### *The Bar: The Seven Buoy*

Ah, the buoy. Number seven, flashing green there, to tell us and everybody else when to turn the corner and head out the channel. Should calm down on the other side of it. Deep dredged channel. I can see some shapes out there. In front of the boat, these spotlights pick up the shapes of the waves anyway. Through the starboard windows, past the pipe rail all tinted green, glowing green from the running light. I painted it orange, I know what color it really is. Beyond the railing, up and down, bucking. THERE! Another flash of white. That one looked like it closed out the whole mouth. Dave must've seen it.

"Steve, did you see that one break out there? That flash when the light came around?"

"Yeah, looks like it's breaking pretty heavy out there. Must be the outside section of the middle grounds. Getting some nice slop in here too. Did you see that one re-form? Sloppy. Look at the moon there! That's nice, coming up over the hills. Beautiful."

"Nice, nice mice," I laugh.

*"Nice, nice, very nice,*
*So many different people*
*In the same device,"* sings Steve, from the 53$^{rd}$ Calypso, *Cat's Cradle* by Kurt Vonnegut, Jr.

Number seven buoy rolling back and forth; flashing green on the four second. If I was outside, I could hear the bell ringing up a storm. Bong, bong, bong... BONG!

["SEVEN, SEVEN... SWEET AS HEAVEN!" SAYS STEVE.
"CLANGING BELL, SOUNDS LIKE HELL!" SAYS PETE.]

Lots of noise now. Whistling! That's not the buoy. Oh yeah, the water is finally hot. Move it back on the stove, wait 'til we get out... or back in. Really looks like it'll be too rough.

Dave cuts the wheel and we head around the light, but it's not as calm as it should be here. The channel always deadens any slop.

Thankin' aye!

We're still getting beat around in here, just as much. We better turn around, we better turn... thank this shit. This isn't any kind of day to be crossing...

"Hey! THIS ISN'T THE RIGHT BUOY! What's that one over there? THAT'S IT! Over there! Look, Peter, Steve! Over there. They put a new buoy out here! Goddamn it! They put a new buoy in! The thanking Coast Guard didn't say a thing about it!" Dave yells, cranking the wheel over to port, trying to get us headed back to the other flashing green light.

It's there; an extra light; *a new number seven*? Now we're sideways to the slop, rolling heavily all over the thankin' place. Getting all crossed up trying to turn in this mess. Loose stuff falling off the shelves. Gary bracing himself against the wall, trying to keep out of the way. Grab a cup before it goes to the deck and stuff it with everything else into the sink; sugar container and the Cremora®.

"Goddamnit! I've told you guys to secure all that stuff hundreds of times. You can't keep stuff just lying around like in a house! Shipshape! Keep it all shipshape," Dave says, holding all the junk on the dash down with his free hand.

Dave's lunch has fallen off the table where he'd left it, unsecured of course. Hanging onto the counter, then the table, I pick up the bag and stick it into the compartment full of canned corn and tuna, under the table seat. Bump my way back to my place next to Dave. Both my elbows jammed on the counter, the front dash sort of thing. Wedged right above the passageway to the fo'c'sle where the counter is cut out to make it easy to get below. Makes a comfortable place to stand, and I can see everything that goes on out front.

"Turn out those spotlights, Peter," Dave says. "I can't see the light with them."

I reach up above my head to the switch, throw it. The flashing green light of the real – I hope – number seven buoy, is brighter now. Most of the white water slopping in front of the bow disappears when the spotlights go out. I can still see the most brilliant of them, those thanking snakes of foam. The moon is taking over, lots of moon this morning. It's easier to stand here, wedged in like this. Just let my knees relax, bend with it, whether we get bucked or rolled. Dave reaches up for the mouse's microphone.

"Ah... you got this thing on there, Ray? Come back. *OK.*" Nothing but static when Dave releases the button.

Again:

"You on this side there, Ray? You got this thing on there, Ray? *OK.*"

"Yeah, ahh, Dave. *OK.*" Ray comes back.

"Yeah Ray, they got an extra buoy here. Looks just like number seven, but it's too far north here. Lead you right into the middle grounds, if you

turn at it. *OK*."

"Right Dave. Right. Saw you, ahh, turn there. We'll be watching for it. We're getting slopped around, ahh, quite a bit back here. We may just wait there at number seven. It's what, ahh, only another forty-five minutes until we get some light here? 'Bout quarter to six now. I think we'll wait there. You come back, ahh, when you get outside. *OK*."

"Fine, Ray, fine. We'll go out and take a look at it. Give you a call back when we get outside. *OK*. I'm clear."

"Appreciate it, Dave, we'd appreciate it. You take a look with that, ahh, *PT Boat* of yours, hah ha. We don't have all the gear out there that you do. We can afford to, ahh, wait for a little sun. *OK*."

> [PT BOATS "PATROL TORPEDO" WERE A US NAVAL CRAFT
> USED PRIMARILY DURING WORLD WAR II
> IN THE PACIFIC THEATRE. AVERAGING 78 FEET,
> AROUND 30 FEET LONGER THAN THE LADY-FAME.
> ABLE TO CARRY FOUR FULL-SIZED TORPEDOES AND
> RENOWNED FOR SPEED AND AGILITY IN
> ATTACKING ENEMY VESSELS MANY TIMES LARGER.
> PT 109 WAS SKIPPERED BY FUTURE
> PRESIDENT, JOHN F. KENNEDY.
> A BOOK AND A FILM MADE FROM THE BOOK ABOUT
> THE PT 109'S ADVENTURES MAY HAVE
> CONTRIBUTED TO KENNEDY'S ELECTION.]

"Yeah, that's right. That's right, Ray. A fellow's got to get out as early as he can. We have to run up to the point. Forty-five minutes would slow us down too much. *OK*. I'm clear."

Dave starts the turn around the buoy, hanging the mic up with just a glance. Things are calmer here. The swell is still bouncing us, but less sharply. Not too cool to go cruising into the middle grounds on a day like the one we've got. This is normal now... just rising, falling... heading out to the end of the jetties... rising, falling... heading to the mouth.

Thankin' scared the pee outta me that buoy. I wonder who the thank's responsible for that little thankup. Weird, but that's that. Back on course now. The South Jetty's wet rocks and dolos just barely visible if I don't look too hard. Like with a star, you can see it if you glance up, but it disappears when you strain to see it.

Heartbeat back to normal, feels like a typical crossing of the bar now. Heavy swell, sure, but we've gone out in this kinda shit before. Sometimes you stay and fish, other times you turn around. Depends on how greedy you're feeling that day. Look back and shrug my shoulders at Steve and Gary keeping warm in front of the stove. There's the number five buoy, and

now a white light... FLASH! Humboldt Bay Light... I wonder if the light itself on that tower revolves... no, probably a mirror. Sure is bright. Seen it on a clear night way up the coast. Maybe airplanes see it a hundred miles... I don't know. Lights up the jetty, that's for certain.

God, it's really glowing back in the middle grounds we just left. All white from moon and starlight... haunting.

Nothing breaking in the channel, at least. Sure are some swells rolling through, though. Maybe Dave will just go out and look. We could be back on the dock in less than an hour. That's always so much fun cruising back in when the sun is just rising. Get back to the dock hours before normal people get up. None of the guilt feelings either. Tried to get out, tried our best to get a day's work in. What more can you do? At least we tried. Guiltless, sitting around talking to all the other fishermen. Dave telling them how rough it was, me backing him up when asked, *Isn't that so, Peter?*

It's nice, one of the most pleasant times in this business. Time on the dock is what I really like about all this. Great on the boat, but... the dock scene, I wish I was there right now, don't need any more money. Twelve hundred bucks, shit, that's enough to last six months in South America, things are cheap... lots of traveling. Calmer, well, maybe not calmer, but no breaks anywhere in sight. There! Big one, when the light hit it, to the north though.

"Who's steaming up my windows?" Dave says.

"Oh... Sorry Dave, the coffee water is boiling, I guess."

"Well, shit, I can hardly see," he says, starting to wipe off the window right in front of him.

"Just a second," turning to the back of the cabin. All I do is look at Steve for an instant and he's pulling off a handful of paper towel.

"Here you go," Steve says, handing the wad across the space. He only has to take two steps. Now, I have something to work on this condensation with. Always seem to be doing this. That water, can't ever remember to move it. No, I moved it. The whole stove top must be hot by now or maybe the pot slid when we were sloppin' around.

Could open the door if it wasn't so thanking cold outside. Ah, this'll get it. Half the problem is probably our hot breaths steaming it up in here. There, this one is fairly clear. More paper here...

"Excuse me, Dave." Arch myself out in front of the throttle. In front of Dave... get at this window here. He's already got some of it wiped off, mainly just smeared. Makes it even harder to see than just the fog. The edge of the dash jammed in my stomach while I wiped the last.

"Okay, okay, Skipper, a clear vision. No problem," I say.

"Thank you, Peter."

Dave, he's not concerned. He's crossed this thing thousands of times.

Normal bar crossing. A bit rough to be precise, but normal, I guess. Now, if Dave was upset, acting even the slightest bit scared, then, I could panic. Gary, he might not know whether it was hard or not, but Steve's just standing there looking interested, like he's learning. He could be taking mental notes on the way Dave's handling each wave. He pays attention. Took me a week when I was green to get the idea of how to even get a crab pot aboard. My mind wanders around too much for this kind of fast-paced stuff. Always thinking about something else. Steve's always learning, concentrating. Thinks linearly. Me I'm thinking in little wads. Well, thank, I'm not doing that bad though. The time Steve tried to run the block, couple of weeks ago, he looked like I used to when I first put my hand on that valve and spit a pot into the side of the wheelhouse. Steve would learn faster though. He'd have the block dicked within an hour.

Thank, talk about wandering minds, I'm supposed to be... supposed to be keeping the window cleared. Supposed to be looking out there for... for what? Something to get scared about? Shit, what difference does getting scared make? If it's too rough to get out, Dave will turn it around. How do you do that, I wonder? Turn around on the bar when it's too big to get out. Never had to think about doing that before. Have to get turned broadside to the waves for at least a little while, during the turn... thank, here you go again. Found something new to worry yourself about. Shit, look at Steve and Dave there. They're not worried. Besides it looks like we've made it, there's the end of the jetty, easy street. We're okay now, Dave knows what he's doing. We got it dicked, buddy boy. All right! Okey dokey. All that sweating for nothing.

It is definitely too rough to pull gear in this sea. There's the beacon on the tip of the South Jetty. Flashing away. Behind us. Behind us is all that matters to me, we're across that thanker for sure. Still rougher than shit, rising way up on these things. Whew, boy oh boy. Look back at Steve and Gary standing there, kind of shrug shoulders and smile, doing that wipe of the finger across the brow routine. Pantomime *whewing*. Steve just sort of nods at me, not smiling. We made it, he should be *whewing* too. Maybe he can't see from back there.

Dave's still concentrating more than I would think he should be. Better wipe the windows again... maybe I'll light up a cigarette here... wipe this one, get them all cleared off...

"Well boys... I think it's a little too nasty to work on it today. There'll be better days than this. Better days than this. I think we'll go on out to the sea buoy and wait for the dawn to lighten things up. I'll tell Ray to go home and get back in bed. Nobody's going to be fishing the crabs today,"

"Yeah... it is pretty rough," I say in my mock disappointment voice, trying to sound like I really wanted to go. Great. A day off, hah ha, after a

whole week of days off. What a loafer. Candy-ass loafer. I can go out to the mall and wander around looking for Christmas gifts. Or maybe just sit and talk down at Peggy's with Steve. Drink coffee. Too bad we don't deliver to Lazio's anymore. That's a great place to sit around for half a day listening to fishermen talk. It'd be a whole lot nicer than spending the day splashing, freezing, and bumping around out here for nothing. Let's see, it's about quarter to six by this clock. Ray said about forty-five minutes to light... but that was a couple of minutes ago. We should be back at the dock by eight at the latest. Great... great...

"Peter, see if you can spot the sea buoy. Keep your eye on it when you do," Dave says, slowing the boat slightly. Always slow it slightly when you're getting up the swell, then when you come over the top you don't mash down real hard and put everybody's head through the roof. I know that much. At the top of the wave, I see the sea buoy, flashing white, not too far out there.

"There it is, Dave," pointing. Dave nods, he sees it too. Heads the boat over a little to port, straight towards the place the light had been. It's gone now. Must be in a trough. This is pretty big out here. Thank, let me get rid of this cigarette, and get the window cleaner than it is. Rising fast on this one. WOAH! That thing splashed water all over the windows! Shit! SLAM DOWN HARD! God! That thing really hit us, thank man. Spray all over. We're sitting half sideways, rough mother thanker... really creamed us. Thankin' aye. Boy...

## Chapter c
### *The Bar: The Sea Buoy*

Dave still has the engine slowed way down from our approach to that wave. Thankin' aye, that had some foam on top! I didn't see it until it was splashing over the bow just before we slammed down. Thank, never seen one like that! Not even on the bar and we're way outside, I know we are, I had my eye on the sea buoy! Yeah, the sea buoy. I had just seen it right there in front of us, seventy-five yards. Right there in front of us – wait, where is it? Over there now since we're sitting a little sideways. Thank, where did that wave come from? Thank me dry, it looked like it was actually going to break! Nah, come on, that'd never happen out here.

Dave's starting to bring the revs back up, starting to straighten things out. Cock-suck, now, that was a new experience, whew.

"Hey, hey," I turn to face Steve and Gary there in front of the stove.

"Now, that was something, eh? That's the first time we've ever taken any water on the windows on this boat. At least for as long as I've been aboard."

Steve kind of pushes a strained half-smile, but both his and Gary's eyes are looking intently out the front windows. Dave chuckles a bit though.

Well, I'll get the windows de-fogged again. Get back wedged into my niche here... here's a piece of semi-dry towel. Dave's getting the boat speed back up slowly, pushing the throttle, starting to cackle... don't want to get in his way. He's looking intently out into the dark, too. Lemme just get the one right in front here... the bow is starting to rise again... get the top of my window wiped now... bow still rising... Dave's grunting, turning, forcing the wheel. I can't wipe the window the glass is rising  engine screaming! EEEEEEEEEEEEEEEEEEEEEEEEEEEEEEEEEEEEEEEE! Oh Oh we're going up and up the face the face THE WAVE  and there  up there up there, way up there  up there it's white  foam  Uh Oh, oh shit IT'S BREAKING! Oh thank, THE ANGLE, THE ANGLE!  Still broached half sideways to it  oh God, all white... glance to my left  Dave...

"Oh shit, we're really going to get hit," Dave says calmly. A quiet voice as he falls to the floor, pulling a spoke of the wheel with him... all white outside... the bow still rising... I let go...

## *Chapter ci*
### *Heaven*

[Clear the skies, no fog nor mist to cloud
the view. From here we clearly see, down, down.
Yet so dark, we must try not to look in order to see.
Faintest hints of white forming the shapes of
breaking waves... O, for gamma... and there it is!
No longer deep black but a dark grey that reveals
our beloved Lady-Fame rising after falling...
Trailing a wake that glows slight green
with plankton luminescence.
There! The blinding flash of the beacons lighting
the foam and the darkness.
Both on the sides and behind...
The steady plodding of our beloved,
heading to that other flash — the sea buoy!
Beyond, and to the northwest, we see clearly
the thin white fringe atop each long
arcing line of approaching waves.]

## Chapter cii
### *The Rogue Wave*

The boat moves up and forward. Slowly. Almost not moving at all. The onward rush of the wave rendering the boat's motion negligible. Not heading straight into the wall of black water, but at an angle. Starboard side, green side, right side, broached and quarter facing the wave. Some lights, dim, but there: red glow and green; a yellowish-white up in the mast; the moon rendering the vessel visible; beacons on both ends of the jetties.

The LADY-FAME is well outside now and the rotating light from the North Jetty cannot flash across its hull. Can barely light up the white foam on the crests of the swells; can't reach down into the trough the boat is rising out of.

Overpowering roar like hundreds of waterfalls. And drowned out in that noise, barely audible, the sound of the boat's exhaust. Slow and idled back. Then a higher pitched cackle, a GMC® cackle, fairly clear. The engine racing, at its limits. And the boat seeming to pick up just a hair of speed as it rises. A tiny bit of a turn to starboard as the angle increases. Not enough. Broaching. The top of the wave is coming over white. The leaning masts looking like the indicator on an inclinometer. Leaning thirty degrees, forty, to port and stern. Nobly the boat tries to climb that impossible slope. Leaning hard yet refusing to fall on its side, climbing, rising. And the face of the wave steepens, until it must collapse. Half of the wave falls over, breaking on top of the boat. Green water and foam mashing it, rolling it over. Covered by the white, pushed along. The swell releases and moves on towards the jetty.

Popping up, a black shape on the now foam white surface, is the hull. Upside down, wheel still turning, now turning in air.

## Chapter ciii
### *The Sea Urchin*

A few minutes before six, on Christmas Eve morning, Doc – father of Bruce quietly meditating in Rishikesh, father of Gary and Steve approaching the sea buoy – awoke. He was going to play golf, but six o'clock in mid-winter is too early for that. Maybe he'd been awakened by Jan's return after taking the boys down to the LADY-FAME. The other times Jan had run Steve down to the boat, she'd dropped into bed and deep sleep as soon as she was quietly back through the door. Today, she stayed up and her movements around the house may have been what woke Doc up.

Bruce, in India, held in his mind two small golden balls rotating, orbiting swiftly around his center.

Doc headed for the bathroom but it was occupied by Jan. So out to the kitchen, still half asleep, puts the kettle on for coffee. Then into the dining room where a television set sat in the corner.

Three summers earlier, Gary, on a sunny, windy, chilly day's hike along Agate Beach, had picked up and returned home with a perfect dried sea urchin endoskeleton four inches in diameter. Out of his pocket, out of the cushioning tissue, he'd placed it in a safe spot, the top of the television set. There it sat collecting dust, undisturbed all this time, but for whatever mild vibration might have come from TV programs.

Just passing by or intending to turn on the TV, we don't know, Bruce's father Gary's father Steve's father brushed the delicate urchin and it fell to the floor, shattering into a hundred purplish brown shards.

Half a world away, the golden spinning balls fell, and Bruce opened his eyes.

♪ *Atlantis*, Donovan

[AT THIS POINT IN OUR SEA STORY, YOUR AUTHOR LIFTS FINGERS FROM KEYBOARD AND PEERS OVER SHOULDER AT YOU, THE READER, ADDRESSING YOU, DIRECTLY:]

I awoke from a vivid dream. The little light on my alarm clock isn't working so I had no way of knowing what time it was. It was dark and cold and sure felt like the middle of the night. In my dream, I had seen the beam of a flashlight coming into the darkened front room where I sat. I went outside to investigate and found several inches of fresh snow covering the house and yard. I could taste the hard cold air when I breathed in. The street was quiet. On the sidewalk on the other side of the hedge, I saw the source of the light and followed, finding a fireman fully outfitted: respirator; gloves; helmet; axe; and heavy soot-smudged yellow protective coat and pants striped in ribbons of reflective tape picking up the light from the streetlight. He moves steadily along the sidewalk, his flashlight beam searching along the roof of our house, his boots lightly crunching the snow. I approach him and say, "Hi, I live here, can I help you?" but there is no response or any indication he has seen me. "Hello. Hello!" I keep saying and my voice has that strange dream quality of trying to shout loudly but nothing is coming out of my mouth. The fireman is now with a group of firefighters that includes a leader of some rank, and this man is pulling away shrubbery to get a good look at the address placard in front of the house, saying when he can see – and I can see it too – "■■ ■■■, no that's not it. We're supposed to be at ■■ ■■■■■■." And he says it clearly! My address, our address! Not sort of says it, but says it as plain and understandable as possible. I try to say, *Hey, that's my house,* and *Hey, let me take you there,* but there's still that dream condition where they can't see me, or hear me... I struggle to get sound to come out, to speak... ah! Ah! AH!

And I just wake right up.

Smart people everywhere respond to bad omens and dreams and the curses of Sicilians and the shattering of sea urchins with a little smirk and a laugh: *How could you believe in premonitions, in these days of science and reason?* But, we live in a hundred-year old Queen Anne house, made entirely of very dry, very flammable old redwood, heated by some sketchy gas-fired wall heaters from the 1950s and a wood stove. And as I patrolled the perimeter outside by flashlight after checking every room inside, I was pretty thankin' sure I could get fifty of the smartest, most reasonable rationalists around to agree with me when I tell you: Only a true thankin' idiot, a real thankin' asshole, would have just rolled over and gone back to sleep.

## Chapter civ
*Hell, Belly*

The noise monstrous breathing the spray COLD cold, it's cold IT'S BLACK only this noise this howling roaring noise in and out IN AND OUT and with every in every howling IN FREEZING spray Flapping swimming paddling in COLD cold water up to neck and AND COLD SO cold and black and can't stand the breathing In and out, in and out God it's LOUD! the pressure and and the horrible INHALE, the mighty breath comes in and the spray with it then the pressure too, pushing against eardrums they can't, they can't CAN'T TAKE IT! I CAN'T TAKE IT! I! I'm still alive! or I'M something CAN'T SEE! I CAN'T SEE! BLACK THE PRESSURE will cave in push into my brain and squash it I I... I can breathe though huuuh huuh huuh.

The sucking OUT now, more noise, the long EXHALE, howling, roaring spray goes down pressure goes down rushes DOWN! my eyeballs gah MY EYEBALLS and my eardrums want to go out with the pressure wherever it's going POPPING out of my head brains being sucked behind trailing in a trail along behind through the spray and flying gah can't see to tell WHERE OR what what what WHERE! THE BOAT! I'm in the boat... Oh, God... Oh, shit... Uh Oh, Uh Oh. OH NO! OH NO! THANK THANK THANK! If this noise would stop for just a second I could think here... thank, I could figure... I could find out. I gotta get out of this water. Can't SEE! the boat... okay, the boat... I gotta figure... and we're there... then we go along... go along in the... and and then, and then we... THANK! I'm inside the boat... My heart is pumping too hard, gah, so hard. It must be from the cold... the cold would do that, right? IT'S BLACK! I can't see my hand here! I can touch my nose. I CAN FEEL SOMETHING SOLID! BUT I CAN'T SEE! SOMETHING UNDER ME Right, so move up PUSH up out of the water as much as I can here, right right right. Breathe in, roaring howling water sloshes pushes pressure, pressure, pressure. Cold spraying my face and mouth choking. COLD! HIT MY HEAD! The edge there... the wall or bulkhead... I CAN FEEL IT! Fiberglass mat, I can feel it. WITH MY HAND! Fingers feeling things... and there? Wood, a board coming into fiberglass... follow it, fingers, over, not very far... more fiberglass... connected. Hands on each side overhead coming together above... no. NO. THE HULL!

NO. NO! That up there... it's got to be the bottom of the hull. The keel, the bottom, UP! OH SHIT OH SHIT OH SHIT! Big trouble. BIG THANKIN' TROUBLE! It's the fo'c'sle all right, got to be... all right, and upside down too. Lots of air though, oh oh oh, oh oh too much air. PRESSURE! Spraying me in the face, pushing the pressure up so high I can hardly... can hardly think. Why can't that howling roaring breathing stop for a minute? I can take the cold... COLD. I can take the dark... BLACK, please just for a second... Heart is racing, really moving. This IS NOT a good place... THIS IS NOT A GOOD PLACE! Gotta move where I can get more of me out of this water... that's important... maybe this shaking would stop and... and maybe I could think straight... maybe, ah ah gah... Maybe I can figure out... Shit, it's so thanking cold, so cold. I can stand here, thank, the boat sure is moving around. BIG EXHALE... pressure drop... Bouncing up and down, up and down.

And the noise, thankin' aye, like monstrous breathing.

## Chapter cv
### Pitch Poling

"GAAA!!" and splashing too. Something there fighting up into the air. An ARM! Flapping. Grab it! I can feel it. I can't see it.

"GAAFFF!" Bald head! Dave's head! Dave getting air into him. Where did he come from?

"DAVE! HERE! DAVE!" screaming at him though we're inches apart.

"UFF... UH... PETE ... WHA... WHAT?"

"D-D-DAVE!" holding on to his arm. Yelling over the noise, shaking from the cold... only the cold, ah ah ah ah.

"PETER, WHA...WHAT... WHERE ARE... WHAT HAPPENED?!" Getting his breath back now, still breathing so fast and hard.

"D-DAVE... WE'RE IN... IN THE FO'C'SLE. FO'C'SLE! IT'S UPSIDE DOWN. UPSIDE DOWN! FLIPPED. AND WE'RE IN BIG TROUBLE!"

"WHERE'S STEVE? AND GARY? ARE THEY HERE?"

"I... D-DON'T KNOW... DON'T KNOW... I... I..."

I move around Dave, half treading water, half pulling with my hands along what might be the bunks. Still so confusing... the next one'll hit us in a second, then... no more cold or noise maybe, maybe. Get myself up next to the bulkhead where Dave must have just come through. WHERE WAS HE! Must've come in through the passageway... but... underwater all that time? What time? Ten hours? Ten minutes? Ten seconds? Now I remember, I let go and fell as we got hit... fell right down into here. No, not *fall*, I didn't fall. Floating in space, I remember... halfway fell... must've sort of floated. Weightless! Because of the flipping of the boat. When it went over... pitch poling. I remember something strange like that for just an instant. The LADY-FAME was vertical, slow slow, then over. Like green gel from a tube, seawater squeezed through the windows at me. Standing there above the hole, the passage to the fo'c'sle, boots wedged, jammed with elbows and upper arms. I just let go, slow, slow, the entire boat rotated around me.

But Dave... Dave I saw fall to the deck on the other side of the wheel... how? How did he hold his breath that long? It must've been minutes and minutes... no. Maybe it just happened. Maybe it's still happening now... Thank, why am I so conscious of it all? I thought that you just got knocked out and weren't aware of anything, dazed and tweety birdies, when you bit it. This is a little cruel, I can think perfectly. I know where I am and I know exactly what's coming. Coming any second there has to be another wave. We must still be in the break, another one to take us into the jetty. Thank, do I have to just freeze here, trapped, and just wait for it to hit? The hull is still floating, probably into the rocks.

I'm thinking clearer now, really clear, perfectly clear. No panic. Absurd thoughts, but then this is a very strange situation. No panic... chest hurts, from the cold of the water, I guess. No panic... odd that I'm not curled up in a corner crying. Pitch black, pitch poled, but I can feel Dave there in front of me getting his breath back, probably thinking the same thoughts. My heart is even slowing down a little bit, can't feel it jumping so hard in my throat. I thought a minute ago it was going to leap out through my mouth. That was so long ago.

Water still up around my chest. Makes it hard to breathe in. I can wedge my feet up here against the sides of the bunks and get my elbows up. Up here... ah ha, most of me out of that cold water, some of the time at least. The water sloshing back and forth like in a bucket... in a belly.

I can feel the long rhythm of each wave as it comes into us, lifting the bow... the air sucking out... my eardrums, thank, my eardrums... up to what must be the top of it, almost feel the floating... then drop down and that spray howling roaring gushing fresh, cold air in with it. But the noise. The

deafening noise, like being in a giant bellows. Breathing in, breathing out… bellows in the belly, and the thanking pressure rises to the sky. No that's not it. When the pressure goes up, we are going down, down. Howling roaring. My eardrums have popped back and forth so many times they're going to get worn out; fly out into the splashing water or push in to jam like a hard finger into my soft brain. Hah ha, worn out, busted. Shit, what the thank kind of difference is that going to make? You're supposed to be seeing your entire life flashing before your eyes, Pete baby, not worrying about your thanking eardrums suffering some kind of thankin' shit minor damage.

## Chapter cvi
### The Fountain

[OUR EYE FLOATS SERENELY OVER THE CAPSIZED HULL, RED-LEAD
HUE BARELY VISIBLE IN THE DARK.
MOTIONLESS FOR A BRIEF SECOND IN THE TROUGH,
THEN RISING UP THE FACE OF THE NEW SWELL ALMOST VERTICAL,
THE BOW HIGH, THE WAVE PASSES UNDER.
AT THE SUMMIT, SO MUCH OF THE VESSEL IS OUT OF THE WATER
THAT JEALOUS GRAVITY, FEARING IT MIGHT SOAR FOREVER,
REACHES OUT, SEIZES!
LADY-FAME FALLS HARD INTO THE FROTH BEHIND THE CREST.
SUCH FORCE! PUSHING UP GEYSERS,
ARMS, STREAMS OF WHITE WATER.
BREACHING WHALE, BEAUTIFUL FOUNTAIN.]

Dave still in water up to his chest, I can hear him breathing and his teeth chattering whenever there's a calm moment. A calm moment? Hey! Maybe things are slowing down, there seems to be a rhythm with the in and out of the air and noise. A break in the roar. A hesitation in the howl, a chance to think. Think? You're in the capsized hull of the fishing vessel LADY-FAME, and you're about to be killed. Maybe I better not think...

"D-D-DAVE, ARE YOU H-H-HURT OR ANYTHING? ANY B-B-BREAKS?"

"N-NO. I'M OKAY, just cold." Dave answers with a calm voice, like this is just an inconvenience or something.

"LOOK... look." A break in the roar. I can lower my voice a little. He's only inches away. "I've got myself w-wedged up in here... it's more c-comfortable. C-can you get up out of the water any? It's t-too cold to be standing in."

Dave shifts around bumping into me, trying to get up and out of the water. With a lot of heavy breathing, he drops back down. He must be too big to wedge in. It's really not too hard to see why he can't get into this position. This way I'm stuck in here could qualify for a form of yoga or some horrible medieval torture. This must be another one of those times when the advantages of being small are revealed. I get a fairly dry though painfully cramped position to crouch in and wait for the wave-axe to fall...

## Chapter cvii
### The Peace of God
### Which Passeth All Understanding

Time must be going by but I can't tell how much, how fast, nothing. This seems like a perfectly logical place to be, a perfectly logical way to go. No questioning. No big "why?"

Fear. I don't feel it. I'm not afraid for some reason. I'm less afraid than I've been in years. No awful rush of panic like I'd expect to come in a situation much less fearsome than this one. No acid flashing. No rush of adrenalin to try and escape, my mind reel around like a psychotic's, having to hold myself back from screaming. Nice normal people aren't supposed to scream. Hah! A nice normal person surely would find more than enough reason in my predicament to scream his lungs out and cry for his mother.

*So it goes. So it goes...* and due to Kurt Vonnegut, Jr. that is the only thing I can think of to say to myself in this extraordinary position. *So it goes.* I wonder if Vonnegut thought it when he was trapped in a Dresden bunker during that firestorm. Lots of people have been caught in extraordinary messes, but we only hear the words of those who survive. I wonder if the last thought of those who don't make it is *So it goes.* Maybe this calm state of mind comes along and lets a guy exit in a nice way instead of crying huddled in a corner.

Hey! Maybe *this* is the peace of God which passeth all understanding?

Did you hear that up there? Maybe just recognizing it counts as my acknowledgment of your existence?

If there is such a thing as a continued existence after this... what the thank, if I blew it, I blew it, salvation-wise. I'll have to spend eternity sitting around with millions of unbaptized babies, Jews and heathens like Gandhi instead of ever knowing the bliss of having Billy Graham preach at me forever. I've never really given any of these ideas much thought, at least not so clearly. It's so clear though, clarity a lot like LSD. Tons of thoughts, but they're all flowing along nicely... not the usual tangle. I figured it would just be lights out, and nothing else. Most importantly no awareness of there being nothing. So, what could be nicer? I wonder if very many people ever get a chance to think it all out like this... yeah, there must be time for everyone, even if it's just a split second seeming to extend into hours, days...

Yeah, Ambrose Bierce, "An Occurrence at Owl Creek Bridge"!

[MR. FARQUHAR! HOW NICE OF YOU TO MAKE AN APPEARANCE AND JUST WHEN WE WERE SPEAKING OF THAT SUBJECT SO LOVED BY YOUR MR. BIERCE! HOW HE COULD TURN A PHRASE, DEFINE A FEELING. WHAT WAS THAT ONE, SO APPLICABLE AT THIS QUIET MOMENT IN OUR STORY? AH, YES:]

**RELIGION *(NOUN)* – A DAUGHTER OF HOPE AND FEAR EXPLAINING TO IGNORANCE THE NATURE OF THE UNKNOWABLE**
*Ambrose Bierce. The Devil's Dictionary*

Like now, I wonder how many minutes or hours have gone by since the wave hit. This time of year, clear skies, it always starts to get light pretty soon after we cross the bar, by six-thirty maybe. It's still totally black in here. WAIT! There in the water. Little greenish yellow lights, hundreds, thousands, like stars floating under water, a glowing wobbly universe.

"LOOK DAVE, in the water! LIGHTS," I say, pretty excitedly.

"That's phosphorescence in the water, Peter," Dave says the words so calmly, so like a skipper, so matter-of-factly that it really shocks me. Shocks me back into awareness of our situation. But it pleases me so much that he can say it with no fear in his voice, like a nature guide giving a tour. It fits. It fits with this... this peace of mind.

*Many... brave... hearts... are asleep... in... the... deeeeeeeep...*

Hah ha, ha, I'm singing it to myself.

♪ *Asleep in the Deep*, The Mills Brothers

It seems romantic, an honor, to die in the fashion of so many noble seamen. Not for me, getting hit by a station wagon full of snot-nosed kids while jaywalking. Even the part about what the crabs will do, still sort of an honor.

Supposedly they start with the eyes...

## Chapter cviii
*A Squeeze of the Hand*

It's getting calmer. Definitely. No doubt. In a lull. Why does it have to be so prolonged? It's obvious that sooner or later one will lift us and take us to the rocks – finish the job that first wave botched. I'm almost sorry that this boat has such an incredibly strong hull. Any other boat would have blown apart under the impact of that first wave. We wouldn't have been stuck in here contemplating the void. We would have been dead long ago, like Steve and Gary. Dead and gone.

They must be gone. Sad. I didn't hardly even know Gary and I knew Steve so well, as well as anybody ever could. It'll only be a few minutes more and then Dave and I will be wherever they are. Gone. It doesn't seem to upset me like I thought it would, the idea of my closest friend being dead, drowned. Because of the nearness of my own departure (now there's a funny word). Dave interrupts my reverie.

"Peter, this is a real bad situation. I'm sorry I got you into it, really sorry," Dave says softly. I can only hear him because the roar of the monstrous breathing has almost totally subsided.

"It isn't your fault, Dave. It was a freak accident. It was nobody's fault."

"Steve and Gary are gone and they were my responsibility. Poor Gary, he'd never even been out to sea before."

"We're in real bad shape here, Peter."

"I know, Dave. I... I can't think of anybody I'd rather be with. I mean..."

I can just make out the outline of his face. Maybe from the glow in the water, maybe it's getting lighter outside. I don't know. Seems like we look towards each other for a long time.

"Are you still real cold, Dave?" I ask.

"Yeah, Peter, it's really taking it out of me."

I reach out my hand to where I think his shoulder is. Find it, and then down Dave's arm to his hand. We put our hands together, hanging on. I hope it makes Dave feel a little better, I know it makes me feel better.

"Not as cold as up in Astoria, but *it is a wet cold*," I'm trying to joke, referring back to our trip last year.

## Chapter cix
### *Astoria & the Frozen North*

Peter, goddamn it! Now do you understand why I was yelling at you so much yesterday morning? Just notching back the throttle that little bit got us up here an hour later than we would've. We could've set the gear and gotten over the Columbia River Bar... tied up and be having dinner... SHIT! Now we're trying to set gear in this gale and all thanked up cat's ass!"

"That's what I'm trying to tell you, Dave! The boom snapped off, the pole snapped off and is flying around the deck!" I screamed back.

"What boom?" Dave yelled.

"The boom, you know, the pole... starboard side pole."

Most all the boats in the fleet were rigged for different kinds of fishing, different seasons. The LADY-FAME had thirty-foot long wood poles mounted amidships on both rails. For crab season they just stayed tied up to the center mast but during albacore or salmon fishing they were let down to run lines off of, much like the fishing poles Andy and Opie might have slung over their backs while whistling, walking down that dirt road. A minute ago we'd gotten creamed by a twenty-foot wave. Helped by the fifty-knot gusts, the starboard pole had jumped out of its rail mounting bracket and, still tied off to the mast, was flailing around like some badass nunchucks from *Kung Fu*.

Grasshopper, we were getting the shit kicked out of us and were in real danger of losing all the gear if we couldn't get it set quick. This storm had come up in the middle of the night after days of pleasant sunny weather. Hadn't seen anything nasty on the way up other than a good sized sea. Two days and a night running up from Humboldt Bay to Astoria chasing the crab.

120 crab pots now seemed barely tied down on a back deck that was really moving around. After sneaking up on and bear hugging the pole, we lashed it back into its bracket. Don ▮▮▮ (Dave's son-in-law, this was before Steve came on board) and I finally did get the gear in the water, but probably not in the perfect sets Dave wanted and would have had, if I hadn't throttled back that little bit... or so he said.

"Just leave it all set like it is," Dave said. "Throttle's set, we should get ten knots. Iron-Mike™ is fine like it is." The Iron-Mike™ was a rudimentary auto-pilot mechanically tied to both compass and steering gear.

"Wake me if there's any problem," and then he climbed down in the fo'c'sle for a nap.

On our way *up the hill*, I had the wheel for a watch during the middle of the night. For the first couple of hours things went along fine. A good breeze out of the northwest, sky was clear, lots of stars.

Then off of Cape Blanco, maybe because of a change in the currents, the seas steepened a bit and the wind picked up. The LADY-FAME had been riding comfortably up until now, powering through the swell, no rolling.

Now we seemed to come off the top of each swell harder, the bow slapping down with a noticeable thump and a roll to either starboard or port. I didn't think it was anything dangerous so I didn't feel any need to wake up the tired skipper, but I figured if I just dropped the throttle a tick or two, we'd get back to that comfortable ride and Dave and Don could get some sleep.

When Dave got up to the wheelhouse four hours later looking for coffee he noticed the throttle right away and chewed me out. I suppose he knew about possible impending bad weather. Knew more than me anyway.

Everybody always talks about how tough the Humboldt Bar is, but let me tell you, the Columbia River Bar is no slouch. There it's like a perpetual hard ebbing tide because of the massive amount of water from the river pushing out into the Pacific. When the Coast Guard wants to shoot publicity stills and films showing rescue boats and motor lifeboats all covered in whitewater, they generally head for Astoria. Oh boy, here we come!

The storm we were in had just arrived from the Gulf of Alaska and since we were now way up north at the Oregon/Washington border, it hadn't felt the need to get all warmed up like it might before arriving in sunny California. Hah, there were two thanking inches of solid ice on the back deck then. If it hadn't been for that guy at the fuel dock having that can of rock salt... shit, I can see Don and me trying to stand up on that stuff, having to pour hot water on the block so it'd turn, snow and sleet hitting hard, trying to keep the windows clear.

On that trip with Don (just back from two tours in Vietnam), when I was helping him back up after he took a bad slip on the frozen dock in Astoria, he declared, "From that shit to this shit."

We crossed that Columbia River Bar in fine publicity photo form, glistening white, foam and ice.

## *Chapter cx*
### *The Honour & Glory of Crab Fishing*

I care for this fat, old, bald-headed guy so much. He must know. All our arguments don't mean anything now. It's so comforting to have somebody near me, somebody I care for, in this shit with me right now. I know I mean something to Dave, we used to have long talks on the way home from pulling the gear last spring. The pots were set quite a ways north, so it was a two-hour run back down the hill to the bar. Don used to sleep, I'd run the boat, and most of the time Dave would sit on the wheelhouse couch and we'd talk. I'd mainly either keep quiet or agree during political discussions, just to avoid arguing. Other times though, we'd talk about life, the religious nature of the sea, all kinds of bullshit. Once he almost said it. But to say it would have been out of character. Dave has three daughters, you see. He doesn't have a son. And I know that he's been a strong father-figure to me and, well, right now down here... he doesn't have to say it.

"Hey... heeeeey..."

A voice! Really faint, behind my head, on the other side of the bulkhead.

"Hey, anybody... hey," the voice is yelling, but so muffled.

"HEY! HELLO! WHO'S THAT? HEY!" I yell back, pounding with my fist on the bulkhead.

"It's me, Gary. I'm in the engine room."

"GARY... GARY... GOOD! THIS IS PETE. DAVE AND I ARE IN THE FO'C'SLE HERE... ON THE OTHER SIDE OF THIS WALL. YOU OKAY?"

"I'm okay. I'm... okay."

"GARY... DON'T TALK, CONSERVE YOUR AIR. OKAY?" Thankin' aye, where did I pull that cliché from? A chestnut right out of an old B movie.

"Okay," Gary answers back. Then he's quiet again. He doesn't want to ask where Steve is. I don't want to ask either.

Dave was excited for a second, but then, remembering Steve, slumps. Gary would have said if Steve was with him.

Thaaaank, poor Gary. First time on the boat, first time out to sea. He's probably really scared. And I'm sitting here thinking about myself. Gary, completely unfamiliar with the boat, completely innocent. He has to sit

there in the engine room all alone. Nobody to hold his hand in the end. Gary hasn't been involved with the sea long enough to take comfort in this being a classic literature-worthy seaman's death. All he wanted to do was take some pictures.

"Gary's still alive... that's good, that's good," says Dave. "I was really feeling bad about Gary, since he wasn't even really supposed to be here... but he's still alive."

I'm thinking it might have been better if he got it right away instead of having to wait it out with us. I mean, thank... any minute now... payment to the crabs...

And Steve, my best friend. The person closest to me. Drowned? Didn't make it to an air pocket? Maybe he was swept away from the boat in its flipping. Nobody could ever swim to shore in water this cold... and no way to get through the surf even if he could... no, no he's drowned.

Jan... what'll she feel? I'll have to tell her. Me? Shit, get serious, you're going to be feeding the crabs in a few minutes along with Steve. The payment to the crabs. I guess it's only right that people who've been taking crabs from the water, selling them to be killed, cooked and eaten (*detestable!*), I guess it's only right that eventually the crabs get a chance to even the score. That seems very logical, ecological too. It all works out. *Nice nice, very nice*. But thank, do they have to start with the eyes?

The horrible roaring breathing has stopped completely. And with it, the fresh air. It's starting to get thick in here. The water's not any warmer, but I'm getting numb to it. Jaw aches from being clenched so much trying to stop the chattering of these teeth. If I open my jaw just a little, the teeth take off. Mashing into each other, out of control. That's another odd thing that reminds me of LSD, my jaws ached then too, but from smiling, uncontrollable smiling. Well, anyway, these teeth with all their holes only have to last a little longer. God, I'm glad I didn't spend tons of money getting them all fixed up. That assumes so much, that I'm going to be here for years and years when, who knows?

Don't go sticking money away for tomorrow's chewing, since tomorrow it may be the crabs' turn to chew, hah ha.

Thank, all that money, stuck away in my suitcase waiting for me to come back and run off with it to South America. Shit!

I could've had a really good time with all that money while I was making it.

Could've had a nice sports car for summer days and nights cruising with the top down. Drink my head off at the bar like everybody else was doing. Shit, stupid, stupid, stupid. What an asshole to save for a future, a future anything!

Shit, when they find that money, they'll probably use it for something even more stupid like a funeral. Poor idiot, on the wake of his big plan, a wake. Naw, they wouldn't say that. Hopefully somebody will do something halfway interesting with the money.

How come I'm not thinking about loved ones and family and their heartbreak? I was nice enough the last time I saw anyone I care for. Elizabeth is in Europe, won't have to hear the bad news for a while, and I won't know what her reaction is. My parents and my sisters and all my friends, I left a pretty clean state of affairs. No regrets. Maybe just one, saving all that money. Tucking it away for... shit.

That must be the lesson to be learned from all this mess. The lesson to be learned! Sure, right, as soon as God comes down and levitates me over to shore, right. As soon as I'm standing there on the beach, I'll look up to the retreating host of angels and say, "Thanks Lord, I've certainly learned my lesson about money management."

[Vibration]

What is that? Felt like something scraping. The mast sticking way down under the boat scraping on the bottom? We must be drifting into shallower water, nearer the break.

Oh, come on. Oh, thank me dry, any second... any second the tip of that thanking mast is going to stick in the sand or some rocks and the next wave is going to push us over sideways and the hull will fill the rest of the way up with water and then... down to the bottom.

No way to get out of this thing in time when it comes over.

The whole hull will be flipping around so fast and so hard that we'll probably all be knocked out... but... but we'll be able to feel the thing start to go over and... shit, don't think about it.

It's not like there's something you can do about it. There's nothing to do. Nothing to do but wait.

Maybe it'll be a surprise. No, it ain't going to be a surprise. The only hope is that these diesel fumes will knock me out before it happens. Then at least I wouldn't have to be conscious of every little part of it.

The fumes are getting stronger, maybe...

I wonder if Dave heard the scraping. I wonder what he's thinking about. Hey, I can see him. I can see him pretty well in fact. It's getting lighter in here.

## Chapter cxi
### Cigarettes

The sun must be coming up. I can begin to see around me, light glowing in through at the edge of this entombing hull. If one must be capsized, there's an advantage to doing it in a fiberglass boat. The white parts of the hull allow sunlight through.

Dave's right in front of me, standing, shivering, water up to his chest pocket. No more than two feet away. He couldn't get farther away if he wanted. The bow narrows just behind him, the very tip of this boat being taken up by a storage compartment. That's what I was jammed next to after the wave hit us.

There's about six feet from me to the end of the fo'c'sle, the tip of the boat. Three feet in between the two upside down bunks, their bottoms lapped by the water line. Six by three by two… familiar measurements… oh, yeah, coffin-size. There's lots more room under the water, you just can't breathe too good down there.

There's stuff floating on the water, sloshing back and forth, gently now, with the coming and passing of each wave. A foam pad from one of the bunks, salmon jigs, tuna fishing gear, and cigarettes. All those cigarettes bobbing around. The cartons of sea store smokes that were stuck away in the forward compartment, got out. Two full cases (tax-free!), twelve cartons to each cardboard case now melted apart during what must have been the agitation phase and those cartons dissolved, so now just a blanket of two hundred and forty bobbing floating, plastic-wrapped little packs of cigarettes. A sea of Tareytons® for Dave and Winstons® for me and Steve. The plastic wrapping seems to be holding up. I wonder if our forty-eight hundred little friends in there are dry?

Now that's something I haven't thought about for a while, a cigarette… Thanking shit, all those smokes bobbing around like they enjoy torturing me.

"You got a dry match, Dave. We could have ourselves a smoke," I say smiling to him, a little levity.

"Hah ha, no. No, mine got a little damp. Besides with these fumes, we'd probably blow ourselves up."

Probably would.

Must be sunny and clear outside. It was clear when we were coming out, I remember. Clear and cold and I could see the stars. Well, at least a beautiful morning for a last morning. People must be getting up all over town, looking out their windows and thinking what a nice morning for Christmas Eve.

Those crazy thankers at the Ice & Cold must be putting on their layers and pushing the first carts into the frozen shithole by now. Maybe Johnny's on the dock looking out, squinting in the sun, waiting to unload some boat. Is Keith up and making coffee? He likes to work at that loom early. Sweet Keith is most likely still unconscious. I can't remember him ever getting up before noon. David would be up at Peggy's, smoking his pipe, reading his *Chronicle,* eating his French toast... happy. Charles and Trini will stay entwined until ten, minimum, and Bill the Carpenter, probably just parking out front, locking his car, planning his day of art making.

I wonder if anybody is thinking about us. Does anybody knows we're out here? Any girls thinking about me?

## Chapter cxii
### *The WACO Meets the Rachel*

"Mate and... checkmate!" exclaimed Rachel for the third time tonight. I thought it was just about getting to the edge of obnoxiousness but she was pretty cute and, after all, I had promised Sandy.

"She was there at the John Woolman School when I drove you up to Nevada City," Sandy had said on the phone. "You don't remember meeting her? Rachel. Rachel ▇▇▇▇. She said she remembered you. Thought you were a runaway jarhead from Pendleton, ha ha," she laughed, coughed and caught her breath. "It was right after you shaved your head.

"Well, Pete, I'm calling you because she joined the Coast Guard and just got stationed up at Humboldt Bay! Her parents were over for dinner last week, they go to meeting with us, very nice people, we got to talking, she doesn't know hardly anyone up there, lives off-base with a girlfriend in Arcata and her number is 822-▇▇▇▇. Are you going to call her today?"

Queen Mab at work, I thought, but I'd called Rachel up, and after some Mexican food we'd come back to WACO for a beer and what I thought would be a pleasant, getting-to-know-you game of chess.

"Hey Rachel, do you want to go across the street to the bar? Maybe I'll be a better match at pool. We can get another beer."

"Sure," she said, "it's a little chilly in here anyway."

"Oh, the Ebony Club will be warm."

We headed down the stairs, out the front door and could already hear music and the occasional howl, as we crossed the street. I pulled the big door open for Rachel and we were both blown back by the smoke, heat and pulsing sound of the very loud music.

♪ *Mr. Big Stuff*, Jean Knight

It was a Friday night, around eleven, so the Ebony Club was pumping at maximum. Fifty people out on the dance floor snapping and jumping and howling. Both the cages were in operation with flashing blue and red spots lighting the girls. Sweaty flesh, skimpy spangly hotpants and those cool calf-high white go-go boots with the tassels.

The tempo dropped a hair when the song ended and I was able to get up to the bar near where Doris was filling pitchers with beer from the tap.

♪ *Brandy (You're a Fine Girl)*, Looking Glass

"Hey Doris, could I get one of those?" I asked politely and then looking up...

"Hi Pete," came a girl's voice from on high. I was almost right under one of the cages, straining my neck up and there was something very familiar about the pretty much all-naked girl smiling down at me.

"It's Carol, remember? Class of '66."

I smiled back and then I remembered. Carol ███! Thank me dry!, she sat next to me in an afternoon class back in seventh grade. I remembered it was spring, strangely warm and she was wearing a cap-sleeved white cotton blouse and when she raised her left hand to ask a question or scratch her dishwater blonde hair, I, just becoming aware, I, virgin and curious, I could see the pale wispy blonde hairs in her armpit.

"How are you?" Carol asked, kind of yelling. She seemed to be taking a breather sipping a beer and smoking, barely swaying to the music. Maybe she just hated this song. Her tits looked great, shiny with sweat, probably why Clyde hired her. Blue light, red light, flash flash, bounce bounce.

"Oh, I'm fine. How are you doing, Carol?"

She squatted down, her face only a few feet above me now, beads of sweat on her forehead and cheek looking like bright jewels in the pulsing spotlights. "I'm doing better now. It was hard for a long time. But... I'm back to dancing... doing better."

"Oh, that's good. I'm glad," I said without really knowing what she was talking about, what had happened.

"Mark left. He tried, well, we tried but it wasn't the same. He couldn't stop crying, couldn't work." Carol took another long drag off the cigarette. "I still haven't been to the beach, any beach, and it's been almost two years. She was just a baby... be almost five now..."

There were some tears picking up the light now, adding to the jewels.

Oh God, I remembered. I read the story. It was on the local TV news. Young family. Day at the beach. Three-year-old baby girl. Sneaker wave. Rogue wave.

Carol's break was over. She stubbed out the smoke, wiped her eyes and face with a towel, and as she rose back up, yelled down to me,

"Hey, what are you up to these days?"

"I'm a commercial fisherman nowadays. Right here," I had to yell, "CRAB FISHING!" gesturing toward the bay, the boat, the LADY-FAME.

"It will eat you," Carol said with a warning tone as she popped her shoulder to the beat and closed her eyes.

"Wha...?" I couldn't quite hear her.

Looking around for Rachel, I thought she might be pretty impressed that I knew one of the entertainers, but she was way over on the other side of the room next to one of the pool tables, waving me to come on over. Must have been free and she grabbed it.

♪ *If You Don't Know Me By Now*, Harold Melvin & The Blue Notes

The music softened and Doris came over to me, across the very shiny, damp bar.

I waved to Carol, who was now slowly grinding, paid Doris, picked up the pitcher and a couple of glasses and made my way over to the pool table.

Rachel racked and I broke but then she took over and cleared the table not once but twice.

We sat together at one of the smaller tables against the back wall trying to talk above the raucous noise. I asked her if she knew Art; felt she had experienced it.

"That's what you're after? Not just pussy? Well, that's not knowable," she replied sipping. "Can't be painted, sculpted, photographed, performed. The art which *can* be known is not the True Art," Rachel said, raising her eyebrows and paraphrasing Lao Tzu.

"Do you want to dance?" she asked finishing the last of our pitcher.

"Naw, I don't ever dance," I sloughed off the request.

Rachel laughed and said that her mother had told her never to get involved with a man who did not dance.

"Yeah, I've heard that before. I used to date this cute young girl up in Crescent City. Wild. She'd ride me around on her Norton Scrambler®, me hanging on real tight. And she'd always want to go dancing and I was always saying no, no thanks, I don't want to, I don't ever dance. This girl also told me that *her* mother had said the same thing. Told her she should never get involved with a man who did not dance."

"So what happened, you started dancing?" Rachel was still laughing.

"No, no, she went off on her motorcycle, off on that Norton®, to go visit her father down in the Bay Area. Well, actually he was doing life in San Quentin. I never heard what he'd done to get locked up, must have been a story there. I did find out later he was known to be quite a good dancer."

♪ *Groove Me*, King Floyd

## Chapter cxiii
### Thunk

[THUNK]

What's that? What is that? It's on the hull, scraping and bumping on the hull, I can hear it... something... no... SOMEBODY! Somebody there on the hull, I can hear it, somebody bumping, tapping.

"Dave, did you hear that? That tapping?"

"Yeah, I hear... I hear... wait a second." Neither of us breathe for what seems like minutes.

Some faint scraping... then, very faint, "tap tap tap."

Thank, THANK! Somebody's up there on the hull... another boat... the Coast Guard. I fumble around in the new shelf formed by the underside of the bunk to find something to hit against the hull: coils of leader; hooks; soggy manuals; a ten-pound lead trolling weight, like a little cannon ball.

BAM! BAM! BAM! BAM! against the hull. It's louder than shit to me. Then wait... "tap tap tap tap," comes in reply. Thank, there IS somebody. How can it be so faint though? Is this hull that thick? Could they hear me banging? Must've, it was an answer, four for four.

"Goddamn, there's somebody out there," says Dave.

God, after all this shit, somebody's going to rescue us? No, it's just not possible... something will have to thank up.

"GARY! GARY, CAN YOU HEAR THAT ON THE HULL? CAN YOU HEAR THAT?" I yell through the bulkhead.

"I hear it... I heard it," Gary answers back.

Gary... thank, Gary's been alone in the engine room for all this time. He must be going crazy. No talking back and forth. Nothing. Nothing since I said something stupid about conserving air. Maybe we should try to get into the engine room. More space. This air is making me a little woozy. Wonder how Gary got into the engine room?

Wait, wait, he and Steve were in the back of the wheelhouse, next to the stove. I remember looking back there right before the washing machine thing happened. Some of the floorboards must've fallen out or up or...

when the boat flipped. They're just set into place. No bolts or hinges.

That must be it! But that would be too far to try to swim. I couldn't hold my breath that long. I can't believe the wheelhouse would be clear; all that crap and the table and foam pads and those heavy floorboards. But there's the hatch right there.

All we'd have to do is duck under this bulkhead and the engine room hatch opening would be right there... straight up. If I can get Gary to make sure the hatch is open...

"GARY? GARY, HOW'S THE AIR IN THERE?"

"Good, the air is good."

"Dave, maybe we should try to get into the engine room. Gary must be real lonely. It would be better than this... I mean... if there's somebody trying to get in."

"Well, yeah, do you think we can make it? I don't know how long we could hold our breath under water, cold as it is. We should try though," Dave says, his voice halting from the cold.

"GARY? CAN YOU GET OVER BY THE BULKHEAD AND SEE IF THE HATCH AT THE FRONT OF THE... AT THE FRONT NEAR ME... CAN YOU FEEL IF IT'S OPEN?"

I can hear some muffled movement, some quiet splashing.

"It's open, I think," Gary yells back, after a few seconds of silence.

"OKAY. I'M GOING TO TRY TO COME OVER THERE! TRY TO SWIM UNDER! WATCH FOR MY HEAD! OR MY ARM! OKAY?" I yell.

"Okay," answers Gary.

"Well... I'll try anyway, Dave. What the thank, it's right there, only about five feet. Now that it's light, I should be able to see."

I should be able to make it, I'm telling myself. It really isn't very far. But that water is so cold, full of fuel and oil and the thought of putting my head under and opening my eyes. Gahh! Well, what the thank, I can always back up.

Take a few deep breaths, get my legs down here under me and drop into it. GAAH, THANK this water is c-c-cold... up to the top of my shoulders in it... it hurts my chest... in... out, IN... a deep one, and AAHHGG! under all the way... it's light! Dim green light from the door... windows? Wrong side it's all wrong, uh, here, board... uh PAD in the way, foam, stuff caught in my arms caught CAUGHT! Can't go forward *no* got to turn *no* up *no* there *no* junk *no* board pad *no no* get up which way? AIR! GOTTA BREATHE! *no* foam *no* back back which way back? BOARD! *no* AIR! *no* foam pad all over me holding holding boots off *no* air air air uh uh, gaaaah hhhhh... gaaah.. Here here here! UP! HUUUUUUUUUUUUHHHHH! Oh, thank, thank air, breathing again.... sucking in so hard it rips my lungs... couldn't make

it... THAAAAnk... exhale GAAAAAH... HUUUH in again like taking a sword down my throat and then whipping it around in my chest... couldn't make it five feet. Not five thanking feet... five thanking, cocksucking feet.

"Wha... What happened, Peter? You alright?" Dave says next to me. It couldn't have been more than a few seconds I was under.

"I'm OKAY, OKAY... GAAH... I just c-c-couldn't make it. There's all kinds of s-s-stuff in the way just couldn't make it, couldn't..." My breath is starting to come back now.

"I c-could see pretty well there, Dave. Th-there's junk floating all over the place. I lost my boots... I lost my new boots, hah ha, shit... I don't think we can get out, Dave... I don't think we can do it... just can't hold your breath in that water for very long."

"That's okay, Peter, I'll buy you some new boots. You tried, at least you tried. Don't worry about your boots," Dave tries to calm me down a bit. It's crazy but all I can think about is losing that pair of boots. They didn't leak like my old ones and I hadn't even had a chance to break them in... Shit.

So, here we wait, again.

"I couldn't... I COULDN'T MAKE IT, GARY.

"Okay," comes his answer, that's all, just okay. Quiet, with maybe sympathy.

"Peter," Dave says, in a nervous sort of voice. "Peter, I gotta do something about this cold. It's really getting to me. I gotta do something about it."

"You're sure you can't jam yourself up here like I am?"

"No. I tried, Peter. Maybe we can get the water out of that foam pad and I can wrap it around me, anything."

We both start squeezing the pad from the bunk, a little water comes out, but no way. No way to keep the pad completely out of the water so it won't suck water back up as fast as we squeeze it out, like a huge, awkward sponge. No way to wrap it around Dave's torso.

"I don't think this is going to work, Dave."

"Yeah... well..." Dave says, letting the foam go, pushing it back against the side of the hull, out of our way.

## Chapter cxiv
### The Forecastle or Fo'c'sle

I haven't been suffering nearly as much as Dave, least not from the cold. I don't know how long we've been in here like this, but all that time, I've been able to get a third of me out of the water. Cramped, wedged up tight with parts of legs and arms going to sleep, but not numbed by the cold like Dave must be. His protective layer of fat probably isn't helping any more.

It's funny. Not *ha ha* but *existential* funny that even though we're obviously going to die, here we are trying to be comfortable. Shit, is this what the shutting-down mind does to protect itself against the reality of impending doom?

*Look there! The contrails of the incoming nuclear warheads, like a hundred wispy fingers of death, soft yet determined against the cobalt sky. One minute out, perhaps two? Is that a slight chill I feel? Should I put on a sweater?*

I haven't panicked. Must mean something. Either I'm a lot stronger and braver than I expected or I'm a lot stupider than I thought I could be.

Maybe you have to believe in some kind of life after death to be scared shitless of dying.

Never had any reason to think about the actual moment of death before, and now that I have a reason there are plenty of conclusions I never suspected. At first there was the rush, the fear, the frog-brain fear. All that adrenalin pumping. But that was when I was caught by surprise, when my subconscious or whatever was fighting to survive. I couldn't think. I couldn't react. Then things changed fast, like slipping through to the other side of something. Then it all seemed to make sense. Maybe it's when I gut-level realized the hopelessness of this thing. Maybe hope is what causes the fear, the confusion, the panic. Maybe hope is the apple Eve gave us. Maybe it's the holding on, clinging to the chance of rescue that does it. When I gave up, let go, I slipped into this. This calm, where it makes sense. It doesn't matter. It doesn't matter what happens... it's the way things go. *So it goes.*

Definitely some form of altered consciousness.

Dave standing there shivering, probably thinking about something more practical than my thoughts. Easy to see everything now, light coming in

from both sides. Diffused, glinting off the water. Lapping sounds, rushing wind noise of passing waves every once in a while. It's relaxing. It really is. I could almost fall asleep, there isn't any reason not to...

It's the air in here! God, the fumes are really starting to get heavy. No new air is coming in! When the boat first capsized, it was bouncing around so much, new fresh air being sucked in... bad air being sucked out. Now, nothing, no air passes through the hull, a coffin-sized pocket for both me and Dave and we just keep on breathing. Oh, wait a second, this is where that B movie wisdom comes in: *don't talk, conserve your air.*

We'll probably float around out here for years, in this hull. They'll put a flashing red light on it, maybe a plaque and a bell too, and all the fishermen will have to go around us.

They'll say, "Look out! Don't want to run into the LADY-FAME, ol' Dave and the fellas. Steer outside of 'em."

## Chapter cxv
### *A Cold & Greasy Death*

Death. I seem to be thinking a lot about death. The air is getting worse, my poor mind meanders over peculiar ground. If I was sitting having a smoke and a beer in a whorehouse, maybe I'd be thinking about smoking during sex or the process of brewing beer.

Nice to have time to think it all over, but what's the point? I can't craft my final thoughts into a work of art for prosperity. Could have been my one true work. Can't be much time left. I'm sure to pass out. I'm cold. Probably better the noble dead never tell the tale of these last few moments. Better the truth stays in Davy Jones' Locker. Not beautiful and romantic as literature makes us feel. Just sad, cold, greasy and wasted.

Maybe people who never know what hit them are luckier. I wouldn't know about that. I know what hit me.

♪ *Give Me Just a Little More Time,* Chairmen of the Board

**DEATH TWITCHES MY EAR; "LIVE," HE SAYS... "I'M COMING."**
*Virgil. Posted in bathroom, across from toilet*

"I really feel bad about Steve being... being gone," Dave says, finally breaking what seems like hours of silence and my mental masturbation.

"Don't think about it. It wasn't your fault, there wasn't anything you could do. It was an accident."

"I just don't know where that wave came from. We were already across the bar. We were right there by the sea buoy. It was a freak. That thing was big."

"I know, Dave, pretty crazy. Just bad timing for all of us."

"I knew it was too rough to fish, you know that. I thought we'd go out to the sea buoy and wait for some light before we came back across. I've never seen any wave like that breaking. Out next to the sea buoy and it was breaking. It's fifteen fathoms out there... waves do not break in a hundred feet of water... don't understand it."

"Pretty weird, all right. I wonder if anyone knows we're out here."

"Yeah," Dave says, "Ray must know, he was right behind us, waiting back there."

"I wonder who that was on the hull," I say, although by now, since that was some time ago and there hasn't been any other noise, by now I think we imagined it.

"I don't know, maybe nothing. Seems like by now, by now there should have been something. We'll just have to wait," Dave says. He doesn't seem as hopeful as earlier; the cold and fumes are really getting to him.

With the sun lighting our little tomb, and because so much time has gone by, now it does seem like there could be a chance. Before it seemed that the very next wave was going to dash us on the rocks, it was so dark and the noise so overpowering.

It's going to have to be with frogmen though. No way are they going to be able to just knock on the hull and say, *Come out, come out, wherever you are.* No way.

They'd have to come in here with spare diving equipment, man, I don't know how else. If they cut a hole in the hull, the first puncture and, *whoosh*, all the air goes out and down we go in the LADY-FAME before we could even say *thank you*.

Maybe if there was somebody out there I trusted and they said it was the only way, the only chance, maybe then I could make the swim. I don't know. I didn't like that feeling I got when I was trying to get to Gary, that drowning feeling. It almost seems better to stay and let the fumes put me to sleep.

"Hey... hey! It's Steve... found Steve! I found Steve!" Gary's muffled yelling comes through the wall behind my head.

"WHAT? STEVE? WHAT?" I'm yelling, "STEVE'S THERE? HE'S OKAY? WHAT?"

## Chapter cxvi
*Kurt Vonnegut, Jr.*

Those books might have been floating in amongst the debris. Maybe Steve pushed one or all three of them out of his way when he was diving for the engine room. Maybe I bumped into one in my failed, gasping attempt. All paperbacks, one was a collection of short stories, Welcome to the Monkey House, the other two, novels, The Sirens of Titan and Cat's Cradle.

A little Kurt Vonnegut, Jr. library, they were my copies that I'd brought down to the boat because I used to spend time in the mornings reading and waiting for Dave to come tell me what was up. We'd been spending a lot of time tied up at the dock, so I'd been doing a lot of reading. Steve too.

Anyway, those three were lost, but replacements were already on the way. The same three books, *Welcome to the Monkey House*, *Cat's Cradle* and *The Sirens of Titan*, were sitting gift-wrapped in a package under the Christmas tree at Steve's parents' house in Cutten. Steve's mother, Marge, thinking ahead for Christmas presents while perusing Northtown Books in Arcata, had picked them out from the eight or nine Vonnegut titles they had on the shelves a couple of weeks before. Good foresight, I guess, but Steve had already read them.

## Chapter cxvii
*Cat's Cradle*

There was, at this time, an empty lot between WACO and Peggy's Cafe, some sixty by sixty-foot square and rounded high with an eight-foot tall vertical redwood plank fence. Naturally enough, as it was so often passed, Steve and I pulled ourselves up on this lichen-covered barrier more than once to survey within.

The empty space started five feet below the level of the sidewalk and was filled, piled high, with the detritus of a failed civilization: rusted water heater tanks; tires; broken glass; crushed televisions; sacks of rotten fruit; torn cushions; shoes without mates; and parts of cars. There were few who actually resided in that part of town, but amongst those who did, this empty lot was a hallowed disposal site for household trash.

Above the fence on the southern and western sides stood two tattered billboards. Fifteen by twenty-five feet, left over from more lucrative advertising days. Facing out over the trash filled pit, blank, whitewashed and ignored. Stenciled lettering at the bottom of each (so hopeful!):

**THIS SPACE AVAILABLE. CALL 443-▇▇▇▇**

Enlisting Steve's help and a promise from Mrs. Mendenhall that she would look the other way, we set about under cover of darkness, and:

∞ Gained access to the western billboard from the roof of the Mendenhall storage garage. The southern one, close and laid out at a ninety-degree angle to the first, could then be reached with a two by twelve plank carried from WACO.

∞ Painted, in black enamel outline, two hands. On the western, the left, and on the southern, the right. These hands were rendered in a manner to suggest they were open and extending out towards the viewer. Some clever foreshortening was needed, but I had prepared templates.

∞ Steve and I dragged what seemed like a mile of the old hemp one-inch rope lying about abandoned in the darker, danker back reaches of WACO.

∞ By tying and nailing and placing eyebolts, we managed during the second night to make a fairly accurate cat's cradle out of this rope, hanging beautifully from one sign, one hand, to the other across the garbage.

∞ Then painted text, words taken from my favorite book by Kurt Vonnegut, Jr., *Cat's Cradle*, in fifteen-inch high black gothic letters:

**SEE THE CAT?**
*Under the right hand on the southern billboard.*
**SEE THE CRADLE?**
*On the western.*

*Chapter cxviii*
*The Resurrection*

Steve alive. ALIVE! Man, he's still alive and I'm jazzed. Jazzed and excited. Like salvation is here. The same salvation I never thought possible. Not the thought of actually being rescued. I mean not literally plucked out of this shit and landed safe on a solid dry shore. No, not that kind of salvation. The kind of rescue that reunites the parts of me. Steve is a part of me and the thought of dying separately, the thought of not being whole, that's what was lurking in the backseat of my brain all this time without him. Steve's alive! At least now I'm all here. The other part of me is just on the other side of a thin bulkhead. And where has he been? Inside? No, that must have been him up on the hull. That's the only possibility. Steve hanging on up there, somehow. Steve making the tapping noises. So, no Coast Guard rescue party out there. Something much better.

Dave has come alive too, and we're both yelling at the top of our lungs to the other side. Practically jumping around in the cramped area. There's no thought in either of us that Steve may be hurt or even drowned. That's not possible. He's somehow in the engine room with Gary. He's somehow OKAY. Oh my thankin'... I can't believe it.

"Yeah... he's okay... he's here." Gary yells.

Amazing, amazing, THANKING amazing. Dave and I are still jumping, almost crying. Steve is still alive!

And if Steve's been up on the hull and now is in there with Gary... well, that must mean something. Maybe it's possible to get out of this tomb the same way Steve got in.

"STEVE!!" I'm yelling. "STEVE, ARE YOU OKAY? STEVE!" Dave is pushing up against me. He's jumping around at least as much as I am. The whole thing has changed. The whole mess has turned around. Dave's guilt and remorse over the loss of Steve has gone. And me, me... Dave wouldn't understand probably. Everybody understands when a person dies within days of the death of a spouse. Maybe it's the same.

"I'm okay. I'm all right... coming over into the fo'c'sle. Watch for me," Steve answers back, barely audible through the wall.

"How 'bout that. How about that, Dave. Steve. Steve is okay! I just can't believe it."

"I know. I know. It must have been him on the hull all that time. I thought he was gone for sure. We're all alive. All four of us. I didn't think that was possible. Going through all of that and still everyone is alive. I didn't think it was possible," Dave says. He looks like a new man. The cold is forgotten completely for now. His face has the color back in it. I'm still shaking my head in disbelief.

"Where do you think he was, Peter? Could he have been out on the hull all the time? He was inside when the wave hit us wasn't he?"

"Boy, I don't know, Dave. I don't know. Yeah, he was standing back by the stove with Gary... maybe he went out through the door. God, I don't know. I just can't believe that he's still alive. It's been hours since we went over. Hours, I think. I just don't... wha...?"

The brushing on my leg stops me. A movement down under me. The water boils a little right in between Dave and I, and Steve pops his head up.

"Hi," Steve says. His hair is slicked down his back, out from under the watch cap still jammed above his brow. Black beard turned into a mass of wet curls, dripping water. Steve's greeting is more of a gasp for air than a word. But it is Steve. Breathing short and fast little breaths right in front of my face.

"STEVE!" Dave and I yell together.

I reach out and put both my hands on his shoulders to touch him, jiggle him just to see if he's really there. Dave has his hand on Steve's arm too. The level of elation is pretty high. And so am I. Neither Dave nor I can really think of the right word. Steve gets his breath back.

"The air in here is really bad. You guys all right? The fumes are really bad." Steve is talking faster than I've ever heard before. Fast and jerky from the cold.

"We're okay," says Dave. "It's you we were worried about. We thought you... well, we didn't know where you were."

"I've been up on the hull since the boat capsized. It's nice up there. A lot nicer than in here. The sun is out and if you stay on the lee side it's almost warm. We should get out of here. There's a lot more room in the engine compartment with Gary. It's just a couple of feet under water, under the bulkhead. We can talk there." Steve's voice is coming back to normal now.

"I know it's not far, Steve. I already tried a while ago. I couldn't make it."

"It's an easy swim. Look, I've got this rope here. The other end is tied off in the engine room. You guys just have to follow it."

"Is it clearer than before? Because I was running into all sorts of floating junk. Got all tangled up and ran out of air." I'm still not too sure about this little swim. Steve's always been a much better swimmer than me.

"Sure, all the stuff is out of the way. It's clear."

"Well, what do you think, Dave? It's got to be better than this place. It'd be nice to be all together."

"Well, I don't really know. If you think it'll be easy, Steve. Remember, I'm not as young as you. I just really would like a chance to get warm."

"It's a lot more comfortable in there. You can get yourself all the way out of the water. A little warmer too, from the engine heat," Steve says.

What the thank. With a lifeline to guide me, maybe it'll be easy. Anything to get out of this tomb.

"Okay?" Steve says and Dave and I nod. "Okay then just hold onto the line and follow it. It'll take you right there. I'll see you there," he says as he takes a deep breath, looks from one of us to the other and drops down below the water.

I'm in a Tarzan movie. Steve has everything under control. He's swimming around through the overturned hull like he knows just what he's doing. He probably does. This is quite a bit different than my attempt to get us out of the fo'c'sle. Bewildering but incredibly comforting that Steve is getting us out of here. I think I'm in the midst of real heroism.

"Okay, come on through. It's okay," Steve's muffled voice from the other side. Huh, well, I guess we'll have to do it.

"Do you want to go first, Dave?"

"No, you go ahead. Tell me from the other side what it's like, okay?"

I know Dave's not scared. But maybe he thinks he might not be able to make it and he doesn't want to be in my way. I guess I better have a try at it. The idea of putting my head under the water again isn't too appealing. But I trust Steve completely. Feeling the same sort of trust that I always had when bowline'd to the end of a climbing rope he was belaying. Like the trust that time on the East Face of Whitney, *the* most difficult climb together. And that crack, that Shaky Leg Crack, not a misnomer. One thousand feet of exposure underneath me, struggling to climb it, and finally Steve up above practically pulling me up hand over hand. Thank. But we made it.

Now here's another lifeline that Steve's at the other end of.

## Chapter cxix
*Shaky Leg Crack*

The truck driver sounded his air horn with a see ya couple of blasts as he pulled the rig back onto the eastern Idaho road. It'd taken me more than two hours to hitchhike back to Idaho Falls and buy a set of wheel bearings for Otto. Steve was relaxing under a tree, his completely black right hand holding a partially black cigarette. He'd finished pulling the Volkswagen®'s right front wheel apart a while ago.

"Any luck?" he asked with a smile.

"Oh yeah, and there was a 7-Eleven® next door to the NAPA®. I thought you might like a nice cool one."

Half an hour later we were headed into Wyoming, headed to Jackson Hole and the Tetons. This whole mountaineering summer we'd been planning and saving for all winter started at Shasta, then up the line of Cascade volcanoes, climbing most of them. A weird ice and windstorm on Mount Jefferson thwarted us there. I kept hoping that when we got above the timberline we'd eliminate the danger of all the widow makers, but an inch of new glare ice on the steep snowfields and fifty-knot gusts convinced us both that there were other kinds of widow makers.

Rainier was difficult in a steady thirty-knot breeze as anyone who's been up there knows. Summited thanks in part to some good technical help from Leonard Smythe of London, England, no less. He'd seen us pulling into the campground in Otto and knew right away, running across the camp in socks and underwear. Turned out because of conditions (that same shit that had thanked us back in Oregon), the Rangers were not allowing any solo climbers. Leonard needed us and I think we needed him.

"Come on then, lads! Ever on and up, now. Must have our summit!"

Back down in the campground around a celebratory bonfire, only me and Leonard's sister Diana (dee-AH-na) were still awake. Leonard and his wife had retired to their tent early and even Steve was now snoring over there next to Otto.

Diana told me she liked a man who knew what he wanted and took it. I said, let's go over by the glacier, sit real quiet and listen to it creep along. When we were thanking away in her VW® bus, she called out, softly, firmly:

"Come on then, lad! Ever on and up, now. Must have our summit!"

When you buy a pass for Grand Teton National Park, it includes access to Yellowstone and both of us had always wanted to see that geyser. Not so great. We'd been spoiled back in Idaho, somewhere near Boise, by the outlet from a reservoir right near the highway. A plug of white water maybe fifteen-feet in diameter, arcing out at 45 degrees – 200 feet! and crashing down into the Boise River.

Steve and me drove on south making eyes at Mormon girls and scaring the elders in the temple. Otto purred along, we'd sleep alongside the road or maybe we'd head up some dirt road behind some rocks, build a fire, eat some chicken, drink some beers, smoke some cigarettes and watch all the stars in the black black velvet.

*"When he shall die, take him and cut him out in little stars, and he will make the face of heaven so fine that all the world will be in love with night and pay no worship to the garish sun,"* Steve quoted.

"That's nice, Shakespeare, right? I'll do that. I promise."

Made it down to the Grand Canyon floor, kind of *anti-mountaineering*, if you know what I mean. Hah ha! But what the thank, we weren't tired yet when we and that little cutdown black bug Otto made it into Lone Pine for a surprise visit to my sister.

"The shower, plenty of soap and hot water, is right in there," said Mary almost as soon as we'd finished with the hugging and greeting stuff.

A little later, smoking and drinking out in their front yard, the East Face of Mount Whitney formed a jagged cutout in front of the sunset. Deep blue sky, with the first stars, changing in short space to hot yellows and oranges which bend out streaming toward us from behind the black line-of-mountain-peaks shape.

"Let's go up there, Pardner," says Steve, exhaling smoke and then pulling again from the bottle. "Okay," I say, full of confidence, dope and beer.

A day later we're halfway up the Washboard looking down on Iceberg Lake and out across the Alabamas to Lone Pine. I was leading, safer we figured, with all the exposure, right up until the Fresh Air Traverse. I was spooked by the exposure, a thousand feet to the unforgiving rock and ice.

"We are *mountaineers* if you please! Not cocksucking Yosemite El Capitan vertical thanking *rock climbers*!"

And Steve says, "Let's do this Shaky Leg Crack variation, straight up instead." Okay and up he goes with me belaying from a strong pinned-in spot.

In following him, there's a reach. I'm pretty short... can't... can't quite... gotta sorta jump up. Steve can see, from above, my faltering and takes up the slack and then some at just the right... my hand gets the knob, right foot finds the edge... the line so nice and tight and warm and loving at my belly. I make it and we're up.

## Chapter cxx
### Reunification in Theory & Practice

A few deep breaths, get all the air I can. Facing Dave, with one hand on the tied-off line, quick smile and I duck myself under. Still thanking cold but the lifeline makes it seem possible... hand over hand... lungs yelling at me already... greenish light... nothing in the way... hand over hand... everything swimming pool fuzzy with my eyes stinging like shit... cold, but up now... water in my nose and... Air! Thank, I made it, I made it. Soft light coming in from both sides of the boat through the hull. Shit floating all around. Dim light, but brighter than the fo'c'sle... and the air, thank, it's really fresh and sweet... lots of it too. The engine room's like a cathedral, man.

"That wasn't so bad now, was it?" Steve's voice from over to my right. And look! Gary too. They're both just sitting there next to each other completely out of the water. Sitting on a perch formed by the underside of the wheelhouse floor. Gary smiles back at me, he looks dark in the half-light, but I can see his white teeth gleaming there.

"Hi, Pete," says Gary, grinning from ear to ear.

"Gary... hah ha, Gary... Thaaank... Hah ha. Good to see you Gary." I'm grinning as much as both Steve and Gary are. I can't stop it. Even though it hurts the same jaw that's already sore from chattering. I am really thanking high. Soaring. It's even a little warmer in here. And so big, so much space. Thank, it's amazing.

I let go of my hold on the front of the engine and paddle over to the perch that's empty on the other side of the room. Lift myself out onto it. Out of the water! Even my feet. Boy, this is nice.

"Hey, this is really some place you've got here, Gary. You should have told me how comfy the accommodations were, I would have tried harder to get over here. Hey, I should get the old skipper to come on over, we could have a little party, hah ha."

"Yeah, get Dave in here," says Steve.

"DAVE! DAVE! COME ON THROUGH. IT'S EASY. COME ON THROUGH!" I yell to the wall, the same wall, just now I'm on the other side. Dave can make it. I made it.

I don't hear anything from the other side, but he must have heard me.

He must be on his way. If he just follows the lifeline he won't have any trouble making it. Nothing can go wrong at this point. Nothing. My face hurts. Can't stop the smiling. Just seeing Gary, the one I was most worried about, sitting over there next to Steve, the one I thought was gone... shit, I can't stop the grin. Everything is right, everything perfect, here comes Dave. Right on schedule.

Dave's hand surfaces first. Close enough to me that I can reach out and grab it, pull on it. His head breaks water and he gasps for air. Closing and opening his eyes to rid them of the sting, he looks around him.

"That wasn't so bad, huh, Dave?" I say, with this grin still on me.

"No... no problem. Even for an old man. Hello Gary, how you doing?"

We're all smiling and giggling, even Dave as he climbs out of the water to sit next to me. The mood is very high. The feeling, well it's like... like we've all made it. NO, I don't mean like we've all made it to safety, but to some kind of collective state of mind.

"It's even nicer on the hull," says Steve. "Beautiful day out there. Hardly any wind, and the sun is really shining."

"This is pretty nice in here. I can get myself out of that water. Now, that's nice, heh heh." Dave rubs the outside of his legs, trying to get the feeling back.

Gary, smiling, but quiet. Steve talks though.

"Yeah, I could hear Gary talking to you guys and I figured I'd better get down here. Pictured him paddling around trying to get his nose in the last foot of trapped air. Shit, I got down here and he's gone and made himself a nest out of the water, he's basking in the warmth of the engine. Hoh! He even had light right from the beginning, that floating flashlight popped up right in front of his face, bumped into something and turned itself on. Shit, hoh ho. Gary made himself a little bed out of one of the foam pads and, I just can't believe it, but he said he went to sleep for a while. Shit, took a nap! Hoh ho."

Gary laughs along with the rest of us. It really is something the way The Fates took care of an innocent. All that time worrying about him. I mean, he'd never been on a boat before... thank, and there he was dozing through it. Hah ha.

"Hey, Gary," I say, "did you happen to get any pictures of the event?"

"No, I kind of forgot my job for a few minutes there. I think I saw the Instamatic® floating around here somewhere. Guess I'll have to buy Dad a new one for Christmas, hah ha. I don't think this one'll work anymore."

It's like a drunken reunion of old friends. I feel like I've taken a mind-altering drug. I think everyone else is feeling much the same since whatever is said is greeted with giggles more than answers. The room is warm, the air fairly fresh. There's only half-light, just what's coming in at the waterline;

two feet above that the bottom paint of the hull blocks the light. An easy ten feet across to where Gary and Steve sit. Across a gulf of slopping water covered with oil and floating junk. I never thought this thanking cramped engine room could look so big. Never even entered my mind all the times I had to crawl around in here to put new oil in or top off the water in the batteries.

Why are the batteries here? No, that's right, everything is turned over, so they would be on this side now. But I wouldn't have expected them to be floating. Well, you learn something every day. It took just about all the combined strength of Steve and me to lower those batteries down here. Now they're kind of bobbing around between Dave and me. That one's got a cable trailing behind it like a stingray, funny. Shit, I wonder if you could get shocked by those things, they do have an awful lot of amps running around inside them.

"I'm going to have to get you boys down here to clean this place up a little. This is really a mess," says Dave, and it cracks us up. I know he could have just quoted the stock market and we would have laughed, so in our state of mind a joke, any joke, really gets us rolling around. Dave rarely makes jokes. It must be a good sign. He must be recovering a little from the cold in the fo'c'sle. That's good. I was getting uneasy from his silence before. Too much reading about exposure and hypothermia, I guess. According to the charts we should have been dead from body heat loss an hour ago. There's nothing like a little practical experience, a little first-hand research, hah ha. I've never doubted his toughness, but shit, he's got a good thirty years on the rest of us.

Things are looking up, things are really looking up. Boy, what a difference seeing Steve and Gary. What a difference seeing everybody all together with no injuries! That's amazing. Completely okay, and I feel like nothing can touch us. Even if we get killed, which still seems pretty likely, even then we can't be harmed.

It's an amazing feeling. Omnipotent, hah ha.

The adrenalin is still pumping, but it makes me glow now. Makes me feel warm inside.

My teeth are still clattering but from excitement not cold.

No fear. Fearless. Fearless and omnipotent, hah ha, sounds weird. But this feeling is weird. Maybe this is the way I've always wanted to feel. What I've always been searching for. How I felt tripping on acid that first time, but never felt again, until now.

Shit, it doesn't even matter that we're going to die in a short while. Thank it, everybody else is going to die in a short while too, sometimes it just takes sixty years instead of sixty minutes. *So it goes.*

"It's even nicer than this out on the hull. The sun is out. Beautiful day

out there. What do you guys think?" says Steve.

What do I think? Well that sounds nice. It'd be nice to see the sun. What the hell. The engine room is pretty nice too. But then, why not climb up to the top? It would be nicer out in the open, where a guy can see what's coming.

Just as long as we all stay together wherever it is.

## Chapter cxxi
### *The Great Outdoors*

Yeah, that sounds all right to me," I say, looking to Dave. Dave is maybe a little bit hesitant, but he says okay, Gary isn't hesitant at all. We'll all go back to the outside world... the other world... where people live. Steve explains the route:

"When I was coming in, I tied off a lifeline to the batwing. So, all we have to do is follow the line out through the door and under the rail and you're there.

"It's easy, I assure you," Steve spoke in the voice of a guide and host, drawing smiles from his audience.

"Nothing in the way... except for that crab block. Now that is kind of in the way, so you have to watch out for it. Just duck, keep your eyes open through it, and hang on to the lifeline."

As Steve explains, he's lowering himself back into the water.

"Okay, now, h-here's where the l-line is tied off."

His voice is starting to get choppy from the cold. I wonder how long I'm going to have to hold my breath this time. Just coming in here from the fo'c'sle was about my limit.

Steve holds on to the engine and works his way around it until he's on Dave's and my side. Moving along treading water and hand over hand. Now past us and down to the back corner on the other side of Dave.

"Now, you d-dive down or j-just sink d-down and the d-door is right h-here," Steve says, motioning with his hand under the water.

"Okay, through the door, t-turn and w-watch for the crab block. Then st-straight up. I'll be th-there to help you up."

Shit, at least somebody's in charge here. I'm just sort of sitting here listening along with Dave. Here comes Gary, already in the water, moving close, one hand on the engine.

It's very relaxing, looking at Steve and listening to the instructions. It's like I'm in a magic class and the master escape artist is telling his pupils how to do it. Steve's obviously worked this out pretty well, right down to every turn, movement, and a rope to follow. I'm not the least bit worried. Both Dave and I are sitting here in awe and Gary is in the water hanging on next to Steve ready to follow.

I look over to Dave, start to say, nice to have someone around who knows what they're doing during a disaster, huh? But I hold back, don't want the old man to take it the wrong way.

"See you up th-there," says Steve before taking in a deep breath. Then he tenses and submerges.

"Okay Gary, you gonna go next?" I ask, although it's clear he is. He's already starting to take deep breaths. Moves himself over to the spot that Steve just left and looks at us.

"Yeah," he says. I suspect he's probably anxious to get the thank out of here. Who wouldn't be? Well, I was just actually starting to get a little bit warm and, well, this is a lot nicer in here than where I was before, but shit, if everybody else is going I guess I am too.

Gary says "See you," takes a few more breaths, and then he too is under. I can look down into the green glow and see his dark form going out through the door opening. There'll be enough light to see.

"Well, why don't you go next, Peter. I'll follow right behind," says Dave. I think there's the old maritime tradition at play here. The skipper always being the last one off the sinking ship. Giving his life jacket away, that kind of stuff. Maybe he wants just a minute alone down here to look at his boat. He can make it. His toughness keeps surprising me.

"Here I go, Dave," dropping into the water. The stuff is easily as cold as I figured it would be. The balls get sucked right up there. Gaah, shit. Short little breaths… chest getting all tightened up… trying to keep as much of me out of it as possible… that's stupid, let yourself drop! Whoa! Gaahh, up to my neck in it. God, it hurts to breathe. Maybe it'll be really warm outside. That's a nice thought. Sun! "See you in a minute, Dave." A deep breath… as much as I can pull in.

"Pete, I'll be right behind y…" he says.

Under.

I am squeezed by the cold. Can see… stinging eyes, fuzzy, light coming down in shafts all green and gold… cold. Hand here on the line… pull forward and the door… through…. BAM! Ow! THANKIN' sill is now at the top… hard too. Can't… have to turn over here. TOO BUOYANT! Floating jammed against the deck… turn over and half crawl out… water all the way down through my nose  here  Here's the line going out over this way… but it's all backwards. No, no, DON'T THINK! Kick with the

legs and pull, facing the deck, weird... the rail... head on into it. The RAIL! Have to push down off rail to get under STILL TOO BUOYANT! have to force push kick to get deep enough. Block! Crab block stanchion in shoulder, uh UFFFT! Through here LET GO OF THE LINE straight up, up, up NO MORE AIR IN ME! Up UP lighter, lighter, bright and and and SURFACE!

Break through... AIR! HUUUUUHHHHH! SKY! Brighter than shit! All blue above... and that light in my eyes... BLINDING! is the sun. Was it always that bright? Air tastes so good. I'm five feet away from the hull. Up there, standing, silhouette, black, there's there's... Gary? Gary?

"HEEEEYY!" I yell, getting a glob of saltwater in my mouth. It *is* Gary turning to look at me. But look at him! His face is black. Black! IT'S THAT FACE! It's that same face! I saw him before... before this whole thing started. Back at the warehouse. In my room. When? When? This morning, yeah, but it's Gary. That black face this morning looked just like his does now, so thoroughly covered in engine oil. Thank, that's what it all meant. It wasn't my imagination, no way. It all makes sense now. *Klabautermann!* The extra person, that feeling of an extra presence. So much for doubting that premonition shit. Thank, but it doesn't scare me now, I mean, it is Gary, after all.

Thank all this wallowing in freezing water and metaphysical thought, I better get out and onto the hull. Paddle not too well, weighed down by clothes. Flop and move towards the side of the hull. Can't move my arms that well, but I'm so near. And there's Gary's hand coming and I can just... just, there. He pulls me up with great strength. Other hand on the edge of the batwing and get a foot or knee into this space... uh... there, slippery, climbing... so tired, Shit... ahhh. Made it.

"Whew, huh, pretty nice day up here," I sort of giggle it out. They both are smiling, and it is beautiful. Steve wasn't saying that just to encourage us. The sun is huge and hot; the wind just a breeze. Over there, to the east, under the sun, the mountains... but different. Only their peaks visible.

Mist from the beach, a thick curtain, obscures the mountains, except at their tops. Mist that also encases the roar of the huge beach break transforming it into a monotone drone. A sound and mist wall, a barrier.

We're far from the beach. South of the jetties quite a ways, and outside any breaking waves. Huge swells pass underneath us, rocking the boat but gently. The air has an edge to it, still early, still cold. Probably thirty degrees in the shade... but that sun, God, I can't get over that sun. Feels like ninety in the sun. The light from it feels so good, the shaking left as soon as its rays touched me... God's Healing Light... let the Lord's cleansing light in.

♪ *Touch The Hem Of His Garment*, Sam Cooke

## Chapter cxxii
### *Clyde Boomer's Cleansing Light*

It was a clear steel-blue day and I was drawing a cloud. The firmaments of air and sea were hardly separable in that all-pervading azure; the buzzing of the intercom interrupted my bliss. A glance down from my eastern most window spotted the hulking beauty of Clyde Boomer, the Man, the owner, in partnership of course with his lovely wife, Doris, of the Ebony Club.

"Aww, what's buzzin' cousin?" Clyde asked in greeting when I got down to the front door.

"Nothing much," I said. "No fishing today, just up there drawing a bit... what's up with you?"

"Aww, y' know, I need some signs made up. Pete, you like to draw and do those lettering things. I was wondering if I could get you to make some signs. Banners for me to, y' know, attract the customers."

"Yeah, sure Clyde... what kinds of things you want on the signs?"

"Well, look," he handed me a roll of three-foot wide butcher paper, "I got this stuff, it's what the guy there at the Safeway® told me they use for the banners in their windows.

"And here's some things I want to have them say," Clyde jammed a half-crumpled up piece of notepaper into my free hand.

"Oh, yeah," he called back to me from across the street, "can't be any longer than ten feet, 'cause that's how long the window is."

As I walked back over to the stairs and started climbing, I read some of the suggestions Clyde had given me:
- ♥ Live topless girls
- ♥ Eureka's only Nudes
- ♥ Topless Happy Hour
- ♥ Live topless dancers (here he placed exclamation points)!!

I can do better than this, I thought to myself poking around my workroom looking for some black acrylic paint.

**TOPLESS GO GO DANCERS - EBONY CLUB - TOPLESS GO GO DANCERS**
**FULL BAR, POOL TABLES, AND ONE DOLLAR BEERS!**

and:

**WOW! LOOK!!!! wOOw!!! BOUNCING TITTIES!!!
FULL BAR, POOL TABLES, AND ONE DOLLAR BEERS!**

Clyde chose the three or four banners I made similar to the first one even though I had spent quite a bit of extra time putting well-rendered nipples into the centers of the two big O's.

"Here, let's have a beer," he said after I gave him a hand taping one of the banners up in the window. We sat at the bar in the completely deserted and quiet club. I lit a cigarette and the smoke and smell dispelled the rancid gloom like a swirling incense burner at mass.

"You know I fished crab for a season or two. You didn't know that, did you, Pete?"

"Clyde, I just thought you always had the club here... with Doris."

"Well, no, about ten years ago. Crabbing was better then, made good money. Doris took care of everything here during those seasons when I went out fishing. I really only did it as a job," said Clyde Boomer, "I didn't get all crazy in love with it like you and Steve."

"Yeah, I guess I do really love it. It's all I want to do these days. I feel depressed... deprived, when I'm off the boat. Felt fully alive and happy for the first time when I started going to sea. It's just so real... such a completely perfect system. My soul feels like it's back in the arms of my mother, the Sea. A while back, it was so thanking rough. We were really pounding into it. Trying to get to that last string of gear way up off of Big Lagoon, you know. The bow was getting covered with green water... wind ripping... spray all over the place. I had on my Helly Hansens® and I wedged myself up there in the guard rail right on top of the bow... as far forward as I could get... then I put my head up, arched my back and raised my arms straight up and with clenched fists I was just screaming out: '*Oh, the rare old Whale, mid storm and gale!*'

"Bam! right into the top of a swell just fringing! Soaked to the bone, Hah ha! I look around and there's Steve and Dave the skipper, there in the wheelhouse just laughing, dancing around and pointing at me."

"Boy you got it bad," Clyde laughed. "You got that grace-with-the-sea shit, bad. You ain't gonna see many fishermen with that condition. For me it was just another job. A job with the distinct *dis*-advantage of not being able to throw down your apron, your gloves, your hammer and say, *I quit!* then walk away."

"Yeah, that's true," I said finishing the beer and lighting another cigarette.

"Tell you something else that's true, Pete," Clyde leaned in close and his voice, normally playful, lilting, turned serious. "That *grace* thing... that connection with the sea, that *Sea is my mother*, that *Sea cares about me...*

that, all that. That's an illusion, man."

"You really think that, Clyde?" I didn't want to argue. Figured it'd be one of those *agree to disagree* things.

"The sea isn't a loving friend or Mother or... God. It doesn't like you or love you or hate you. Not out to embrace you or out to get you. The sea is just a force, just nature rolling along. It doesn't know you exist. But don't feel bad about that, it doesn't know *anybody* exists, it doesn't know *anything* exists. The sea doesn't know *it* exists."

"Huh?" I said.

"Sorry, man, just motor-mouthing. Look I just about forgot, I got to get this place mopped. Doris is gonna call any minute and the first thing she's gonna ask is: *Did you get the floor mopped?* Give me a hand and I'll share the lunch Doris dropped off for me, okay? Real authentic soul food: black eyed peas with ham hock; collard greens; okra and some of her perfect corn bread. Be good for a starving white boy artist fisherman! C'mon!"

I was stabbing at the floor with the rag mop and Clyde just about grabbed it out of my hands saying, "Let me show you. Christ, who doesn't know how to mop a floor! You gotta dance with it, move it smooth, long sweeping arcs, like this..."

And it was like he was dancing with the mop, swirling around that empty floor while I stacked chairs on tables.

"Hey, hit that B-3 on the juke box. You like *Patches*? You heard this new Clarence Carter?

♪ *Strokin'*, Clarence Carter

"Riiing!"
"Oh shit," said Clyde, "That's Doris."
"Riiing!"

## Chapter cxxiii
### *The Hull Upturned*

"Diiing, din din dong..." The entrance bell buoy. The number two red. So there it is. We're pretty close to it, south of it though. It's rising and falling, leaning over enough to ring its bell. Got pushed, or drifted, way back in and south. The sea buoy... can't see it or hear it. We must be south. Otherwise it's so quiet. The beach's roar is there, but lulling, once in a while the bell ringing. The water is sparkling so much.

"That wasn't so bad now, was it? Where's Dave?"

"You were right about it being nicer out here. I'm glad you talked me into it, hah ha."

"Was Dave coming out behind you?" he asks again.

I'd forgotten about Dave in my thrill to feel that air, light and sun.

"I guess so. Said he'd be right behind me. He should be along in a minute. Probably wanted to look around for a second."

Gary's not the only one who looks strange. Now that there is light and my pupils are beginning to adjust, Steve has a good load of oil on his face too. I can't see my own, but I can't figure why it would look any cleaner. Maybe. Gary was the one who spent all the time in the engine room. Oil must have poured out of that thing when it flipped upside down. Black, dirty engine oil. All over Gary's head, all in his hair and beard. I mean, Steve's dirty and all, but, thank, Gary looks like he's in blackface.

Thank, hey! I didn't lose my jacket. My genuine horsehide flight jacket, with the soft fur collar, shit thank, there's gooey black stuff all over, but that's not so bad. I can clean it, no holes, nice to have it on. Sit down here. Thanking aye, Steve wasn't kidding about it being warm. The hull is dry here!

Bumping near the stern of the boat! Dave? I'm up and slipping fast along the keel with Steve and Gary. It is Dave. His bald head just clearing the water at the stern. An arm goes up to grab at the hull, slips. Then...

"Gaaaffmmmf," Dave's fighting for it. Splashing. Steve and I are both hanging onto the rudder with one hand and reaching down to grab him. The current is pulling him away! Steve gets a hand on his shirt. Then in his flopping and gasping Dave's hand lands on mine and I grab. Pulling together we have him to the hull. His head slips under. Full strength we lift

him, gasping! He's up! Hauling, sliding him up onto the hull. Thank, oh shit, *that* I could do without.

Dave's okay! Still gasping a little, but on the keel. He's getting his breath back. Thank, after all this, all this shit, to have Dave just float off and drown. Cock-biter, that was too thanking close. But he's okay! Thanking aye!

We're all together again. Sitting together on the keel. Dave breathing fast. We're trying to relax again after this unexpected excitement. That was just too close. We exchange glances to acknowledge just how close.

"Lost hold of the line... uh, couldn't get over the rail. Ah, I just kept bumping my head against the rail. Ahhh... and the current was pushing me along... ahh... Nice to be here, I thought for a minute there...," Dave breaks off in mid-sentence. It's nice to have him here too. Now we're all together again. Everybody drying out a little in this sun. Everybody breathing a little easier in this air.

"Well, heh heh..." Dave chuckles. We chuckle too. Tough guy fishermen aren't supposed to hug each other, so we don't.

We drift placidly around. Sitting close together on the batwing. Rising up and over the swells as they come through. The rhythm gets itself set. Quiet, then soft rushing and gurgling as the landward side of the hull dips. A feeling of rising, but softly, then dipping the other way as the hump passes under. More gurgling and the wind from the back of the wave pushes over us, cold. Again and again. Pleasant, soft and hypnotic. My mind drifts also. This is the nicest feeling I've ever gotten from the sea. Its ability to lull. The hours in the fo'c'sle, from another time, they couldn't be related in any way to this gentleness. The horror of a rogue wave hitting us, the ticket to wherever I am now. The stacks and the other landmarks are right there, plain enough to see. The steam rising straight up making the only cloud in all this blue. Like on a Saturday morning ten years ago, I knew that meant I could play baseball all day and it would be warm.

Lap, lap, and lap again at the side of the hull. Doesn't matter that this thing is upside down. Nice day for going to the beach. Probably people fishing off the jetties right now. Would they notice the four of us sitting, talking on the capsized LADY-FAME?

Any boat has the potential to capsize. And if it does, the lack of something to hold onto could be the fatal blow to any survivors trying to cling to its hull. I mean, you could hang onto the shaft, the wheel or the rudder, that's true. True, if you could get up the slick sides to reach them. But these batwings let you climb right up and when you get up on top, they form a real nice bench to sit on. No boat should be without them: *"Now, just lookie here on the bottom: A BatWing*™*! Now, you don't want to be caught at sea without one of these! Skipper, when your fishing vessel is in its normal*

*right side up condition and that sea is kinda rough, this little baby will keep things copasetic. Ride real smooth, cuts way down on the rolling and tossing and puking, get much more work done. That's all fine and dandy, but a BatWing™ really shines when that occasional capsizing occurs! You, Skipper, you and your crew can get right on up there and sit on your BatWing™ all day long waiting for rescue. Sit around talking, smoking cigarettes, maybe even come up with a plan to save yourselves!"*

Shit, I'm not supposed to be sitting here enjoying this. This reverie. All those people on land would be disappointed if they knew I was sitting out here enjoying the view. I'm supposed to be panicking. Supposed to be pulling my hair out trying to figure out what to do. Especially since it's becoming obvious that we are drifting in towards the beach. Not into the beach to have the LADY-FAME gracefully land on the sand and the four of us calmly step off. No. Not exactly.

INTO THE BREAK: *first*, to be thrown from our refuge on the hull; *next*, swept down by a massive wall of white water; *then* the struggle for air; and *lastly*, tons of force smashing us against the bottom (those few seconds will seem like years), the boat crushed, exploding into millions of fragments.

Nothing to hold onto, nothing to keep me afloat, and no way to swim in. After the first wave crashes down, the undertow will hold me against the bottom, tearing me across the rough sand. Then, maybe, for a second I'll be able to move up towards the air, if I know which direction up is. But no matter, when I reach the surface, exhausted and desperate for air, air won't be there. The surface will be covered with sea foam, two, maybe three-feet thick. A layer thick enough that I won't be able to get my head out through it into the real air. Starving for oxygen, unable to fight any longer, I'll try to breathe it. Breathe the foam. You can't do that. A couple of gasping, choking seconds and that will be that. Lungs filled with foam.

So what, it's a nice day. In fact, it's a beautiful day. Like Chief Dan George said in that movie, *Little Big Man*, "It's a beautiful day to die." Maybe he said it was a *good* day. Doesn't really matter.

Steve is up and doing something on the other side of the hull. Gary carefully moves over to help him. I guess I may as well stand up, move these legs a little, butt's falling asleep. Now I can see what's up. Steve is hanging on by one hand to the batwing. His feet wedged in along the edge of the wing, he's reaching out to grab the float there. Got his knife, probably wants to cut the line and save that float.

Oh yeah those floats...

## Chapter cxxiv
### The Tits

Englund Marine had them in stock. I'd never seen anything like them before but as Steve explained it, long liners in the Gulf of Alaska were using them now to mark the end of a set; the end of a string of hooked lines baited for cod or halibut. Steve had this idea to use them as bumpers for the LADY-FAME, buy a pair and give them to Dave, to the boat, as a sort of present for the start of the new season.

Dave hated the old, discarded tires we and every other boat in the bay used for bumpers. His hull was perfect – smooth, white fiberglass – and every time the boat shifted against the dock the crappy old tires would rub leaving filthy looking black marks. Part of my boat puller duties was scrubbing off those marks and trying to keep the tires secured in a way that they wouldn't constantly rub.

"Can't you keep those damn tires from marking up my pretty hull?" Dave yelled at me more than once.

"You're supposed to be so smart. Figure something out!"

It wasn't just me who figured something out. Steve said that he'd seen some hoity-toity yachts in San Francisco using these things, these floats, as bumpers. They worked as well as any tire and left no marks.

Expensive as shit but we'd been making good money, so we each got one. "For the LADY-FAME! For Dave and the LADY-FAME!" we'd cheered only half mockingly.

Back at WACO, we headed straight for Bill ▇▇▇ (the Carpenter) because we were sure he had a basketball pump to get these things inflated.

Almost a perfect twenty-inch diameter ball when full of air, the *Polyform*® A-series buoy was made of a spectacularly bright magenta rubbery plastic material. They seemed very, very strong and the three of us played with them as pretend basketballs for a few minutes right next to Bill's work area.

What kept them from being perfect balls and made the dribbling difficult were the large molded eye-holes for tying them off. I grabbed the two floats by the eye-holes and held them up, chest high in front of me.

"Bazooms!" laughed Steve.

"Big ones!" howled Bill ▇▇▇.

So, with that established, I got the idea; maybe this is what Dave

meant when he said, *you're supposed to be so smart*. Bill ▇▇▇▇▇▇ had some permanent black markers laying around and it didn't take the three of us very long to mark on some very acceptable renderings of nipples and areolae.

Bill the Carpenter was an excellent draftsman so these nipples were very nicely rendered and included believable three-dimensional shading of the central pencil eraser peak and random little raised pimply things out in the pouty surrounds.

I didn't tell Dave about the floats, we went down and tied them off on the side of the hull. Steve threw the old tires on the dock just as Dave arrived. We weren't going fishing that day, too rough, but he'd wanted us to do some cleaning and mount a new powerful spotlight he'd just bought.

I thought he might be pissed, might consider these new fluorescent magenta balls on the LADY-FAME's side to be the territory of phony commodores and dilettante sailors.

But it was nothing like that.

"Thanks, boys," he said and I think he was a little choked up.

"That looks very nice."

The way the balls, the tits, hung, he couldn't see the nipples, just caressed there by the water line.

## Chapter cxxv
### The Symphony

Maybe this stems from all the yelling Dave has done in the past about the value of things that can't be replaced at sea. These floats did cost an unbelievable sixty-five bucks a piece. Maybe that's why Steve's trying to cut it off and save it. The other one's still there too, further astern. We can use them to wave at prospective rescuers, they are bright. Shit, they would have been here by now if they could get out across that bar. Now, if we had a nice helicopter based around here, but they'd have to get here pretty soon the way the LADY-FAME is heading for that break. Maybe Steve's gonna rig a life raft with them, maybe survive through the surf.

Steve somehow gets the line cut without falling in and with Gary's help

passes the float to me. I jam it in under the batwing for safe keeping while we three move aft to get the second. Steve must be tired, I don't want him getting drowned over a thanking titty bumper. If I use his knife and he holds onto me, I can use both hands. No batwing back here to hang from. I get dunked a couple of times, but I get it cut and back to Gary.

And I didn't drop this precious knife, which will be enshrined in the WACO Museum of Holy & Precious Artifacts (if we get out of this): Charles Motherthanker III will gesture with open palm toward Steve's Buck® knife mounted in a glass case like the shinbone of St. Stephen *with his rose, in and out of the garden he goes.* Charles Motherthanker III will say, in his tour-guide voice, *And this is the knife He used on that remarkable day.*

Steve turns back to me and smiles. Both he and his brother climb onto the bench-like batwing and sit looking towards the beach. Dave moves around from his place on the hull and up to the keel near me. Slips a bit, steadies himself with a hand on my shoulder. He and Gary still have their shoes on. The anti-fouling bottom paint, dull red with a slime of algae, is easier to walk on in socks. Dave stands on the keel and looks to the sea buoy. Then, turning a little, he pans around past the jetties and finally gazes into the misty beach. Easy to see what he's thinking about. I already did my thinking on that subject.

It was a clear steel-blue day. So rich the blue sky that the firmaments of air and sea were difficult to distinguish; hardly separable in the azure. Above, the cold air was soft and pure like the look of a beautiful woman and under us, a man-like mighty sea heaved rhythmically with long periods of repose between the thundering swells. A giant breathing in his sleep.

*From here now, I can look back through that clear sky and see how long ago it really was. I was 24. Forty... forty years ago and then some!*

*When I think of this life I have led with its solitude. The selfishness of the artist. Leaving behind the happy peace and quiet of home and family to forever slide into this other place, this war. Forty years of waging war, of launching myself against the battlement of ART!*

*Wife, beautiful wife, children, beautiful children, making of her and of them a widow and two orphans. But if I had drowned then, would she still be my widow had we never met and our children never born? Unfathomable. Always she would promise to await my return; to climb the highest hill to first glimpse the top of my sail on the horizon. Selfishly I continued on. Why? Am I better for it? Is the world better for it?*

*What a fool I've been. Fool... fool... old fool... what?*

"Looks like..."

What?

"...we're still drifting south, and into the break," says Dave. "We're further inside of the sea buoy now."

Steve is finishing tying the two floats together. We all glance around, but we've pondered our fate too much for the official announcement to make any difference. I just nod in agreement.

## Chapter cxxvi
### The Anchor

"I was thinking we might be able to get the anchor dropped to stop us." Dave says. Maybe it's possible. At least it'll give us something to be working on, something to keep our minds off that shore break.

"How can we do that?" asks Steve. "Is that winch set up so it could be released?" The look in his eyes says he's already drawing diagrams in his mind. It would be hard to force myself to get in the water and dive under the bow, but Steve looks anxious to do just that.

"Yeah," Dave answers, "if somebody could reach that valve and put it into the middle position, the neutral position, the anchor should just drop of its own weight."

"The hydraulics don't have to be going, then. Right?"

Steve and Dave planning now, Gary and I listening. Steve has got a lot more guts than me. I know he must be tired, more tired than any of us. I should be the one to try this. But he is a better swimmer. I couldn't even make it from the fo'c'sle to Gary's engine room alone. Steve is stronger, tougher, right? I can't kid myself. I don't think I could do it. Shit. Not the all-important dive under the hull that saves us. Is this cowardice masked?

Steve is readying a piece of line to tie himself off with. Cutting, measuring and getting all the details straight with Dave. Pointing to the bow, going over the location of the valve, where it should be on the upside down deck of the upside down bow. And all the time the boat is drifting. Noticeable changes in the size and steepness of the swells that are lifting us. The wind off the backs of the waves getting stronger with each one that passes. Urgent to get the anchor down now. Time looks to be running out. Steeper, sharper waves now affect the steadiness of the hull. Steve climbs down the batwing, slipping, grabbing, and enters the water. The hull is slopping around quite a bit. With the passing of a wave, the bow comes back into the water hard,

blowing out spray as the trapped air escapes. It's getting too risky to have Steve swimming underneath with the bow jumping so crazily about.

He's a good, strong swimmer, but... thank, the thought of that bow coming down, something, the guardrail, the anchor winch, anything could come down on the back of his head.

Steve's all the way into the ocean, dog-paddling, treading water and half hanging on to the hull. Gary's holding the end of the rope tied around Steve's waist. A wave comes through. Lifting us quickly, dropping us even quicker.

Steve is jostled, pushed... goes under for a second... by the force of the hull hitting back down. The rest of us steady ourselves, holding on to the wing. The hull settles again between waves. Steve pushes away from it, paddles to the bow and takes a deep breath. We're all focused on him. A slight glance up to us, and then down, diving, his feet coming back out into the air as they kick. All we can look at now is the rope jerking.

"I don't think I could have done what Steve did. Diving under with the lifeline to us like that. And now this, back in that water again. I'm pretty impressed. I don't think I could've done it. Do you think you could have, Peter," Dave says, turning to look right into my eyes.

"No, Dave. I couldn't have done it. Remember I couldn't even get under the bulkhead to Gary."

The line moves in Gary's hand. We start the rise up the next wave... shit, Steve, get out of there. Thank, we'll figure something out. Thank, don't get yourself killed. Come on, Steve... c'mon. God, it's been minutes. Must be out of air. But he's still under when the hump of a massive swell moves past and the bow rises, rises... drops... WHOMP! Spray bursting out from all sides, oh shit, Steve, get out of there! There he is! THERE HE IS! Thank! Not hurt. Just gasping for air, hanging on.

"C-couldn't... find it. C-couldn't find it!" he yells, his voice quaking from the cold. "C-can't see very well! Everything's j-jumping all over! Try again!" Oh shit, Steve, not again. Don't push it, don't push it, don't push it! Come on Steve, get out of there! Can't handle you getting killed now!

Steve treads water next to the bow as he takes huge breaths filling his lungs as much as possible. Trying to figure the timing of the next big swell that would rattle the bow. He goes back under. Thank, he's got to be a little crazy, or am I just rationalizing again. The lifeline pulls tight in Gary's hand, he lets out some more slack, looks over at me. I wonder what's going through his mind, back there behind that oil-black face. Gary must be one of those strong silent types. He sure has been quiet. Maybe he's come to the same conclusion about me. Thank, all I can do is sit here while Steve is doing all the work. All I can do is watch and worry.

We must still be getting closer to the beach, the roar is definitely louder.

Not lulling anymore. Just as long as Steve doesn't get hurt. Now, there's a paradox. A strange thought. Don't want Steve to drown under the bow, his head split open by the anchor winch dropping on him. I've already decided that we're going to get snuffed on the violent trip into the surf and I want us all together for that.

Where are the rescuers, hmm? On this lovely clear day. Shit, I could see a person on the beach if there was one there. They'd be able to see us too, "Look, Honey, a fat red whale wallowing on the surface with some big birds sitting on it. I must get a picture!" Hah. Everybody, including the Coast Guard is probably watching a football game. I myself would like to be watching a football game. I don't even know if the 49'ers won or lost yesterday. Yesterday, thank, what a mess that was! Don't dredge that shit up again.

Steve is up again. His head out of the water, anyway, getting air. Thank, he must be finished, must be done, he can't want to go down again. Good, he's coming back to the batwing.

"C-couldn't do it. I just c-couldn't get that v-valve to release. I'm not s-sure I had the valve. Too dark."

Steve hangs onto the wing for a few seconds. Getting his breath back, blowing water out of his nose. Hanging there, soaked to the bone in that freezing water apologizing for failing to do something that none of us would have had the courage to even begin to attempt. Well, I can't really say none of us, I don't know for sure. I know I wouldn't have been able to do it. Maybe, right at the last second, when it wouldn't have made any difference, but I just couldn't bring myself to put my head inside that cold ocean again.

This must be the second rule of *How To Respond In A Disaster;* the rule that comes right after the useless first one:

1). Say the appropriate dialogue from an old B movie.
2). Have a person of heroic nature immediately available.

Seems only logical to me now. The thing that's getting to me is that this is definitely the most real, and I mean gut-level real, situation that I've ever been in. My mind has never been functioning so clearly. My whole person has never felt so completely aware.

And yet... in the back of this clear mind, I'm thinking that this whole episode is unwinding like a movie. Not an Ingmar Bergman film either. Maybe John Ford... I could script this adventure out and make it into a film exactly, exactly like it's happened, and no one would believe it.

"Hah hah," they'd say, "real people in real situations don't act like that."

Maybe yes, maybe no. What do you know? Do you know?

Gary and I help Steve out onto the hull and he sits, teeth chattering, lips blue and tells us:

"I... I th-think I had m-my hand on the v-v-valve. C-couldn't get it to m-move. D-dark under there. Anchor was hangin'... could see that... just couldn't... g-get the thing loose. Banged my head on the guard rail when that wave roughed everything up."

"Well, you tried Steve. You tried and that's a whole lot more than I could have done," says Dave.

## Chapter cxxvii
*On the Beach*

Dropping the anchor. That's the last way, the only way of keeping this boat from going into the surf. It's a relief not to have to think about it anymore. Whether it'd work or not. The anchor might grab bottom too close to the break and keep the boat from rising, thereby sinking it. Or it might not have grabbed hold in the sand at all. Doesn't matter anymore. You can't stop the tide, as they say. Our tide is flooding, towards the beach and doom.

So is everybody else's. Different beach maybe. John V used to always say, "See you at the beach!" Nevil Shute wrote *On the Beach*. Neither were talking about swimming or sunbathing.

Lots of time to consider the beach and doom anyway. Time to look at the birds cruising the waterline, the sun getting higher, and the foam of the break.

Rising and falling, dum, de dum, up and down.

Rising and falling, gentler... gentler.

The roar of the surf, lulling...

Yeah, right... lulling. Softer. Quieter. And getting further away! I think we're drifting back out! Some kind of rip. Some kind of cycle.

"We're drifting back out to sea, aren't we?"

I think I'm the last one to notice. Too lost in thought to see the other three looking around checking bearings.

We're no longer drifting southeast toward the beach. Now, the current must be taking us out. The last bunch of swells I remember were gentler, less steep than those when Steve was diving around the bow.

"I think so," says Dave.

A change in plans here, Pete. Looks like survival. Looks like living and getting back to land and telling people this story and seeing friends and walking around and... thank, in the fo'c'sle it was goodbye, get up here, it's hello. Shit, here comes the beach, goodbye – and now hello, hi, hello.

Steve, still dripping, is up and looking at the sea buoy.

"Yeah, look at where the sea buoy is now. Look at the stacks there, see? They were sitting right over the end of the jetties a while ago, now the angle's different. And from the swells, the way they're going under. Yeah, we're going back out. We may not have to make the big swim after all." He's smiling now, so are the rest of us.

Steve looked around for a minute after speaking, but then sat down with us, like before. We could be in a huge eddy of some sort. First in the break near the sea buoy, then slowly drift down and into the beach to the south... in, out... and then north for a while, back to the beginning to start the cycle again.

I read about some poor old seaman who floated out here on a hatch cover, back and forth, in and out, for five days. Always within sight of the beach and safety, never close enough to swim for it. Five days. Never further than a few miles from the point his ship went down. Of course this was a sea story from the good old days of iron seamen and tall ships. And maybe it was summer. This non-ferrous seaman is going to get pretty thanking cold as soon as the sun goes down.

"If we could get one of the drag boats out here, I think we could get this thing turned back over and save it. It'd be nice to save it, only got hull insurance on it. That wouldn't be enough money to build a replacement for this boat," Dave says, sounding very hopeful of survival; starting to think of the LADY-FAME and of tomorrow. He used a word I'd never heard before: Parbuckle.

## Chapter cxxviii
*Parbuckle*

Parbuckle, (verb): A traditional technique for lifting and shifting cargo, large logs, or, capsized vessels. A line, or even better, two lines would be run from a drag boat stationed stern to the hull of the LADY-FAME. Those lines would pass over the top of the upturned keel and down the far side of our boat. Then, divers would take the lines under, across the submerged deck and wheelhouse of the LADY-FAME and secure them to the rail or gunwale on the side now closest to the tug. Airbags would be inflated within the hull and also along and under the far side. Winches on the dragger haul the lines in and if the hull is solid and airbags are in the right spots – *Eureka!*

## Chapter cxxix
*Briefing for a Descent into Hell*

I would like to see a drag boat, see it and get on it. Then, maybe, I'd be thinking about saving this boat. I mean, I appreciate the fact that this hull has seen fit to withstand a tremendous beating by those waves. Seen fit to hold air trapped in itself to keep us afloat... keep us, three of us anyway, breathing. You know, I really appreciate that whole bit. But, uh, shit thank, I want to be sitting on a right side up back deck, drinking coffee and smoking cigarettes. Then, I'll start thinking about tomorrow. I'm still not sure anybody will be coming out today anyway... Christmas Eve... Easter would be more appropriate what with rising out of our fo'c'sle tomb.

Roll away that stone there, mother thanker... Uh Oh, blasphemy... don't see any whirlpools or Jonah's whale though.

"Do you think one of the draggers will come out today, Dave? They wouldn't want to start a trip the day before Christmas, would they?"

"No, no, I mean if Ray told somebody that we'd gone out, they might want to come look for us. Ray must've gotten worried when he couldn't get us to come back on any of the radios."

"Well, it'd sure be nice if somebody did come out. I think it might get a little cold out here tonight," I say.

"Hah, yeah, they oughta be able to. Look," Dave motions to the bar. "Look, the tide's flooding now. Bar probably isn't that bad."

"It'd be nice," I say.

It's true that what we bumped into this morning was partly a result of the tide rushing out and running into the swell, pushing it up, steep, impossibly big. Maybe now, with the tide going the other way, they can cross the bar.

Looks like we're going to drift for a while. I hope that after all this shit, somebody did notice that we're missing.

I read this Doris Lessing book that had the principal character drifting at sea in what was left of a dismasted sailboat. Drifting around in a great clockwise circle in the mid-Atlantic. All alone. Coming close to Africa only to swing south and west. Eventually nearing Brazil, only to move northeast out to mid-sea again. Stuck in the doldrums, the constant Atlantic currents, the Horse Latitudes or whatever. Round and round. The crazy thing was, this guy was actually in a mental institution in England the entire time! I don't really know what prompted Lessing to seize upon this as being the best metaphor for complete detachment from reality, but she got it right.

♪ *Sisters of Mercy*, Leonard Cohen

## Chapter cxxx
### Purgatory

Steve glanced at me. His big smile and clear blue eyes guided my attention towards Dave in the wheelhouse. I shot a quick look over my shoulder being careful to not lose my pace, my rhythm, and I caught a quick glimpse of our skipper, ecstatic, bouncing almost dancing with one hand on the wheel, the other pushing even more RPMs out of the diesel with that throttle. Dave turned back as if knowing my eyes were there and put out a huge shit-eating grin and what might have been a howl. I couldn't hear through the closed door and over the screaming cackle of the GMC®.

That stove must have been cranked way up in the wheelhouse because when Dave popped out the door he was wearing only a T-shirt and saggy white briefs. Face all red and fat belly bouncing, still grinning like shit, he fired off three or four rounds from the boat's .22 revolver into the overcast sky at nothing in particular and let out a howl like a crazy wolf. Then back to the wheel within ten seconds. (I'd seen that happy pistol dance before, but it was warm then, back during salmon season, early July – Dave's birthday.)

We were going through the gear as fast as possible. As fast as any crab fishermen on the North Coast of Anywhere have ever gone through gear. Faster, mother thanker! Three sets of sixty already. Less than a minute went by from the instant I put the hook around that top buoy and wrenched the line into the block, wrapping under that first spindle over the top in the groove under that back spindle and then push the valve all the way open and the line screams spitting saltwater all over us as it flies onto the deck, coiling almost by itself with just the slightest direction from my hand. The pot is on the rail on the landing and we have it open dumping, picking crab out, tossing females back, baiting the holder with fresh squid, snapping the lid tight again. Steve tosses it back to its watery abode, arches out of the way and I throw the coiled line and buoys after it. Turning, shifting at the same time as the release like the highest paid athletes we are, to grab the fourteen-foot long bamboo with its hook, then instantly on the next buoy. There's no slowing, no throttling back, no missed buoys. Dave has the spacing of the set perfectly timed. Full blast, mother thanker!

There's a fifteen-minute run up the hill to the next set and I grab coffees for the two of us while Steve lights two cigarettes.

"Thanks, Pardner," I smile and take the smoke while handing him the navy mug.

"It's starting to snow," Steve says, looking in toward the beach.

"So it is, so it is," I hadn't really noticed but in the last hour the sky had clouded with a soft grey overcast matching almost perfectly the color of the sea.

Looking toward the beach, I could see nothing but grey. A single tone, uniform from the rail my hand rested on and out as far as I could see. Unvaried when I looked overhead and followed down to the opposite rail. No horizon, no bright patch of clouded sun to offer bearing.

The only relief from this grey purity – fat, soft, white snowflakes drifting slowly down everywhere.

We smoked and gazed, outside of time, until Steve, tossing his butt over the rail, said:

"Perhaps this is it."

"What, heaven?" I asked, suspecting his thoughts were in the same place as mine.

"No, not quite. We just keep doing this, endlessly running through gear, forever, for eternity. All grey, with fat white snowflakes falling. Purgatory."

Only a second or two later, he yelled,

"Heads up! There's the first buoy!"

♪ *Music for 18 Musicians,* Steve Reich

*Chapter cxxxi*
*The First Sounding of The Sea Buoy*

"Thought I broke it, but it's only bruised. The edge of the batwing really jammed into me, when that wave broke right on top of us. Got flattened backwards, hoh... oh!"

"Let me see there," says Gary.

Steve slips off his red suspenders and pulls the tails of his hickory shirt out of his black Ben Davis® pants and lifts it up, so Gary and I can see a nasty red bruise near the small of his back. Doesn't look too serious, not bleeding, fortunately. Must hurt like shit.

Let's see: Steve's bruised back; Gary covered with oil (but thank, he took a nap!); Dave, possible hypothermia, but no broken bones; and me, just a small half-moon of cut and pushed back skin on the first finger of my right hand. Dull white now, must've been bleeding before.

So, that's it. Nobody hurt. It would seem hard to believe when we got tossed around like that. So many things to crack a skull against, so many ways to break a bone. Pretty thanking lucky, I guess. Or what, a fluke?

When your number's up, you'll slip and crack your head in the bathtub, no way to avoid it. When it isn't, well... look at all this shit that's happened. I can't say I wasn't warned something was up. That feeling this morning was pretty clear... *Klabautermann*! Hah Hah! Maybe just before they die, everybody gets that feeling. No one ever says anything about it. Especially since it wouldn't make any difference. Stay in bed or go skydiving. That *feeling* brings with it the full understanding that it doesn't make any difference what you do. *Somewhere beyond the sea, somewhere waiting for me...*

♪ *La Mer*, Charles Trenet

I'm singing, to myself of course. But I could sing out loud. As loud as I wanted, these guys wouldn't care. I'll have to remember not to mention how pleasant it is right now, basking in the sun with the fellas, to all the awestruck listeners as I tell this story. Maybe I'll build up all the horrible parts. I don't really have to, the truth is weird enough. Maybe it'd be a better story if I seemed nonchalant:

*Well, ya see, it was then that the forty-foot wave hit us...* and watch for their dropping jaws.

Shit, what am I thinking about here? What's going on? The rebirth of the Ego? Didn't think I'd be seeing that little thanker around for a while. But, here He is, sneaking back in, asking for his old job back. There have been some changes made here... mother thanker! Yesterday is a long ways away. I was somebody different then. I hadn't died then. It's all changed now. Poor Rich, I could help him now. All the anguish yesterday and last night seems so far away and yet so connected to where I am right now.

"We might be able to get a line on it and tie the boat off to it. Keep us from drifting around all over the place out here," Steve says.

He's talking to Dave and Gary about something. I must have been drifting all over the place myself.

WOOOOOOOOOOOOOOOOOOOOOOOOOOOOOO aaaaaaa.

SHIT! The sea buoy. As mournful as any hobo's, any country guitar strummer's, lonesome midnight train whistle. The sea buoy is closer than ever. Steve must be thinking ahead, figuring that if we pass close enough to it, we could tie off.

"There isn't enough rope right here Dave, but I could dive back under and get some."

"That seems like a good idea. Think you could lasso that thing, heh heh. Keep the LADY-FAME out of the surf until we can get back out here with a big enough boat to flip it back over," Dave says.

"Well, it, looks like we'll come real close to it. I could swim over to it," Steve suggests. Should be my turn but I can't swim worth a shit.

The spot to the north of us, the area between the sea buoy and the jetties, is where all the wave action is. An occasional set comes through with one or two cresting impressively, white fringe on the top, spray flying back. I hope help gets here before we reach that shit. Tying off to the buoy doesn't look like it'll be much fun, if even possible. We'd be bouncing all over, have to tie ourselves to the hull as well. Thank, if we're still out here after dark we could thank up the buoy light somehow. The Coast Guard base is right there, I can see the tower on top of their building. Steve said when he first got up on the hull, hours ago, he could see them inside turning on a light here, turning another off. We were closer then, but shit... eventually, it'd dawn on them that the sea buoy was out of order. Maybe Ray told them about us and they're on their way. They may not want to cross that bar. Looks like it's closed out all the way across. They do have those forty-four footers. Those motorized lifeboats that are totally unsinkable.

"Do you think we'll come pretty close to the sea buoy? We must still be two-hundred yards away," I say to the others.

"It's a chance. I think I could swim fifty yards to it, if we came that close. It'll be a long time before we have to worry about that anyway," Steve says. "It's a chance. Something to keep occupied with."

## Chapter cxxxii
### *The Second Sounding of The Sea Buoy*

Yesterday is a long ways away. I was somebody different then. I hadn't died then. It's all changed now. Poor Rich, I could help him now. All the anguish of yesterday seems so far away and yet so connected to where I am right now.

"We might be able to get a line on it and tie the boat off to it. Keep us from drifting around all over the place out here," Steve says.

He's talking to Gary about something. I must have been drifting all over the place myself.

WOOOOOOOOOOOOOOOOOOOOOOOOOOO aaaaaaa.

SHIT! The sea buoy. Closer than ever. Steve must be thinking ahead, figuring that if we pass close enough to it, we could tie off.

"There isn't enough rope right here, Gary, but I could dive back under and get some."

"That seems like a good idea. Think you could lasso that thing?" Gary asks.

"Well, it looks like we'll come real close to it. I could swim over to it," Steve suggests.

The spot to the north of us, the area between the sea buoy and the jetties, is where all the wave action is. An occasional set comes through cresting impressively, white fringe on the top, spray flying back. I hope help gets here before we reach that shit. Tying off to the buoy doesn't look like it'll be much fun. We'd be bouncing all over, have to tie ourselves to the hull as well.

I can't swim worth a shit, and if we only get one shot at it... Ego or not, it'd be stupid to lose our one chance. Steve's just planning ahead.

"Do you think we'll come pretty close to the sea buoy? We must be a hundred yards away," I say to the two of them.

"It's a chance. I think I could swim twenty-five yards to it, if we came that close. Still some time before we have to worry about that anyway," Steve says. "It's a chance. Something to keep occupied with."

## *Chapter cxxxiii*
### *The Third Sounding of The Sea Buoy*

Yesterday seems like years ago. I was so different then. I hadn't died then. It's so different now. That poor sad Rich, I could help him now.

"We might be able to get a line on it and tie the boat off to it. Keep us from drifting around all over the place out here," Steve says.

"What?" I must have been drifting all over the place myself.

WOOOOOOOOOOOOOOOOOOOOOOOOOOOO aaaaaaa.

SHIT! The sea buoy. The sea buoy closer than ever. Steve must be thinking ahead, figuring that if we pass close enough to it, we could tie off.

"There isn't enough rope right here, Pete, but I could dive back under and get some."

"Think you could lasso that thing?" I ask.

"If we come real close to it... I could swim over," Steve says.

This time, should be my turn. But I can't swim worth a shit, and if we only get one shot at it... Ego or not, it'd be stupid.

There to the north of us, the area between the sea buoy and the jetties, that's where all the wave action is. Tying off to the buoy... if even possible... those waves are pounding through there big... we'd be bouncing all over, have to tie ourselves to the hull as well.

"Do you think we'll come pretty close, that close to the sea buoy? We must be fifty yards away," I say.

"It's a chance. I know I could swim ten yards to it, if we came that close. It'll be a while before we have to worry about that anyway," Steve says. "It's a chance. Something to keep occupied with."

## Chapter cxxxiv
### The End

Looked like fifty, sixty yards, a distance I used to specialize in back in Eureka High track days with Kento, sprinting, but I was never much of a swimmer. When Steve, Kento, Groovy Daddy and I headed to Shelter Cove for surfing, I started taking along a camera and tripod. Sent away mail order for a telephoto lens and started taking pictures. A way of being fully immersed in surfing without being fully immersed in surf.

WOOOOOOOOOOOOOOOOOOOOOOOOOOOOOO aaaaaaa.

"I saw a shot of line under the bow last time I was down. Big coil of that new green poly that Dave just bought. Those were all twenty-fathom shots. Should be enough," Steve said.

"It's starting to get thanking bouncy again, Stevie. The swell must be building again."

"Maybe just a set... there'll be a lull comin' up here..."

On the LADY-FAME's reddish greasy hull (seeing the sun now for the first time since the ways), both of us seamen waited, inactive, nearly dry now. Moving our hands in phantom smoking pantomime to our mouths. Our four mesmerized eyes intent on the sea buoy. Red and white, its vertical stripes leaning from forty-five degrees beach ward, then back to the vertical, then forty-five to the sea. And all with its mournful wail!

"FAREWELL... OOOOOOOOOOOOOOOOOOOOO... farewell...

Closer now, closer still than we had ever passed and though the seas were of great height, Steve pulled his watch cap tighter down over his ears and quickly slipped down the side looking back at me with only a "Well..." in his eyes. I pulled my way tighter to the batwing as the drop on the backside of swells was jarring, and when that bow came down it pushed out a white fountain of foam.

Steve dog-paddling, timing (in water so cold!), waiting for a lull (so short now!), then down under and under the bow for the line.

I see the rogue swell and it's on us, under us, we and this hull are like a surfer turned turtle, jammed tight as a short fringe of green and white actually breaks over us pushing the stern back and holding it then RELEASE! as the hull goes through and the bow snaps down too hard bashing into the hollow left by the sea passing. WHOOOOOOMPPPP!!

# THE END

"STEVE! Steve! STEVE!" I'm screaming but I can't see him in the water. Where is he? Why so long? I get out from under the batwing and stand almost up, one hand holding, hull is steadying but the sea buoy... so close now!... is over almost horizontal.

WOOOOOOOOOOOOOOOOOOOOOOOOOOOO aaaaaaa.

Maybe I slipped, doesn't matter now... I'm in it and under... insane insane cold. I pop up.

"Ste-Ste-Ste-Ste-Ste-Ste..." can't even voice his name. Where? mother THANKING shit! Steve was under the bow and... and... I'm under again. My eyes are open, my eyes are open, mother thanker. I see the anchor block, hatch still closed to the fo'c'sle, I can see the window openings thick cold water green soft outline of wheelhouse STEVE! WHERE? Can't see him. Thank. THANK. THANK! Did he get pushed back inside? Oh shit Shit gotta get air AIR! Gotta breathe Up Up Up GAHH!

Gasping as I reach the surface, my head passes through a coil of crab line like a fool playing with a cocksucking Christmas wreath! THANK ME DRY! It's the coil Steve was after! I hold myself on the bowsprit... the ocean has settled into another lull. What the thank happened?

WOOOOOOOOOOOOOOOOOOOOOOOOOOOO aaaaaaa.

Cock-bite! The thanking sea buoy is right there! Ten thanking yards! I gotta do it, I gotta do it. Has to be! Has to be! Steve must have been pushed through an empty window, yeah he's okay, maybe a little shaken up... probably right back up into that nice warm engine compartment, mother thanker! Laughing and figuring how funny this is. Hah Ha! Has to be!

I gotta tie off. I gotta, then Steve will be all right. Once it's tied off, Steve will pop right up and we'll be back to warming ourselves like seals on a rock, yeah, hah!

Working my way down the hull to the batwing with frozen hands that just barely open and close but I can hold this rope this coil this line. I'm going to hold it, Steve! Pull out the tits from their tight spot under the batwing and now I'm a real swimmer with my water wings! My tits of float! My Mother Arms! Manage to get a good solid bowline on the rail at the bow.

WOOOOOOOOOOOOOOOOOOOOOOOOOOOO aaaaaaa.

Thaaaank, that is SO loud. But the sea is quiet now... that was it, that last rogue was the last rogue. I can half paddle half kick my way to the buoy... got it! Cold hand on cold hard steel. Water in my eyes my nose my mouth. Hooks to grab onto and... thank... it's pulling me down. A huge wave pulling the three-ton sea buoy over on its anchor but I gotta tie this line.

WOOOOOOOOOOOOOOOOOOOOOOOOOOOO aaaaaaa.

Thank me! THANK ME! No human ear was ever meant to be so close

to that sad horn. Buoy's really laying over... Shit I'm a little tangled shit TANGLED caught here get this line  can't get my left arm out  tight and tighter around my chest  the line pulls back strong to the LADY-FAME and STEVE! Sea buoy massive and powerful taking me, bound to it, down with it  no breath  where are my tits?  don't matter  don't matter  don't...

WOOOOOOOOOOOOOOOOOOOOOOOOOOOO aaaaaaa.

I rise up in the spray and foam now  can't thanking  line wrapped around me so tight  if I can jus... right arm floating free and up... under, under, pulling hard, pulling to boat  so tight  too tight...

Where's the boat? There! Foam, spray, and SLOWLY COMING UP! righting itself in the passage of the swell. Mast and guys trailing long black kelp... dripping, fading phantom. Breeching upright to forty-five degrees. Glimpse again that proud name painted LADY-FAME! And now she slips under, bubbling, spraying... concentric circles of foam seizing all round and round in one vortex... carry all trace... slips out of sight. Burning saltwater in my eyes filling my mouth and nose... no breath... hull going down, sounding, crab line holding fast pulling sea buoy down... me still tightly bound... pulling all all... down.

The tits, there! someone... someone. Under. Under. Steve.

*Finis*

♪ *Pleasures of the Harbor*, Phil Ochs

[EPILOGUE I]

[ROUND AND ROUND, THEN, DRIFTING WITH HEAD
HELD BACK BY THE GNAWING, SCRAPING ROPE UNDER
ARMS AND THESE FAT BUOYS TIED TO IT.
UP WHEN A SWELL COMES THROUGH.
VERY SWEET LIKE A MOTHER HOLDING.
WARM AND SWEET AND MOTHER'S TITS.
THEN PASSING UNDER. FLUTTER, FLUTTER WIND.
MOTHER MOTHER PASSING UNDER,
SPITTING MIST IN EYES BLINKY BLINKY TEARS.
BUZZING, BUZZING, FLY SO FAT ABOVE THE KITCHEN TABLE,
GOOEY DRIBBLE OF HONEY.
SLOW AND BUZZING JESUS WAY ABOVE HEAD IN THE SUN.
BUZZING SLIGHTLY, FADING AND PULSING BACK WAY
ABOVE HEAD HELD SO FAR BACK, BUZZING ABOVE HEAD,
BUZZING THEN GONE, ECHO WHEN WATER LAPS IN EARS
AND OUT, BUZZING, STRAIGHT UP ABOVE IN FRONT OF THE SUN
AND SPINNING ROTATING A TINY JESUS ON HIS CROSS,
A BLACK SPINNING CRUCIFIX SPINNING CALMLY,
SLOWLY BUZZING, SLIGHTLY, WAY, WAY ABOVE HEAD HELD BACK.
BUZZING ABOVE THE LOW ROAR AND THE PULL OF THE SEAS
SO RHYTHMIC AND WARM AND SWEET,
BLACK SILHOUETTE CRUCIFIX HIGH AGAINST THE SUN
AND DEEP BLUE. JESUS. IT'S NOT A JESUS, IT'S A LITTLE TOY
AIRPLANE. GOING SO SLOW AND LOWER NOW.
AND AROUND AND AROUND.
TRY BUT FAIL TO RAISE A HAND IN SALUTE AND WAVE AND YELL,
"HEY! FRIEND. HELLO!" BUT ARMS ARE NOT THERE.
CAN OPEN MOUTH IN A SMILE BUT MAYBE JUST AN "O".
A SOFT SMILE. THE AIRPLANE TIPS HIS WINGS TO SMILE BACK.
THIS IS REALLY OVER NOW. DRAMA ALL DONE.
VERY QUIET WARMTH RINSING THROUGH GROIN
AND SPINNING WITH HEAD HELD BACK BY THE ROPE,
THE BUOY ROPE AND BUZZING. NO WIND NOW, BUT THE WATER
AND SALT LAPPING UNDER CHIN GENTLY MAKING NECK, EARS...
GIVING THAT NO FEELING... THE COLD.
ANOTHER SWELL PUSHES UP. CAN FEEL THAT.
THEN ONLY THE TINY BREEZE WHEN THE WAVE PASSES
UNDER AND ON THE BACK SIDE, THE OUTSIDE.
"LADY-FAME?"

THE SUN VERY BRIGHT IN EYES.
THERE IN THE BRIGHT A VOICE ASKS,
"LADY-FAME?
"IS THIS THE LADY-FAME?"
"AYE, I... AYE... I, ONLY..."
"IS THIS ALL SOULS FROM THE LADY-FAME?"
ASKS THE BOATSWAIN'S MATE FROM THE BOW
OF THE FORTY-FOUR FOOTER.
HER THREE MATES ALL LOOKING IN... MY EYES... GLISTENY
IN THEIR BLACK WETSUITS... ALL LOOKING DOWN AT... ME...
DRIFTING, FLOATING, BUOYED BY TITS.
"AYE... I ONLY..."
"YOU? YOU ALONE?
"ARE THERE ANY OTHER SURVIVORS?
"IS THIS ALL SOULS?" ASKS THE COXSWAIN.
ALL SOULS, YES, THAT'S IT.
LOOK UP AT THEIR FACES. YOUNG. LITTLE BOYS. A GIRL.
THEY SEEM SCARED.... MAYBE IF I SMILE... MAYBE I CAN SMILE.
MAYBE IT IS THEIR FIRST TIME.
THE COXSWAIN ON THE OPEN BRIDGE THROTTLES BACK
TO WHERE THE ENGINE IS JUST BARELY TURNING OVER, ONE,
MAYBE LESS, REVOLUTION PER SECOND.
A SOFT BUBBLY THUMP... THUMP... WHUMP... WHUMP...
"WHAT IS YOUR NAME?" ASKS THE BOATSWAIN'S MATE.
SHE DOESN'T YELL, IT'S ALL SO QUIET NOW.
HER VOICE IS SWEET AS SHE SLIPS INTO THE WATER NEXT TO ME.
"CAN YOU TELL ME YOUR NAME? I'M BOATSWAIN'S MATE
RACHEL ████, AND I'LL BE RESCUING YOU TODAY,"
MY... MY BOBBING HEAD AND HERS ALMOST BUMPING
AS SHE REACHES FOR ME... ME!
"SURELY... SH... ," AND THEN I SAY IT.
I REALLY DON'T KNOW WHY I SAY IT,
AND IT COMES OUT IN A WHISPER:

"I ONLY AM ESCAPED ALONE TO TELL THEE."]

[FINIS]

*Epilogue II*

The wind's died again. Down to just a flutter. Now the roar from the beach is being matched by the roar of the bar. Not that either is really making a lot of noise. Just a steady, low roar that's there in the background. The bell on the bar buoy clangs when the right sized wave pushes it over far enough. Every once in a while the soft ringing. And that drone. Buzzing of an airplane, a long ways to the north, beyond the jetties. There it is. Over the top of where the old airport used to be, the Samoa Drag Strip now.

Droning along, getting louder and heading right for us! Jesus, they might see us. They could tell someone! They will see us!

Up on my feet looking, so are Gary, Dave and Steve. They've heard it too. We all see the little plane now. Closer and louder, a small Cessna it looks like. Gold and brown and white. I look around at the others, all of us starting to jump and smile. Dave looking younger than I've ever seen, laughing, bouncing, smiling, grinning wide, hooting too, even Gary, hooting and slapping each other on the shoulders. And Steve taller than ever, big smile, big smile to me and slipping, slapping, laughing.

It's obvious. The plane is coming right for us, as though it spotted us from a distance, as though it was looking for us! Looking for us! We all jump and yell and wave our arms madly like you're supposed to. Can't help it. The plane doesn't mind. Brave and true and right on top of us! So close I can see someone looking down and they are waving too. The airplane is waving! Waving its wings, circling over us. So close. The pilot circles and heads back towards the jetty. It takes a minute or so for us to stop hooting and jumping and all the back slapping. We are going to make it! We are really going to be rescued! I promise I won't ever laugh at people waving and yelling at a rescue plane in the movies. It just happens, you can't help it!

The Cessna flies on north, until it's over the bar. Following along with my eyes, it starts to turn... look down... and there's a boat! A boat!

"A BOAT!" I yell. Everyone else sees it too. White hull, just outside of the North Jetty. How did it get out? It's turning NORTH! No. It turns, the plane is guiding, circling. They both start to head straight for us. We are going to be rescued, and soon.

Right now!

The four of us can't get the grins off our faces. No talking just laughing. Only a few seconds pass, and then the sound of the throttle cutting back on the forty-four foot motor lifeboat. Bobbing right there next to us.

I can hear the radio, distorted, saying things in the background. One of the Coast Guardsmen, dressed in a red and black wetsuit, steps out to the bow. Ten feet away now.

"Is this the LADY-FAME?" he yelled.

"Yes," Dave answers.

"Is this all of you? Is this all souls? Is this all souls from the LADY-FAME?" the Coast Guardsman asks. Souls, maritime tradition.

"Yes," our skipper says.

The Coast Guard boat slips its bow right next to our hull. The boatswain's mate has his hand out. We each step, a long step, to the lifeboat's bow. We are off the hull quickly. I am off the hull. I am saved. This writing is done, this curse of truth-telling broken, lifted after so many years. I can lie. I can lie. I am saved.

*Finis*

♪ *A Change is Gonna Come*, Sam Cooke

## Chapter cxxxv
*Steve's Story*

[Handwritten in ballpoint pen on both sides of lined notebook paper, several days after the incident]

*23 asked Gary if he wanted to go along crab fishing and take some movies.*
*24 morning - Jan woke me up. It looked like it was blowing so I called Pete to see if we were going fishing. Pete didn't know but called back a few minutes later after having called Dave and said yes.*

*– Gary Jan & I drove down to Lazio's. Driving into the parking lot I ran into a timber. Pete and Dave were already there. We cast off and went up the bay to Nor-Cal and got our bait. We made bait and went into the wheelhouse. Nothing remarkable going down the bay.*

*– Surprised to find a new green buoy off the corner of north jetty.*

*– As we were nearing the bar I noticed the roughness and went out on deck to look around. I stayed on deck a few minutes and came back in as we were going over the bar. The waves were starting to get sharper.*

*– Still going out. Dave asks Pete if he can see the sea buoy. It keeps disappearing.*

*– a very sharp one appears - fringing on top and it slaps us as we go over it. it knocks the bow around and Dave is bending over turning the wheel around. We spot the sea buoy, we are not far from it. It's quite bright.*

*– Dave looks thru the window and says "This is going to hit us hard." as I look out the window to the right. I see a large mass of white growing larger and larger.*

*– The bow lifts suddenly.*

*– concussion and a loud roaring begins.*

*– as we are hit I see 2 or 3 windows being pushed in simultaneously. They are followed by green water.*

*– darkness, cold, spinning, the fear.*

*–*

*– I realize my face is in the air. I start to breathe. A humming, a vibration. The engine is running and my head is against it. We are upside down, the floorboards have fallen out.*

– The water is rising. The engine stops. Time to move. I take a breath and start for the door.

– I pick the right direction and have my hands on the door jamb immediately.

– as I pull myself thru the door I feel the turbulence again. Another one hits us. I reach out and grab a chain (stabilizer). It's there. I clamp on with both hands. Very turbulent! I try to relax all my body but for hands and arms. Splish splash. Then Quiet.

– I pull up the chain to the rail and duck under.

– The hull looks really big. It's very peaceful and quiet out here. The moon is out. The water's glassy and dark. Lots of things floating around the boat.

– I climb up the batwings and look around. Is someone out there. "Gary!" "Pete!" "Dave!" My voice scares me and I shut up.

– Try to walk along the hull but I slip. into the water. I swim back very fast and up the batwings. I throw my boots away.

– I sit on the batwings and look around. Still dark and very peaceful. The lights of Eureka and Humboldt are very clear. So are the lights of the Coast Guard station and the jetties, especially the range light. Flash. Flash. Flash. I can see the sea buoy NNW. We've drifted south. It's very quiet. Large swells are passing under us and the LADY-FAME is rocking and gurgling. Mostly quiet.

– Occasionally (5 or 10 minutes) a cleanup set comes thru. I can see them coming when we're on the top of the swell. Fear. It takes them a while to get here. The other waves are big but these are something else. I'm sure they're going to break. One comes marching in. Steep and steeper. As it passes underneath it pushes the air and really makes it cold. As it passes I can see the next one. This one will surely break. It passes underneath too. 7-9 to a set. Some of the last ones are fringing on top. Some break 100 yards inshore. There must be a slight offshore. as they break a mist comes raining back. cold.

– Several of the sets have come by and I'm getting nervous. I don't know if the boat has much of a chance but I want to stay with it. I really don't have much of a chance swimming around by myself. I'd better get secure.

– I climb down the batwing and into the water. and start feeling around under the rail. I grab a coil of crab line and cut it off. and back on top.

– The batwing has a hole in it so tie about a 40-50 foot life line thru it and crouch down and wait. Hopefully I can stay with boat like this.

– There's not much to do now but think. And not many positive things to think about. I can't tell if we're getting closer to the surf line or not. The only thing I really regret is getting Gary killed. Apparently they're all gone. It's getting light anyway!

– I just sit and wait for the sets to come, occasionally glancing around, a beautiful morning.

– A big set comes. Very scary. ~~As I~~ As we go over one I know it's the end, the next one will break. The waves are quite far apart. It's quite a ways away and

it's really steep. A section of it breaks to the north. It gets closer and I jam into my niche. The top starts over and I close my eyes. Right on the boat.

– I managed to stay aboard but I think at first I broke my back but just roughed up. Not that it's very critical. Very strong pessimism. Not long for Steve and the LADY-FAME.

– Things start to pick up. I can see we've drifted to the southwest. The sun's coming up.

– I hear a knocking and put my ear to the hull. A voice. It's Gary, "I'm in the engine room. I'm in the engine room." I try to knock back but I can't make much noise.

– Then I hear another voice. The voice and Gary are talking. I can't tell who it is but try not to think about who's missing.

– I decide to go inside the boat. For several reasons. I want to talk to someone and they might want to come out.

– Back in the water. I try to go under the rail but get tangled up in the crab block. Catch my breath and try again: between the block and the rail. I find the door with my hands (it's still fairly dark under there) and start to pull myself thru. I bump my head on the foot step. I pull down and thru and bump into a bunch of junk floating in the wheelhouse. Out of breath. I follow the line back out and climb back on the hull. Later!

– I decide to try when it's lighter and spend my time spacing out and occasionally trying to figure the route between where I am and the engine room. The brain is not working very fast. It tries to but I slowly force it to work out a solution to the problem. Try to think.

– I sit for about an hour. We have drifted even farther to the SW. It's light enough for another try. But I've started to dry off a little and am feeling a little warmer. But I force myself to imagine them inside the hull with the air getting worse.

– I climb down till I'm knee-deep but I stop again and start playing games with myself. I want to try the swim between sets, but I diddle around and by the time I'm worked up enough to get back in the water, another set comes. This goes on for 20 minutes. Finally, I get disgusted and get in the water and wait for a calm.

– First try is half-assed and I get mixed up in the crab block. Then I get to the door but have trouble with the door; back up for a breath.

– Back down under the rail, find the door, thru the door, I'm inside but can't figure where I should go to get to the engine room. Air! Back out.

– I hang on the side and try and concentrate and visualize my path. Deep breath and go. No sweat, I pop up in front of the engine. There's Gary. "Hi Gary!" "Hi Steve!" "Hey, I found Steve"

[HERE, THERE IS A DRAWING OF A FACE.
CURLY HAIR, BEARD, FACE ALL BLACK WITH
ENGINE OIL EXCEPT FOR WHITE TEETH,
WHITES OF THE EYES.
AN ARROW POINTS TO THE DRAWING
WITH NOTATION: "GARY – THE BILGE RAT"]

– *Silence from the other side of the bulkhead. Fearing the worst, I say hello and hear Pete & Dave. Gary & I talked for a minute, then into the fo'c'sle.*

– *Gary had comfortable arrangements. Lots of room, dry places to sit, good air, a flashlight that turned on as the boat went over. Pete & Dave were standing in water up to their chests in the cramped fo'c'sle. The air was stale when I got in there. But the company was good and in good spirits. We all went back to the engine room for a few minutes. Then swam out.*

– *Things looked good. We were all O.K. The boat was floating very well and not taking any water. The sun was out. And we were quite a ways out of the surf. We sat out of the slight northerly breeze and soaked up the sun and talked. It was very pleasant compared to the 4 hours previous.*

– *After a bit we notice that our S. Westerly progress has stopped. We occupy our time trying to determine our direction. It becomes apparent that we are drifting back to the north and inshore, too. We start to worry and make a few attempts to get the anchor out. Failing that, we sit back and wait.*

– *a noise*

– *a buzzing noise*

– *an airplane that comes nearer and nearer and finally right over and wags its wing.*

– *a short time later we see the motor lifeboat.*

[THERE FOLLOWS TWO PAGES OF DRAWINGS:
A MAP SHOWING THE POSITION OF THE LADY-FAME
RELATIVE TO THE HUMBOLDT BAY ENTRANCE JETTIES
AND THE SEA BUOY AT THE TIME OF THE INCIDENT,
6:00 A.M., WITH A DASHED LINE SHOWING THE CAPSIZED
VESSEL'S DRIFT UNTIL 11:00 A.M. –
THE ARRIVAL OF THE COAST GUARD;
DIAGRAMS SHOWING POSITIONS OF THE ENGINE ROOM,
THE FO'C'SLE, ANCHOR BLOCK, CRAB BLOCK,
AND WHEELHOUSE DOOR.]

[The humboldt bay light is mounted
fifty-seven feet high on a tower north
of the jetty near the brick and concrete
remains of the original lighthouse,
now covered by shifting sand.
That brilliant white light, flashing every
four seconds, illuminates the beach and
the rusted roof of an old cutdown
volkswagen® beetle, drowning, forever
stuck in the side of a high dune.
Wind and rain have pulled the sand
away from the car's side, partially revealing
a black door, and that brilliant white light,
every four seconds, now lands on
a red star painted there —
a red star with an eye.]

*For Steve*
*1948 - 2019*

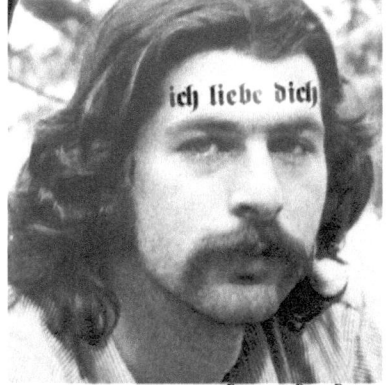

PHOTO - RON BAKER

*Steve, 1971 (shown here with tattoo).*

Steve Dockter spent half of each year sailing the Sea of Cortez and the other half in Humboldt as a builder, sage and highly sought out dinner guest. This book and its author, this Sea Story and its teller, would not exist today if not for his efforts on that day, December 24$^{th}$, 1972.

*Pete, 2014 (shown here with beard).*

Peter Santino is a contemporary artist who lives in a hundred year old house in Eureka with his wife, Shirley Lee Santino, the Editor of this book (and that title, Editor, would suffice had we left it at four drafts and a single galley proof. But something happened during additional passes through: each page read again and again, examined for visual and narrative strength; the two of us side by side, left brain, right brain; with lifelines to our wise offspring, Luciano and Hazel – only then did *LADY-FAME; or, The Fluke* find its sea legs).

My heartfelt gratitude to the many supporters of this endeavor.

Small, sad and necessary edits were made for this 2nd Edition. [PS]

*The Spotify® List*

♪ LADY-FAME PLAYLIST ♪
From the beginning of this LADY-FAME project, I felt there had to be music. A soundtrack of the music of that moment; music we listened to in cars, in bars, at WACO and on the LADY-FAME.
The list that follows is available free as streaming music on Spotify.com.

♪ *Roundabout*, Yes
♪ *Baba O'Riley*, The Who
♪ *Mississippi Queen*, Mountain
♪ *Seemann, deine Heimat ist das Meer*, Lolita
♪ *Ooh La La*, Faces
♪ *You're So Rude*, Faces
♪ *Drug Store Truck Drivin' Man*, The Byrds
♪ *Roundabout*, Yes
♪ *Suzanne*, Leonard Cohen
♪ *Sugar Magnolia*, Grateful Dead
♪ *This Side*, The Firesign Theatre
♪ *The Parable Of Ramon*, Richie Havens
♪ *Candy Man*, Roy Orbison
♪ *Do You Know What I Mean*, Lee Michaels
♪ *Venus*, Shocking Blue
♪ *Willie The Pimp*, Frank Zappa (Captain Beefheart vocal)
♪ *In C*, Terry Riley
♪ *A Rainbow In Curved Air*, Terry Riley
♪ *Communication Breakdown*, Led Zeppelin
♪ *Come And Get Your Love*, Redbone
♪ *Whole Lotta Love*, Led Zeppelin
♪ *Groovy Situation*, Gene Chandler
♪ *Here Comes The Sun*, Richie Havens
♪ *Astral Weeks*, Van Morrison
♪ *Cyprus Avenue*, Van Morrison
♪ *Something In The Air*, Thunderclap Newman
♪ *I've Got A Tiger By The Tail*, Buck Owens
♪ *The Rapper*, The Jaggerz
♪ *You Ain't Goin' Nowhere*, The Byrds
♪ *Time Has Come Today*, The Chambers Brothers
♪ *Raga Kausi Kanhara*, Ravi Shankar
♪ *Morning Glory*, Tim Buckley
♪ *Bold As Love*, Jimi Hendrix
♪ *Draft Morning*, The Byrds
♪ *Wasn't Born to Follow*, The Byrds
♪ *Abba Zaba*, Captain Beefheart & His Magic Band
♪ *Ballad of Easy Rider*, The Byrds
♪ *Have You Seen Her Face*, The Byrds
♪ *Happiness Runs*, Donovan
♪ *Sin City*, The Flying Burrito Brothers
♪ *It's A Shame*, The Spinners
♪ *Cross My Heart*, Phil Ochs

*The Spotify® List*

For easy access to this playlist: www.santino.tv/LADY-FAME

James Barton, *Wand'rin' Star (Both Steve and I prefer Lee Marvin's version from the 1969 film)* ♪
Marty Robbins, *El Paso* ♪
Grateful Dead, *Uncle John's Band* ♪
Johnny Cash, *A Boy Named Sue* ♪
Gene Autry, *Back In The Saddle Again* ♪
Chad & Jeremy, *A Summer Song* ♪
Peter & Gordon, *A World Without Love* ♪
Robert & Johnny, *We Belong Together* ♪
Sly & The Family Stone, *Thank You (Falettinme Be Mice Elf Agin)* ♪
Looking Glass, *BRANDY* ♪
Bill Withers, *Use Me* ♪
The Raspberries, *Go All The Way* ♪
Bob Dylan, *All the Tired Horses* ♪
Brook Benton, *Rainy Night In Georgia* ♪
Norman Greenbaum, *Spirit In The Sky* ♪
Steve Reich, *It's Gonna Rain* ♪
Captain Beefheart & His Magic Band, *Safe As Milk* ♪
Neil Young, *Heart Of Gold* ♪
Cat Stevens, *Here Comes My Baby* ♪
Sly & The Family Stone, *Hot Fun in the Summertime* ♪
The Flying Burrito Brothers, *Hot Burrito #1* ♪
The Incredible String Band, *The Juggler's Song* ♪
The Hollies, *Long Cool Woman (In A Black Dress)* ♪
Sam Cooke, *You Send Me* ♪
Little Feat, *Dixie Chicken* ♪
The Incredible String Band, *Sleepers, Awake!* ♪
Hugh Masekela, *Grazing In The Grass* ♪
The Byrds, *Jack Tarr The Sailor* ♪
Ray Stevens, *Everything Is Beautiful* ♪
The Rascals, *A Beautiful Morning* ♪
Gilbert & Sullivan (D'Oyly Carte Opera Company), *Captain of the Pinafore* ♪
Donovan, *Atlantis* ♪
The Mills Brothers, *Asleep in the Deep* ♪
Jean Knight, *Mr. Big Stuff* ♪
Harold Melvin & The Blue Notes, *If You Don't Know Me By Now* ♪
King Floyd, *Groove Me* ♪
Chairmen Of The Board, *Give Me Just a Little More Time* ♪
Sam Cooke, *Touch The Hem Of His Garment* ♪
Clarence Carter, *Strokin'* ♪
Leonard Cohen, *Sisters of Mercy* ♪
Steve Reich, *Music for 18 Musicians* ♪
Charles Trenet, *La Mer* ♪
Phil Ochs, *Pleasures Of The Harbor* ♪
Sam Cooke, *A Change Is Gonna Come* ♪

www.santino.tv/LADY-FAME

www.ingramcontent.com/pod-product-compliance
Lightning Source LLC
Chambersburg PA
CBHW021810170526
45157CB00007B/2531